THE BUSINESS OF STUDIO
PHOTOGRAPHY

AMF
CIR

THE BUSINESS OF STUDIO
PHOTOGRAPHY

How to Start and Run a Successful Photography Studio

Edward R. Lilley

ALLWORTH PRESS
NEW YORK

Published by Allworth Press
An imprint of Allworth Communications
10 East 23rd Street, New York, NY 10010

Cover design by Douglas Designs, New York, NY

Cover photo © 1997 Edward R. Lilley

Book design by Sharp Des!gns, Holt, MI

ISBN: 1-880559-66-8

Library of Congress Catalog Card Number: 96-79669

Contents

Contents

Preface

This book is dedicated to those people who have chosen to make studio photography their full-time occupation. This is not to dismiss part-time photographers as insignificant, but my major concern is with those photographers who have risked everything they own on their new profession. You know who you are, and you know what the cost of failure is.

The two major assumptions I am going to make at the beginning of this book are (1) that you want to be successful, and (2) that you want to make a good living doing what you love to do, photography. If you want to fail, you don't need to read any further! If you want to stay poor, save your money and don't buy this book.

Carl Van Clausewitz wrote, "Many assume that half efforts can be effective. A small jump is easier than a large one, but no one wishing to cross a wide ditch would cross half of it first." It is a hard fact of business life that if you can't focus all of your energy into your business, you stand a high chance of failure. If you have to devote energy to a second job to insure an income, you'll be stealing time from your new business, which is courting failure.

To quote Bruce Williams in his book, *In Business for Yourself*, "The current estimate of failed businesses is 400,000 annually in the U.S. These businesses failed for a lot of different reasons, but let me point out the one that is seldom mentioned, lack of commitment. They failed because the going became rough, and the part-time business was exposed for what it really was, a hobby." In this book I am going to assume that when the going gets rough, you will have to buckledown and make your business work, not quit and go back to your old job.

I also want to stress that the information contained in the following chapters is aimed at the new studio business. More established studio owners may find fault with some of the approaches to business contained herein, and they might debate the details. That is OK. These ideas will work for you, and hopefully you will outgrow them.

Introduction

I wrote the first edition of this book because I saw a huge gap in the materials available to new studio photographers to read about being in business. There are tons of books and tapes on photographic technique and on sales/marketing techniques, but there is very little about starting a new business. Helping you start your new business with the fewest bruises and the least amount of wasted energy is what this book is all about.

The important thing you need to know about my background is that I was almost entirely self-taught in photography up until the time I decided to go into full-time studio photography. I opened my first business right after I quit graduate school (about six months short of finishing my Ph.D. in space physics). My wife Sue and I, with our one-year-old son Hayes, left the ivory tower for the reality of business. I thought I knew a lot about photography and had an extra strong dose of self-confidence. Our first business was a flop. To put food on the table, I worked in a camera store where I learned about business and selling. I also met some potential customers in the wedding and portrait areas.

On March 15, 1974, Sue (carrying our second son Bryce) and I borrowed three thousand dollars from a bank and opened up E. R. Lilley Photography in an old hardware store on a main business street in Lethbridge, Alberta, Canada, a town of about 50,000. I opened a photography studio without ever having been in a proper professional studio before, and that was a mistake. Luckily, in Lethbridge the other studios were wise enough to realize that a sincere effort by a floundering newcomer could not hurt them. They helped me to get on track through local, provincial, and national professional associations. I attended every seminar, convention, and workshop I could to learn technique and business skills. Sue learned finishing, retouching, and selling and became a vital part of our business.

As we were originally from New England, Sue and I eventually grew homesick. In late 1978, we sold our by-then-very-successful studio, packed the three

boys (Wyeth was one year old) into the station wagon and headed east to beautiful Cape Cod. The cost of our new home and an unanticipated delay in the sale of our Canadian house left us with almost no money to finance the new studio in this totally different market. That was a tough year, but we made it work. We made a decent profit and started growing. By 1986, I had been elected president of the Professional Photographers Association of New England, president of our local business group, and appointed to the most powerful committee in the town government.

In 1987, we decided to build our dream studio and invested $250,000 in a new building attached to our home. Relying on my usual sense of economic timing, we chose to build at the peak of the real estate market. The nineties mini-crash followed and life got interesting for a while. In 1990, I finished the first edition of this book after four years of off-and-on work. The responses to the first edition were wonderful, so I decided to do a second edition. This edition is leaner. I have eliminated the two technical chapters. There are many other sources for technical information for you to read, so you don't need mine. I personally think the best guide to building and using a studio camera room are Dave Newman's books, and I strongly recommend that you buy them. (See chapter 12 for information.)

I have updated many areas because in the four years since the first edition was published many things have happened. We went through a mini-depression, have seen the rise of digital imaging technology and the spread of the franchise studio options, all of which I cover in the text.

If one learns from making mistakes, you are reading the writings of the smartest man in the world! I have made more mistakes in my business life than any of you will ever make. Trust me on that point. Learn from my mistakes. Save yourself some pain and suffering. To quote Harry Truman, "The only things worth learning are the things you learn after you know it all."

I also have an attitude. I enjoy photography both as a personal outlet and as a job. I have learned that I am not the best technician or the most formal person in the world. In fact, "rules" bore me. I have tried to keep my observations about business on a chatty, person-to-person level. When I write down a Lilley's Law, it is usually something I have learned the hard way, which I think might be valuable for you to learn, too. I do not make up rules flippantly.

I also have not tried to teach you my "style" of photography. It is my style, not yours. You must develop your own style. There are many gurus out there selling tapes on style and technique. Listen to them and learn from them, but don't take anything as gospel until you try it out and see if it fits your own growing style and locale.

I have another attitude that may benefit you. I believe strongly that you can succeed! I am a very positive person in this regard. I encourage my local peers in this business, and many of them have succeeded. The nicest compliment given to me was by the Professional Photographers of Cape Cod (a group which I helped found) when they gave me a plaque (with a camera and a lobster on it) and a poem. The poem is my peers' opinion of me, and I think it's true.

> We feel it is time for a tribute to Ed
> For all that he's done there is much to be said.
> When he came to the Cape most of us were not here,
> Or maybe just trying to get it in gear.
> He counseled, encouraged, and challenged us, too,
> To do even more than we thought we could do.
> He gave of his talent and gave of his time

To help us along on our upward climb.
Some of us would not have been where we are
Had he not inspired us to reach for a star!
There's business enough for us all he decries
Competitors—sure—but friends and allies.
As members of PPOCC were gathered today
There's no need to gild this Lilley we say
Now it's time to bring this poem to an end
Our tribute to Ed, our mentor, our friend!

There are many people I have to thank for helping me with this book. The two biggest supporters of the first edition were H&H Color Lab (thanks Wayne Haub and Ron Fleckell) and Burell Color Lab (thanks Kevin Raber). They believed that I could help make better photographers of their customers, which would benefit both their customers and their own businesses.

Again, thanks to Macintosh for the best computer. Thanks to Jennifer Goodnough for being the proofreader and my mentor for proper English and communication skills. I would also like to thank Mr. E. Carl Cierpial of California, one of the first purchasers of *Making It Click!,* for his painfully accurate list of errors in the first edition. He was correct in every instance, for which I thank him.

This book is dedicated to you, the new studio photographer. You have no idea of how far you can go, up or down. I do, and I hope that this book can make your path smoothly upward.

This book is also dedicated to Sue, my beautiful wife and business partner of almost thirty years, to my three sons Hayes, Bryce and Wyeth, and to Jim and Jennie Goodnough who share our business dreams and efforts, and most of all to good friends and better competitors, here and everywhere.

ED LILLEY
Harwichport, Massachusetts

Note: In the text, I refer to books by the author and title only. Publisher and date are listed in chapter 12, "Sources of Information." Names and addresses of organizations, publishers, and suppliers are also listed in chapter 12.

Getting Ready

You can't play at work! —Tom Hopkins

George Burns defined success in his early days in vaudeville (before Gracie Allen): "I worked with anything or anybody that would work with me. I thought I was a success because I loved what I was doing. In other words, I'd rather be a failure in something I love than be successful in something I didn't."

This thought applies to most beginning photographers. They are in love with the craft and art of photography, and that is almost enough reward in and of itself. Money doesn't seem to matter, at least at the start. Money becomes more important when the kids go hungry and the bills need to be paid, and most importantly, when one's ego needs satisfaction other than pride.

Tom Hopkins, a nationally known sales trainer and motivational speaker, defines success as, "Achieving one's written goals, setting new goals, and continuing onward with life." The bad news: if you count financial security and a high standard of living as a measure of success, you are entering the wrong profession. There are very few studio photographers who can net over $50,000 per year, and those who do have had a long hard struggle to establish successful businesses. There are many other professions that return higher dollar rewards for the same amount of effort required in photography.

If you think that having a regular lifestyle is important, again, you have chosen the wrong profession. Like most service businesses, you have to be available when the clients can come into the studio. Clients do not care about your schedule, and, until you have established a reputation and a select clientele, you have to go with the customer's schedule. Most established studios have periods of being very busy followed by periods of almost no business. These peaks and valleys can play havoc with your nervous system as well as your cash flow. If you are in the portrait/wedding business, 60 to 70 percent of your income will be made on weekends, so forget about Saturdays off with the kids.

The good news: if some of your personal goals in life are independence from

anyone other than your clients; warm and intimate contact with other humans on a one-to-one basis; giving pleasure and meaning to other people's lives; to do different and sometimes exciting things and to meet interesting people; and to create skills so that you will never fear being out of a job anywhere you want to go in this world, then studio photography may be the profession for you.

To me, success is the ability to say to myself that I am in control of my life; that I do not have to ask anyone outside of my family for permission to do anything. I want to walk down Main Street of my town and have people smile at me and respect me for who I am. I also enjoy sharing some of the most intimate and important moments of people's lives, at their weddings, graduations, banquets, and other events. I want to travel, meet new and interesting people, and to give as much as I receive of the human spirit. I also want to earn a good living so that my family can share the American Dream. I do not think I will ever grow rich through photography alone, but I will earn a good living. If I invest some of it wisely, I hope to someday be able to sit back and enjoy my golden years in comfort. Most of all, I do not ever want to stand in line to kiss someone's posterior to get anywhere in life. I am my own person, for better or for worse.

The goals section of chapter 9 will help you to learn methods for determining your own goals and choosing your path to achieve them. Once you have thought about where you are going, you have to plan a course of action to get there. That is the purpose of this book, to help you get started on your path to success. Periodically, you have to re-evaluate your goals and your path and adjust them for new circumstances in your life. That is why there can be no one way of doing anything, only an outline for you to proceed forward in life. You must make your own path to reach a unique goal.

What Type of Person Can Succeed in Studio Photography?

Stephen Harper, author of *Starting Your Own Business,* says, "Most people believe starting a business is a labor of love. Most entrepreneurs are quick to acknowledge that the labor often exceeds the love."

Twelve general characteristics of the successful person are: (1) Appearance—you don't get a second chance to make a first impression. Clothes don't make the man, but can kill a sale! Don't overdress if it is not you, but don't underdress for "effect." (2) Pride—in work, in success, in professionalism, in self. (3) Confidence—the faith in skills, techniques, equipment, and ability to handle all situations, no matter what. (4) Warmth—likes people, enjoys their company, loves their love. (5) Assurance—looks confident, acts directly, no wasted motion. (6) Wants just reward for hard work—demands to be paid what he or she feels he or she has earned. (7) Desire to achieve—wants to be better, always. 8) Ability to overcome fears—shortcomings, fear of rejection, fear of failure. (9) Enthusiasm—looks and acts like it's fun and exciting. (10) Caring—is truly concerned with welfare and lifestyle of his or her clients. (11) Doesn't take rejection personally—in business, business is business, and rejection is part of any business. (12) Continually educating himself or herself to be better—never satisfied with self. Always seeking out those he or she respects and learning from them, plus exploring new ideas and areas on his or her own.

John Kenneth Galbraith, famous economist, in a study of why there is poverty in a free society, made a profound realization. He observed that no one person is "placed" in poverty in our society, but that people learn to "accept" poverty as their place in life. He termed this mental process "accommodating to poverty," and pointed out that people in a free society such as ours always choose the economic level they'll accept, it is never thrust upon them.

Certain people may have bad luck or suffer from repression and injustice, but it is up

to each individual to respond to negative circumstances by making things better, not to lay down and accept his or her circumstances. What are you willing to accept? In your personal life, in your professional life, and in your business? Think about it.

Getting Started in Business: General Requirements

Here are some thoughts from the excellent book, *So You Want to Start a Business,* by William Delaney. Five things an entrepreneur needs are drive, thinking ability, human relations ability, communications ability, and technical knowledge.

Also, are you willing to gamble with your own money? We all make mistakes, but do you learn from making mistakes? "Learn from the mistakes of others. You can't live long enough to make them all yourself," said Martin Vanbee. You must be a doer, not a follower. You must be an optimist and be persistent. You must accept responsibility when things go wrong. You must have gut feelings about your business. If you can't feel it, you'll fake it, which won't work for long. You must realize that being in business is not a one hundred meter dash, it is a marathon.

Coming to Photography from Another Business

In my years in photography, I have met a few people who came into photography after being successful in other types of unrelated businesses. What I have observed is that even though they had the same minimal technical skills as the majority of entry-level photographers, within a few years they were making a good profit and were well on their way to excellence in professional photography.

The point is that these people made most of the mistakes in their first businesses and could apply their business knowledge to photography and be financially successful. I often think that I could go into another business venture and do well, after learning the specific knowledge required by the business. The other point is that you have two things on which to concentrate when starting a studio: going into business, and going into photography.

Getting Ready

Begin where you are. But begin. Act. Move—just don't stay where you are.
—AUTHOR UNKNOWN

A good friend of mine once looked into purchasing a McDonald's franchise. He applied, had some financing available, and met with the people from the head office. They told him that in addition to the money for the land, building, and business, and the fees to McDonald's, he wouldn't be accepted as a franchisee unless he committed to working eighty to one hundred hours a week in the store for the first year. They knew that in the beginning, to make any business run properly, the owner/manager has to be there, running the business. From counting the money to sweeping the floors at the end of the day, you have to be involved. Without this time commitment, you're courting failure, even with an established business such as a McDonald's where there is a formula for doing everything and a strong support system for a new manager.

If you are going into a new photography business, you must be able to make this type of time commitment to your business. For the first year, you will be working a lot of hours, and lots of days. Don't plan on a vacation or too many relaxing Saturday afternoons with the family. These things will come, but only with hard work and time. The

formula for success in this book requires that you add a lot of sweat, love, and time. Your eventual reward will be success, pride, love, and money.

There are speakers on the lecture circuit who will preach that you don't have to work as hard as I will describe in this book or spend as many hours in the studio as I am going to tell you. They present a polished selling format for making a living out of three portrait sittings a week and two weddings a year. The "secret" is to get these few jobs to pay you thousands of dollars each! The other "secret" that they don't tell you is that to get those few big spenders into the studio you need a good reputation, which only comes through doing business in the lower strata of the consumer market for many years. They also don't tell you that the selling skills required to achieve the big sales are as difficult to learn as any of the technical skills you work on in learning how to take good photographs. Some of the lecturers you hear advocate selling techniques that I personally think border on deception and trickery. If every sale leaves a bad taste in your mouth, can you look at yourself in the mirror in the morning? Be careful, it's a jungle out there!

Beware of people selling books and tapes that promise to show you "the way." They are in the book/tape business, not the photography business. You are their target market, and they could care less if you go bankrupt in a year; they have your money.

Service: a studio photographer is in the service business. If you wish to be successful, recognize this fact immediately. You are not a rare artist, a valuable craftsman, or an indispensable personality. You are there to serve your customer. Commit yourself to the concept of customer satisfaction, or even better, of customer euphoria! Give your clients more in value than they expect, which is the best way of reminding them that you were the correct choice for their job.

Customer satisfaction doesn't necessarily mean that "the customer is always right." Generally, a photographer's customers have no idea what they are buying, but at the end of the transaction they understand and they appreciate what you did for them. Mix customer education, coaching, and salesmanship.

The Three E's: What You Need to Be Successful in Your New Business

When starting out in the photography business, what do you need? I would like to say you need a two-year degree from Brooks Institute and a portfolio review by a committee of your peers. Unfortunately, or fortunately, in this country, the only requirement needed to call yourself a professional photographer is to have the ink dry on your business card and a fresh roll of duct tape. There are no tests, no standards, no limits, no preconceived notion of what you should be, and no requirements on the quality of your work by anyone other than your customers.

To start in professional photography, you need only two things, but you'll need a third to succeed. The three are energy, enthusiasm, and excellence.

Energy requires no skill or talent, just the drive to put in both the physical work (long hours, long days, long months) and the emotional strength to animate your clients. When photographing people, you must provide the energy most of the time. After a long hard week, it is not easy to keep up your energy at the late wedding on Saturday, but you must because that is your job.

Enthusiasm for yourself, for your client, for photography, for life! If you don't look like you're enjoying your work, then your client won't enjoy working with you. Even when you are feeling sick you must look like you are sincerely having fun. People are extremely sensitive to false or forced actions. You can fool some people some of the time, but faking it won't work in the long run. If you don't love what you are doing, it shows. Studio photography is not just a job, it has to be an obsession. If the only thing you look

forward to is quitting time, do us all a favor, quit permanently, and go do what you really want to do!

Excellence is the skill part. When you first start, you probably have some skill with a camera. You have a lot to learn; we all do. You can produce pleasing photographs with minimal skills and lots of energy and enthusiasm. To succeed in the long run, you have to add technical refinement and develop your knowledge of technique, materials, business, and people. To be successful, don't ever stop learning and growing.

Excellence is a state of mind. It does not mean being the best, but being the best you can be. It means always looking at your work critically to see what's good and what's not good about it. It means constantly monitoring your exposures and your negatives. It means reshooting sittings because you didn't think they were good enough. It means sending work back to the lab because it was printed the wrong color. It means you care about the photography you deliver to your clients. It means you seek and accept criticism of your work in a constructive and productive manner, as a means to improve yourself and not as an affront to your ego. You want your work and your client's prints to look as good as you can make them.

Energy and enthusiasm are personality traits which you either have or don't have. Energy is a trait that must be harnessed to work for you. You must plan your time to direct your energy to the most productive areas of your work. You must conserve your energy for long shooting days so that you don't burn out. You must reach deep down sometimes to finish important jobs late at night and still have something left for the morning shoot.

As you get on in years, the energy gets a little harder to come by. You must remain physically fit to maintain your ability to generate energy. Get into a regular physical fitness routine to keep your body in good shape. You must maintain your health as best you can, which sometimes becomes more difficult as you get busier.

Enthusiasm is inherent in your personality. It can also be enhanced with acquired skills. People show enthusiasm in different ways. Learn those ways and show yours in the way best suited to your client of the moment. You can learn tricks to get your self "hyped-up" for a tough or unpleasant job, or to help when you're physically ill but have to carry on. There is a wealth of information on motivating yourself and doing your best. In chapter 12, you will find information on such speakers as Zig Zigler, Brian Tracy, and Tom Hopkins. These men produce audiotapes and books to help you rekindle and then channel your enthusiasm.

Enthusiasm can wane with experience and familiarity. Department store photographers start off with lots of enthusiasm, but often, after a few months of screaming kids and endless lines of mothers, they lose their edge. The job becomes a bore. Too much of anything will crush the creative spirit. You must learn to deal with this. Vacations, learning new photographic techniques, trying new marketing approaches, and involvement in activities outside of photography are all things which keep you fresh.

Energy without control = chaos

Energy + Enthusiasm without Excellence = amateurism

Excellence without enthusiasm = boredom

Zig Zigler says, "Efficiency is doing things right. Effectiveness is doing the right things."

Excellence in Business: What the Best Companies in America Have in Common

One of my favorite business authors is Tom Peters, author of *Excellence in America, In Search of America,* and *Thriving on Chaos.* These books contain studies of large and small American companies that compete effectively against Japanese and German companies

in the world market or are just considered the best in the domestic market. What applies to these companies (some of the examples consist of only one retail outlet) applies to small companies like your new studio business. Here are Tom Peters's eight attributes of excellent companies: (1) A bias for action—do something, anything. Don't be afraid to experiment. Don't mindlessly follow traditional ways of doing things. (2) Stay close to clients. Listen closely to them and conform your business to their needs. (3) Autonomy and entrepreneurship. That's a small studio. Don't hook your star to anyone else. (4) Simple form and lean staff. Don't complicate your format, and don't hire people just to get bigger; operate more efficiently instead. (5) High productivity through people. Since the staff is you, you must be productive, i.e., produce a high return for time invested. (6) Hands-on, value-driven. Be involved in all aspects of your craft and business. Don't delegate important management tasks to others. Base your actions on the basic business values of customer satisfaction, pride in workmanship, and efficiency. (7) Do what you know best. Don't try to be all things to all people at all times. Focus on areas where you are good and where there are customers who need your talents and skills. (For example, stick to photography and don't try to do video.) (8) Within your system of values, be flexible.

Harnessing Your Energy and Getting Organized

I always love the old sports coach pep talk, "Give 110 percent." This is pure nonsense and has nothing to do with reality. If you gave 100 percent you would die because there would be nothing left. Most people go through life giving only a small percentage of their energy to anything that they undertake. If we could only learn to tap our potential more fully; to give 50 percent, 60 percent, or even 70 percent of our energy to any particular task, we would succeed greatly in anything we attempted to do. An example of harnessing your energy and controlling your use of valuable time is the simple practice of writing down the night before six things that you will do and complete the next day. The list of things may include simple tasks such as, write a new price list, call the ABC frame company and order new stock for the Christmas season, or get the Jones's wedding proof book finished by 3:00 P.M. When you write down these tasks, make sure you follow through systematically. Complete each job. When the list is completed, you will have actually accomplished something. If you don't do this, the tendency is to start one job, get interrupted by the phone or a client, start another project, etc., etc. By the end of the day, you have five or six jobs half-done and none completed, and Mrs. Jones is mad at you because her proof book was not ready at 3:00 P.M.!

It sounds so simple, yet it is one of the most powerful tools you have in your fight against inefficiency. Write down what has to be done in a given day, and then do the tasks in the order you wrote them down. One completed job is worth five unfinished jobs. You will go home at the end of the day feeling much better about yourself and life if you know you have done something productive. Going home with unfinished work on the bench is frustrating and inefficient. Read Lee Iacocca's autobiography to see that even at the high corporate levels you have to do one thing at a time and see that thing through to completion before starting on a new task.

Art Versus Profit

Many people begin a career as a studio photographer with the feeling that they are "artists" and should be treated as such. This is one of the worst mistakes in attitude you can make at the start of your career.

Photography (with a capital P) is an Art (with a capital A) as done by a few people. However, as done by most people, photography is a craft, i.e., an area of skilled workmanship in the production of a graphic product. There are photographers out there stretching the frontiers of our senses, making exquisite statements about our world, our inner and outer selves, or simply taking our breath away with the majesty of their vision and sensitivity. Then there are the rest of us; the other 99.9 percent of us who work with photography to produce pleasing, salable images. Don't trip over your own feet because your head is in the clouds.

My definition of Art has a capital A. True art stretches the mind and requires genius levels of expression, thought, and sensitivity as well as great craftsmanship in the medium of choice. All great artists are great craftspeople. They know and use their mediums with skill that allows them to express themselves as no one has ever done before.

I live in an area known as an artist colony in the United States, yet I know of only a few people who can consistently get over $5,000 for a canvas (which may have taken a month to complete) and only a very small number who can net $50,000 a year from the sale of their artwork. This profit most often comes from a lot of physical work and good marketing skills. The vast majority of "artists" in this world are dabblers who are doing it for the love of it, not for profit. While there is nothing wrong with doing something for the love of it, isn't that the definition of an amateur? Successful artists make money the same way successful photographers do; they know how to market their products and skills actively and they work at it full time.

In the narrow world of photography there are very few, if any, photographers (after the death of Ansel Adams) who can make a good living from the sale of their art prints alone. Most of the big names in the art photography world have to take commercial assignments and/or get grants from institutions to continue with their work and feed their families.

I find no problem with thinking of myself as a craftsman rather than an artist. I strive to make my craft better and dream about having that inspiration or insight into life that would make me an artist. Photography at a personal level is still an outlet for my creative spirit, but I never expect to make any financial gain from it.

If your customers want to call you an artist, do not discourage them. Encourage people to associate your name with art and artists, but don't fool yourself.

Note: While you may not be an artist, you work in a field of art. You should strive to know as much about photography as befits a professional in any field of art. You should know the history of photography and be conversant with the current trends in photography.

The First One Hundred Customers and the Chain of Success

You want to offer products that don't come back, and offer them to people who do.
—STEPHEN HARPER, *Starting Your Own Business*

Just because you have a business card in your wallet doesn't mean everyone in town is aware of you. You have to go outside your place of business and promote yourself. Advertise within your budget. Get all the freebies you can. Make cold calls to commercial accounts. Do mailings to selected markets. Use all the marketing techniques described in chapter 5.

The most important thing for you to do in the first six months of your new (or a redirected) business is to get clients, lots of them. In the beginning of any business, the number of jobs completed counts as much as the dollars generated by those jobs. Do

any job at almost any price to get clients. Clients produce more clients if you have any skill or talent at all. A five-dollar copy job, if you did a good job and treated the customer right, may bring you a thousand dollar wedding. A simple passport sitting may get the family to come in, and they'll tell the cousins and neighbors, etc., etc. The trick is to use the lower income jobs to get higher paying jobs. You have to start with any job to make the chain of success work. The little jobs lead to bigger jobs, which in turn beget more bigger jobs, etc. This is the chain of success.

In the following chapters, I am going to make some recommendations that run counter to most advice you hear from popular speakers on the lecture circuit. The single most important thing for you to do to start a successful business is to get those first one hundred customers. As you develop skills and product quality above the bare minimums needed to start, you can become more selective in who you want for clients and how much you can charge them. For now, getting clients is paramount. Nothing else matters. You will do jobs for no profit, or at a loss, in order to get potential clients. You will spend hours on jobs that will earn pennies in order to get clients. Very few photographers can open a new business and charge top dollar for their work at the beginning and survive.

When we first moved to Cape Cod in 1979, there was a period of about two months when I couldn't do any photography because of renovations and replacing my studio equipment. We did have a sign on the front lawn saying "opening soon." One day in February, a woman knocked on the front door and said she "desperately needed slides of her paintings for PR work." The artwork was excellent, and the lady turned out to be a true professional artist who worked very hard at producing good paintings and marketing them correctly. This copy work was about the only job I could do with my lone 35mm camera. I did the job and delivered the slides. She loved them. In the next two years, this woman brought me weddings, reunions, portrait customers, and lots of fellow artists. She has become a dear friend, but it all started with a simple four-dollar copy job well done. You never know.

Being the new kid on the block usually means that you have to use price as one major incentive to attract clients. Don't be ashamed of being the cheapest when you're the newest. In fact, you are going to use these first hundred customers to practice on and learn your craft. Hopefully, you're going to get better. Most beginning professional photographers should rightfully pay their clients. Take your time and try to do your best on every job that you can get, no matter how much you may lose in the process. If you have to reshoot, or reprint a job ten times, do it. Get it right for the customer. Most intelligent people can appreciate a sincere (if not expert) effort, and it will add to your reputation as being a caring person (if not the most competent).

If you are any good, either as a photographer or as a businessperson, and you do not throw your money away or do rash and foolish things, and you are willing to work one hundred hours per week, you'll probably make it through the first year.

Friendly Competition: The Key to Enjoying Being in Business

Sue and I have always been blessed in this profession by having some of our best personal friends be our best competitors. I love competition, and I love to love my competitors. I actually had a studio right across the street from a friend's studio. Each morning we would look at each other's windows and think "How can I beat that sucker today?" We did it by going to seminars together, helping each other critique our own work, sharing ideas and techniques, and sharing many things in our professional lives. The competition kept us on our toes. It was also nice to go to conventions together, take trips with our families, and, most of all, to have an understanding shoulder to lean on when

things didn't go right. Who understands what you're going through better than a person who has done the same thing? When your professional abilities are good enough and you respect each other, there are also some (not many) joint ventures that can be of financial benefit to both separate businesses.

Most established studios are a little leery of new studios. It is up to you, the new kid on the block, to make contact with them. Call for an appointment to introduce yourself to the owner. When you go, do not attempt to tell them how to run their business. Explain how you are approaching your business (honestly and fairly) and that you would like to be their friend. Bring a sample album or some sample photographs. In most cases, they will think of you as a new friend and send you some business, mainly wedding referrals for booked dates, portraits/commercial jobs for people who don't want to pay their prices, etc. What may be junk work for an established studio can be good work for a studio just starting to build up a business. If you don't make the effort to at least go and talk to your competitors, they will usually form a negative opinion of you, and you'll get nothing but negative publicity and no work. If they give you the cold shoulder, don't get mad, get sad. Any person who snubs a sincere effort by another doesn't deserve the title professional.

When you enter an established studio, do so with some respect. You may think you're the hottest photographer in creation, but you have not yet established a track record. The established studio may feature boring or technically poor photography, but they have established themselves for some reason. Listen and look, but never comment on the business reputation you may have heard about the studio or the quality of the work on the walls unless it is sincerely positive. If you're going into a good studio, look, learn, and listen. Try to promote friendship. Never bad-mouth a competitor, no matter how bad it is. It doesn't do you any good, and it hurts professional photography in general. If a potential client says, "I heard that Jones Studio across the street drugs children to make them sit still," you should defend its reputation. If a potential client complains about the other studio's high prices, respond not by agreeing, but by selling your good points (which are usually cheaper). Sell yourself. Don't downgrade the competition. No one is really the "best." That judgment is in the minds of the customers. You won't look better by lowering the level of your competitors. Do not ever comment on anything you don't know to be an absolute truth.

I have also seen established studios start slur campaigns against each other, using both mail and public advertising to downgrade each other in the hope of stealing a few high school seniors. In all the cases I have witnessed, both studios lost, in term of customers, reputation, and overall profit. There is nothing wrong with saying, "I'm the best," but you should never say, "I'm better than so and so."

What if an established photographer snubs you or, even worse, questions your pedigree and heritage and ability in public? Don't try to get even. Getting even is a personal emotion. This is business. Name-calling or revenge will cost you money and business. Instead, you should feel sorry for the other person. Become better than they are. Beat them in good photography. That is good business. Five years from now, you'll appreciate this course of action, even if they don't.

What You Need to Start

The following is a list of things needed to open a new portrait studio.

- Camera systems: a 2¼ system, a 35mm system (optional), a Polaroid passport camera (optional)
- Small to moderate black-and-white darkroom

- Lighting system for use both in the studio and on location
- Camera room equipment: tripods, backdrops, posing stools, etc.
- Computer
- Business licenses and/or permits (state, local, federal)
- Tax ID numbers, federal, state sales tax
- Business phone and Yellow Pages listing
- Sign(s) for front (one that just says OPEN) and for inside your studio
- Frames for sample photographs
- Stock of frames for sale *(See note 1, below.)*
- Stock of mounts, folders, folios, mountboard, etc. *(See note 1, below.)*
- Stock of bags, wrapping materials, etc.
- Sample wedding albums
- Stock of proof books/albums
- Couch and three chairs (minimum)
- Round table (high or coffee) for sales room
- Small bookcase for sample albums, small frames
- Shelving for frames and other displays
- Filing cabinets for negatives and paperwork
- Coat rack
- Lighting for sample photographs
- Stand for samples
- Large easel for display
- Printing calculator, cash box
- Insurance: liability, equipment, health *(See note 2, below.)*
- Toy box (with toys) for children
- Work stools
- Desk accessories
- Stationery
- Receipt book, invoices, ledger book, daily cash sheets
- Retouching bench supplies
- Paper cutter
- Shelving for storage of orders, finished and in progress
- Camera room props
- Two slide projectors and a dissolve unit (optional)

NOTE 1: An established small studio usually has an in-house stock of frames, mounts, and folders worth from $4,000 to $8,000. When buying an initial stock of frames, mounts, and folders, exercise extreme caution. Only buy a limited number of frames for stock to sell. Buy a bigger variety for your sample photographs with the assumption you can order them if the customers want to buy. The same goes for mounts, folders, and folios. To start, pick a style that is available from a convenient supply house. Stock enough to meet week-to-week business. I know you can get much better unit prices on frames, mounts, and folders by buying large quantities of them, but if you are borrowing money to get started, any savings you gain by buying in quantity will quickly be eaten up in interest. Often a new studio owner misjudges and buys the wrong type of frames. This is money thrown away if you can't sell them within a year. Keep in mind that frames are not the highest percentage profit area of your business.

NOTE 2: Insurance is a necessity to run a business today, as necessary as film for your camera. You'll need liability insurance for your location, as well as an umbrella liability policy that covers you for anything that could conceivably happen anywhere you work.

Consult a number of independent agents about the various rates available. Check out various combinations of liability, personal property, equipment, auto, etc. Liability should be at least in the $1 million range through an umbrella policy. Ask your agent.

Equipment insurance can be attached to your home or business fire/personal property policy. These are called "riders," and they require a written inventory of items to be insured with serial numbers as IDs attached to the policy. Some riders only pay "depreciated" value on lost or stolen equipment (or "real value" as the insurance companies call it) and have severe limitations on coverage of equipment outside of your place of business. The most desirable policies insure for "replacement" cost for the equipment listed, and cover everything everywhere. Professional Photographers of America (PPofA) has an excellent equipment insurance program, and it is well worth considering. Use the PPofA policy as a point of comparison in shopping locally.

If you are married and have a family, you should have health insurance. A single person or a childless couple can chance going "naked," but there is a big risk involved. In my opinion, a couple with children cannot afford to gamble with their kid's future health. Health insurance is outrageously expensive. (I was paying $400 a month in 1995 for a $2,000 deductible policy!). Check your local independent agents for what is available. Also check on Blue Cross membership. Many times a local Chamber of Commerce will provide a group coverage with membership. Check to see what the Blue Cross enrollment requirements are in your state. I have also found out that Blue Cross is more expensive than some privately sponsored plans available through local agents. Shop around. Look at HMOs. Get a number of quotes from a number of insurance agencies.

Beware of policies that get you started at a reasonable rate and then raise their rates 20 percent a year. Many of the so-called associations for the self-employed are actually insurance-selling schemes that use this tactic on new businesses. Be wary of good deals in this area. Consult your regular insurance agent on various policies. He/she can usually get you the fairest deal, if not the cheapest.

If workman's compensation insurance is available for yourself, take it. If you get injured on the job, it pays you for the period you can't work. Unfortunately, this type of insurance is not available in all states to self-employed people.

Other types of insurance are: life insurance; business interruption (or disability) insurance, which pays the business bills when you get sick or injured; insurance on a partner, in case one dies, to enable the other to buy out his or her half of the business; hospitalization, etc.

If you bought every type of insurance offered to you, you would be broke very quickly. Get what you need, and shop around for it. But don't go naked. Each state and province has different requirements on insurance, so check on the minimum required by your area.

One advantage of having an American Express card is that for the $55-a-year membership fee you automatically get a great deal of free insurance. The card member has an automatic disability policy built in, as well as travel and auto rental insurance. When buying certain types of equipment with the American Express card, the manufacturer's warranty is also doubled and the item is protected from some theft and loss. Not a bad deal. Check out the exact details with American Express.

Getting Ahead Through Education

I love the story that's told about Vince Lombardi and the Green Bay Packers. Lombardi believed in the basics of the game of football, or any game for that matter. He believed that the team that performed the basics better would beat a team that concentrated on the fancy plays. He also didn't leave anything to chance. Every year at the first day of

training camp, he would gather all of his professional athletes around him, pick up the ball, and start: "Gentlemen, this is a football."

Starting out, you probably feel that you have some skill as a photographer, some level of technical ability that enables you to produce pleasant photographs of a person, scene, or an object. You also realize, by viewing other photographers' works, that it is much better than yours. How do you improve? This is a very basic question, and there is a simple (though not easy) learning process to help you. There are five simple steps to learning.

RECOGNITION: Become aware of your limitations and needs in specific technical areas by reading, visiting studios, going to conventions, and being involved in print competitions. Find someone who does well what you can't (or don't, or won't) do as well. Watch him; study her. He/she can be a platform speaker at conventions, own the studio across town, or have written a magazine article. Get some details. Get a sample of the technical goal so that you have something physical to aim for (i.e., the final image).

REPETITION: Try to perform the desired technique. Don't be discouraged by initial failures. Keep trying until you get it right. Avoid using the technique exclusively on a customer until you have almost perfected it. Mix it in with other techniques you have already mastered.

UTILIZATION: Use the new techniques on customers in your day-to-day business, in addition to techniques you know work well.

PERSONALIZATION: Make the techniques part of your toolbox of techniques, giving them those little twists that make them your own. Do not be afraid to modify the techniques to suite your style, personality, and studio equipment.

REINFORCEMENT: Periodically review your techniques. See if you're in a rut. Compare your skills with those of the person you learned from initially and with other respected photographers. Always look at your works as a group (not your best images or your failures separately). Always seek new techniques to keep you fresh (go back to step one). Never assume you are the best, or that "I always was able to do that." These are excuses to slide into a rut and to be satisfied with mediocrity. The only difference between a rut and a grave is the depth of it.

Joining Up: Getting Involved in Professional Organizations

If you are practicing professional photography full time, it is critically important for you to join your local and state Professional Photographers Associations (PPA) and perhaps the PPofA. Below is a list of groups available and some information on them. Refer to the names and addresses of many national, regional, and state organizations in chapter 12.

National Organizations

PPofA's full portrait/wedding membership includes "indemnification" insurance (if you get sued because you goofed up a wedding, for example), access to various insurance programs, a magazine, and a national convention. Send for a complete list of membership benefits. PPofA is nationwide and is the largest of the PPAs. Membership is expensive for what the average member gets. If money is limited, this one can wait.

PPofA does have programs for you to gain recognition, including the Certified Professional Photographer program, which can provide you with a marketable status in your community. There are also specialty groups on marketing that teach you a great deal about selling and promotional techniques.

Wedding and Portrait Photographers International (WPPI): The dues are considerably less than for PPofA. A spin-off of *Rangefinder* magazine, WPPI holds an annual conven-

tion and publishes very useful articles on wedding and portrait photography. It's a good bargain for information but not for making contact with other photographers in your area, as there are no regional or state affiliates.

Regional Affiliates

These are the second level and cover groups of states or provinces, such as New England (PPANE), the Rocky Mountain PPA, Southeastern PPA, Canada (PPOC), etc. These groups hold annual or semiannual three- or four-day conventions, sponsor print competitions, and many offer week-long training schools where you can get some useful education. Typically, dues are low and the programming top-notch. Membership in the regional affiliates is the best buy in the business, and you should join and attend.

State PPAs

State programs vary widely. Strong states have monthly or bimonthly meetings, annual conventions, all-day seminars, and various levels of print competitions. Good state organizations offer the photographer a great deal of educational and social interaction. The dues vary based on how the programming is charged to the members. Some states include all of the meetings for higher annual dues, while other states have lower dues, but charge for each separate program attended by the members. The state level gives you important contacts with other photographers in your area and broadens your view of what is going on in photography today in your state. I feel that the state level is a must for you to join. (In some of the larger states, sectional units serve a similar purpose.)

Sectional (Local) PPAs

These groups are usually more socially oriented and attract more photographers because of low dues, lack of competition, and more personal benefits. Locals can range from a single city, half a state, or portions of multiple states. A local group can be your best source of personal contacts. These are the people in your immediate market area. These are the people who can lend you a camera when yours breaks down, cover you at a wedding when you get sick, send you their overflow weddings, and, most importantly, become your friends. If you don't have a local group, form one.

Since coming to Cape Cod, we have helped form a local group, Professional Photographers of Cape Cod (PPOCC), among our competitors. The Cape is now a much better place to be in the photography business than when we first came here fifteen years ago. PPOCC has seminars, mall shows, cooperative media advertising efforts, and some of the best parties you could want to attend! We have a wedding referral service to steer weddings among members (a real boon to the newer studios in the group) and an active job-passing network. During my first years on Cape Cod, none of the photographers here were active in either the state or New England PPAs. At the 1987 PPA of New England annual convention, Cape Cod photographers took home more print trophies than any state save one. These trophies were earned by the individual photographers on their own merits, but all of our photographers have a support group to encourage and cheer them on to higher goals. At the 1990 PPA of Massachusetts Convention, almost half the platform speakers were Cape Cod photographers. The Cape is now well represented at national, state, and regional conventions. What a good feeling.

One other advantage of a local group is the ability to advertise professional photography as a group. Groups have better access to malls for displays than do single studios. They also have access to the media through public service projects. The Connecticut PPA photographs the Special Olympics every year as a good will project, with many personal and public relations benefits for its members. One group helped man the phones at a PBS

fund-raiser, giving the group and many of its individual members tremendous exposure on local TV.

Schools for the Working Photographer

Once you are actually in business, it is imperative to seek more education in both the technical aspects of your profession and, more importantly, in the financial, planning, and marketing aspects of business. Where do you get this education? Most local adult education programs do not offer technical courses of any value to a professional photographer. Local community college or adult education programs may have courses in accounting and general marketing which would be valuable to a new businessperson. However, these courses are general and do not provide specific ideas that you can readily adapt to your new studio business. Where do you go?

There are many week-long photography schools around the country, usually run by the regional or state affiliates. In New England, for example, PPANE runs the New England Institute of Professional Photography (NEIPP); in California, there are the West Coast School and the Bay Area School; in Pittsburgh, there is the Triangle Institute; and many others too numerous to list here. (See chapter 12 for a complete list.)

These regional schools usually operate on a one-week format, typically Sunday evening to Friday noon, so you can be back in the studio on Saturday to do your weddings. Class sizes range from a dozen to a maximum of thirty. Typically, you will receive forty hours of instruction in many areas, including retouching, marketing, business, and all facets and levels of photography. If you don't mind a little travel, you can find a school in almost any season somewhere in the country.

I cannot recommend strongly enough that you plan on taking at least two week-long courses a year for the first three or four years you will be in business. Pay the fees and schedule the time; the return on your investment will be great and immediate. Choose one course a year in business, marketing, or retouching. Make the second course something on technique and photography. Each week you attend will help you evaluate your personal strengths. You will also make many new and valuable friends from your area and around the country. You will become plugged in to the exciting international world of professional photography. Take my word for it. This is the most valuable money and time you will spend in your professional life. If you think you can't afford to do it, believe me, you can't afford not to.

A personal example that I clearly remember was a one-week course I took at the West Coast School in Santa Barbara, California, while I was still living in Alberta. I had been in full-time business three years and had been progressing fairly well in the technical areas of studio photography. I took a course from Victor Avila, M. Photog. Cr., of San Diego. Victor is one of the finest portrait photographers I have ever met, as well as being one of the warmest and most outgoing people I have had the pleasure to know in my life. In the class, Victor concentrated on teaching how to get a portrait sitting started correctly, i.e., what you had to do before you got behind the camera—what to do to make the subjects relax and feel comfortable. He also taught how to read people—little gestures that mark each individual—and how to use this information to take a better portrait of them.

I flew home to Alberta on Friday night and had a full schedule of sittings in the studio on Saturday. Using the new techniques that I learned from Victor, I tripled my average sale on all of the sittings I shot that day. All of this without spending a cent on new equipment. I mark that course as the point where I stopped taking pictures of people and started to do portraiture.

Who, What, When, Where, Why, and How Much?

This chapter covers the basic practical questions you will have when starting a new studio. Even if you are already in business, it is still a good idea to read this chapter. Some of the information may help you find new and more effective ways to run your business.

To Start from Scratch or to Buy an Existing Studio?

One option when starting out on your first business venture is to purchase an already established studio. In photography, there is a constant flux of people going in and out of business. There are times when purchasing an existing studio may be a good option to exercise.

PROS: (1) Saves you the start-up costs of a new business. (2) Provides instant initial customer recognition. Saves lots of advertising dollars. (3) Saves experimenting with business format; hopefully you purchased a successful one. (4) Gives you a greater degree of financial security. You have a reasonably well-known business volume and profit for the first few years. (5) Gives you the ability to coattail on the previous owner's reputation. (6) If you can't borrow money to start on your own, you may be able to borrow money from a bank to buy an existing business because of its known value and cash flow.

CONS: (1) You must pay to buy out the previous owner. (2) You must, initially, conform to the style of photography, prices, and business format of the previous owner. (3) Business volume may be tied to the owner's personality, and when he/she leaves, the business leaves. (4) The previous owner may have run the business into the ground. There may be little good business left. (5) Your skills or energy are not up to the previous owner's level and you lose a lot of volume.

For a person with little experience in a photography studio, buying an existing

studio is a great expense and will be a great burden if your skills don't develop very, very quickly. If, however, you do have some experience, such as having worked for an established studio for a number of years, or you have attended a good photography school, or you can't raise the money through regular financing options, then buying a studio can be well worth considering.

What is an existing studio worth? There are four elements to consider: (1) What physical assets go with the business? These may include equipment, stock, real estate, or long-term leases for an established location. (2) What volume of business, cash flow, and what net profit does the business currently generate? (3) How long has the business been in the location (or area), and what is its reputation? Is it going up, or is it going down? (4) Will the current business stick with you for a year or more if your skill level is not up to that of the former owner?

If a good deal of the studio's business is with a few choice accounts, which the former owner kept with his or her strength of personality, will these accounts look elsewhere when that personality is gone? Is the customer loyal to the business, or to the person? Will the former owner help in the transition period?

The longer a studio has been in a community, the more valuable it is. If a studio has had a good reputation for many years, people will come to that studio for a while no matter who is actually running the studio. A studio that has only been in business for two years has little or no value in this sense. A studio that has been in business for fifty years is an institution and worth a lot more money. Any studio that has been in full-time business for less than five years at a given location has no value to you, other than its equipment and real estate. A home studio has a negative value unless you are also buying the home.

Good will, or *blue sky,* is the accounting term for the intangibles in any purchase of an existing business. It pays for the name, the expected business, and the reputation of the owner. The purchase price for an existing studio is usually the real value of the equipment, real estate (if any), stock (frames, mounts, etc.), furniture and fixtures, plus a sum for the good will of the owner. The first number is easily arrived at by inventory. If you are considering buying, make sure that you don't pay for old stock which is not salable. If there are wedding albums in the basement from twenty years ago, don't take them. Don't accept old or useless equipment unless you absolutely have to. Bargain for fair market value, not current price for the equipment.

Do not assume that the negative file of an established studio is worth very much. Most portrait/wedding orders are placed within six months to a year of completion and there is little profitable business left after that. In fact, the work in keeping the negatives filed and stored properly is usually not worth the profit in net long-term sales that one can expect from those files.

One way to insure that you are buying the loyalty of the existing accounts and the extended good will of the owner is to tie the purchase price into a two- or three-year pay out of the good will portion of the offer. Make part of the sale price based on a percentage of the business retained.

Let's say that you find a studio and that it has a real value of $30,000 and you determine that you are willing to pay $10,000 for the good will. For example, let us assume that the business you are considering was grossing $100,000 and had a net profit of $35,000 last year. Make an arrangement with the owner to pay the $30,000 real value in cash (borrowed or from your savings) and to pay the $10,000 good will portion in two (or three) annual payments, which will be multiplied by the percentage of the gross business you did after you took over, as compared to the gross business before you took over.

Let's say that in the first year you lost a school contract and your gross was only

$80,000. You would then make the first payment of $5,000 times 80 percent, or only $4,000. In the second year you get the contract back, and increase the volume back up to $110,000. At the end of the second year you pay the owner a full $5,000. This method helps insure that the previous owner will work at helping you to retain the business in the first few years. If the former owner is sure of the business and its true value, there will be no objection to some similar deal for good will. If a studio has been in business a long time and has a much higher value (say over $75,000), then try to arrange for the previous owner to carry some of the financing over a period of four or five years. If the previous owner is not willing to, then you should suspect the true value of the investment.

It is vitally important that any sale of a business be handled for you by a lawyer. It is worth the expense to have a third party negotiate the fine points of the deal. You should have a noncompete clause in the sale, which will prohibit the previous owner from reopening another studio within twenty-five miles for a period of five years. The rights for you to use the former owner's business name and the right to use the owner as a positive reference for business and credit with suppliers is vitally important. The agreement must take care of any existing business debt, as well as accounts receivable and a host of other details.

Again, I would not recommend that you consider buying an existing studio unless you have a good deal of experience working in a studio as an employee or a very good education from a top-line photography school. The only other reason to buy an existing studio is that you often can obtain the money needed to start your business from a bank easier than borrowing for a start-up business. To a banker, an existing business has a track record of cash flow against which to loan money, especially if the former owner is financing part of the purchase price by carrying some of the initial purchase price over a period of time. Essentially, you are using the profits of the existing business to purchase it. This is not an uncommon practice among large corporations buying each other for millions of dollars. This is referred to as a *leveraged buyout.*

Another method of acquiring an existing business is the *lease-option* method. If you see a studio that is starting to run down (perhaps due to the age or health of the owner) but has a good potential if run more efficiently and/or aggressively, make the owner an offer. You'll lease the business for twelve months at a monthly payment, and run it by yourself. At the end of twelve months you will have the option to purchase the business at a price negotiated at the start of the lease. This concept assumes the owners agree to carry some of the purchase price for a few years. After six to nine months of hard work you'll know if you have a winner or a loser. If you have improved the cash flow, volume, and profit of the business, you can go to a bank with a proven track record and get a loan for the down payment and improvements. If the business is indeed dead, walk away. You have only lost your time and little of your valuable cash. This method is a good way of checking out a potential business in-depth. There is little you won't know of the business, making your buying decision a truly educated one.

The Franchise Option

A new choice in the mix of studio types to consider is a franchise studio. A few well-known names are Expressly Portraits and Hot Shots. Why a franchise? The main reason would be buying a tested format of style and business experience. These formats have been shown to work. The problem is that they have worked for specific people in specific places. The question is, will they work for you in your location?

I looked seriously at some of the franchises. I thought about expanding and didn't want

my name associated with a different business format. Some of these franchises may well have been a good idea for me because I possess a great deal of experience and resources. I have talked to well-established, high-end photographers who run "Kiddy Kornor" low-end children's kiosks in malls and make good money. They personally don't do the photography, but they do know how to manage these businesses and they know their markets. I have also seen inexperienced people trying to run a franchise studio. They paid the fees, bought the equipment, copied the marketing techniques, but couldn't take a good photograph to save their souls. They were doomed to failure after paying out a substantial amount of money for a "foolproof" business format.

Some of the franchise options require a huge investment in equipment and leases. Most of the successful franchises need high-traffic mall locations to attract customers. These locations do not come cheap. One franchiser required that you purchase $120,000 in equipment after paying the franchise fee, plus rent a high-visibility space. This option is no place for a beginner. Don't consider a franchise until you have gained lots of experience on your own or from working for someone else. Make your own mistakes; don't buy them. If you do have extensive experience, franchises may be a reasonable consideration. If you have been an active staff photographer for a large studio and can handle sales, employees, labs, and volume shooting, then give the franchises serious consideration. Write for all the particulars. Visit established outlets of the franchise in other locations and talk to the owners. Find out their feelings about the parent company and the format of the franchise. Don't accept everything the franchise company tells you as gospel. You must take the time and effort to get independent opinions.

Be careful not to buy in on a fad. Many of the franchise studio offers are in the glamour and makeover markets. I am not sure that these are long-term markets and I wouldn't be willing to put my life savings into one of them. Other formats, like babies and families, are good, solid concepts and more worthy of serious consideration. These markets will always be with us and smart marketing will always win a good share of the business.

In his book *Entrepreneurship*, James Halloran explains why not to consider a franchise. "Franchise owners will often feel that they have just changed jobs. The restrictions and regulations of many franchisors will take away from the feeling of independence and the satisfaction of self-determination that comes from starting your own business. In addition, the revenue-sharing agreement with the franchisor that seemed so fair at the start may not be so agreeable a few years down the road when the franchisee knows the business better than the parent organization. Also, the initial cost is going to be higher. The security, identity, and training that your are going to acquire is going to cost more...."

Choosing a Location

Decision time! Ask any real estate agent and he or she will tell you the three most important assets of commercial property are location, location, and location. You've decided to open your own full-time photography business. This is an important decision, and I hope you will take the time and effort to weigh all of the pros and cons listed below.

The first choice you have to make is where to locate your new business. You have four general choices: (1) A home (or residential) studio. (2) A Main Street studio. In this context, Main Street means a storefront on a main business street, in a strip mall, a downtown area, or on a commercially zoned thoroughfare away from the downtown area. (3) An industrial area studio located in a commercial park out of the main business district. (4) A shopping mall. In this context, a shopping mall is an enclosed mall where

people park and enter a central area to access individual stores. This is different from a strip mall where people can pull up to and enter the front of a particular business. A strip mall is really a Main Street location, as listed above.

Let's look at number four first. Shopping malls are today's downtowns in terms of social interaction and foot traffic. People go to malls to walk around as much as to shop in specific stores. Shopping malls realize the value of this foot traffic and charge accordingly. Rent in a busy mall is by the square foot and is extremely high, ranging from $12 to $40 per square foot per year. The space required for a studio with a camera room is usually too great to be feasible for a new studio. Older and more established studios can generate the dollar volume to warrant the high rent, but seldom can new studios succeed. Many of the new franchise studios make use of highly visible mall locations to succeed, at a great cost to their owners. Is it worth it? I would say no for the typical start-up studio. In certain situations, where a good rent can be obtained through special circumstances, it may be a consideration.

If you want to open a commercially oriented studio servicing industrial and commercial clients, the number three choice is a viable option. Most commercial/industrial studios do not depend on foot traffic or high visibility. A centrally located studio, relative to your potential clientele, is suitable. Rents in industrial areas are usually reasonable. Since the buildings are designed with space in mind, it should not be too expensive to modify them for commercial studio use. An industrial area would not work very well for a portrait/wedding studio, because it has little aesthetic appeal and is usually too far out of the way for an average consumer.

If a mall or industrial park does not suit your purposes, then your choice is between numbers one and two. Do you want a home business or do you want to rent a storefront location in a commercial area? If you live in Smallville, the downtown area may only be ten stores. In larger towns and cities, strict zoning may prevent you from opening a home studio, forcing you into a commercial area. Different communities have different building types, different landscaping rules, different road layouts, and different geography, all making the above choice a local decision.

Class and Ethnic Variations

There are tremendous variations in the value various class and ethnic groups place upon photographic services. (Please note: the observations below have nothing to do with people's worth as human beings, but only with their potential as photography customers.) For example, in Islam there are no images of Allah allowed, so Islamic art developed into areas such as calligraphy, architecture, and the drawing of complex abstract images in mosaic tiles. Western Christian religion used statues to create images of Christ, God, and the saints, while Eastern Christian religions banned statues but encouraged paintings (icons). All of these general cultural concepts give people raised in these cultures a different appreciation of the graphic portrait image we produce. It has been my personal experience that Russian or Greek Orthodox families spend more money on photography per capita than other groups. I have never sold a portrait to a Moslem. Western Christians are your middle-of-the-road types, with Catholics better customers than most Protestants (again, from my personal experience), with some notable exceptions. If you are in the family photography business, Mormon and Dutch Reform churches greatly emphasize family life and family values, including family photography. (Remember, what may be holy to one culture may be sacrilegious to another.)

The best guide to people's buying habits in photography is what is on the walls of their homes. I have been in homes with literally hundreds of photographs (none larger

than 8 × 10) on display, and I have been in homes with no photographs visible. These homes have been next door to each other.

Coattailing

I always read with a chuckle the ads in the back of photography magazines that advertise "Studio for sale." A lot of them read "Studio for sale in Nowhere, N. Outback, no competition within two hundred miles!" What they really mean is that there is no market for professional photography within two hundred miles! Lack of competition in photography usually translates into an uneducated consumer market, one that will have a lower per capita expenditure on photography than a market with good competition. The more successful studio photographers in a given area, the more likely it is that a good new photographer can succeed in the same area. This seems like a contradiction. Why? Let's analyze it.

Kodak published studies some time ago that showed that for every ten to fifteen thousand people in a typical area, there exists the potential for a successful portrait/wedding photography studio. There exist so many potential portrait sittings, so many weddings, so many schools, etc. The percentage that will use a studio's services, and what they can afford, will vary with the demographics of the area, e.g., age distribution, religious and ethnic composition, the economic condition of the area.

The other major factor to consider is the population's awareness of professional photography. This factor will determine how many of the potential customers become actual customers of any studio. A major factor in consumer awareness is how well they have been treated in the past and how often they are exposed to professional photography in their everyday lives. An area with a greater density of good studios is usually an area in which those studios advertise and promote aggressively. Advertising acts to increase everyone's awareness of professional photography, not just of the advertiser's studio. When one studio runs an ad in the paper, other studios may gain a customer, and vice versa. The major point is that the average consumer is subjected to more advertising per day than in areas where studios are not successful and do not advertise, and are not making any money because they have they have no customers. (A rather circular argument, isn't it?) The consumers also learn to value professional photography more highly because they see good photography in their day-to-day lives.

I have lived in two extremes of the above scenario. Luckily, I happened to be able to coattail when I was a raw beginner. Lethbridge, Alberta, Canada, where I started my first studio, is a town of 50,000 serving a market area of about 160,000 in the surrounding farm areas of the Canadian prairies. It was a one-newspaper town, slightly isolated from the big city of Calgary (120 miles away). When I opened my studio (as a complete novice) there were five successful studios already in town, plus the usual contingent of part-timers. One studio had been operating under the same name for over fifty years, and, under different owners, had always produced good photography. One studio was owned by a former mayor who was also an extremely popular local morning-radio talk-show host. By any standards the work produced by these studios was good to excellent. Almost every night you could pick up the local paper and see at least one studio ad, usually a quarter page or larger. There were differences between the studios, but all of the studios were busy most of the time. The average per capita expenditure on professional photography in that area was two or three times the average in other areas with which I am familiar.

When I moved into that market as a newcomer, my prices were lower than the established studios. With such a large consumer base there are always people looking for

a bargain, and they were willing to try out the new studio. They also appreciated good photography, and I couldn't get away with poor quality for very long. Fortunately, I had customers to work on and a chance to develop my talents. They also paid the rent and fed the kids. I got many of my early customers because of the groundwork laid by the more established studios.

We moved from Lethbridge to Cape Cod in 1979. Cape Cod is a cluster of small towns in New England's major summer resort area. Harwich is a collection of villages of about 10,000. The total Cape Cod market is 160,000 full-time residents. In the summer, the population swells to 500,000 with the influx of summer visitors and people who own summer homes. When Sue and I moved here, there were a number of studios, only two or three of which I considered fair to good. The most prominent studio, the one with the most visibility and the most school contracts, was bad. The studio was bad in terms of its photography, its "buyer beware" attitude toward customers, and its business practices and dealings with local schools. The few good studios did not aggressively promote themselves or professional photography. There was a constant turnover of new studios opening and failing. The existing studio owners as a whole did not communicate with each other. Few photographers ever attended state or regional conventions.

Starting a new studio in this market was far more difficult than in Lethbridge. It took a lot more time and money to reach the same levels of business volume I had in Lethbridge, even though I had more technical skill and greater business experience. We had to work much harder to educate the public about good photography and to teach our competitors, by example, that they could and should talk to each other.

So, if there is an open space across the street from the best studio in town, that's the ideal place for you to open your new photography studio. Hitch your success to the already established success of the other guy. It will work. Your competitors will not necessarily like it, but in the long run it might make them better.

A Home or Main Street Studio: The Pros and Cons

The difference between paying extra rent for a storefront location or putting in the extra work to build up a business in a home studio is one that will vary tremendously with location (rural, small town, big city, etc.). Home studio or storefront is one decision which must be made with your investment capital in mind, as well as your desire for quick growth in the market you have chosen to start your business in. Some studio owners become successful in a storefront location and then move to a residential setting to save money and improve their lifestyle. For the beginner, the decision is a tough one.

Home Studio Operations

The major business difference between a Main Street and a residential location is that in the home setting you have little or no walk-in traffic, no front display windows, and a hesitation on the part of the legitimate buying public to accept you as a "real business." Home studios don't earn the respect factor (except in rural areas and small towns) as quickly as Main Street studios do, even when the photographer is experienced and competent. I have run both types of studios and speak from experience.

The residential studio operation must reach out to the market more aggressively than a Main Street studio. It must encourage people to pick up the phone, instead of walking in without an appointment. Emphasis on location sittings (in the client's home, or in a park setting, etc.) for families and individuals must be stressed. If you don't have a large camera room, don't even try to do large families or full-length bridals in the studio. Your

results will look worse than Kmart or Sears unless you have great skill in posing. You can attempt direct mail and cold-calling on potential commercial clients. You should have a portfolio of good commercial shots, both small products, large-scale subjects, and some creative pieces.

I experienced the difference between a home studio and a Main Street studio quite strongly a few years ago. In October of 1988, we demolished our "barn" studio in order to build our new facility. I rented the house next door as an office so that we could continue to do wedding interviews and other nonshooting business. Remember that we had been in business here for nine years and had established a good, solid reputation, especially in the wedding market. We used the home office for six months. Our wedding bookings fell off dramatically. Even though we were showing the same sample albums, had the same reputation, and had the same samples on the wall, people would still think of us as part-timers and not worthy of the high prices we were charging. A few months later we were in our beautiful new studio and the bookings skyrocketed. People who walked through doors that cost $5,000 were impressed! This was no fly-by-night operation, but one worth paying for.

The major positive consideration for opening a home studio is that most of the money you put into your studio "rent" will be returned to you someday when you sell your home. Rent paid to a landlord is gone forever.

HOME STUDIO PROS: (1) Generally cheaper than renting a Main Street commercial location. (2) Requires less investment in furnishing to use. (3) A home location saves immense amounts of time and expense in manning a downtown location. (4) Home studios can offer easy access to landscaped outdoor areas. (5) Homeyness appeals to a certain type of clientele. (6) Home studios are convenient for you. Many sittings and order-placing appointments take place in the evening and being home saves you time. (7) A home studio means less travel time and less time away from your family. A lot of the busy work of a studio operation can be done while watching TV with the kids at home as well as it could be at the office downtown. (8) More time spent with your children, especially when they are young (see Cons). You always know where your kids are, and they see how hard you have to work for your money.

HOME STUDIO CONS: (1) Requires correct zoning and/or variances in most cities. (2) Severe restrictions on sign size, traffic flow, and parking. (3) No (or little) walk-in business. (4) Usually has limited space for camera room and darkrooms. (5) Most home septic systems are not adequate for darkroom effluents under stricter EPA regulations, and local waste-disposal laws are getting stricter all the time. (6) Most clientele don't feel the same degree of respect that they do for a Main Street studio. (7) Difficulty in finding location of the studio deters potential clients. (8) No (or very little) display advertising is usually allowed (front windows). (9) People know it's your home and will come or call after regular business hours, intruding into your private family life. (10) Your kids intrude into the business at times.

In smaller communities, many small service businesses are operated out of homes, so the respectability factor is stronger. When searching for a building to purchase for a home studio look for the following: (1) Easy access. (2) Land to landscape for outdoor sittings. (3) Enough land to expand or to build a camera room. (4) A neighborhood willing to accept your type of business. (5) A home that is large enough for you to separate your living area from the public area. (6) A neighborhood where the property value will increase with time. (7) Enough space for customer parking.

MAIN STREET PROS: (1) Higher visibility and more respectability. (2) Ease of public access. (3) Correct zoning for business use. (4) More generous limits on signs, front window displays, etc. (5) Walk-in traffic for passports, business portraits, framing, etc. (6)

When you're closed, you're closed. No customers knocking on your door on your day off or after hours. (7) You are a legitimate business. (8) Usually more usable space for camera rooms, darkrooms, etc., than the average home. (9) Sometimes possible to have landlord renovate space for increased rent, thus allowing you to preserve capital.

MAIN STREET CONS: (1) Expensive (more than home studio, less than a mall, in general). (2) Two rents to pay, home and studio. (3) Studio must be manned during regular business hours requiring at least two people most of the time (one to shoot, one to be a receptionist). (4) Time and cost of traveling to do evening appointments or proof pick-up/returns. (5) Renovations may be expensive, and they stay with the building if you move to another location. (6) Parking can be a problem. (7) Character of neighborhood can affect hours of business.

Some things to consider when evaluating a storefront location are: (1) Quality of the neighborhood, number of churches, families, ethnic makeup, upswing/downswing. (2) Visibility from the street, amount of window display space. (3) Amount of traffic on the street (both vehicle and foot). (4) Parking easily available? (5) Amount of floor space/ceiling height/plumbing, etc. (6) Will landlord renovate for you (carpets, wall, lights, etc.)? (7) Long-term lease available with prescribed rent increases over next five years? (8) Amount of rent? (9) If the previous store had some displays, can you incorporate them into your new studio?

Which Way to Go?

I have started two studios, one in a home setting and one in a Main Street setting. Both have their place. If I were to start over again, I would have to reevaluate where I would locate according to the size of community, nature of the new studio, availability of locations, the ages of my children, and whether my spouse was also involved in the business. There is no perfect answer or simple formula. Which way should you go? A storefront rent can vary tremendously from location to location. In New York City, the rents would be many times the rents in Small Town, Kansas. Can you run a studio out of an apartment? In smaller towns, storefronts may be rented at reasonable rates, depending on local growth and economic strengths.

If you decide to go with the Main Street location, shop around. Whenever you see an empty store, contact the owner. By asking and looking, you will be surprised at what's available. In many towns, the malls have drawn a lot of retail business out of the downtown areas (as well as the foot traffic), leaving behind a small vacuum of lower rents. Sometimes a run-down neighborhood will be making a comeback, and you can get a good rent and be in the middle of a new posh neighborhood in a few years. These things require some judgment and crystal ball gazing. Consult a reputable real estate agent who specializes in commercial properties.

What Should You Call Your New Studio?

What to call yourself: John Doe Photography, J. D. Photo, Smallville Studio, The Urban Studio of Artistic Intentions, The Zen Zoom Shoppe, Main St. Photography, Photos by John? I call my studio E. R. Lilley Photography because I think photography, especially in the portrait/wedding area, is a very personal business. You build a reputation based on your personality. Even if you are in a partnership, a single name on the door, even if it is a fictitious one, will give the clients the feeling that they are dealing with a person and not a corporation. Eventually that studio name will mean more than your own name.

Two friends bought an existing studio. I will call it the A. B. Jones Studio. After a while,

people would call both partners Mr. Jones, even though their names were Smith and Williams. They paid for name recognition when they bought an existing studio, and they got it! The only problem occurred a little later when one of the partners left and started a new studio. He found that he had to work hard to make Mr. Smith mean something different than Mr. Jones, which he was already known as. On the other side of the coin, a generic name, such as Smallville Studio implies that no one person is in complete control. When a wedding couple signs up with the Smith Studio, they expect Mr./Ms. Smith to do their wedding. If Ms. Jones shows up, they can be upset if it had not been explained to them in advance. At the Smallville Studio, they wouldn't be quite so surprised.

Don't get too fancy. I have seen tons of studios with art photographer–type names go down the tubes. Don't get trapped into a corner with Studio of Elegant Portraiture if you also intend to do commercial work. However, if you want to specialize in weddings, don't be afraid of naming your studio Joe's Studio of Sparkling Wedding Photography. If you have a name that is hard to pronounce, you may wish to go by your first name, such as Photography by Ed. If you live in an area where you feel that there is an ethnic prejudice that your name will trigger, you may wish to use a more neutral "stage" name; Lilleyovitch may become Lilleyson or Lili. The opposite may also be true. If you are Italian and work in an area with a large Italian population, calling yourself Roma Photographie may bring you more clients. I saw an extreme example of this ploy on the main street of Revere, Massachusetts, a heavily Italian, working-class suburb of Boston. A Chinese restaurant called itself Cathy Roma. Talk about covering all your bases.

The basic rule is keep it as simple as possible. If you have a name that you can play on, do so tastefully. I once bought some old equipment from a studio operated by Mr. Knight and Mr. Day called Day and Knight Photography. Kind of silly, but easily remembered, which is the major point. A nearby community is Centerville. A barber there capitalized upon the town name by calling his shop The Barber of C-Ville. If you were new to the area, where would you go for a haircut?

Business Hours

Your business hours and the hours that will be most productive will depend on your specialization. You also have to choose which hours your studio will be open to walk-in customers, and which hours you will reserve for assignments. For commercial studios, you will want to operate during normal business hours: Monday to Friday, 9:00 A.M. to 5:00 P.M. These hours are when most people with whom you want to do business work. Portrait studios will usually do utility portraits during normal hours; small children on weekday mornings and weekends; high school seniors in the summer during normal hours and, after-school hours after September 1; family portraits on weekends and evenings; and young adult portraits on evenings and weekends when they are not working.

Weddings: 75 to 80 percent on Saturday, with some Fridays and Sundays. Hours are all day! The more Jewish people in the population, the more Saturday night or Sunday events. Many wedding interviews must be scheduled in the evening or on Saturday/Sunday, as many modern couples both work. The time of day is a local tradition. On Cape Cod, most weddings take place at 10:00 or 11:00 A.M., and I am home by 5:00 P.M. In Alberta, the typical wedding began at 4:00 P.M., and if I covered the entire reception, I would work till midnight.

Here's the bad news. Most families with working parents and schoolchildren find it difficult to come to the studio except after work or on the weekend. Most extended families, unless there is a planned function, such as a midweek reunion or anniversary party, can't get together except on the weekend. If the sitting takes place at a large party, the

family may get together on Sunday because the large halls will be busy with weddings on Saturday.

There are a few popular lecturers on the speaking circuit who preach, "I will never work another weekend in my life!" (They are usually saying this while they are being paid to teach other photographers, on weekends.) They claim that you can convince potential clients into altering their schedules to fit yours. A famous lecturer on motivation, Zig Zigler, tells this story (I am paraphrasing it): Want to feel frustrated? Go out onto a four-lane expressway. Stand in the eastbound lane and shout, "Go west!" Nobody will obey you. They may slow down a bit, but all of your efforts will not make any of them go west, no matter how much energy you put into yelling and waving your arms. Now go twenty feet further into the westbound lane and shout "Go west!" Guess what? They all will go faster with your encouragement. The same amount of energy applied to the correct audience will produce a much greater result.

The moral? Don't fight natural law or circumstances over which you have no control! You have to spend too much time and energy fighting circumstances beyond your control to gain a small advantage, and you will lose too many profitable situations. Later on when your reputation grows and your selling skills improve, you can restrict your hours more, but not at the beginning. Photography is a service industry. You must service your client's needs when they need it, not when it is convenient for you. If you want a normal lifestyle, go into commercial work. If you want to be a portrait/wedding photographer, forget normal.

Seventy percent of my business income (now totally portrait/wedding with almost no commercial accounts) is produced on weekends. Of the 30 percent on the weekdays, seniors are scheduled after 2:00 P.M., and my undergraduate work is scheduled in the mornings. See the graph of my time distribution for both the week and the year, below.

When we lived in Alberta, many of our customers were farm families, who could adjust their schedules to ours, and we led a more normal life. When first starting out, you must be available all of the time! If you do all of the photography, you must shoot Sundays, evenings, and your day off, if it is worth it. As you develop your business, you can choose which days you wish to be closed to shooting. There may be a local custom. In many small towns, all small business establishments close on Wednesday afternoons. You should only plan on one full day off a week until you become well established. Your studio may be closed for two days, but you should be in the darkroom printing or in the office doing the books or designing the promotions which will bring you new business in the next six months.

There are also seasonal considerations. Christmas is a natural stimulator for family and individual portraiture. In the three months before Christmas, you will get the most phone calls for sittings. Do the work. You will still get few days off. In January, February, and March (in northern climates) there is usually very little portrait/wedding business, so you can take a lot of time off then. If you stress commercial work, there may be seasons for your market that may not line up with the calendar year. If your clients have to produce catalogs for the pre-Christmas market, you may be working all of July and August and then have nothing in December. Each industry has its own season. Adjust your schedule to these seasonal trends.

Photographic Time Management

There are two concepts you should memorize and repeat to yourself every time you set prices and/or try to organize your work year. (1) You really only have one thing to sell: little segments of your time. (2) There are only so many hours in a given day, week, or

month. You can never create twenty-five hours in a day or eight days in a week, no matter how hard you try. When you first get started in a business, you'll find there never seems to be enough time some weeks and then there is nothing to do the following week. Time management is planning your weeks and months to maximize the productive use of your time.

What kinds of time are there? (1) Photography time: when you are actually taking photographs for hire. (2) Pre- and post-shooting time: time spent getting ready for a shoot and the time after dealing with the products of the shoot, such as putting equipment away, sending film to the lab, and writing invoices. (3) Production/finishing time: creating prints in a darkroom and/or doing the finishing work to produce a quality product. (4) Selling/marketing time: time spent preparing marketing efforts and executing marketing schemes; time spent with customers other than shooting time, including interviews, proof delivery, order-taking, and clothing consult. (5) Management time: time spent doing bookkeeping, preparing forms, paying bills, doing bank deposits, answering mail, general filing, dealing with suppliers and/or employees, planning time. (6) Education/Association time: time spent at conventions, seminars, workshops, or reading to learn about new ideas and techniques. (7) Vacation time: we all need a break. (8) Schmooze time: sometimes we have to take time to socialize with our neighbors, customers, and peers.

If you worked forty hours a week for fifty weeks, you have a potential of two thousand hours a year of "work time." Of course you can work eighty hours a week, but that makes you grow old fast. I have worked sixteen hours a day for many days in a row, but not forever. As you get older, you have to learn to work smarter, not longer.

When you are just starting your business, it will probably just be you or you and your spouse's time involved in doing all of the work. If you work alone and you follow my advice and start to build up a good business, you'll soon need some help. At first you'll need help with office management (answering the phone, making appointments) and customer contact jobs. Then you may need help with the unskilled labor parts of production and finishing. In our busy season (July to November), there are days when the phone literally does not stop ringing all day. It takes three to four hours of concentrated effort just to answer the phone. If I had to do this, I wouldn't have any time to take the photographs that pay the bills. Even with Sue and I working, we still need another full-time person. There are days when we cannot get to any work in progress because we are taking new orders, making new appointments, and answering the phone. In February, answering the phone is a lot easier because we are not doing much business.

You are only generating income when you are behind the camera. You also earn money when you are selling and marketing, but your main purpose in life is to take photographs. The graph below charts my shooting time for the year 1994.

TOTAL SHOOTING HOURS 1994: 1,038 hours (51.9% efficiency based on 2,000 hours)

BY MONTH

Jan	Feb	Mar	Apr	May	Jun	Jul	Aug	Sep	Oct	Nov	Dec
1	3	34	199	95	104	97	145	139	146	52	23

BY DAY OF THE WEEK

Mon	Tues	Wed	Thurs	Fri	Sat	Sun
12	60	100	90	175	475	160

I have been in business twenty-five years and I have learned to control my time. One thing I plan on is very little work in January, February, and March. There are jobs I can get, but I have worked hard from April to November, and I need the time off. In my early days, I would do hockey leagues, run specials, and work at getting some money, because I had to pay my rent and feed the kids. We close our studio on Mondays. Again, everyone needs at least one full day off. In my business I do work a lot of Saturdays and Sundays, so Monday is my no-customer day. In the busy times I may work in the darkroom or in the office, but there is no shooting on Mondays. I do a lot of convention/special-event photography in the spring. I generate 25 percent of my income in a seven-week period.

Because I live in a resort area, I do more work than the average studio on weekdays in the family portrait area. I do almost no commercial photography. I also use other photographers on a per job basis, so I count their hours as shooting time. In 1994, I also spent twenty days (160 hours) doing association work and/or attending schools, conventions, and seminars.

There are major seasonal variations in weddings, portraits, and seniors, so I know I have to be focused on work for the entire fall. I try to do all of my planning and marketing before the busy season because I know I won't have time when I'm busy. I could shoot more in November and December. However, by that time I am tired, and Sue and Jennie are working to capacity getting orders from the previous months ready for customers. They couldn't do any more work, so we don't try to get more.

As you can see from the chart on page 26, Friday, Saturday, and Sunday are the busiest shooting days for a portrait/wedding photographer. You'll probably earn 60 to 80 percent of your income on the weekends if you are a wedding and portrait photographer. Those weekend hours are worth much more money. You will need to educate your friends and family that the weekends are your primary earning times, and that it is difficult for you to get away for family functions like most other people.

You can focus additional marketing efforts on getting weekday morning work. Perhaps there are accounts that you can bid for at a lower hourly rate if they fit into the slow hours of the week. The sure-thing accounts I discuss are usually jobs that fall in these slow hours. Avoid scheduling your low-end promotion during the good hours. Confine your public service time to your slow hours.

In the winter and spring months, it may well be worth your while to do time-intensive marketing plans, such as trade shows, mall shows, direct mail, and cold calling. It is better than you sitting in the studio doing nothing. Just remember that if your marketing works, you won't have time to do it, so plan for the time in advance. What are the tools you need for effective time management? There are two major devices: your appointment book and your wall calendar—a markable calendar that shows the entire year.

Your appointment book is usually a central item in your day-to-day business life. In it are all of your customer's times. You must also put in your appointments with yourself. You must schedule (in advance) time to do the important things involved in running your business. Since you know you'll be busy around Christmas, schedule a midweek morning in June to plan your promotions. Schedule education and seminars as you learn about them. Schedule periods in each week to pay bills, balance the books, etc. Put important deadlines, such as print competitions, bill deadlines, and contract deadlines in the book so you won't forget about them.

The wall calendar should be hung in a prominent place. Block off times for education, conventions, vacations, and family trips. Schedule in special promotions around holidays and seasons, and then figure out when you must have the marketing materials ready. Schedule the time needed to produce the marketing materials.

The wall calendar gives you an idea of your weeks and months, while the appointment book deals with the hours in a day and the days in a week. One trick is to schedule similar work close together. If you only do three portrait sessions in a week, it is much more efficient to do them all on one day instead of spread out over three different days. It is not always possible, but it is a good time-management goal. In high school senior work, limit the days and hours you will be available if you can. When you are new, flexibility is an important asset that you must have, but you must also strive to be as efficient as possible.

One thing you learn from experience is that certain jobs require a lot more support work than others. As discussed in chapter 7, a high school contract involves many hours of support labor, photographing sports, activities, and other events. These hours can be taxing if you are not aware of them. They may not be prime hours in the work week, but they can make a work week seem endless. Other work may require a great deal of travel and/or studio preparation for each shoot. Account for your support work in your price list and in your time-management plan.

Business Formats

There are three basic types of business formats: (1) the sole proprietorship, (2) the partnership, and (3) the corporation. For most new studios, forming a corporation has few benefits and some liabilities. Incorporation involves a lot of additional paperwork, and the tax preparation and additional tax costs outweigh the limited liability benefits or tax advantages that incorporation offers to larger firms. Corporate status is advisable for a larger business, but not for a new studio. The two other choices are basically the same, except that in a sole proprietorship only your name is on the paperwork, and in the partnership two or more names appear. For convenience, I am going to treat a married couple as a sole proprietorship, even though a married couple should set up their business as a legal partnership.

A partnership is a formal agreement between two or more parties entering into business concerning ownership of shared assets, division of debt and profit, contribution of investment capital, and division of labor in the enterprise. Many people go into business with friends because of a shared skill or interest in a specialized area. Any business requires talent, time, energy, money, and hard work. If, after a while, one partner feels that he/she is working harder or putting in more productive hours, trouble starts. Most people, especially in studio photography, are unaware of their own potential skills and abilities when first starting off. How can you evaluate another person's skills when you cannot evaluate your own properly? Perhaps at the start you had equal skills, but soon one or the other shines brighter, and this disparity will lead to dissension.

Most people form partnerships because they are unsure of their own skills and ability to run a business; they do not have the money to start the business without help; and they enjoy the other person and feel that they can support each other equally. It is my personal observation that it is much easier to find a spouse than to find a good business partner. There have to be two major characteristics shared by the partners to create a successful business together.

Skill levels: Both partners must have very similar levels of technical skill, business drive, involvement, and personality, or complimentary areas of business and technical skills that allow each partner to be different, but make the business more successful as a whole. Some studios have one partner do all of the photography and the other do all of the marketing and selling. Whatever is most productive is best. There is no magic formula for determining proper roles, just characteristic number two.

Complete trust in the other partner(s): This is the hardest to find. As soon as one partner

feels that the other is not pulling his or her share of the load, a little seed of distrust is planted. Another area of potential problems is when the partners in a business are also married to spouses outside of the business. Usually spouses become involved in a business in some way or another, and the spouses become part of the mixture. If two men are partners and their wives can't get along, there is trouble brewing. If one wife wants to help out, suddenly there are three partners. This combination can be an explosive situation. I have seen it happen! I have seen lifelong friends split up because the little seeds of distrust grew so out of proportion to reality that they threw away years of hard work and thousands of dollars to get rid of each other. A business split-up is usually as, if not more, traumatic than a divorce.

You can form a successful partnership if you and your partners get organized and commit yourself to the time and effort at the start. In my experience, I have seen very few nonfamily partnerships that have worked over the long term in the photography studio business. There are some, but they are the exceptions, not the rule. If you are going into a new business with a partner(s), it is essential that you sit down with each other over a pot of coffee and write down the following possible problems. Then write down how all of you will solve the problem(s), if they arise.

(1) One partner wants to quit the business. (2) One partner dies and his/her spouse now owns part of the business. (3) How the profits and/or debt of the business are to be divided. (4) How the distribution of the work load is to be divided. What if one partner feels that the distribution is not equal? (5) Roles of spouses in the business. (6) How the total value of the business is to be determined in the case of a split-up of the partnership, and who can buy out who for how much and how the buyout can be financed. (7) How the ownership of the business name and logo will be determined in the case of a breakup.

Consult a lawyer and have him or her draw up a partnership agreement specifying your answers to the above problems. I am sure a good lawyer will come up with lots of other problems for you to solve before entering into business. The main idea is to consider all of the possible situations and to record the agreed-upon solutions in writing before you enter into the heat of battle. This precaution can save bitter and costly fights between partners later.

In my opinion, a photography studio is the home of the single or married North American entrepreneur. Doing it on your own is capitalism at its best. If you need money, go to a bank or borrow from family or friends. If you are afraid of hard work, don't go into business at all.

Family Partnerships

Family partnerships are different because people tend to tolerate a relative more than a friend. There are also roles associated with family that allow one person more authority without hurting the other's feelings. In more established studios, there are a lot of parent/offspring partnerships as children grow up and become part of the business and develop skills which allow them to pull their own weight. Many married couples are partners in business, especially in the more modern world of two-income households. Married couples usually trust each other implicitly, and they have their own ideas as to who runs the family (or the business) and how they share those responsibilities. The same feelings have to extend to the business that operates in the home setting. Exactly how those feelings will manifest themselves will depend on each individual couple. Who wears the pants in the family is a matter for each couple to decide, not society or the business community.

Husband/wife teams comprise a large proportion of portrait studios. In some, both are photographers. In others, one learns to photograph, and the other learns the finishing and selling. The important thing is that to feel purposeful, each must have his or her own role and areas of professional responsibility reasonably well defined. It has been my experience that my marriage grew stronger because Sue and I are in business together. When we were first married, I was in academic science, which my wife didn't understand or care about. (It was pretty dry stuff.) Sue was an executive secretary accustomed to running an office. When we first started our studio, Sue did not participate very much. I had a friend who was going to help out. That arrangement lasted about two months and Sue had to start helping because we couldn't afford to hire anyone. At the time, neither of us knew much about the field, but we had enthusiasm. Sue learned to retouch, to finish prints, and to organize the day-to-day business of the studio, while I learned to photograph and print. Today we can subdivide our business into our areas with some kind of common ground. There are also lots of jobs we both do in selling and running the business, but we both need our own space.

Sue and I share all aspects of our lives, and neither of us brings home baggage from the "other life" that people who work for large companies do. For us, and a lot of other couples, our business strengthens our marriage. This may not be the case for all couples. If one of the marriage partners has no skills, no interest in photography, or just has a poor personality for business, you cannot force him/her into a new venture. Both the business and the marriage will suffer. It can also destroy a marriage if it generates conflicts about who is in charge and egos get mixed in with ability and defined roles. Each of you reading this book must evaluate your own spouse in this regard.

Banks and Financing

Unless you're independently wealthy or have a rich in-law who will stake you to all the money you need, you'll probably get to know your banker very well in the next few years. You should realize at the start that money is a commodity, just like your photographs or a loaf of bread. A bank is in the business of lending money so that they can collect the interest and pay their depositors. The availability of money varies from time to time, which is usually reflected in the prime rate. The prime rate is the interest rate at which the big banks will lend money to their biggest customers. You, as a small businessperson, will pay more than the prime rate.

Banks offer three basic types of business loans. The first type is called the short-term demand loan. If you need money for a short term (one to six months, for example), the loan will be given to you on a "demand basis," which means that the bank can "call" the loan at any time, and you will have to pay it back. The interest on a demand loan is calculated in advance, and, in some cases, paid in advance. You agree to pay the entire loan by a specific date, usually in one lump sum. Banks usually do not call in legitimate loans, so you have little to worry about.

Another type of loan is the installment loan. Banks use these when the length of a loan is longer than a year, and you want to pay the loan in monthly installments (some banks can set up seasonally adjusted payback systems for businesses that have a great deal of seasonal variation). The installment loan is usually used to purchase tangible items, such as equipment, autos, and other items, which themselves act as the collateral or security for the loan. Most banks will hold a chattel mortgage on the items until the loan is paid. The other major difference between a demand loan and an installment loan is that the interest on an installment loan is usually calculated by the rule of 78s, which builds the entire interest charge into the loan payments before the repayment of the prin-

ciple of the loan. It usually will cost you more to pay off an installment loan early because you've already paid the interest for the entire contracted length of the loan.

The home equity loan is another common type of loan. If you have owned your home for any length of time, it probably has increased in real value. The difference between the real value and what you owe on the mortgage(s) is called your equity. Most banks will loan you money based on that equity, and will take a second (or third) mortgage on the property as collateral. Real estate is one of the safest forms of security for a bank, and they generally will let you use that equity for reasonable purposes, usually at a better interest rate than an installment or demand loan. Be careful. Shop around for the best rates and beware of "points," which are a premium charged by banks for the favor of lending you money. It is imperative that you understand all of the costs involved in the home equity loan, for they can be substantial.

Types of Banks

Most banks are not in the business of loaning venture capital to new small businesses. Venture capital is defined as money risked on a new business with no proven track record in the hope that it will become successful, so that the investor can sell out at a huge profit. (This is what you do with your money when Las Vegas gets boring.) Banks will lend you money to buy equipment if the equipment is the collateral. They will lend you money, on a demand loan, to help pay some of the start-up costs of a new business. The amount of the start-up loan will depend on your credit rating, on the banks estimation of your ability to pay the loans on time, and on your other fixed assets (such as real estate or securities).

The two most common types of banks are commercial and savings banks. Some banks deal with large and small business loans, while others only get involved in residential mortgages, auto loans, etc. Deal with a commercial bank, preferably a smaller one, that knows your community and has a reputation for dealing with small businesses. You may have your other dealings (e.g., your mortgage, car loan, and credit cards) with a consumer bank, which you may think will help you get a business loan from them. Unfortunately, it doesn't usually work that way. Consumer banks usually have strict rules of income for granting loans. A person about to start a new business has no proven income for the next few years. A commercial bank understands business conditions and can evaluate your ability to pay them back based on this knowledge and business savvy.

Since the first edition of this book in 1989, many changes have taken place in the banking industry. Because of questionable lending practices in the eighties, many banks failed. The banks that survived are much stricter in their lending practices than before. This newer strictness means that you must plan your business better. In the older banking system, your character was an important part of the qualification requirement for a loan. Today, character considerations have been replaced by rules and requirements. Even in a small town, with a fifteen-year success record, I am now required to fill in forms for transactions approved on a handshake in the past. It is not always the fault of the local bank, as they must comply with new rules imposed by the federal government.

Keep track of business articles in your local paper concerning banks and small business loans, and follow government actions to loosen up money for small businesses. Also, consult your local Society of Retired Executives (SCORE) office (see "Getting Some Help") about finding a small business–friendly bank to deal with. If you are a member of a minority group (women are considered a minority group), additional assistance may be available from the Small Business Administration (SBA) for start-up business loans. There are special programs for new businesses run by women, veterans, and minorities which may help you. Make use of these advantages.

Bankers

The key to approaching a commercial bank for financing for any new business, such as opening a photography studio, is to have a plan. If you wave your hands in the air about how wonderful you think you are and how many weddings you are sure you can book in the next year, they will laugh at you. Bankers see hundreds of people starting many enterprises. Many of these potential entrepreneurs have no business sense, and don't understand business at all. Bankers want to see plans in writing, backed up by facts. They want to sense that you have an idea of where you want to go, and how you are going to get there.

Steve Harper, in *Starting Your Own Business*, lists the six C's of commercial lending: (1) your character; (2) your capability to manage the business; (3) your business's capacity to pay off the loan; (4) the conditions, or terms of the loan; (5) the context of your proposed business; and (6) your collateral.

Using the planning guides provided in chapter 9 you can demonstrate C's two through six, which, hopefully, will improve the banker's estimation of number one. When you go to see your banker, you should have in writing the following facts and information.

YOUR NET WORTH TODAY: house, car, outstanding debt, spouse's income, part-time income, savings account, personal belongings, the photographic equipment you own now, etc.

YOUR CAPITAL EXPENDITURE NEEDS: List in detail the equipment and fixtures you think you will need to open your business (use the lists provided in this book as a guideline). Have current prices and copies of price lists for major items to show that you will be buying good equipment from reputable dealers.

YOUR START-UP COSTS: renovations, initial advertising budget, stock of frames/folders, initial samples, stock of film, etc.

YOUR ESTIMATED EXPECTED COSTS OVER THE FIRST TWELVE MONTHS: rent, heat, phone, lab bills, advertising, personal expenses (see planning sheets in chapter 11), etc.

YOUR EXPECTED CASH INCOME OVER THE FIRST TWELVE MONTHS: Here you have to think creatively. You must reduce to writing what you will be charging per unit, how many units you expect to sell, and when in the next twelve months you'll sell them. Consult chapter 9 on planning for some guidance in determining these figures.

If you have all of this information in a neat package, the banker can easily see how much money you will be needing. He/she will then decide how much of this money the bank will loan to you and how much will have to come out of your savings or from somewhere else. Most banks will not finance 100 percent on a first-time venture. You have to have something to give to the business, even if it means remortgaging your house or borrowing money from a relative. If the banker is satisfied with your credit history, the sensibility of your plan, and your financial involvement, he/she will tell you how much, and in what form the bank will help. Usually, the bank can provide some money for equipment with an installment loan and some money for start-up with a demand loan on a short-term basis. Many banks will also establish a line of credit for you. Most of your needs will be in the set-up stage, but as the months go on, you'll need more money to pay the ongoing expenses until the income starts carrying the business. A line of credit is a prearranged upper limit for your borrowing to meet these ongoing expenses.

Preparing this information for the bank will also help you to understand the amount of business you have to generate in the next twelve to twenty-four months. A good commercial banker will tell you if your figures are off in your plan, or if you forgot some major expense area. They are available through the year to assist you with business questions. They are also helpful in supplying credit information on potential clients if

you are extending credit to a large commercial account. Your banker is on your side. Use his/her knowledge as well as the bank's money.

There is one pitfall I should warn you against. When getting a loan, don't ask for too much money. If you have good credit, the bank may be willing to lend you more than you really need to complete your business plan. This can trigger a spending spree that may hurt you in the future. I have seen new businesses get a loan and then spend the money on fancy furniture, a fancy new car for the business, or other extravagances that don't produce income. Be frugal. Look at used equipment, cars, and furnishings to save cash for the months ahead. Just because the bank gives you a lot of money doesn't mean you have to spend it in the first week.

Estimating the Start-up Cost and First Year's Operating Expenses

In the list below, I have estimated the cost of starting a small studio from scratch. I have intentionally used a low, gross income figure for the first year, but one which should be obtainable with some skill and a lot of hard work. Some of the figures will be quite variable depending on where you live. Rent in the big cities is much higher than in small communities, so factor in urban versus rural costs. Some areas of the country have different heating/air conditioning requirements or different utility and insurance rates, etc.

Typical Start-up Costs for a Studio

(Assuming an $80,000 first-year volume for calculating material costs.) All figures in $1,000s.

ITEM	HOME STUDIO	MAIN ST. STUDIO
Camera system #1	3 to 7	3 to 7
Camera system #2	1 to 2	1.5 to 2.5 (passport)
Lighting equipment	1.2 to 4	1.2 to 4
Tripods	4	.4
Backgrounds	.4	.8
Props	.5 to .8	.8 to 1
Darkroom (B&W)	.6 to 1	.6 to 1
Miscellaneous Equipment (cases, etc.)	.6 to 1.5	1 to 1.8
Spraying Equipment (optional)	.6 to .8	.6 to 1.0
Furniture	.5 to 1	1 to 3.5
Improvement/renovations	.1 to 2	3 to 6
Office Equipment	.5	.5 to 1
Frame stock	.5 to 1	1 to 2
Mount/folio stock	.2 to .5	.5 to .8
Film/paper stock	.3 to 1	.5 to 1.5
Stationery	.2 to .4	.2 to .4
Business forms	.3 to .5	.3 to .5
Memberships	.5 to 1	.5 to 1
Training/education	1 to 2	1 to 2
Signs	.2 to .4	1 to 2
Insurance	.9 to 1.9	1.9 to 2.9
Samples	.6 to 1	1 to 2
Deposits on phone/utilities	.2 to .4	.2 to .4
START-UP COSTS TOTAL	14.3 to 31.5	21.6 to 45.5

FIRST YEAR'S EXPENSES	HOME STUDIO	MAIN ST. STUDIO
Rent, annual	2 to 4	6 to 12.0
Heat/electricity/water	1 to 1.8	1.8 to 3.6
Advertising/promotion	3 to 4	3 to 4
Lab fees	20 to 24	20 to 24
Travel (auto)	.5 to 1.5	.5 to 2.5
Film/materials	1.4 to 3.0	3.0 to 5.0
Stock	1 to 2	2 to 4
EXPENSES TOTAL	28.9 to 40.30	36.3 to 55.1
FIRST YEAR'S EXPENDITURES TOTAL	43.2 to 71.8	57.9 to 100.7
FIRST YEAR'S PROFIT/(LOSS)	36.8 to 8.2	22.1 to (−20.6)

Getting Some Help

Before you go to the bank with your business plan, you should contact your local office of the Small Business Administration (SBA) and learn about one of the best sources of advice I know of (and it is free). The SBA sponsors the Society of Retired Executives (SCORE). These people are willing to share their experience and expertise with small businessowners. At SCORE, there are ex-bank managers, ex-advertising people, and people who have run their own companies. These people are there to help you. And best of all, all of this help is free. SCORE is a totally volunteer organization.

SCORE can review your business plan and help organize it properly before you go into the bank. There are usually a number of retired bankers, so they can give you good practical advice on what a banker is looking for. They can also give you good solid advice during your first few years of business and also alert you to any SBA programs which may be of assistance. Go to SCORE at the beginning of your new business, not after you get in trouble! These people know the questions you should ask, as well as the answers you'll need to have prepared. They will help guide you through those tough months ahead.

In Canada, I know from experience that the Province of Alberta had an office of business development which provided professional assistance specifically for photography studios. These people were trained in our specific business practices and were usually retired business executives. The Alberta program was great. The person in charge would help you set up a bookkeeping system, help you sort out your financial affairs, and would give you some custom-made forms for financial planning and forecasting. I am not sure of the other provinces, but it is worth a call to the provincial capitol to see what programs exist and what help is available.

There are also low-cost loan programs for people starting their own businesses. These programs come and go with the various swings in the political winds, so you will have to do a little homework to see what is out there and if you qualify.

What If the Bank Says No?

If you present your business plan and it is rejected by your banker, what do you do? You have a number of options. I'll refer to these choices as "guerrilla financing" and many of these ideas came from the book *Guerrilla Financing* by Bruce Blechman and Jay Conrad Levinson, author of *Guerrilla Marketing*. If you have been turned down, I strongly recommend that you read this book. It is full of ideas to help you get the money you need for your new business.

Some things to do: (1) Look for another bank and/or banker. (2) Look for government

programs for assistance. (3) Look for financial participation of suppliers. (4) Look for financial participation of relatives. (5) Look for an "angel." (6) Go to real guerrilla tactics.

LOOK FOR ANOTHER BANK OR BANKER: Not all banks are equal when it comes to lending to small businesses, especially new ones. Even within a given bank there may be different loan officers who judge small businesses differently. The key is to find that loan officer who is more positive about small business.

Some banks are more aggressive in trying to obtain new business. As a new enterprise, you will also represent deposits as well as a loan risk. The bank makes money on deposits, so that may add value to your proposal. Large banks with lots of money are not good prospects. You need to go to small banks (only one or two branches) or credit unions that treat every depositor like a customer. When approaching a new bank to present your case, ask to see the senior lending officer, one who is empowered to make decisions.

How do you know you have found the right banker? Blechman and Levinson say, "If the first thing you are asked is how long you have been in business and how much collateral you have, you are wasting your time. On the other hand, if the banker shakes your hand, gives you a chair, and says, 'What can I do for you?' you may just have met an aggressive banker. Your chances of getting a loan from this bank and banker are much higher than a more sedate bank looking to do business only with Fortune 500 companies."

GOVERNMENT PROGRAMS FOR SMALL BUSINESSES: If your business plan does not impress any banker, you will need some help. One source is through a multitude of government programs. When one mentions government programs, the first name that pops into people's minds is the SBA. However, the SBA is only the tip of the iceberg on government programs. There also exist thousands of local, county, regional, state, and other federal programs which may help you to obtain the financing you need. Look in the phone book, under government, local, county, state, and federal, for agencies whose names include the words "business development corporations." For a list of small-business development centers, contact the Association of Small Business Development Centers, 1050 17th St. NW, #810, Washington, DC 20036; phone (202) 887-5599.

Contact your local SBA office. The SBA does not give loans directly, but guarantees loans given by local banks to small businesses, except in special instances. If you are handicapped, a member of a minority, a war veteran, or a woman, you may qualify for a direct loan or a grant! (You don't have to pay back a grant.) If you fit into any of the above categories, you can get aide easier. It is well worth the effort to check it out. If you don't have a local SBA office, contact the U.S. Small Business Administration, 1441 L St. NW, Washington, DC 20416; phone (800) 368-5855. Some other federal programs are the Office of Small and Disadvantaged Business Utilization, 400 7th St. SW, Room #9410, Washington, DC 20590; phone (202) 366-5335; and the Minority Business Development Agency, Dept. of Commerce, 14th St. between Constitution and E St. NW, Washington, DC 20230.

LOOK FOR FINANCIAL PARTICIPATION OF SUPPLIERS: One reason many loan applications are rejected is the business has a debt-to-equity ratio that is too high. Banks usually only offer a debt-to-equity ratio of two to one. In other words, for every one dollar of capital you put into the business, you can borrow two dollars. One trick to improve your equity position is to reduce the amount you need to borrow from the bank by having your suppliers finance their products.

If some of your loan is for equipment, check and see if the supplier (either the manufacturer or the retailer) will lease the equipment to you. In a lease, the monthly payments are part of your operating expense, but not part of your debt or liabilities. Some camera

distributors and computer retailers offer extensive leasing programs. They usually require a small down payment and the equipment itself acts as the collateral. If you are renting a Main Street location, have your landlord pay for any renovations or leasehold improvements in return for a higher rent. Again, the rent is a monthly expense and no debt shows on your financial balance sheet. Barter your services for space to another firm. For example, if you want to go into the glamour/makeover area, start up your studio inside a beauty shop. You'll attract new customers for the salon while getting yourself a track record. Some similar ideas may work with wedding businesses.

Tenant partnerships may also help. Find other businesses to share facilities in noncompeting but complementary areas, such as a commercial photographer with a graphic artist or a printer. Another area would be a wedding studio with a bridal, tux, or flower shop.

This one is tricky and dangerous. If you have good credit, save three or four of those "pre-approved" credit card applications you get in the mail. Mail in all of the applications in the same week so you can honestly say on the applications that you only have your original number of credit cards. If you get three or four new cards with credit limits of $1,000 to $3,000, you now have $3,000 to $12,000 of cash purchasing power. The drawback, of course, is the high interest rates and the danger of not being able to pay off the bills. This is a last-resort technique. This will also reduce the amount of cash you have to ask for from a bank loan to purchase day-to-day supplies.

LOOK FOR FINANCIAL PARTICIPATION OF RELATIVES: The more cash and credit history you can include in your proposal, the more likely the bank will look favorably on the loan application. If you have a relative with some resources who is willing to become a financial partner, use him or her to increase your financial position. If a relative has a large equity in a house or other property, see if you can use it to guarantee the loan. If you have a relative with a good business background, and he or she is willing to let you use his or her credit and reputation, by all means do so. Banks are impressed with experienced businesspeople supporting a new venture. Just remember that blood is thicker than water. If you fail, you'll lose something far more valuable than money. However, if you follow my advice elsewhere in this book, you won't fail if you have the talent and energy to work hard and intelligently.

ANGELS: *Angels* is a new term in small-business financing, and one which I think could be a major source of financing for a new studio. The full term is *adventure capitalists* (in contrast to venture capitalists, who specialize in big loans to risky ventures). Angels are people who finance new businesses based on their potential rather than on their track record and assets. They are primarily people in your local area looking to invest $10,000 to $50,000 dollars in a small business like yours. They want to earn a higher return than mutual funds or bank CDs pay. Some of them also want to be connected to the excitement of a new small-business venture. Many angels are successful businesspeople who want to give a little back to the world and make more money. Some are professional people, like doctors or lawyers, looking for a good return on their money. Others are middle managers of large companies, who are bored and looking for a little action as well as a return on their investment. The important thing is that they will lend you money based on your potential, not your history. Many angels will also have experience in business or a solid business reputation in the community. If you can get a person with some influence in your community to invest in your studio, he or she may be able to open certain doors to new opportunities for you by the strength of his or her personality. How do you find an angel? The easiest way is to place a classified ad in your local newspaper worded something like, "Photography Studio seeks capital to expand in proven marketing concept. Will offer substantial equity position. Call (your number)."

An equity position means they will become partners in your business until you pay off the money they loan you, with interest. You will want an angel who has no wish to be an active partner, but one who will advise or be totally passive in the management of your business. Beware of people looking to buy a job or start a career shift from a large company about to downsize. If the angel has extensive business experience you want to tap into that resource, but don't give up control. The typical angel will want to see a good business plan, commitment on your part, sound marketing plans, and good character.

If you use this technique, have a lawyer draw up any agreements between you and the angel. Since you are taking on a partner, many details of control and management, as well as the repayment schedule and interest to be paid, must be negotiated and agreed to in writing. The typical angel does not want to own your business. He or she wants to help you get it going and make money from your efforts. He or she also generally wants to be out of your business within three to four years. Read *Guerrilla Financing* for more information about angels.

How to Determine Prices

The price you charge a client for a job will determine your profit. This concept sounds so simple, but it's one area where most photographers reject science and common sense and turn to voodoo economics. In the following sections I will outline some methods for systematically determining prices. (Note: the prices mentioned are for example only and are not intended to be copied or construed as recommended prices.) Some of the techniques outlined below work best for huge companies such as Sears or Kmart, or for large supermarkets. Others work for small, artistic, or skill-oriented service businesses, where the skill labor charge far outweighs the materials used.

Pricing Techniques

Eight pricing techniques will be explained below: (1) fixed markup method, (2) fixed-profit method, (3) what-the-market-will-bear method, (4) what-the-competition-is-charging method, (5) intrinsic-value method, (6) the blue-sky technique, (7) the seat-of-your-pants method, and (8) the Lilley dollars-per-hour technique.

FIXED MARKUP METHOD: Your selling price is a fixed percentage above the cost of the materials and services involved in producing the product. In a supermarket, the mark-up on canned food products is fixed and may only be 12 to 15 percent, out of which the overhead of the store must be paid. To make a good net profit, they have to sell millions of cans of soup. In a photography studio, the mark-up may be six to ten times (a 600 to 1,000 percent mark-up) the cost of the print being sold.

The key to using this technique is to identify the true cost of the item being sold. Take for example an 8 × 10 print. Your cost from a lab may be $3.09 for the print. To this cost you must also add the postage to the lab, the cost of any retouching, the cost of a folder, any mounting material, and any finishing spray, as well as the cost of the paper bag in which you deliver the total order at the end of the transaction. You must be able to account fully for these real costs to use the mark-up technique correctly. The mark-up percentage will be determined by three factors: your overhead costs, the volume of units you do in a year, and the net profit desired at the end of the year. If you only plan on selling three prints next year, your mark-up must be substantial. If you plan on selling a million prints a year, your mark-up may be much lower.

FIXED-PROFIT METHOD: With this technique, you determine that each transaction (or unit) will earn a fixed profit. Businesses with a lot of small sales, such as an ice cream

stand or a deli, often use a fixed profit for each transaction. Fixed can mean fixed dollar profit or a fixed percentage profit. Each item sold earns the same profit, regardless of the selling price. A corned beef on rye earns the same gross profit as an egg salad on white, even though they are priced differently. The profit per unit, or the percentage profit, is determined by the same three factors as in method one.

To illustrate the difference in the net profit between these three techniques, let us look at the selling of different sizes of photographs (first print, which includes all of the initial retouching costs). Again, these numbers are not for you to copy; they are examples to illustrate the math of profit calculations only. First: let us determine the real costs of a finished print. These prices were taken from a popular nationally known lab's current price list. Five-by-seven and eight-by-ten are deluxe economy, and the larger sizes are custom enlarger prints, and I have included retouching.

SIZE/COST	PRINT	MT/SPRY	FOLDER	RETOUCH	ETC.	TOTAL
5 × 7	2.10	1.75	0.95	5.00	2.00	11.80
8 × 10	3.00	1.95	1.55	5.00	2.00	13.50
16 × 20	21.50	7.50	10.00	3.00	42.00	
24 × 30	61.00	25.00	20.00	6.00	113.00	

FIXED MARKUP: *300% markup (300% is not a recommended mark-up)*

SIZE	TRUE COST	SELL PRICE	GROSS PROFIT
5 × 7	11.80	35.40	23.60
8 × 10	13.50	40.50	27.00
16 × 20	42.00	126.00	84.00
24 × 30	113.00	339.00	226.00

FIXED PROFIT: *make $30.00 per unit sold*

SIZE	TRUE COST	SELL PRICE	GROSS PROFIT
5 × 7	11.80	41.80	30.00
8 × 10	13.50	43.50	30.00
16 × 20	42.00	72.00	30.00
24 × 30	113.00	143.00	30.00

FIXED PROFIT: *make 50% (again not recommended) gross profit per sale*

SIZE	TRUE COST	SELL PRICE	GROSS PROFIT
5 × 7	11.80	23.60	11.80
8 × 10	13.50	27.00	13.50
16 × 20	42.00	84.00	42.00
24 × 30	113.00	226.00	113.00

Remember that your overhead must also come out of net profit.

WHAT-THE-MARKET-WILL-BEAR METHOD: What is the true value of anything? The best definition, for a commercial enterprise anyway, is: what you are willing to ask for and what is a buyer willing to pay? Or to put it more clearly, "You have a sale when the price equals the value." Value is a relative thing, and finding the person who thinks your photographs are worth a million dollars is the quest for the grail.

How do you know your 8 × 10 is not worth $150? You will never know unless you ask. If it is worth it, then someone will pay you the price you ask. If you never ask the price, no one will ever offer you the higher figure. In 1977, I first heard Mr. Bob Becker

speak at a convention. (Sadly, Bob was killed in an airline plane crash in 1984.) Bob told us how he changed his life. He determined that his 8 × 10 was worth $150. He decided to get serious and ask what he felt his product was worth. He also realized that he would have to be in an area where $150 would not seem like a lot of money. He moved to the wealthy Sunbelt suburbs in Florida, into a posh mall in a classy neighborhood. Bob's photography was excellent, but no better than a hundred other excellent photographers who thought that $50 was the correct price for an 8 × 10 (I was charging $25 at the time). Well, it worked for Bob. He sold a good volume and made a comfortable living.

If you are prepared to ask very high prices for your photography, you must believe your photography is worth the price and deliver a consistently fine product. With this technique, there is no formula for pricing. You ask more and more. When people stop buying, you have gone too high. I know people who charge $1,800 for a sitting fee and average $5,000 a sitting. They also don't do many sittings.

At a Joe Zeltman seminar in the seventies, I met a couple from Seattle who related their own pricing problems. The Seattle photographers were skilled and had built up a good volume of business, but were only charging $15 for their 8 × 10s. The photographers were approaching burn-out, feeling they were working too hard for their dollar return. Yet they lacked the confidence to raise their prices, fearing a loss of volume which would cost them net income. Joe told us that if you double your prices and lose half of your customers, you'll make more net income. Your fixed cost didn't change but your production costs would be less, so you make more profit for half the work. My Seattle friends went home, tore up their price list, and doubled everything. They didn't lose a single unit of business and didn't add a cent to their cost. They increased their net income by a factor of two. After six months, they doubled their prices again to a $60 8 x 10 and still didn't lose any units of volume. They were making four times their original net. They were also good photographers and were worth what they were charging at the end of the exercise.

Joe told a little joke about extending this principle too far. He said that you could continue the doubling process until you were down to one customer who was willing to pay the price. Then he dies. Now you're in deep trouble.

WHAT-THE-COMPETITION-IS-CHARGING METHOD: This technique is one of the most common used by photographers just starting in business. Most new photographers spend a lot of time asking their competitors "What do you charge for an 8 × 10?" They ooh and ah when someone haughtily replies "I ask $100 for mine," and pooh-pooh someone who says, "I sell mine for $25." Just because someone asks for a price on their price list, don't assume they are selling any units.

When setting your prices by this technique, you usually try to find out what your competitors charge and you try to fit in. There is one strong pro and two major cons with this price-setting method. The good point is that the prices that you have copied have been established in your area, if you copy from an established and successful studio. The first pitfall is you may have copied the prices of someone who is going broke. They are not making any money at these prices (even though they may tell you that they are), and you probably won't make money either. The second pitfall is that you and the other studio may have vastly different overhead or material costs. They may be getting prints much cheaper or more expensively than you, or they may be paying a much different rent or other overhead expense. Do not try to use someone's price list who operates his or her own color lab when you are bidding for volume work, such as schools or proms. The lower cost available to a studio with an in-house lab is difficult to beat if you have to pay a lab to produce your packages. Be careful.

Starting off with a "good" studio's prices is not a bad way to create your first price.

Be careful not to copy any local competitor's price list verbatim. If your prices and services look too similar, you can create some bad feelings. It can also give consumers the chance to compare apples and apples when phoning different studios looking for a deal. Make your price lists slightly different in structure, so that people have to compare apples and oranges.

INTRINSIC-VALUE METHOD: When you reach the level of Karsh, Ansel Adams, or Richard Avedon, your prints have a value regardless of the subject. The name has a value, and the photograph is considered a work of art and worth paying the extra money. The value is determined by the image rather than the size of the print. In this sense, a 4 × 5 would be priced only slightly less than a 30 × 40 because the value is in the name, not the cost of the paper. There are few photographers whose names have a value, but making your name worth something is a worthy goal. When you are first starting out, unless you have a strong reputation from some other area of success in life, intrinsic value is not a very useful technique.

THE BLUE-SKY TECHNIQUE: I think that this is the most popular method when you start thinking of actually selling your photographs. You pick numbers out of the blue sky! I still have my first price list that I made up when I was in college. My 8 × 10 was $1.50 (black-and-white, toning was 75¢ extra). I had no idea what an 8 × 10 was worth, and I also had no overhead. I considered hours of darkroom work recreation and not labor to be charged to the consumer. You must make a profit. You must go through the exercises in chapter 9 to realize how much your time is worth. Do not guess at prices; calculate them.

SEAT-OF-THE-PANTS METHOD: You are sitting in the coffee shop and Joe of Joe's Widget Mfg. Co. comes over and asks, "How much for a couple of shots for a sales brochure?" It has been a slow month and the rent is due and $100 sounds good today so you say, "$100." He agrees, and you do the job. Three months later you are booked solid with weddings and seniors, and Joe calls back with another job (exactly the same as before). You are tired and you have a positive balance in the bank account and you say "$500, take it or leave it." Joe will probably leave it.

Do not quote prices unless they are based on written price lists and fixed pricing policies. You will look like a fool or a crook when your different rates are compared. If you are quoting different prices for essentially the same services, you are hurting yourself more than helping yourself financially and professionally. Don't make deals on regular jobs. There are always clients who want a little off. Do not bend unless they offer you substantial volume potential, or a substantial single order which enables you to save on unit costs by volume purchasing of materials or lab services. Treat everyone equally, and you won't have to cope with a disgruntled customer.

LILLEY'S DOLLAR-PER-HOUR TECHNIQUE: Using the forms in chapter 9, determine what your goals and needs are. The sum of these two figures is your projected bottom line, or the amount of net profit you need to generate. I use the concepts that there are one thousand potential contact hours in a work year and that you will only keep one-third of what you gross. Multiply your projected bottom line by three and divide by one thousand. This will be your base dollars-per-hour goal to make the profit you determined is necessary for you to be successful in your business. Using the forms for different types of work, such as portrait, weddings, commercial, determine how many hours each type of job will require. Multiply the hours by your hourly rate and this will give you a base price to charge.

Using this method you will always earn a good profit at any type of work that you do. The only trick is to determine accurately the time factors involved. To be safe, you should overestimate your time to be spent. As you develop your skills, you can reevalu-

ate your calculations and revise them accordingly. Be careful of doing jobs where your costs are too high a percentage of the price and you stand a risk of not being paid. An example of this would be in the sale of postcards to a commercial client. Typically, one charges a usage fee for the photography and the list price of the printer for the cards themselves, which may be three or four times the photography charge. If you order the cards and prepay the bill, and the client refuses to accept them, or takes a long time to pay for them, you have lost money instead of making money. Try very hard to avoid heavy exposure to carrying charges for any type of work. In the portrait/wedding market, you should never be exposed to these types of expenses. This simply means getting paid a substantial deposit on any work you do. A minimum of a 50 percent deposit on portrait work or wedding reorders. Weddings should be paid in full before you send the film off for proofing.

The Theory of Affordability

In a given population, there are a range of perceptions of what each individual consumer can afford to spend on a given product or service. In chapter 5, I discuss how the value of watches varies between different consumers. One person may think that a watch should cost $29.95, while another may think it should cost $3,500. As long as it is affordable, people will buy if they think it is worth it. However, if I think something is worth $1,000 and I do not have $1,000, then it is not affordable. In a study published in the *Professional Photographer,* a number of prospective brides were asked how much they (before they had actually gone around pricing different studios) expected to pay for their wedding photography. The study reported that 27 percent said less than $300, 46 percent said $301 to $500, 22 percent said $501 to $1,000, and only 3 percent expected to pay over $1,000.

The point is that the more moderate your prices, the more potential customers there will be in a given market. As you can see, the biggest group was in the middle. Most people have some idea of the value of things and don't always assume the lowest price is the best price. However, when you get up into the higher values, the number of people who would be predisposed to paying out the higher fees diminishes. If you work in a small town, the small percentages imply a limited market. The difference between what a consumer thinks something should cost and what he or she will eventually pay is a function of marketing and selling on the part of the merchant.

You will hear many lecturers discuss how to sell higher prices to customers once you have them in your studio. My point is that high prices, without supporting consumer education, good marketing skills, established reputation, and word of mouth, will deter potential customers from ever coming into your studio. The trick is to find the best price that will bring the better customers to the studio for the maximum profit. It is not an easy trick, and no one I know has the perfect answer.

Conclusions on Pricing

Most successful studios use a mixture of the fixed markup, what-the-competition-is-charging, and what-the-market-will-bear techniques. This mixture is especially true on the price of larger prints. Most studios plan on a much higher profit margin on prints larger than 11 × 14 than they do on 8 × 10s and smaller. There is no logical reason for this practice. Most of these people think that a large print is worth more than a small print.

If you reduce your profit to dollars-per-hour earned, compare the rates for different print sizes. If you use a lab, there is virtually no difference in the amount of labor on

your part between an 8 × 10 and a 24 × 30, yet you make (using our 300 percent mark-up table for this example) $27 versus $226, i.e., 8.4 times the net profit per hour worked.

On page 48, I offer some suggested price lists for you to start with. They are based on the philosophy that you should make a good profit across your print categories, and there is more net profit in large prints. My larger prints are less than many published photographers, but I sell them more frequently. Asking a high price and not selling them does your ego wonders, but does nothing for your bank account. The day you feel you are selling too many big prints, raise the price.

How Big Is Big? Print Sizes and Templates

A number of years ago, I heard a great idea in a lecture. The speaker said that only we, the photographers, buy our prints by the square inch. Most of our clients have no idea of what a 30 × 40 or a 16 × 20 really represents relative to anything in their home; however, the number of inches used in photographer's price lists sounds awesome. Most clients also have a few preconceived ideas of what sizes are "real," e.g., 8 × 10 or 8½ × 11. He suggested naming the print sizes larger than 11 × 14 instead of using their dimensions. Call them anything but inches. I like simple things, so I named mine A, B, C, and D. I list them and give a second name that suggests their most likely use, such as "small wall," "sofa size," or "large wall."

The speaker used transproofs exclusively, and only had to point to sample sizes on the projection room wall to illustrate the options to the clients. In our studio, we still prefer to use paper proofs, and I had to design a way to make this idea work outside of my studio. I invented (to the best of my knowledge) the size templates. Size templates are nothing more than tissue paper cutouts of the standard print sizes we offer. I put folded up D (16 × 20), C (20 × 24), B (24 × 30), and A (30 × 40) templates in a 9 × 12 manila envelope that the clients can take home to help them visualize what the print sizes mean on the walls in their homes. Because the templates are tissue paper, the envelope is easy to carry and easy to use.

Before any customer leaves the studio, we carefully discuss the templates use in choosing the correct size for the space in the home or office. By taking these templates home, it forces the clients to confront the wall they have in mind, which usually shows them that a 16 × 20 is simply too small. The customers make rational buying decisions without any input from us. It isn't our size recommendation, it is their judgment. Since we started using this system, over 85 percent of our family portrait clients purchase large prints. Over 75 percent of these prints are 20 × 24 and larger. All of this without transproofs or high-pressure selling techniques.

On the front of the envelope is an instruction sheet, How to Use the Size Templates. It instructs the clients to first consider the portrait's location in the home or office. In our business, we automatically assume that our family portrait clients are going to purchase a wall portrait, and we want to get them to think about where in the home the portrait will look best. Once they have decided where the portrait will hang, they can then hold up the size templates to see which size fits best. They determine what is best without ever talking about inches. For our family sittings, we give the templates to the client at the clothing consultation. Many of our families arrive for the sitting with a 24 × 30 already picked out to fit in the space they have chosen.

The templates are the best passive sales tool I have ever used. For pennies, you have the most powerful commonsense sales tool in the business. I strongly recommend that you incorporate this idea into your first price list. The trick is to train yourself and your staff to stop thinking in inches and start using the names you give the sizes.

Sitting Fees

Most portrait photographers separate the sitting fee, i.e., the charge to the client for the shooting of the original photographs, from the purchase of any prints or proofs. There are occasions where it may be easier to put both the sitting fee and a first print into a special package, but not under most normal circumstances.

First, what do you call the sitting fee? The normal term is *sitting fee,* but there are a host of other synonyms being used by photographers such as *creation fee, professional fee, photographer's fee, camera charge.* It is still the charge for your professional talent and time and usually does not include any prints. In Massachusetts, because a sitting fee is a professional fee, it is not subject to sales tax. I separate the sitting fee from the print prices on my price list to save my clients 5 percent. The sales tax–exempt status only applies if nothing other than labor is included in the charge. Check your local department of revenue to see their rulings on professional fees versus sale of tangible items.

How much? The philosophy on what to charge for a sitting fee is varied. Some photographers will argue that you can't sell anyone a print unless you get them in front of the camera. They will argue that a high sitting fee scares people away from having a sitting, and that you will have no chance to show them how wonderful a good portrait can be. At the other end of the spectrum, others will argue that a low sitting fee attracts too many bargain hunters who are not interested in buying many photographs. It is the old 80/20 rule in action again.

If you only learn one thing from this book learn this: never have a zero sitting fee for regular sittings. Even if you only charge $5, have a sitting fee. Remember price equals value, and zero equals zero. You may offer complimentary sittings valued at $X, but never a free sitting.

When you first open your studio business, you will need clients to photograph. You will need to practice your craft on them and use them to forge the links in your chain of success. One way of attracting people is a low sitting fee. With a low sitting fee, a client does not have to risk very much money up front to have a portrait done, i.e., it is not a bad gamble on you and your new studio.

As your reputation grows, you can start charging more for your work and start raising your sitting fee. Seldom do experienced photographers cover all of their costs and overhead expenses for a portrait session with the sitting fee they charge. Higher fees act as a filter to eliminate the cheap customer who doesn't value what a photographer can do. However, once you have reached a reasonable limit, you hit a point of diminishing return between price and loss of potential clients. Charge enough to make them respect you, but not enough to keep them out of the studio. Remember, you are in the reprint business, not the photography business.

Most studios charge different sitting fees for different types of sittings. Typically, a family is charged more than an individual. Outdoor sittings cost more than indoor sittings because they take more time and there are risks of weather-related cancellations. Fees for babies and children (if shot midweek in the off hours of the day) are less than for adults. Boudoir and model portfolios have a much higher rate than regular sittings because they take more time. There may also be separate sitting fees for bridals, business, black-and-white, deluxe, economy.

I would recommend the following structure for you when you first get going. Only have four basic sitting fees: children (not in prime hours), studio sittings of all types, outdoor sittings, and location sittings (more than a ten-minute drive from the studio or that require that your bring studio lighting). Remember that high school seniors are treated as a separate group. (See chapter 7 for details on senior sitting fees.)

The studio fee is the same for brides, business sittings, families, or individuals, keeping your price list simple. You should only separate children, models, and boudoir. When shooting families, it is not unusual to photograph subgroups from within the family. I usually suggest these shots because they boost print sales. However, when doing an extended family that requests a long list of additional groupings, you could charge an additional sitting fee. Typically, this amount would be one-quarter to one-third of the initial sitting fee. Use your discretion. It pays to create more groupings, to a point. However, doing every grandchild with every grandparent as a separate portrait does not have a good potential return and should be charged as a separate, additional sitting.

Packaging the sitting fee with a print is a common way of creating a special. Our most popular special packages the sitting fee with a large print in a wooden frame. It makes for a simple complete transaction for the client. At one time, we were frustrated with sittings of individuals or couples who indicated that they only wanted to buy a single print. The cost and time of doing a sitting was only partially covered by our sitting fee. If the client only buys a single small print, we don't make any money. We thought of raising the minimum, requiring a minimum purchase of an 11 × 14 with the sitting. This idea took so long to explain and caused so many hard feelings that we dropped it and returned to our simple system. We appeared too inflexible to our clients and confused our good customers to spite our bad customers.

It is also a standard practice to offer special seasonal promotions in which the sitting fee is reduced or eliminated. These seasonal specials are usually offered in the slow seasons of January to April and tied to occasions like Valentine's Day, anniversaries, birthdays, or other holidays. If you discount your sitting fee, you don't have to discount your reprint prices, which is where you make most of your profit.

In today's market, there is no difference between black-and-white and color photography as far as pricing is concerned. Your sitting fees and print prices should be the same. The only difference should be in utility work, for which you do not guarantee the longevity of the prints past eight weeks. In reality, you should charge more for a good black-and-white sitting, as it requires more expensive materials and much more labor to do a good job. The buying public still does not understand that idea, and you have to educate them.

RESITTINGS AND RESHOOTS: Sometimes, when doing portraiture, a sitting turns out to be less than what the client expects. They don't like any of the poses and want a resitting. What do you do? First, realize that portraiture is still an art and not a science. You can't get them all right all of the time. There are various philosophies in the profession about resittings. Some photographers feel that it is their professional responsibility to provide the client with an acceptable portrait, and that if the client is not satisfied, for legitimate reasons, they will reshoot the sitting for no additional charge. By a legitimate complaint, one assumes that the client is sane, rational, and that the problem was not one caused by the client changing the conditions of the sitting. For example, if a person changes hairstyles a week after the sitting and thinks that the new style is preferable, that is not a legitimate excuse (you run into "the hair argument" with high school seniors, so be prepared). The client should pay an additional sitting fee. If the client did not listen to your advice at the clothing consultation and wore a garment that made him or her look heavy, then a complaint about looking too heavy is not legitimate.

Other photographers will argue that the sitting fee only pays for their time, and that if they made a legitimate effort in trying to produce the sitting, and made no "technical" errors (e.g., leaving a lightstand in the photograph), they are entitled to an additional sitting fee for a resitting. Many photographers from this school of thought will charge 50 percent or 75 percent of the original fee instead of the full amount.

If you charge a moderate sitting fee, I feel it is your job to provide willing and coop-

erative customers with a good product that pleases them. If they are not happy, you should not be satisfied, and your professional pride should make you redo the sitting. Especially when you are new in the business, you will be making a lot of mistakes in handling people, if not in the technical areas of portraiture. A happy customer is worth more than a few dollars for a resitting fee. If you charge a discounted sitting fee, such as in a baby special or a senior sitting, that doesn't cover the costs of materials, you have a right to charge on a borderline case (i.e., where the complaint is half due to the subject's fault and half due to your fault), or in cases where the client changed his or her appearance. When a sitting is really bad, I will suggest a reshoot to the client. Sometimes a client will come in with a cold because he or she couldn't reschedule easily. If the client's nose is red and eyes are puffy, he or she won't like it, and you owe him or her a sitting. If he or she could have rescheduled easily, he or she owes you another sitting fee.

If you plan to charge a resitting fee, you must state it clearly on your price list so that there is no question about your policy or your fee. It should be on the price list right below the initial sitting fees in the same typeface as the sitting fees. No small print.

The Importance of Deposits

There are two major reasons to require a significant deposit on any type of photography that you do. (1) If a person has made a real financial investment in a wedding or portrait appointment, he or she will make a real effort to keep that appointment. (2) Once most people have paid a deposit, they forget about the money. The sale of additional prints is easier because you can deduct the value of the deposit.

For many years, we did not ask for a deposit for our regular or senior portrait sittings. Our policy read, "payment at time of sitting." I would estimate that 10 to 20 percent of our booked sittings would never show up. When we phoned them (while wasting our time waiting for them to arrive) we would get answers like, "I didn't feel like it today," or " I changed my mind." In the last few years, we have refined a system, which I strongly recommend you adopt at the very start of your studio operation. We now require (unless there are very extraordinary circumstances) that the potential client comes to the studio and gives us a check (cash or Visa/MasterCard) for the sitting fee and the proof deposit (which happens to be $150, total, as this is written) to book a firm appointment. We explain to them that the deposit check or Visa/MasterCard number is held until the day of the sitting in case we have to cancel due to inclement weather. Most people leave us a check and/or their card number.

There are three reasons why client deposits should be a firm policy. (1) Paying a deposit in person brings the potential client into your studio for a clothing consultation. This eliminates the "I didn't know where you were located" excuse and helps familiarize them with your style of photography and good clothing ideas. They may have heard of you through a friend but don't really know what you do. Show them. (2) It commits them financially to their appointment. Most people feel that they will lose their deposit unless they arrive at the studio on time. In our studio, since adopting the above policy, we have had zero no-shows of people who have paid their deposits. If there is a real reason for rescheduling the sitting, such as sickness, or one of the family was not able to get to the session, the clients call us to rearrange the appointment. They seldom reschedule on the day of the sitting so that we are not wasting our time waiting for deadbeats. (3) Most people, once they have paid this deposit, forget that this money is theirs to use. I don't know how many times (especially since we do a lot of mail-order business) that our clients forget to deduct the deposit from the total order and send us a check for the full amount. It is a pleasant surprise for them to receive a refund check.

In our direct studio selling, we use the phrase "this print will only cost you $X more." The $X is the list price of the print size being discussed minus the deposit. Most people think they have already spent the deposit and only want to know how much more their order is going to cost them. Thus, the higher the deposit you can collect in advance, the more you can sell them after the proofs are delivered.

DEPOSITS: WHOSE MONEY IS IT ANYWAY? When you collect a deposit, it is, in fact, a sum of money held in trust until a certain service is performed or a product delivered. It is not your money. Some courts have held that even if the client breaks his or her agreement with you, you do not have any right to keep the money without giving some value back. In these cases, you may retain the deposit, but the client can use some other service that your studio offers at a future date and use the deposit to pay for it. In a number of small claims court cases with which I am familiar (in Massachusetts), the judge allowed the photographer to retain the deposit on weddings canceled on very short notice. However, in all of the cases, the photographers were told that the client still had claim to the money in terms of future services.

Most wedding contract forms have some kind of statement such as, "In the event of a postponement or cancellation of the wedding, the deposits paid are not refundable" (this is taken from the NEBS Wedding Contract, form #136-(3)). In twenty-one years in business, I have only kept three wedding deposits, and one of these used our services the following year. I never heard from the other two again.

In the portrait sitting scenario described above, we do not actually deposit the check (90 percent are in the form of checks rather than cash or charge cards) in the bank until the sitting has actually been done. There are cases when we couldn't actually do the sitting (because of bad weather in outdoor sittings or because of an illness or other unavoidable problem), in which case I return the check to the client. Even when I start a sitting and have a very uncooperative child who makes it impossible to get a salable photograph, I will give the check back to the parents. Such a refund is a personal policy and one which many other studios do not follow. I believe that if I can't get any good photographs from a sitting of a child, I don't want the money, even if I have invested my time and some film.

In the case of wedding photography, you must use common sense. If a wedding is canceled months before the date, and you have a good chance to book another wedding, give the money back. If the wedding is canceled only a few weeks before a busy weekend, then you have been damaged, and I feel that you should keep the deposit. Just remember, the people who gave you the deposit can book a portrait session or another wedding and apply the deposit.

Where is the dividing line between keeping a deposit and giving it back? That is a question that requires good business sense and not legal or logical thinking. In wedding photography, the wedding cancellation is a traumatic experience for both parties, and keeping the money only exacerbates the situation. If you return the money, you will be a nice guy, and perhaps both of the parties might come back to you for the next wedding. This outcome has happened to me in the past, so I won by being forgiving and generous.

I also experienced a situation where poor business judgment gave our profession a black eye. I was speaking at the Oregon PPA (PPO) at the same time as the ground phase of the Gulf War. A headline in the Portland newspapers read, "Photographer Cheats Local War Hero's Bride." The couple had booked the photographer, paid a deposit on their wedding, but the groom had to go to the Gulf, where he was killed in action. The poor bride called the studio with the bad news. The photographer refused to give her the deposit back. The newspapers got this story and made mincemeat out of this guy. We

took up a collection at the banquet at PPO to give the girl her money. As I have said before, you need to use good business judgment.

Working for an Average in Pricing

A good approach to pricing in all areas of photography is the "average per job" or "average per contact hour" concept. In this approach, you work toward a pricing policy that will guarantee an average dollar amount per job or per unit time, providing you with the profit you expect from your business.

For example, let us say that you want to generate $100,000 in gross revenue in the coming year, as determined by your business plan in chapter 9. You also have to think about how many potential jobs you can do and the average sale per job. Let us assume that the portrait section of your plan projects one hundred sittings at a $500 average, including the sitting fee and reprint orders. You should structure your pricing policy to achieve the average with a large initial purchase (such as a wall-sized print), and then use more creative pricing to encourage higher averages. In our studio, we use the proofs as an incentive to encourage our portrait clients to make the average sale that we expect from each sitting. Once the order exceeds our predetermined average, we give them the proofs as a bonus. It works. Many times people who only needed a few prints will order that little bit extra to make the average and get the bonus. The more copies you order, the less they cost you in lab fees and handling, so you win with both a lower cost and a higher net profit.

The philosophy of a sliding price scale is simple. All of the work on your part is concentrated in the first print from a given negative, i.e., all of the filing, the negative retouching, the ordering, and bookkeeping paperwork. To sell a second print requires no additional labor (except print retouching, if necessary) and will usually qualify for a reduced price from the lab on the additional print. To encourage the client, give them a good price break on the additional prints. Reduce the price substantially after you have made your average. Just do it consistently for everyone.

There are people who will argue that each image you produce is worth the highest dollar value you can get for it, and that the second image should not be discounted. Most of the people teaching this technique make their living selling a few large prints for big bucks to a select clientele. I would not recommend this approach for a new studio. The point is to increase your average by selling more units to the clients you have in your studio at the moment. The other trick in creating a price list with a sliding price scale is to keep it simple enough so that the client can read it without getting confused. We have tried many formats over the years and have not found the perfect list yet for small prints. We continue to look for the ideal format.

Creating a Price List: Some Rules and Ideas

Price lists are a necessary evil in this world. When you hear some lecturers on the speaking circuit, they will tell you "We don't have a price list in our studio." That works fine in a well-established studio looking to sell a few big prints for big bucks to a select clientele. When you're just getting started, you must supply the customers with a printed list of what you are selling and for how much. You can turn customers off with too arrogant an attitude.

The elements of a good price list are as follows. (1) Simple wording. People don't read all the fancy language you may wish to write about every detail. Too many words actually confuse customers. (2) Clear pricing practices. With regard to finishes, retouching,

and extras. Do not confuse the customer, because it will cost you sales. Keep it simple. (3) Clear discount procedures. For multiple prints from the same pose, for volume purchases, proofs with large orders, etc. (4) Specific statements about what the client gets regarding sittings, prints, and packages. Separate sitting fees from print prices unless you package them for certain conditions. Be clear. (5) Make the price section a separate insert section from the description section. Invest in good printing for the description part and quick printing for the prices. Too many times, a studio won't raise their prices because they have invested a few hundred dollars in printing fancy price lists and don't want to waste money by discarding them. (6) Tables of prices. Arrange your prices in tables so that it is clear that buying multiples of the same pose leads to a discount. (7) Use sliding price scales to encourage bigger orders. (8) Use proofs to elicit larger orders. Sell proofs at regular prices with small orders, discount them with medium orders, give them as a bonus with large orders. (9) Use different print finishes. Sears-Roebuck has built an empire on the basic sales tool of good-better-best. You hope to sell the better, but offer the good to have low prices. Offer the best to make the better look like a bargain. The pricing is all relative, but it works. We have always used the terms *economy, custom,* and *heirloom canvas.* Other studios use much fancier terms, but we feel that the language violates the keep-it-simple principle without adding any buying incentive. *Economy* has a cheap ring to it, while *custom* has a sense of honor about it. (10) Packages. When you are established, you may not choose to offer them, but when you are starting, offer packages. Design your packages to fit what you want to sell, not what the customers want to buy the most. Use Christmas cards to build packages. Built them around larger (11 × 14 and up) prints. Price your lowest package at the average price you want to get for your average sitting.

What to Charge: Some Suggested Starting Prices for a New Studio

A good place to start a price list is at the national average for the particular services. These numbers reflect what studios charge across the country and are safe to use in the sense that the average is halfway between the top and bottom. We will assume that the bottom half is being poorly paid or is going broke shortly. We will further assume that the top half is where you are heading in your business.

There are economically distinct regions of North America. I happen to live in the prosperous Northeast where the cost of housing and other services is much higher than in a rural area in the South or West. I will list two sets of figures, one high and one low. Use the set appropriate to your economic region. If you live in a major metropolitan area, such as New York, Boston, Atlanta, or Los Angeles, add another 25 percent to the high figure to account for the higher cost of doing business and the higher wages paid in these areas.

Portrait Studio

Sitting Fees

	HIGH	LOW
Studio	40	25
Location	50	35
Requiring Travel	60	45

Reprints: High/Low

SIZE PRINT	1ST PRINT	2ND PRINT	3RD PRINT	EACH ADDITIONAL
Size A (30 × 40)	450/350	less 15%	less 20%	less 25%
Size B (24 × 30)	300/275	"	"	"
Size C (20 × 24)	250/225	"	"	"
Size D (16 × 20)	165/140	"	"	"
Size E (11 × 14)	110/95	"	"	"

Copies of the Portrait

8 × 10	45/40	"	"	"
5 × 7	35/30	"	"	"
4 × 5	25/20	"	"	"

Wallets

Set of four or six of the same pose = same as 4 × 5.

Note: When the second, third, each additional copy column says less 15, 20, or 25 percent, it refers to the first copy price, not the price of the print just before.

Proofs

Four-by-five (or five-by-five) proofs are $15.00 each unless the portrait order is over $350.00, after which the proofs are $7.50 each. If the total portrait order exceeds $500, the proofs are included at no charge (excluding any folios which contain the proofs).

Note: All prints larger than 8 × 10 are mounted on good quality double-weight mount board, are lacquer protected, and include basic retouching. Additional charges apply for extraordinary retouching (airbrushing), canvassing, or other extra finishing services. Eight-by-tens and smaller, except wallets, should be mounted on single-weight backings, sprayed for protection, retouched for minor blemishes, and presented in a good-quality folder. High prices apply to economically healthy areas in the country! The low prices apply to areas which may be more depressed. If you live in a major metropolitan area where prices and wages are higher, add 25 percent to the high figures for a reasonable starting point.

Growth

Plan to increase your prices by 5 to 7 percent every six months. Have a new price list on June 1 and January 1 for the next five years. This will keep your prices in line with your abilities.

Wedding Prices

National average most popular packages	HIGH 700/LOW 550
My recommendation	HIGH 1200/LOW 850

Create a package which includes: bride's album (art leather or leather craftsman) with thirty to forty "sides," an engagement sitting, a prewedding casual sitting, two or three black-and-whites for the paper, and six to nine hours of coverage time (depending on local customs and formats) on the wedding day.

Think of the album as thirty to forty sides, each side consisting of one 8 × 10 or two 5 × 7s or four 4 × 5s. Offering mixed formats has a lot of appeal and not much more cost to you. I use the word *side* instead of *page* as many people will think of a page as two

sides. If you offer thirty pages, they may think they are getting sixty 8 × 10s. Be careful how you word your price lists.

Proofs

Do not include any proofs in the original package. Sell the proofs for $3 each or $250 for the entire set for a full wedding coverage (assuming 150 to 200 proofs in inexpensive proof books).

Wedding Reprints

About 25 to 33 percent less than your portrait list. I would not recommend using various finishes as a sales tool on your wedding reprint price list. Wedding reprints are usually economy prints, but with the additional retouching you would use in the bride's album.

Partial Weddings

A four-hour coverage at 65 percent of a full-coverage price, but including an album with only sixteen sides.

Parent Albums

Base price on 50 percent of portrait list price for print size plus the actual cost of the album.

Accessories and Other Services

FRAMES: Cost (including freight) plus 130 percent
COPY AND RESTORATION: Cost plus 200 percent
PASSPORT: $15 to $10 (Polaroid)
UTILITY B&W SITTING: (include two 5 × 7s) $75/50
MODEL PORTFOLIO: (four looks, four 8 × 10s plus contact sheets) $300/200
MODEL HEAD SHOT: Regular sitting fee
FORMAL BRIDAL: Regular sitting fee
CHILDREN'S PORTRAITS: 25 to 33 percent off of regular sitting fees and senior package prices

Commercial Price List

In questions on pricing concerning national accounts, please consult the American Society of Media Photographers (ASMP) Pricing Manual. The ASMP book deals extensively with usage rights, prevailing rates, etc.

DAY RATE, STUDIO	600/450 (in large cities 1,000 to 1,200 is typical)
DAY RATE, LOCATION	700/550
HOURLY RATE, STUDIO	75/50
HOURLY RATE, LOCATION	75/63

Expenses are usually billed out at a 20 percent markup over actual costs, unless the item is billed directly to the client. For example, a model agency charges $100 for a shoot. If you pay the model agency and bill the client, you would bill $120. If the clients pays the agency, they would pay $100.

Items you normally bill are: film (regular and Polaroid), processing (including any pickup or delivery charges), rental of props or space, models, materials for backgrounds,

travel expenses, travel at twenty-one cents per mile for your own vehicles, special ser-
vices (such as retouching, makeup, and stylist), phone calls related to the shoot, etc.

Some studios charge for overhead costs as a separate item. This charge should be
clearly stated when bidding a job, as it is not a universally accepted practice.

USAGE RATES: Highly variable with area of use. See ASMP list.

PRINT PRICES AND OTHER SERVICES: 100 percent markup over cost.

Senior Price List

Typically, a high school senior sitting fee will range from $15 for a basic studio sitting
to $70 to $100 for an elaborate location, multi-outfit shoot. The object in a senior sitting
is to cover your basic costs and not to make a profit. You can't sell them a package if
you don't get them into the studio.

Senior Sitting Fees

Basic 6 to 8 pose, no change of clothing, in-studio session	15/10
Deluxe 12 to 16 pose, one change of clothing, in studio	30/25
Deluxe outdoor/indoor, 15 to 20 poses, two changes	45/35
Super deluxe, 30 pose, three or four changes, indoor/outdoor	75/55

Typical Senior Package

National averages, three units	75/60
National average, à-la-carte units	35/30

Recommended Starting Packages

PACKAGE A	2 REGULAR UNITS + 1 WALLET UNIT	70/60 economy
B	3 + 2	105/90
C	4 + 3	140/120
D	5 + 4	175/150
E	6 + 5	210/180
F	7 + 6	245/210

The typical economy senior package is a negative retouched but not sprayed or
mounted on any type of backing. A custom package would include spray and additional
print retouching. A custom package would be 25 to 30 percent higher than an economy
package.

Larger prints should be priced at 25 to 33 percent less than your regular portrait price
list. You can build larger packages by including large prints with the smaller units.

Templates

This form should accompany the tissue print-size templates discussed earlier in this chapter.

How to Use the Size Templates

Enclosed are a set of templates. These templates are to help you decide which size por-
trait prints will best fit your home and/or office. There is no one size that is best for all
wall spaces, so we have made these simple-to-use templates to make your choice logi-
cal and easy. First: decide where in your home and/or office you feel your portraits should
go; e.g., over the couch, over the mantel, in the bedroom, in the family room, behind
your desk. Second: have someone hold up the various sized templates in the chosen spots.

View the templates from normal viewing distance, ten to fifteen feet back. Remember the framer's rule of thumb: a work of art should cover at least one-half of the wall space under consideration, otherwise it is more wall than art. Third: change the templates until you find the sizes that best fit your chosen space. Fourth: you may also consider a "cluster grouping" instead of a single larger portrait print. A cluster grouping is a number of portrait images grouped together on one wall to give a variety of feelings captured in the portrait session. Fifth: write down the size and a description of the colors of the wallpaper, the furniture, and the rug in the room. This information will aide us in selecting the best setting for your sitting and later will help you to choose the correct framing materials to go with the portrait.

If you have any questions, please do not hesitate to call us.

Hanging a wall portrait is like adding a new window to your room! Every time you look at it, you will be looking out at the beautiful setting of your portrait.

3

The Marketplace

Customers don't generalize, they specifize! *Do you buy your shoes at a department store or at a shoe store? Most people buy at a shoe store. The* specialist *has the upper hand in the mind of most consumers.*
—Al Reis and Jack Trout in *Bottom-Up Marketing*

The major point I wish to make in this chapter is that very few financially successful studios are generalists today. Very few studios can make a good profit on all of the business that walks through the front door. Successful studios specialize to some degree. The most successful studios usually specialize very narrowly and market strongly on those narrow fronts. I realize that these are broad generalizations, but after extensive research and discussion with many photographers, I think they are true.

Portrait Niches: Segmentation and Specialization of the Portrait Photography Market

A very important and profitable part of the studio business is the portrait photography market. This generally can be subdivided into families, individuals, and couples (separate from the wedding market). Each subdivision can be further broken down into niches, usually identified by style and/or price elements. For example, families can be photographed in the studio, outdoors, in their homes, in color, in black and white, traditionally, contemporarily, low end, carriage trade, mid range. A niche is any combination of the above technical/style/price elements that appeals to a significant number of potential clients in a given market. For example, my business on Cape Cod stresses family photography in color on the beach. Mike and Helen Boursier, very fine photographers in a neighboring town, stress family photography in black and white on the beach. We are actually working to slightly different audiences in the same market, and both of us are doing very well.

Each niche requires different equipment, different photographic skills, and different marketing approaches to be exploited successfully. I define *successful* here as financially profitable. Not all photographers currently doing business as professionals have all of the skills/equipment required to be successful in every niche.

Most new studios are generalists by necessity. They don't know what their skills and strengths are and take any job they can get. They use this business for on-the-job training in both the technical and business ends of photography. They haven't the time or the experience to see what their market area really wants or needs from a photography studio. This general approach is also true of some established studios. Many working photographers lack important practical knowledge and have little or no technical experience in many profitable areas of studio photography.

Niche specialization, especially when it is new to a given locality, has to be marketed to potential clients; they usually don't walk in and ask for that style of work. Trying to ride on the coattails of a niche developed and successfully exploited by another studio can be a disaster. The second studio will often try to match the first studio's style, often with very unprofessional results.

I think that most photographers are marketing lazy. They do wedding photography because brides come looking for them, or high school seniors because the yearbook editor told the kids they needed a portrait done now. No one will knock on your studio door asking for a hand-colored, black-and-white, 24 × 30, canvas boudoir portrait unless they have been shown this style by a strong marketing effort on your or someone else's part.

Here are some of my rules of niches: (1) It isn't easy. Be thankful. If it were easy, Sears and Olin Mills would be doing it for $9.95. The only way to beat the big guys is to be better in a smaller arena.

(2) If too many studios are marketing in the same niche in the same market, the style loses it uniqueness and its value, which results in prices dropping and profits disappearing. You must be different to be profitable. To quote Stephen Harper in *Starting Your Own Business*, "If your business activities are simply going to be a lukewarm rehash of what the person down the street is doing, then you had better reserve some space in the obituary section of the newspaper for your business." I have seen many photographers who are always looking for the easy way to make money. They will go to a seminar, hear a success story about a certain niche by a photographer from somewhere else, and decide to go for it. They beg, borrow, or steal all of the speaker's marketing materials, copy them exactly onto their letterhead, buy three or four ads in the local paper and sit back and wait for the customers. Unfortunately, they usually don't invest the time and money into marketing the ideas correctly, as the speaker had done in developing the niche in his or her home market area, and the copycat effort flops.

(3) You can't always copy other photographers' marketing programs. However, you can learn their principles and apply them to your market.

(4) You must also realize that developing a niche takes time and effort. You must educate the public, separate yourself from the competition, get examples of your work into the public eye, defend your niche from encroachment, and be on the lookout for new opportunities to introduce into your business.

(5) You cannot profitably compete head-to-head with a niche owner, so don't try. Find a better niche that you can exploit at your talent level for higher profit. When it comes to marketing photographic services, one photographer is not really better than another (in the eye of the consumer) in a skill sense, but one can be more determined and/or more focused on certain areas of business. Compare the typical Yellow Page ads one sees around the country. Some studios have a laundry list containing twenty or twenty-five areas they "specialize in." Consumers aren't that stupid. Typically, the more successful

studios only promote two or three specialities in their ads. The very highest grossing studios (in terms of profits) don't use the Yellow Pages very much, and, if they do, they only promote one area. They are indeed, "specialists." The most successful studios don't use the Yellow Pages much because it is too indirect a media. They know where their customers are, and they have learned how to reach them with much more effective marketing programs.

One the newer elements in the market mix of studio photographers is the franchise, such as Expressly Portraits, and Glamour Shots. These franchises are very niche oriented, such as the glamour makeover style for individuals, or the quick midquality, midpriced family portrait. They make good use of highly visible mall locations, high-tech gadgets, and price-oriented marketing. For years, Olin Mills has been active in the low to middle end of the portrait and wedding market, and the department stores own the low-end baby market. These companies know their market, and they know how to advertise and market effectively.

How do you find a niche? This is a chicken-and-egg-style paradox; which comes first, your skills/knowledge level or the awareness of a niche that requires these skills? (1) Keep your eyes, ears, and mind open to what's new in your market area. Read articles and go to seminars, schools, meetings. Socialize with your neighboring photographers to see what they are doing. (2) Be brutally honest with yourself regarding your talent, knowledge, capital investment capabilities, how much time you can devote, and your ability to focus your energies. (3) Remember that some niches come and go with changing market attitudes, fads, and styles. (4) If you find a good niche and exploit it, will you be happy doing that kind of photography over and over and over and over and over and over and over?

I knew a photographer who owned a studio that did 2,500 weddings a year in the low-end market. He had found and successfully exploited a niche in this market. He was miserable! He was making a lot of money, but he hated the idea of going to work every day. Recently he died of a heart attack while still in his early fifties. Is this what you want?

Our neighbors, Mike and Helen Boursier, started in a generalist business and quickly learned to specialize. Their initial success was in the boudoir style. After a few years, they had a change of mind and switched their emphasis from boudoir to families in black and white. The reasons for the change were personal to Mike and Helen, but they are skillful marketers and were able to keep their dollar volume growing while switching style directions in midstream.

There are many niches in photography. They offer different creative and personal challenges to some photographers and not to others. Being happy in business is finding the niches that satisfy the creative side of your brain while supplying money to the bean counters on the other side of your cranium. I have come to realize that my business is composed of a series of niches and not a continuous series of photographic styles. I know what I like, and I also have found out what the consumers in my markets want to buy. By controlling my expenses and my marketing, I can make a higher profit with less effort than trying to be a generalist studio.

What Type of Photography Do You Want to Do?

When talking to students attending photography schools, it seems that 80 to 85 percent of them feel destined to be commercial/advertising photographers in New York City. Many new photographers coming into the profession from the backdoor say that they think that the commercial area is where they would prefer to aim their career. If you ask them why, they usually think that there is more business, it is easier to get, and is

more creative than weddings or portraits. Many of these new photographers speak from a position of ignorance of both their own talents and the conditions of the photography market. Most people just getting going in photography have very little experience in many areas of possible development. They have done some of what they considered commercial photography and perhaps a few weddings and portraits. Most of the commercial work is usually some type of property still life.

Most new photographers are very uncomfortable handling people, and this shows in their portraits and results in a fear of doing more. They like commercial work because the inanimate products don't make them feel uncomfortable, and they can concentrate on photography more and do a better job at the skill level involved. A survey published in 1988 showed that of the 120,000 professional photographers in the USA, 35 percent were employed in the portrait/wedding area and only 22 percent in commercial/advertising with smaller numbers in medical/research, government, industry, photojournalism, and elsewhere.

While there are some successful commercial studios outside of the major centers of commerce, they get rarer as the manufacturing/production business community gets thinner. In rural settings, there are about ten or fifteen portrait/wedding studios for every one commercial operation. In the big cities, there are many more commercial studios per capita, in fact too many in the major centers. In New York, talented young photographers arrive by the busload. There is a lot of talent for a limited number of jobs. Ad agencies and other buyers realize this situation and play off the new people against the established studios to keep prices low. (A New York photographer's day rate may seem astronomical to a rural photographer, but you must remember that the cost of doing business and living in the Big Apple is also much higher than in Smallville.) Talk to any fairly successful New York photographer, and you will find out what the word *competition* means.

My advice to you as a new photographer is not to get too specialized in your first few years. You have no real idea of your potential talents, and you need to exercise yourself in all directions to find your strengths. You also don't know your market as well as you may think. There may be little niches of specialization that you aren't aware of, which can make a good living for you and be very enjoyable. Leave yourself open, which will help you pay the rent. You may find out you hate kids and love art directors or vice versa. You may find out you love the detail and perfection that is involved in complex commercial shots or that you prefer the "shoot on the run" excitement of wedding photography. At the end of two or three years, you can start thinking more in terms of specialization, but only after you've discovered yourself and established a client base.

Is Your Market Ready for You?

Very few beginning photographers really research the best possible location for their new studio, and then move to that location. Most of us go into business in the neighborhood where we live or were raised. Market research is a very scientific part of the advertising and public relations industry. Large companies spend millions determining who is interested in their product and where these people are located. Before opening a new McDonald's, the head office will determine very accurately if there are enough potential clients in the neighborhood to warrant opening a new store. This type of research costs a lot of money, and is usually not done by a new photographer.

How to Evaluate Your Neighborhood as a Potential Business Location

The numbers listed below are important to your potential success. There is no magic formula to guarantee success from the information, but you can help determine your potential better if you know the numbers. A good example is that if there are no churches or synagogues within a reasonable distance of your new studio, getting wedding work will be a much harder job than if there are three churches or synagogues within walking distance. (Did you ever notice that funeral homes tend to be right across the street from large churches?) If there are few teenagers living in your town, you will have a hard time attracting high school seniors to your studio. In the following section, a "market" is defined as the area in which you can reasonably do business. In New York City, that might be an area one-half mile from your address, while, in Alaska, it might be a circle of two hundred miles. The numbers you have to determine are for your chosen market.

- Number of people in the area
- Average income of people in that area
- Average family size
- Average age and age distribution
- Number of churches or synagogues in your area
- Number of schools (and which age groups they specialize in)
- Is the area growing or shrinking in population?
- How is the economy in the area? Is it growing or shrinking?
- What is the ethnic distribution of the population in the area?
- What is the style of the area? Upscale, preppy, working class, etc.
- What is the competition in the area of photography in which you wish to specialize?
- What is the economic base of the community? What are the outside forces?

Where do you want to grow? Is there potential business there for you? Some of these numbers and answers can be determined from your local census, town clerk, or chamber of commerce. The grow/shrink questions are judgment calls in which your banker can assist for an accurate and meaningful answer. Some of the numbers require a great deal of knowledge of the buying habits in photography for various age and ethnic groups. This information can be gained from the professional photography associations in your area.

Where's the Business?

For the new studio, there are a number of markets readily available and some markets in which you can get burned, if you don't know what you're doing. If you've only done ten or twenty portrait sessions with friends, relatives, or neighborhood kids, don't think you can walk into your local high school and bid on the yearbook contract. It has been (and can be) done, but you probably will not survive the problems.

Let me make a few assumptions about where you are in your professional life if you're reading this book. You've photographed some children, some friends, done a few model portfolios for some pretty girls or handsome guys, done some weddings for friends of friends, and maybe some as a stringer for a more established studio. You feel your photography is as good as half the local studios. You have some friends who keep telling you you're wonderful, you've won some blue ribbons in the local craft show, and may have even had a one-person show at a local gallery. You've sold some art prints and a few scenics and you've read a couple of basic books on photography. With some luck, you may have attended a state or regional PPA convention and viewed the print compe-

tition and heard a couple of speakers talk about "how they did it." You're ready! Bring on the customers.

The largest photography markets that are readily available, in terms of dollar volume, to the typical new studio are: (1) weddings, (2) high school seniors, (3) children's portraits (including preschool market), (4) service or utility market (passports, copy work, P.R. portraiture), (5) small commercial market, (6) groups (teams, leagues, etc.), (7) family and individual portraiture, (8) volume portraiture market (school, church directories, bank promos), and (9) speciality markets (unique to your locale or your background and talents).

The wedding business is the easiest to get started in for two reasons. First, there are a lot of them (2.351 million in 1992–93 in the USA). Second, photography is traditionally a part of the ritual, and the families are looking to hire a photographer. There is always room for one more wedding photographer, especially when he or she is starting at the bottom. The air gets thinner as you move upward, but there is always room at the top for the best.

The high school senior business is also good for the same two reasons as the wedding business: there are a lot of them (2,461,000 graduates in 1992), and they are looking for you. Competition in the high school senior market is greater and more organized than in the wedding market, so it is harder to break into, but it is an accessible market that, with a little effort, you can penetrate.

Be careful to avoid jobs that require specialized skills, equipment, or knowledge, or which require you to do a high volume quickly and efficiently. With only twenty sittings and a 35mm camera, don't walk into a billion dollar corporate headquarters and ask to "shoot" the boss. Don't submit a low bid to a high school and realize you have to do three hundred sittings in one month, including retouching and finishing, plus all of the sports and activities for free. Don't bid on a major catalog shoot if you don't know how to use a 4 × 5 view camera.

Sure Things: Your Edge to a Certain Cash Flow

Most successful studios have a number of "sure thing" accounts. These are accounts that almost unfailingly deliver business to you at predictable times of the year. They are worth their weight in gold and worth competing for. This is especially true of commercial studios. Sure things may require more service per dollar than an ordinary account, but they provide lots of dollars at specific times of the year. My professional business depends on $150,000 of sure things annually. The best type of sure-thing business comes in the normally slow months of the year when little else is available.

Examples of sure things include the following. (1) Some organizations require convention photography every spring, thirty groups—thirty 8 × 10s each—paid in cash in advance. You had better give them a good rate, because you are going to make a great deal of money, and you don't want to starve the golden goose. (2) A local manufacturer needs an annual catalog shoot in the winter months, not very high-tech, but good, competent black-and-white developing and printing. (3) State or local beauty pageants, local little leagues or other sports programs, and local schools can become sure things. (4) What about the local manufacturer that takes its own photos but needs one thousand 8 × 10 black-and-white prints (yesterday)? If you're broke, there's a source of quick cash.

There are a lot of sure things out there. Just make sure they don't interfere with your other busy seasons, or weekends. Once you've found a sure thing, treat them well. Raise your prices realistically, but never haggle over the service you'll provide.

Photography Markets

1. WEDDINGS
 candid
 studio formal
 formal
 partial
 complete
 black-and-white
 video

2. PORTRAITS
 babies
 children
 young adults
 high school seniors
 graduation
 engagement
 couples
 families
 reunions
 business
 passports
 boudoir
 glamour
 model portfolios
 weddings
 pets
 animals
 toys

3. SMALL COMMERCIAL
 real estate
 small products
 storefront photography
 interiors
 fashion
 public relations
 hair salons
 business portraits
 postcards, brochures
 local government
 animals (farm/breeders)
 bands/entertainers
 decorators/scenics
 art photography
 stock photography
 photojournalism

4. LOCATION/STYLES
 in the studio
 natural outdoor environments
 urban outdoor environments
 in the home
 create fantasy sets
 candid/formals
 landscape of the mind
 projection backgrounds
 black-and-white
 digital
 lifestyle
 hand-colored black-and-white

5. GROUP MARKET
 proms and dances
 schools (private, public, church)
 small schools (day care, nursery, dance)
 sports leagues/clubs (hockey, little
 league, figure skaters, gymnasts,
 judo, football, soccer, bowling
 leagues, etc.)
 motor sports clubs (auto, motorcycle,
 etc.)
 boating (yacht club, etc.)
 civic groups (fire, police, church groups,
 organizations, fraternal groups, vet-
 erans, service groups, social clubs,
 square dancing, choirs, bands, tour
 groups, bus tours)

6. LARGE COMMERCIAL
 catalogs
 large set construction
 architectural interiors/exteriors
 major ad campaigns

7. COPY AND RESTORATION
 straight copies
 restoration
 digital

Selling Art Prints or Scenics

Most of us like to take pretty pictures of landscapes, seascapes, flowers, or other interesting subjects. This is the type of work that got us into professional photography in the first place. It would be pleasant if we could sell our creative works for a good profit. Unfortunately, there is not a big market for art prints in photography. There is some market, but it is slim and it requires a lot of searching and prospecting to find, and then a lot of work and material cost investment to develop a salable stock.

A simple example is selling scenics of your local area. People often admire a beautiful shot of some local scene, but they will seldom pay much for it. I found that I couldn't sell a 16 × 20 print, matted and framed, for much more than $75 to $100. The amount of labor required to print, mount, mat, and frame a supply of prints was horrendous, and not creative (unless you like framing). We also found that no matter how careful we were in mat and frame selection, the client always seemed to want some other combination. We sold scenics for four years (in a popular tourist area where there should be a good market) and realized we were not making much profit, especially compared to the portrait/wedding business in which we do most of our work. The scenics helped us get into a lot of homes and markets, but by themselves they were not worth doing.

Today's Portrait Market: Value, Variety, and Volume

Being in business for oneself should bring a number of rewards that define success. There are monetary rewards that enable you to enjoy a lifestyle that you desire. In our society, value is associated with the amount of money a person is paid for his or her labor. The proverbial "starving artist" is a picture of a person with some respect but little value. Value is related to the dollars one is paid for one's efforts. There's personal satisfaction, in the sense of pride in workmanship, accomplishment, joy in working, and a feeling that one is doing what one desires. There's also the respect of your community. The feeling that others in your community respect you for what you do and respect you for your success.

Being a successful portrait photographer today is a complex and, to me, a very interesting life. I love what I do, and I feel I have achieved the rewards listed above. Achieving a satisfactory level of success took time and a lot of changes in my aptitude, attitude, and approach as I matured in this business. What I want to communicate here is what I wished someone would have told me twenty years ago when I first started out in business. Maybe someone did tell me, but I was too focused on my future to listen. I do know that nobody wrote this information down for me to read and ponder when the bumps and pitfalls of business came my way.

When I first started in photography in 1969, I had this fuzzy idea of becoming the village photographer, like Norman Rockwell's vision of the country doctor, doing all kinds of photography for all kinds of people in my hometown. As I grew in skill and experience, I realized that I didn't enjoy certain types of photography (commercial, for example) and that I couldn't make much money doing some types of photography for particular segments of my community. I also have learned that any given market area is not a uniform mass of people. A given market is more like a Swiss cheese; there are good parts, a lot of empty spaces, and some parts that stink. The key to success is to find the good parts and to avoid the holes and the stink.

The portrait market today consists of a series of niches. I don't know of any photographer who makes much money doing "everything." Most successful studios have their

strong suits and their weak areas. The key to a successful business is learning to cut the bad areas from your business agenda and concentrate on the strong areas.

A niche is a combination of a type of photography and a style of photography, in a certain setting and in a certain price range. I do families on the beach in color in the mid-range price. The Boursiers do families on the beach in black-and-white in the high range of prices. They are different niches. From a photographer's point of view, it may be difficult to see the differences. You must step back and take the uneducated consumer's viewpoint. The consumers are the ones paying the bills, and their viewpoint is much more important than the photographer's.

There are photographers who make most of their living in only two or three of the niches listed above. In my own business, I work in about five niches. There are very few who work in a single niche only. I'll use Larry Peters of London, Ohio, as an example. He does over a million dollars a year in high school seniors only! I am not sure if he does anything else, but I think that if he does, it is for variety and not for additional profit.

What determines which niche is good for you? This is a question that all businesses ask themselves when they want to start or expand. The potential is determined by the local market you operate in. How many families, groups, individuals, etc., can afford your services in your planned price range? "Afford" in this context means how many people will be willing to spend a given amount of money on a portrait of the type you want to do at the price you want to charge. Affordability is a function of the following: (1) the amount of money available to the potential client. Average disposable income is a good measure of this factor. (2) How much value do these potential clients place on your photographs? There are huge variations between certain ethnic/religious/social segments of the population in this regard. (3) The number of people the potential client has to give the portrait to as a remembrance.

In other words, a millionaire with no close family who has attended an Ivy League school where they were taught that photographs are gauche is a poorer potential client than a couple just below the poverty line who love their children and come from a large, traditional family. You'll hardly ever see the rich person in your studio except for a utility portrait. You'll see the poorer family far more often. They will be a greater factor in your net income than the millionaire.

Going to a lecture and hearing a speaker tout a particular style of photography to a high-level clientele is meaningless, unless you have exactly the same potential clientele that the speaker has. Many times what you are hearing is how someone had exploited a unique niche in his or her market area. To be successful, you must find your own niches in your own market area and not try to import niches. There are new and unknown marketing ideas, styles, or techniques of photography that you can learn from others and apply to your market, but there may well be a niche existing right in your backyard that you haven't tried yet.

Where's the Money? The Myth of Price

I'd like to define areas of portrait photography by dollar value of the total sale potential from a single sitting with reprints. The divisions are arbitrary to some degree, but are based on my market experience and many conversations with experienced and successful photographers across the country.

LOW END	MID RANGE	HIGH END
Under $100 avg.	$100–$999 avg.	Over $1,000 avg.

I will refer to subranges also:

RANGE	LOW	MID	UPPER
Low	$20 avg.	$20–$60	$60–$99
Middle	$100–$350	$350–$700	$700–$999
High	$1,000–$2,500		Over $2,500

To gross $200,000 per annum, you must do ten thousand $20 sittings.
To gross $200,000 per annum, you must do four thousand $50 sittings.
To gross $200,000 per annum, you must do four hundred $500 sittings.
To gross $200,000 per annum, you must do one hundred $2,000 sittings.

What about the net profit from the $200,000 per annum gross generated above? How much time will it take to do the number of sittings involved above? How much help will you need to do the number of sittings above? How much rent will you need to pay to provide a facility to do this level of work? Let us now calculate what the costs and profits would be. I base the overhead figure on the ideal goal of keeping overhead costs at one-third of gross income. This is a valid goal for a well-run business and a standard you should work for.

RANGE	LOW-LOW	LOW	MIDDLE	HIGH
Cost	$5	13	$70	$250
Overhead	$6	$17	$170	$700
Net Profit	$9	$20	$260	$1050
Time Required	1 min.	15 min.	1½ hrs.	5 hrs.
Total Time	166 hrs.	1,000 hrs.	600 hrs.	500 hrs.
Net Profit	$90,000	$80,000	$104,000	$105,000

Which Would You Prefer to Do?

The above does not take into account other expenses which may alter the profit picture. A $20 average on a one-minute sitting is elementary school photography. This can be done with one photographer and some part-time help and no rent for a separate office. Generally, someone doing four thousand non-school sittings a year needs additional help to manage the volume and an accessible business location. This overhead comes right out of the profit margin. The middle-range photographer may not need full-time help and can manage with part-time help, but requires a more upscale studio space. The high-end photographer can probably do his or her work with no additional help and may be able to operate from a home location.

The point I am trying to make is that one can make a good profit at all price levels in portrait photography. In general, one has to be more efficient to make money at the low end and one has to be more effective (in creativity and marketing) to make money at the high end. However, the high-end market does not exist in many communities while the low-end market exists everywhere.

If you choose your target niche to satisfy your ego or because someone else told you to choose that niche, then you may be heading for failure. Ego has no place in business. Decisions about what type of work you wish to concentrate your efforts on should be based on the market you are going to work in. If your market won't support the type of work you wish to do, then you either have to move to a market area that will, or forget about that line of endeavor.

The Studio

When people walk into your place of business, they make their first evaluation of your skills and abilities from your studio's appearance. When starting, you probably won't have the cash to invest in furniture or professionally designed interior decor. You usually have to invest your cash in areas such as paying the rent and capital equipment.

Studio Decor: You Don't Get a Second Chance to Make a First Impression

There are tricks to help you create a positive selling decor in your studio for the least investment, until you can afford to decorate your studio in a manner which will impress your clients.

BIG PRINTS: If you haven't got fancy furniture, direct the customer's eyes to the walls. If you don't have fancy wall coverings, make sure the wall is a plain white or off-white surface to enhance your photographs best. Use sheetrock rather than textured or colored paneling. White is a common color in many homes and is easily accepted by clients. A patterned wallpaper, while perhaps more in line with your taste, may not be in line with your average client's taste. Later, when you are ready to invest in studio decor, hire an interior decorator to assist you.

Make feature walls: use 30 × 40 and 24 × 30 prints in nice frames grouped into areas of common interest (families, seniors, scenics, etc.). Don't cover every square inch of wall space, because it will look cluttered and not like someone's home. Do not use small prints (8 × 10 or 11 × 14) on the wall. Make 16 × 20 your minimum. Use easels to fill in corners. If you have awards or university diplomas, design a corner devoted to yourself! Customers like to know something about you, and they do look at plaques and awards. If you hang a print at your state or regional PPA, hang the print there with the ribbon or trophy. Strut your stuff!

PLANTS: Greenery fills up lots of empty space with a wholesome, friendly at-

mosphere. Plants can also be used in the camera room for props! If you have a black thumb like I do (every living thing I plant seems to die in about two days), consult a knowledgeable person about the right types of plants to buy. There are also some excellent silk arrangements that are hard to tell from the real thing if you keep them dusted. In large cities, there are services which will place plants in your business and care for them on a weekly basis.

FURNITURE: If you can't afford nice furniture, choose simple items. Director's chairs are inexpensive and comfortable. Choose everything you buy in the same color scheme. Stick with neutral colors which don't vie for attention with the portraits on the walls. Many office-supply firms sell basic office chairs that are sturdy, stack, and look nice. The going price is about $30 per chair. You will need at least four.

BARRIERS: Don't build a counter. We built a counter in our first studio and can say from experience that it is a negative element. If you are trying to sell high-ticket items, don't do it over a counter. Use a desk or a bookcase to separate the reception area from the sales area in the studio. Keep the paperwork in drawers, out of sight. Try not to wait on people across a barrier, sit with them at a table, preferably a round one.

LIGHTING: Make sure the light level in the rooms compliments your photography. No fluorescent lights, except in work areas. Track lighting accents feature wall samples and offers flexibility in moving the lighting units around as you change your displays. Good light must fall on any table where you present previews and albums. Frame lights on large samples add a rich look to a room at low cost.

DECOR: If you can't afford carpeting, buy inexpensive floor tiles in a dark, warm color. You can install peel-and-stick tiles easily for little money. There are cheaper types of carpeting or flooring available, which may not last, but will serve through the early stages of your business. Avoid anything with a busy pattern or bright colors.

SOUND: Play low-key, pleasant music. Tune to an FM station with an easy-listening format when customers are expected in the studio, or have a new-age CD playing. If you deal with teenagers, more upbeat music might be appropriate, but keep it in the background! Don't assume that your tastes in music are shared by your clients.

SMELL: Keep your sales areas and camera room smelling fresh. Sometimes the smell of the darkroom/retouching area can intrude into customer areas. Don't heavily perfume the air, but keep it as fresh as possible. If you smoke, it is essential that you freshen the air in the studio on a regular basis. Today, 65 percent of adults do not smoke, and a non-smoker walking into an area occupied by a smoker will be overwhelmed by the stench! Don't lose potential customers because of your bad habits. There are various types of commercial room-freshening devices, but be careful to not overdo it. If you have carpets, a periodic cleaning with an odor remover is important.

Business Forms You Will Need in Your New Studio

1. Basic cash receipt/invoice
2. Longer form invoice
3. Price lists: portrait, wedding, seniors, commercial, specials and promotions, children, schools, etc.
4. Contracts: wedding and commercial
5. Daily cash sheets
6. Inventory record form
7. Checkbook, register, deposit slips
8. Stationery: letterhead with envelopes, business cards, memo pads/quick notes
9. Brochures

10. Petty cash receipt
11. Charge card invoices/credit slips, deposit slips, electronic machine, and printer

Setting Up a Visa/MasterCard Account

When establishing your line of credit with your banker, have them set up a Visa/MasterCard account for you. Accepting credit cards is a must in today's business world, so that you don't have to extend credit to customers. If they don't have a card, in most cases, they are not a good credit risk. Let the bank lend money while you concentrate on taking photographs.

The cost of setting up a charge card account is minimal. You must buy an imprinter ($25 to $40), but the bank will provide the forms needed for your transactions at no charge. You will need charge slips, deposits slips and envelopes, and authorization phone numbers. In addition to the small setup cost, the bank will charge you a monthly service fee, based on your total monthly volume of charge card deposits, and your average ticket value. Ask your banker to explain carefully your risks and responsibilities when using cards. Accepting credit cards is easy, but you can be taken by dishonest customers if you are not careful. It is also important to realize that you can be taken by this method of consumer protection. A couple can pick up a wedding album, pay the balance on a card, and then contest the charge, claiming inferior merchandise. If this happens, you will have to prove to the card company the worth of your product and delivery. Just be careful.

Most studios don't have the volume to earn a good discount rate, but they do usually have a high average-per-ticket rate. I currently pay only 1.5 percent discount rate. A new studio should expect to pay 3.5 percent to 2.5 percent. If a bank wants anymore than 3.5 percent, you're at the wrong bank.

If you develop any volume of credit card sales, it is worth looking at the electronic card readers and printers. These machines automatically phone in the sales information and print out the charge slip. At the end of the business day you only need to total the sales and/or credits and send them in via the machine. The deposit is electronically entered in your checking account the next day. The machines save a lot of time and paperwork. They cost from $150 to $200 to purchase, and there is a service charge from the bank monthly. The plus side is that your business will usually get the better discount rate.

One way of keeping your average high is not accepting charge cards for small items. Many businesses have a minimum of $25 for charge card purchases. Another trick is to charge the whole order instead of just the deposit when the client is placing the initial order by charge card. Explain to the customers that paying the full amount reduces the paperwork and saves money. If they balk at paying all the money up front, explain that the credit card companies have a mechanism to protect them from deceptive and shoddy business practices. They can contest the charge with the charge card company if they feel they have received inferior merchandise.

Logo, Stationery, Brochures, and Business Cards

Every business owner needs to create a letterhead for business stationery as well as a logo that represents the studio name. Logos can range from simple block lettering of the business name to elaborate crests with symbols and filigree to enhance the actual name.

Many studios use a camera-related image in their logo, such as a symbolic lens diaphragm, or a tripod, or a schematic camera. I have seen the film pattern of sprocket holes

also used effectively on a card. If the studio name is related to a local scenic landmark or area, that landmark may become part of the logo. When I first went into business, I used a crest with a fleur-de-lis (for Lilley), thinking it gave a little class to my logo.

When designing a logo, just remember to keep it simple. Logos should be quickly recognizable as your name and type of business and should not confuse a potential client. A graphic of a horse running has little to do with photography, unless you specialize in horse race photography. A fancy engraved logo may also be hard for a printer to reproduce, leading to less-than-professional-looking printing, especially on Xerox or quick printing. So, keep the graphic elements simple. As I argued in the section on choosing a business name, I think in the portrait/wedding business, the studio name should be a person's name, even if it is not your own name. A commercial business should choose a name which features their photographic specialty. The logo should always be clear and simple and easy for the client to remember.

Once you have chosen a logo, incorporate it into your letterhead. A letterhead usually has your logo plus your address and phone number. I also recommend that you use your memberships on your letterhead to enhance your reputation by association. All of the PPAs have logos for the members to use. If you have earned the distinctions the PPAs offer, such as Certified Professional Photographer, use them on the letterhead. If a potential client doesn't know anything about you from experience or reputation, the logos identify you with well-known national organizations. Those organizations will not speak for you, but you can profit from your association with them.

Hire a professional graphic artist to design and lay out your letterhead and business card. The typeface, the letter size, and the location of the various elements are critical, and you need a good graphic presentation to show your clients. Don't be cheap and use the stationery from the mail-order, office-form houses. Your business card is your little silent salesperson. It often gets filed in a card file by potential clients for future reference. It must stand out to be effective. I would strongly recommend that you choose a high-quality colored stock. Most business cards are white. Selecting a different color will help yours stand out. Your name, address, business hours, and business phone are the vital information that must appear on the card. A brief description of your business strengths can be added, but do not make a page-long shopping list of everything you can do. People don't read them. In fact, it turns them off. If you really hope to attract equal amounts of wedding/portrait and commercial work, you may wish to have two cards made for each type of business.

The most important thing is to give them to everyone you meet. If you are standing in line at the movie, introduce yourself as Ed or Sue, the photographer, to the people around you and give them your card. Every time you go to a business meeting, to a wedding, into a retail business to buy something, or to pay a bill, give them your card with a friendly handshake and a nice smile. If you do this enough, it won't be long before everyone in your neighborhood knows who you are, what you do, and has your card to keep in the file. People keep cards and use them for reference. Pin your card on bulletin boards in stores and restaurants or anywhere else were they are displayed.

Photographic business cards are a good idea. Consult with your lab regarding making a good photo business card. Have a number of cards made up for the different areas of your business. For bridals, use a good bridal photograph, for families, a family, etc. These cards are more expensive than plain cards, but they convey your message in two ways and are a wise choice. You may wish to have a plainer card printed for distributing in bulk at shows or public displays, and save the fancy ones for potential clients.

After your letterhead, logo, and business cards are designed, make sure you choose a good-quality printing paper. It is not that much extra to get a quality paper that will make

your letters more appealing to a client. The quality of the paper forms a first impression with a new client, so don't be cheap. I would also not invest in too many copies at the start. You may find out that you want to change the direction of your business shortly after starting, which may mean a change in logo or letterhead. You may earn an award or degree that would be valuable on the letterhead, and you will have wasted a lot of money on the old stationery. Printers usually print five hundred as a minimum, and that should do for the first year. Remember to order matching envelopes and second pages. When the printer runs your stationery on the good-quality paper, also ask them to run some on plain white (computer compatible) stock. You can use these white letterheads to type masters for Xerox or quick-print copies, as colored and textured stock does not reproduce as well. *Rangefinder* magazine runs a monthly column called "Griff on Advertising." The column is devoted to showing good examples of letterhead and logo design, and is an excellent source of ideas.

Today, it is important that the paper you choose is compatible with your computer printer. Some papers bleed when used with an ink-jet printer, which causes the type to smear. There are papers made specifically for ink-jet printers or laser printers. To be safe, get some samples from your print shop, and test them in your computer printer.

Brochures can be considered grown-up business cards. They contain more room for you to expand on your services and space to show off your photography. When I first started, brochures were expensive to produce, especially if you wanted color pictures included. Today, things are much better. There are a number of companies that sell beautiful stationery that is preformatted for bifold or trifold brochures. You only need to format the text on your computer to fit the format and then print the brochures on your computer's printer. If you need a large number of brochures, take the originals to a printer for a press run.

Once you have the brochure designed, order bulk color photographs from your lab. Wallet size works perfectly on trifold format brochures. Attach the photos with double-stick tape. In this manner, you can customize the brochure for each individual client. We keep a stack of many different types of photos handy for this purpose. If a client inquires about pet photography, we customize the brochure with animal photos. In the wedding area we have two photographers, so we make sure that the brochure going to a prospective bride contains only the photographs of the person who will be shooting the wedding.

The Phone: Your Major Connection with Your Clients

I cannot stress strongly enough the importance of good phone technique. In a Main Street portrait/wedding studio, I would estimate that 75 to 90 percent of initial inquiries are by phone. In a home studio setting, 95 to 100 percent of inquiries are by phone. You must make precise use of this instrument to be successful. The first step is to train everyone who potentially will be picking up the phone in your studio to say the same thing in the same way. It is important that they (1) sound cheerful, (2) greet the caller (good morning, good afternoon, etc.), (3) identify the studio, and 4) identify the speaker. Sound complicated? No! It sound like this, "Good morning! This is E. R. Lilley Photography, Ed speaking, how may I help you?"

Have note pads and pencils by all phones to facilitate taking messages. If anyone answers on an extension away from the appointment book and the call is about scheduling an appointment, write down the information first and then tell the caller you'll put them on hold while you go to the other phone. Go as quickly as possible and open the book to the date you had written down. Pick up the phone and be prepared to instantly

get back to business with the caller. If the call is an inquiry about your services, start filling in a sitting card. Ask questions and write down the information.

The best way to teach all of your staff (and yourself) is to write out in detail all of the possible customer questions and some trial answers. Write out trial sales closings to get bookings, and write out objections clients may have and how you will answer them. If the caller says, "That sounds very expensive!" prepare a positive response. Post price lists by all phones so that you can instantly answer questions of fact and policy as written. Don't guess. Once you have written down your phone responses, don't read them to callers. Learn them by heart. Reading something sounds very impersonal. In addition, don't make the responses too long or you'll bore the caller. Periodically review your phone scripts—listen to each other if you have employees or a spouse.

If you are alone at the studio and you have client appointments scheduled, turn on the answering machine. Don't interrupt your face-to-face client to answer a phone call. Record a message saying you'll call back within thirty minutes or so. Answering machines have become the norm for most people, so you will not lose many phone calls this way. However, you may offend a current client if you constantly interrupt the appointment to answer the phone.

Outgoing phone calls are just as important as those coming in. If you have a receptionist who is doing nothing very much for hours a day, or you have nothing to do for a few minutes or hours a day, then you should develop a telemarketing plan to get more customers. Develop an offer that lends itself to a telemarketing scheme, or contact commercial clients periodically to keep in touch. In the slow seasons, call your past portrait clients to offer a sample sale. Tell them you have selected their image for a public display and ask their permission to use it (98 percent will be flattered). Then tell them they can purchase the sample for 25 percent to 33 percent off regular prices when the display is over. Guess what? Only people who respond to the promotion go into the display along with some good crowd pleasers. Tie this promotion to your lab's big-print sales in the spring so you can save money on the prints. Call your local phone company to see if it offers training courses in phone technique. You can often get excellent training for yourself and your staff at little or no cost. The phone company has many profitable ideas that you may wish to incorporate into you business.

The Answering Machine

Even if you are not physically present in your studio, you can use that most wonderful modern invention, the answering machine. Here are some rules to follow: (1) Buy a good-quality machine. (2) Keep the outgoing message short. (3) Listen to the messages at regular intervals, and answer the calls in a timely fashion. A good machine will not malfunction and will give you years of good service. Don't be cheap! These machines will generate a lot of business for you. We now use a digital answering machine. This machine is very easy to program and very easy to access from a remote phone. There are also no tapes, so the sound quality is better.

Your basic message for after-hours should say: "Hello, this is ABC studio. Our regular business hours are. . . . Please leave a message at the tone, and we will return your call during regular business hours. Please make sure to leave a phone number where you can be reached during these times." A second message may be (for when you are out of the studio on assignment) "Hi, this is ABC studio. We are unable to answer your call at this moment because we are with a client. Please leave your number and the time you called and we will return your call as soon as possible." Another may be: "Thank you for calling the ABC studio. We will be on vacation (assignment) for two weeks, June 4

through 18. Please call back after June 19. Sorry for the trouble. See you on June 19." A machine with a remote playback feature is essential if you travel for extended periods of time, as you can check your messages often from any location with a phone. You must still answer your calls promptly.

Handling Complaints

A recent study showed that about one out of every four purchases in the USA involve some type of customer problem. Most people who experience a problem with a consumer purchase do not complain, but many do. You work in a profession that is part art and part science. You will not do every job perfectly. You will eventually have to deal with an unsatisfied customer.

A complaint comes in many forms, from a polite question to an aggressive attack. You must learn to deal with customer complaints as a normal part of doing business. Here are some tips on handling unhappy clients. Don't assume anything, listen carefully. Stay calm, even if you are being insulted. Acknowledge the customer's anger; it often calms them down. "Yes, I know you're upset and we have a problem here. Let's see what we can do." Apologize when necessary—even if something wasn't your fault. Give the customer your undivided attention; don't answer the phone! Be an active listener and let them finish; don't interrupt until they have it all out of their system. Don't pass the buck. Involve the customer in the solution, and never leave the problem unresolved—follow through! You should always thank the customer for bringing the problem to your attention. This makes them feel better, which is very important.

Remember the anonymous saying, "People are usually willing to meet each other halfway; the trouble is, most people are poor judges of distance."

The Portrait Camera Room

The heart of any studio is the camera room. In this room, the studio photographer produces many of the photographs needed to make a living. The most important factors in designing a good camera room, or in looking at a space to rent for possible use as a studio are: (1) size (and shape), (2) ceiling height, (3) color, (4) availability of natural light, and (5) ease of access. Here are some basic considerations when looking at a potential space. For a portrait studio, the ceiling height should be eight to twelve feet, ten feet being the ideal. Too low a ceiling doesn't allow room for backdrops, lightstands, or for the fill light to bounce around easily. A ceiling more than ten feet eats up light, requiring a lot more power for any fill light setup. Sometimes you can get an older retail store with up to fourteen-foot ceilings. It is not difficult or expensive to put in suspended ceiling panels to lower the height to ten feet. It also saves on heating bills in colder climates.

An ideal portrait studio, which can be used both for individual and family portraits, must be wide enough to pose a group of fifteen to twenty people comfortably and still have enough light quality for individual close-ups. I have seen photographers producing dynamite photographs in an eight-by-twelve-foot space equipped with only one umbrella light source and a few rolls of paper. I have also seen a converted supermarket with thousands of square feet of space being used poorly! Making do with what you have is an important part of learning the fundamental techniques of photography. The room does not take the photographs; you take the photographs in the room. Some rooms are much easier than others, but any room will work with some effort.

Backgrounds

Today, a portrait room can be equipped for both high- and low-key photography options simply by changing the background. Some people like a built-in, high-key sweep, made of Masonite or Formica sheets bent in between the wall and floor (you can also use the back of inexpensive linoleum as a sweep). To get a low-key setting, simply lower a canvas background in front of the high-key set. Others build in a dark background and use white roll paper for high-key. The floor of a studio can be carpeted in the low-key basic setup. For a high-key setup, install a linoleum floor. The color of the floor can be changed by having sections of various colored carpets available to roll out when needed.

For many years, the standard background has been the painted canvas backdrop with a diffused classical pattern of muted dark tones and a highlighted central area. When you first begin working with these painted backdrops, you can produce pleasing and professionally acceptable results with little effort. Today, we see more and more high-key work in family, senior, and fashion photography, as well as the use of more vibrant colors like red, yellow, and blue. These colors can be achieved simply by using color gels over the background lights to color white paper, black paper, or muslin backgrounds. Tin foil, muslin dropcloths, satin sheets, lace curtains, and plants are also usable. Look through popular consumer magazines for contemporary ideas. If you have a chance to see Wah Lui of Seattle or Nancy Bailey of Indiana talk on photographing seniors, or the Perrins of Portland, Oregon, speak on glamour photography, you'll get hundreds of ideas on backgrounds and props that are easily used in the studio. (See chapter 12 for the names and addresses of suppliers of these background materials.)

To facilitate changing backgrounds, there are a number of pole, ceiling, or wall-mounted background holders available that can hold three or four long rolls of paper or canvas. These holders range from cheap, simple, manually operated designs to expensive electrically operated versions. Even the most basic will be useful in any studio. See models by Bogen, Denny, and Studio Dynamics.

The important point is to be able to change your backgrounds to suit your subject. You cannot have every color available in roll paper or canvas. A typical studio will have two or three main backgrounds (usually one high-key and one or two low-key). To produce good photographs, a good studio spends a lot of time discussing the client's clothing choices so that the photographer can coordinate the subjects with the available background colors. If you only have a brown low-key background, cool colors will not flatter your subjects. It is part of your job to convince them to wear clothing that you can compliment with your available backgrounds. The clothing consultation is a critically important part of any portrait sitting because you must explain the various color options that will produce the most pleasing results.

Props

The most basic props are (1) the posing stool, a simple stool of adjustable height; (2) the posing table, a small table with adjustable height for individual portraiture; (3) the three-step poser, a small set of steps which can be used to separate children, pose adults, and generally stack things up in small spaces; (4) a variety of boxes, strong enough to sit or stand on, in various sizes and colors (to match popular backgrounds); (5) a set of old encyclopedias or $2 \times 12 \times 12$ wood blocks for people to stand on or to boost someone sitting down.

After these basics we get into true props. Many studios that photograph a large number of families usually have some handsome Victorian style chairs to seat people. Some

studios have beautiful love seats on which to pose women and brides. A standard for the senior studio is the wicker butterfly chair. Child specialists use baby posers and lots of big pillows to help keep the kids in one place. There are also special posing chairs that are designed to help pose large groups.

Keep your props to a minimum, especially when you first get started. There is a tendency to find a chair or other prop that you think is great and include it in almost all of your photographs. If your customers don't think much of the prop, you will lose sales. Acquire props with some sense of design to aid you in posing people. The props themselves should not dominate the photograph. If you're not careful, you'll be like the old-fashioned, dress-up studios in the malls, more props than photography. Too many props create a storage problem. Unless you have a huge studio, more than a couple of chairs and set of stools will trip you up and destroy your ability to work easily and quickly in your space.

Camera Supports

It is absolutely necessary to use a tripod or other camera support when shooting portraits or any critical commercial work. If you hand-hold a camera, you lose the use of your most creative portrait tools, your hands and your facial expressions. Instead of looking at a person, the subject sees a mechanical device and hears muffled instructions coming from behind it. You cannot use your hands to direct the eyes or to adjust the pose without affecting the stability and aim of the camera. Do not hand-hold. In commercial photography, sharpness is the most important requirement and hand-holding does not lead to sharp focus or good control of movement.

Don't compare portrait photography of average people with the high-fashion shoots you see on TV. If you work with professional models who are great at projecting good expressions and you have an unlimited film budget, then you can hand-hold your camera and concern yourself with changing angles and moving around for the best composition. Fashion photographers have very different problems than you do in your studio with average people.

After years of working with tripods in the studio, I finally bought a good studio monopod. I can go from six inches off the floor for kids to six feet in the air for adults with no effort. It is sturdy and takes up less floor space than a tripod with the legs fully spread out. In the beginning, to save money, use your tripod, but look into purchasing a studio stand eventually.

I would strongly recommend that you purchase Dave Newman's book *The Camera Room*. Dave goes into great detail on the layout and equipping of a portrait camera room. There are sections on painting your own backgrounds, lighting equipment, building props, and determining good exposures. No studio should be without this book.

Lighting Equipment

When discussing modern color portrait lighting, we will be considering only electronic strobe equipment. Quartz or hot lights are still used in black-and-white portraiture and for many commercial applications. In general, they are not practical for color portrait photography, except occasionally as accent lights. A well-equipped portrait studio may have more invested in lighting equipment than in camera equipment, and rightly so, since the lights do most of the work. There are a number of manufacturers out there trying to sell you their products. Be careful. When looking for a brand of lights, you should consider these factors.

For a new studio, I would recommend that you purchase at least four self-contained units, such as the Photogenic Powerlights or the Ultras from Paul Buff. They don't all have to be the most powerful, as some will be used for backlights and hairlights. Four lights will give you lots of power and versatility. You may also wish to buy some smaller accent lights that can be used for hairlights or kicker lights. You don't need a lot of power and adjustability for these lights, so some of the small, self-contained units will work very well. See the equipment recommendation section later in this chapter for more specific information.

When purchasing your first set of lights, consider that they will have to work not only in the studio, but on location as well. You may be photographing large groups, lighting large buildings, or doing other jobs where power is everything. I would recommend at least two units with a minimum of 600 w/s with enough control over power output distribution, so that the unit will put out a small amount of power as well as its full potential.

The Commercial Camera Room

Size requirements depend very much on what you intend to photograph in your studio. If you are going to photograph tractor-trailer units, you'll need an eighty-by-sixty-foot room with twenty-foot ceilings and doors wide enough accommodate the rig. If you are only going to do passport sittings, you'll only need a camera room about four-by-eight-feet with seven-foot ceilings. Often the size of the camera room is limited by the physical structure of the building, especially in older downtown buildings. Space for a major commercial studio should have easy access to the street so that pieces of large and/or heavy products can be transported in and out easily. There must be room for set construction, large light sources, etc.

The main difference from a portrait studio is that space must be more open, allowing for construction of sets or elaborate lighting of large subjects. There is very little need for fixed backgrounds, fixed lighting patterns, fancy floors, or props. The floor should be solid to facilitate moving equipment and placing sets. The ceilings should be higher than nine feet (the higher the better) to allow for booms and placing large light sources overhead. The walls can be light or dark, depending on the preference of the photographer. Some useful basic props for the commercial studio are: a light table; sturdy sets of sawhorses and sheets of plywood of various sizes to make tables; sheets of Plexiglas, Formica, and other materials for modern product backgrounds; large rolling reflectors of matte and shiny composition; large light-diffuser scrims on wheels; lots of light stands, clamps, clips, glue, and devices to hold lights and products in various positions. The decor of a commercial camera room can be more utilitarian than a portrait studio because you are not trying to get the clients in a mood with your decor, but only to photograph their products. Carpets, low lighting, and fancy furniture have little value; good photographic equipment does. If you do any work that is related to food, you must have a kitchen facility available.

The lighting equipment for a commercial photography camera room can be either hot quartz lights, strobe, or both. A great deal of commercial product photography is done with just a few hot lights and long exposures. As long as there is no motion in the set, hot lights are great. Many commercial photographers I have talked to prefer hot lights over strobes, claiming that they can see the lighting patterns more accurately than they can with strobe lighting, and that tungsten-balanced films have better color saturation than daylight films. However, as soon as the products start moving or you have models in the sets, you probably will need strobes. Most commercial jobs require sharpness for reproduction, which means small apertures and lots of power for the strobes—2,000 to

2,400 w/s into two or three heads is not uncommon even in simple setups. Some large commercial studios have 50,000 w/s available in a single light source to light very large objects. There never seems to be enough power for the commercial photographer.

Recommended Equipment for Your Studio

In making these recommendations, the important qualities I have considered, in order of preference, are (1) flexibility, (2) dependability, and (3) price.

Cameras

Lilley's Law #1: Buy two bodies! I don't trust any of them that much. In the cameras listed below I would get the 60mm lens if the use was primarily weddings and the 50mm lens if you did any amount of commercial or large group photography. I think the 60mm is superior to the 50mm for wedding candid work. Lilley's Law #2: Do not invest in more than one camera system at a time. Buy one complete system before changing to another system. Trade a whole system for another system if you want to change. You'll get a much better deal doing it this way.

CHOICE #1: Bronica ETRSi with 50mm or 60mm, 75mm, and 150mm lenses, Prism (nonmetered), two 220 backs, one 120 back, one Polaroid back, pro-shade. Optional accessories: speed grip, motor drive, metered prism. Pros: Moderate price, leaf shutter sync, dependable, easy to use, magazine film loading, excellent repair service from distributor. Good wedding camera and decent studio camera. Lightweight, easy to hold. Good design. Dedication capability. Cons: Smaller negative size for studio work. You must rotate camera for horizontal to vertical formats. Not the cheapest. Poor design of shutter when using cable release.

CHOICE #2: Hasselblad 503CX with 50mm or 60mm, 80mm, and 150mm lenses, prism, 220 and 120 magazines, Polaroid back, grip, lens shade. Pros: Lightweight and compact. Great wedding camera if you like square format. Great optics. Very dependable. High value retention on initial investment. Great line of accessory items. Dedication built in. Cons: Square format. Expensive.

The best defense against breakdowns is system duplication, i.e., owning more than one of everything you use on a daily basis. The advantage of a less expensive camera is that for the same number of dollars you can get two bodies and important lenses instead of one. To be really safe, you must have duplicate prisms, lenses (the ones you use most of the time anyway), and magazines.

Studio Strobes

CHOICE #1: Photogenic Power Lights. PL1500, at $545, delivers 600 w/s; the PL750, at $395, delivers 300 w/s; and the PL375, at $325, delivers 150 w/s. All units come with infinitely adjustable power controls, to 1/32 power in the 1500 and to 1/16 power on the 750 and 375 models. Prices quoted are list prices. Discounts available from some suppliers. Pros: Excellent flash-tube and modeling light design. Sturdy and dependable. Photogenic makes a full line of reflectors and attachments for these lights. The sixteen-foot parabolic reflector is still the best portrait lighting tool in the world. Excellent warranty and excellent service backup for these units. Photogenic also supports many of the week-long photography schools by supplying all of the lighting equipment they need at no charge. When you attend any of the schools, you may usually purchase the lighting equipment used at the school for a good discount from the list price.

CHOICE #2: The Ultras, made by Paul Buff from Nashville, Tennessee. They come in 600 w/s, 1200 w/s, and 1800 w/s, at a cost of $450, $550, and $650, respectively (no dis-

counts except special sales sometimes during the year). Pros: Inexpensive for the power. Total power output control over a five f-stop range on all models, built-in slave, built-in modeling light control, inexpensive modeling lights, a control unit capable of controlling four units from the camera, available for $100, five-year factory warranty, excellent service. Very lightweight for the power, 2.8, 4.6, and 7.4 pounds, respectively. If you need power, the 1600s can't be beat. Purchase directly from the manufacturer.

I have owned these units for seven years and have only had a few problems with them, and my units travel a lot. When I did have a problem, they were repaired within a week at no charge, not even shipping!

If you buy Photogenic, I recommend you get two 1500s and two 750s as a basic starting package. If you buy Ultras, get two 1200s and two 600s as a basic starting package. For a commercial studio, I would recommend the Norman lights. They have powerpacks up to 4,000 w/s and an excellent line of heads, reflectors, and accessories.

Portable Strobes

CHOICE #1: AUTOMATICS: Metz 60CT-4. Pros: Great power, very accurate automatic sensor, great battery, rugged design and construction, good service, long lasting, some good optional accessories including dedication modules for TTL metering with cameras. With a Hasselblad you don't need an external module. Cons: No internal battery option so you are always using a battery pack; a little heavy for some.

CHOICE #2: AUTOMATICS: Metz 45CL-4. Pros: Good power, very accurate automatic sensor, built-in battery so you don't need a powerpack, off-brand powerpacks available (See Quantum), lighter than 60CT-4, dedication modules for TTL metering. Cons: Less power than 60CT-4, smaller light size.

CHOICE #1: NON-AUTOMATICS: A tie, Norman 200B or Lumedyne. Both equally good. Pros: Great power, consistent, great battery, well built, and long lasting. There are differences in options, but both are equally good units. Choice of reflectors and bare-bulb option. Multihead operation. Cons: Heavy, you must pay attention to light output and camera settings.

Meters

CHOICE #1: Minolta IV. Pros: Flash (cord and noncord), ambient, multiflash reading capabilities. Accurate to one-tenth of a stop. Can measure either in f-stops or in contrast. Memory for measuring ratios. Great line of accessory attachments. Cons: Expensive and a bit delicate.

Hot Lights

CHOICE #1: Lowell Location Kit. A great setup with different types of lights for most commercial applications.

The Darkroom in a Small Studio

First and foremost, when considering installing any kind of a darkroom facility in your new studio, be very careful to check with your local health or environmental officer to see what rules apply to disposal of spent chemistry. In some parts of the country, Massachusetts being one of the strictest, it is illegal to put any photographic chemicals into a septic system. Many cities with sewer systems are also banning dumping of untreated chemical wastes into the sewer system. When considering a full-scale color darkroom, you must also plan to install a waste disposal system, which is usually a combination of a chemical evaporator, to get rid of the water, and arrange for periodic pickup of the re-

duced residue by a government-approved waste hauler. You must cross all of your t's and dot your i's when dealing with waste disposal in this day and age. I feel that the restrictions and regulations will tighten with time, and the cost of these restrictions will be a significant part of the cost analysis of buying or installing a lab.

In studio photography, the majority of money-making jobs today are photographed in color. However, there are a significant number of jobs which require black-and-white prints and a growing market in high-quality, black-and-white portraiture and wedding photographs. The more basic jobs include passports, public relations and publicity sittings for business, wedding engagement announcements, some copy work, some product work for newspaper use, and sports and activity photos for high school yearbooks. Most of these basic jobs do not require an elaborate darkroom setup with full archival processing facilities. There is also a growing market for good black-and-white portraiture and black-and-white scenics, which do require a good black-and-white darkroom. These areas also require skills that most color-trained photographers don't possess without additional training and practice.

When first starting, I would recommend a simple, utilitarian black-and-white darkroom with a minimum of equipment. Most black-and-white work listed above does not require archival processing, but only RC type papers, which will last long enough to serve the specific purpose. You will need a 6 × 6 or 6 × 7 (depending on your camera format) simple enlarger ($200 to $300), timer ($70 to $100), film development tanks ($30 to $90) and reels ($30 to $60), safelights ($10 to $40), trays and bottles ($10 to $50), and a Graylab timer ($50).

If you don't wish to develop your own film, you can use Ilford XP-4 film. This is a black-and-white film that is developed in the standard color negative chemistry. You can take the film to any one-hour lab and get your negatives in a hurry. All Kodak RC papers have a developing agent built into the emulsion. These developing agents only have to be activated by a strong basic chemical to develop almost instantly. The development time is about ten seconds! There is a chemical called Kodak Ektamatic Activator, which will be a great asset in the small darkroom. It is available from any photo supply house.

To process prints using Kodak Activator and RC papers, you only need three trays and a wash sink. The first tray holds the activator, a second tray holds stop bath, and the third tray holds rapid fixer. After exposing the paper under the enlarger, put it into the activator. The image is fully developed in five to ten seconds. The print is then drained, put into the stop bath for fifteen to twenty seconds, then into the fixer for one to two minutes. After the fixer, the print is washed in running water for one to two minutes, squeegeed, and then air dried. If you are in a hurry, a hair dryer will accelerate the drying process. (Note: If you do a large number of prints with this setup, it prolongs the chemical life to use a water rinse between each of the chemical trays.)

The Rebirth of Black and White

In the past few years, I have witnessed a resurgence in interest in quality black-and-white portraits and weddings, especially among upscale types. They see black-and-white as something different and, therefore, more desirable than old-fashioned color portraits. Black-and-white portraiture offers a very challenging medium in which to use your photographic skills. Take it from someone who learned photography in a black-and-white darkroom and who now operates a fully equipped color lab, good black and white is technically harder to do properly and is much more labor intensive than color photography. However, a good black-and-white darkroom requires only a fraction of the investment of a color darkroom and offers a creative photographer a multitude of

opportunities. Black and white may be a niche waiting for an occupant in your market area. Consider it carefully.

Black and white offers the following positives. (1) Excellent control of contrast through proper exposure and developing techniques. (2) Ability to do processing in-house with minimum investment. (3) Represents a more artistic medium to consumers. (4) Can be hand-tinted to give you more creative control and add uniqueness to the value of the prints.

Mike and Helen Boursier have published two excellent books that will provide you with a wealth of technical and marketing information if you are interested in developing a black-and-white market. (See chapter 12.)

Black and white can also be used successfully in the high school senior market. Again, the appeal to young people is that it's different. Don't be afraid of using this approach to make a name for yourself. A variation on black and white is to use Ilford XP-4 film printed on color paper at your lab. The images look like old sepia photographs or they can be printed in a blue-tinted way. Both variations appeal to teens and could boost your business with seniors.

A moderate black-and-white darkroom can be set up in a limited space by using tube development instead of tray development. You will need a good enlarger and a sink large enough to wash the size prints you wish to make. The prints are exposed and put into a tube instead of a tray. Chemicals are then poured into the tube as it is rotated, giving even development in a limited space. At the end of the development time, the chemical is poured out and stop bath is poured in, followed by fixer. With the use of RC papers, you don't need elaborate drying systems. See Mike Boursier's great little book on compact black-and-white darkrooms.

If you think you want to get into more elaborate black-and-white photography, you'll need sinks big enough to handle four or five 16 × 20 (or larger) trays, and sophisticated washing and drying arrangements. You'll also need a 4 × 5 enlarger, film tanks, etc. Consult the Kodak publication, "Designing a Darkroom," for specific ideas. Then read Ansel Adams's wonderful books on the Zone System. Helen Boursier's book covers hand-coloring black-and-white photographs, which is quite popular today with upscale clients and may be a market niche you can exploit in your new business.

Color Print Darkroom

Most photographers who have their own color lab do not develop their own film. Most send their film to a lab for developing and proofing, and process only the enlargements in-house. This method saves the time and equipment needed for the C-41 film processor and proof printer, but does lengthen your turnaround time. I would only consider a C-41 lab if turnaround time is critical and there were no labs, even one-hour labs, close by. C-41 is a critical process, and any error in developing leads to big problems in printing. Automatic machines for the C-41 process are expensive and require a great deal of maintenance.

To produce color prints efficiently, you need an RA-4 processor. There are a number of models available from Durst, Hope, Colenta, and other manufacturers. There are table-top models that will accept up to sixteen-inch-wide paper, and floor models that will accept up to sixty-inch-wide paper. The price goes up accordingly with the size and speed of the processors. I own a Hope 2626, which runs up to twenty-four-inch-wide paper at twenty-six inches per minute. It cost $16,000 a number of years ago. It is an excellent machine, and I get a lot of work accomplished with it.

The investment for an RA-4 color darkroom will include: enlarger with lenses, $2,500

to $3,000; twenty-four-inch RA-4 paper processor, $5,000 to $18,000 new (consider used equipment); a color analyzer, $500 to $800; a chemical waste disposal system; assorted easels, paper-safes, and focus devices. To do volume printing, you'll need a cluster lens ($5,000 to $8,000) and a roll easel ($1,500 to $4,000).

Color print processors need to work. The chemistry in a color process will go bad if it sits too long without being used, or is underused. If your only need were to make a few prints once in a while, I would not recommend that you invest in a color lab. A color lab is most efficient when you have a lot of volume printing to do or when you specialize in large prints and can maintain a regular volume of work. Where is the cut-off line? I initially started color printing because the service I was getting from the labs available to me was substandard and took too long. I now get good service and turnaround from my lab, and I only use my in-house lab for volume work where I can save money or for custom jobs where I can use my skills to produce a better quality custom print of subjects, especially large prints. In fact, I shut my lab down for about four months each year when my volume drops off.

Is it worth it? Pros include: (1) Better turnaround time when needed. (2) Lower cost per unit. (3) Better quality control (with some experience). (4) Less dependence on outside sources. (5) Christmas season. (6) Business which wouldn't have been possible without in-house lab. (7) Lots of samples for displays and albums. Cons: (1) Takes a lot of labor, time, and initial investment. (2) Business subject to breakdowns. (3) Quality for beginning printers usually isn't good. (4) Takes a lot of capital. (5) New and more stringent pollution control laws make disposal of chemicals more difficult than in the past.

If you have the Nirvana Color Lab next door to you, where you can get consistent quality and turnaround at all times of the year for a reasonable price, having your own color lab is an academic argument. The problem is that most labs are inconsistent, especially during the busy times, like senior season and Christmas.

Working with a Commercial Color Lab

You probably have already used the services of a professional color lab in the early phases of your introduction to studio photography. It has always struck me as funny that people who do color photography and claim to be artists and craftspeople leave the most critical step to an outside agency. I have this mental image of DaVinci thinking up the *Last Supper* and then calling up Giuseppi's Paint Application Service to actually put it on the wall, or Monet on the telephone with Pierre's Color Canvas Painters trying to get the shades right on his *London Bridge in the Fog*.

Great artists are also great craftspeople. They work in a medium and learn to manipulate that medium to express their genius, a far cry from your typical professional photographer. We buy a roll of film made by Kodak, shoot it, and then send it off to a color lab to make color prints for us. Sometimes they come back yellow, sometimes green, sometimes light, and sometimes dark. You usually have little say or control over the look of the very product you are trying to sell, the print. Well, it is usually not quite as bad as that, but it can be. Your color lab can make life miserable or great for you. You must learn to work with them.

Color labs seem to come in two sizes, small or big. In very small labs, if you have a problem you can usually talk to the owner, who will be very sensitive to your wishes because he or she values your business. As soon as a small lab gets good, it attracts more clients and must hire more help. The first person they usually hire is an account executive, whose job it is to answer the phone and divert you from the people actually printing your work. When you phone with a complaint, you get one of these problem solvers

and not the people on the line actually doing your work. Sometimes they are good, and sometimes they are hired just to have a thick skin, take all of the verbal abuse one gets on the phone, and do absolutely nothing to help you!

What you need from a color lab, in order of importance, is: (1) Consistent quality of printing from consistently well-exposed negatives. (2) Consistent delivery schedule throughout the year. (3) A range of services. (4) The right price. It is not always the most expensive labs that deliver the best service and quality, so price is not the major qualifying factor, consistency is. The problem with finding consistency is that most labs have slow and busy seasons just like you. They have many times the volume from September to December as in January through March. They have to hire and train new staff and put them on the production lines with their more experienced printers in the middle of the greatest demands on their systems. The quality of your printing will depend on whether you get an experienced printer or a trainee. The bigger the lab becomes, the less personal your service gets. Sometimes, the senior quality-control technician will quit, and for a month you'll get junk. Sometimes a medium lab works very hard to clean up its quality. The result is usually that it will get swamped with new business, hire new people, and end up right back in the same boat.

There are a few large labs in the country that limit their new customers so that they can control the seasonal variations in their workload. One of these is H&H Color in Raytown, Missouri. They only accept new accounts in January, and then only a predetermined number. This is the lab I have switched to, and I have been very pleased with the work and service I have received. Miller Color Lab is also a limited-access lab with a fine national reputation. There may be others of which I am not aware.

The only way to deal with a lab is to establish a working relationship with it, which involves a series of compromises. It means opening up the proper lines of communications with the people who actually work on your photographs, so that they realize what you want from them in terms of print quality and color balance. You may not necessarily work with only one lab. Some labs are stronger in some specific services areas than others, such as in senior package printing, custom portraits, print finishing, wedding proofing.

How do you find a good lab? It isn't easy, but the following suggestions may help you. Ask around at your local PPA meetings who your peers use and their opinions of the quality and service they receive. This is usually a regular topic of conversation at social hours at most PPA meetings. Establish contact with a service rep. You need someone in the lab who you can call directly if you have a problem. You don't want the account rep on the service desk. In conversations with a service rep, review delivery times, return policies, and how to order things in a lingo that you both understand. For example, don't send a group of three people and write on the envelope, "Crop out the guy on the right." The lab might not know whether that means to crop him out or to print a photograph of him separately from the rest of the group. You must be specific.

Ask the lab to evaluate your exposures periodically. A lab cannot produce good prints if you do not provide good negatives. Ask them to randomly test your negatives. They will usually provide this service for free because it makes their job easier. If you think your work is consistently being printed too cool or too warm, ask your service rep how to correct this problem. You may have to write "Print warm" on each envelope or ask the lab to set up a better tracking system for you.

You have to remember that a typical color lab works within broad standards of acceptability for print color and density. The lab (especially on economy prints) cannot be expected to print exactly consistent color and density from order to order, or even within one order of different sizes from the same negative. If you start sending back orders

because the 4 × 5s don't exactly match the 5 × 7s, you may start to receive the cold shoulder and all of your work will come back sloppy and late. They want to get rid of you because you are a pain in the posterior.

However, you must constantly monitor the lab's output. Do not accept badly printed material and insist that it be reprinted quickly, even in the busy season. Loyalty to one lab has its place in business, but not to the point of hurting your business. Using a lab is a lot like having a roommate in college. You have to live together, yet you don't have to love each other. It is a relationship of necessity forced on you by circumstances beyond your control.

Package Printing, Economy Printing, or Custom Printing?

Most labs offer three types of color printing services: (1) economy or machine prints, (2) custom prints, and (3) package prints. Economy or machine prints are made on automatic printing machines. There is no human intervention in the process. You must use pre-specified cropping guides to crop the image, and you cannot burn or dodge the image. Any special effects you want to appear on the print must be photographed on the negative. Custom prints are done by hand by skilled (a debatable term with some color labs) technicians on a regular enlarger. You can specify any cropping you wish and also indicate any burning or dodging to improve the image. Typically, custom prints cost three to five times more than an economy print.

The third type of printing is package printing. Here the lab uses a cluster lens to print your packages. A cluster lens will print one 8 × 10 (or an 11 × 14) or two 5 × 7s or four 4 × 5s or eight to nine wallets in one exposure. Each deck of the cluster actually consists of the same number of lenses as prints in the unit. All of the lenses are carefully prefocused and color balanced with each other and the other decks. A cluster should provide exactly the same color and density between sizes from the same negative. Package printers do have some cropping options available, usually through the use of cropping cards. The amount of cropping available will vary with the equipment the lab owns. Package prints are usually much cheaper than economy prints after the first unit is purchased.

With care in shooting and lighting, you should be able to use economy or package printing for 90 percent of your portrait color printing needs. Use of soft focus and proper vignetting of the images is essential for good professional images with a minimum of manipulation in the lab. That is unless you really enjoy paying three to five times as much for your prints as you need to!

E-6 Labs

If you are involved in commercial work, you will need to establish a relationship with an E-6 lab. E-6 labs are very different from print labs because they are simpler in some respects and more critically controlled in terms of color consistency than the C-41 or RA-4 processes. The basic service is the developing of your slide film quickly, cleanly, and consistently. Most large cities have E-6 labs that will pick up and deliver film within four hours. These labs usually have good competition, so price and services are pretty good, and consistency is tighter. Good E-6 labs also offer such services as slide duplicating, print-film printing, prints for reproductions, R-prints, and other services to produce images for publications.

Delivery

If you live outside of a major city with no one to pick up film from you, you must depend on UPS, FedEx, DHL, Airborne, or regular mail to pick up and deliver your film and prints. Shipping can be a problem and cause delays and potential damage. As a professional, it is your responsibility to make sure that the exposed film gets developed properly. If the film gets lost in the mail or the lab has an accident, you are liable for any costs to the client in producing those images. The courts have ruled, especially in wedding photography, that it is one of your professional responsibilities to see the films through the processing steps. You cannot pass the blame off on the post office or the lab, if the film is damaged or destroyed. Photographers have had to pay damages averaging about $5,000 per settlement in cases that actually went to court concerning weddings. The lab's responsibility ends with replacing the roll of film. So take care. I know one very fine wedding photographer who will drive sixty miles to his lab every Monday just to be sure. It also helps him establish a better bond and mutual understanding with the lab because he checks out his orders while standing in the lab's front lobby. The lab knows it won't get away with bad printing.

I've had $7,000 worth of film lost by UPS. The envelope was torn open, and the film was missing (seven rolls of VPS220). I had to refund all of the $7,000 to the customers, and UPS gave me $8 per roll of film as replacement cost. Needless to say, I was not happy. You must use great care in packaging and labeling your film shipments. I prefer the delivery services over the post office because it can track shipments better.

Labs Have Specials Too

Most labs have slow periods in the post-Christmas season. They usually will run low-price specials on large prints for samples. This is a good time of year to stock up on samples for the walls or to offer an off-season special to your customers. Plan such promotions around the lab's specials for added profits. Some of the larger labs will also have Christmas card specials, business card specials, etc., to promote various service lines they want to feature. Check with the labs you use, and coordinate your promotions with theirs. They often will have advertising and promotional materials available for a low price to assist you with your promotion.

Dealing with a Color Lab

When I wrote the first edition of this book, I said I had yet to find a lab that provided the qualities I stress above, and I had tried a lot of labs. As a regional and state president, I knew a lot of lab owners/managers personally. They would ask for my business, promising wonderful service. I would explain exactly what I expected from them in terms of color quality, delivery time, and printing consistency. Usually, the first few orders would be great, and then quality plummeted. I would phone, yell, scream, but I could never get the consistency I wanted. I tried a number of national color labs and got better results in overall consistency. However, I found an inflexible communications system designed to keep me away from the people actually working on my prints. I wasn't pleased. I had to talk to an account manager, or customer service rep, and technical problems never seemed to get solved.

Almost by a fluke of fate I finally found the ideal lab. The discovery started with this book. I had sold a copy of it to a lab in the Midwest at a trade show. A month later I got a letter from the marketing director requesting a second copy. A month after that I got a

call from the same lab. Ron Fleckell explained that his lab, H&H Color in Kansas City, Missouri, runs a lending library for its accounts. He bought my book for the library, but the first two people who checked it out decided to keep the copies and paid for them. Ron said he'd like to read the book as it must contain some good information. A little later Ron called back and praised the book. He also asked if H&H could buy a quantity to give to their customers as a Christmas bonus. He explained that he preferred to give an educational item rather than a basket of fruit to good customers. After some bargaining, H&H bought a quantity of books.

In fairness, I decided to give H&H a try. For three years I had employed a full-time printer to do my portrait and wedding printing. He was leaving me after Christmas and I didn't want to replace him. I also found out that H&H only accepts new customers in January. The lab didn't wish to take more customers in a year than it could effectively handle. It knew how many people it needed to employ in September and October from the numbers in January, and planned its year accordingly in order to maintain consistent delivery in the busy as well as the slow seasons.

The lab is in Missouri but it shares the air express charges through Airborne Express. Every weekday my film gets picked up and it's at the lab the next day. All of our return orders come in by Airborne, so there is no shipping delay. In fact, I get better turnaround from Missouri than I was getting from local New England labs that would do film pickup twice a week from my studio. My proofs are consistently back on the eighth day (Shipped on Monday from my weekend shoots and returned on the following Tuesday during the busy seasons. Sometimes in the slow seasons the turnaround was four days.) More importantly, the color was consistent and excellent. Once I felt the color of my wedding proofs was shifting to the red side of warm. I called to complain. I was connected to the line manager of the proofing department. We chatted, he made the corrections, and everything was fixed with one call. We have had to return very few orders for redos, and when we did, they were done instantly. The overall color quality has met all of my expectations.

Is H&H the only good lab? Of course not. Burrell Color of Crownpoint, Indiana, also impresses me with its very high level of customer service and consumer education programs. Good photographers I know are happy with Burrell's quality, service, and price. Luck Color in Cleveland, Tennessee, also has excellent service and is good to work with. CPQ, also of Cleveland, Tennessee, has developed a good reputation over many years as a fine lab with good service. I strongly suggest that if you have not established a lab contact yet, you try one of the aforementioned firms or a lab that is well spoken of by your regional peers. Establish good communications with your rep. Always remember that good printing requires good exposures, and a good lab will work with you to refine your exposure technique.

The Computer in Your Studio and Digital Imaging

Not too long ago, a computer was used mostly for bookkeeping and management in a photography studio, with some helpful applications in graphic layout for price lists, brochures, and the like. If one thing has changed in photography in the past five years, it is the introduction of the computer as a photographic tool. The rise of digital imaging (DI) is overwhelming, to say the least. DI is a rapidly expanding field that may very well replace regular photography (our current film and print technology based in nineteenth-century techniques) in the next five to ten years. If this sounds like science fiction, just remember that the original Macintosh computer was first introduced in 1984. The Mac and its clones totally changed the world of publishing and writing, so don't think it can't

happen to photography. Today's engineers and scientists have not even thought of the equipment that you will be using in ten years.

If you are not using a computer is your business already, I strongly recommend that you acquire and learn to use a computer as soon as possible. At present, the computer is still a business tool, but you need to become familiar with it. The DI applications can be practiced and learned now so that when the day comes when you need to use these skills in your day-to-day business, you'll have some experience and training. DI is not quite ready to sell to portrait/wedding customers, but it is almost there. If you do any amount of commercial work, DI is developing rapidly and you'll need DI skills in conjunction with your photography to satisfy clients.

I can hear you now. (I am paraphrasing my wife here.) "DI will ruin photography! Any fool with a computer will be able to make any picture look perfect! Nobody will pay you to take a good photograph in the first place!" I can remember older photographers saying the same thing about automatic cameras and strobes in the sixties and seventies. The best answer I can tell you is that DI is not simple; it requires a great deal of skill and equipment to use effectively. DI is a tool you can use to make your photography better, not to replace your present skills. You get paid to push the button, my friend, not to develop, to print, to finish, or to frame prints. All of these factors are important skills in delivering top-quality photographs to a client, but the single most important skill you have is knowing how and when to push the button to create the image in the first place. That is photography. All the rest is technology. If you don't have a good expression on the kids' faces, you won't sell a print to the parents, no matter what techniques you use to produce the prints. However, with DI you can save sittings at which you didn't get a good smile on everyone at the same time. You can "trade faces" between poses to make everyone happy, which makes for happy customers and bigger print sales.

I currently do not use DI in my studio. I have started to train myself by attending a week-long course at a well-known school, and by acquiring new computer equipment to begin practicing. The first area where we will use DI is in copy and restoration. I have not done copy and restoration in many years because the copy work and printing of the restored prints was tedious and didn't pay enough to justify my time. With DI, we can scan the prints to be copied immediately, do the corrections needed relatively easily, show the client the image on the computer screen, and then sell copies. We will send the copied and restored file to our lab, which will produce any copy negatives and prints we need for the client.

A DI Primer

I don't have the expertise or the space to give a comprehensive review of the entire DI technology, but I'll try to give you some terms that may be helpful in deciphering computer articles in magazines. There are many good books on the market, and I strongly recommend that you buy one and start learning. I would also recommend that you start learning on your own computer system, which is a chicken-and-egg argument about which system you should acquire first. To be very general, you have two choices in life, the Macintosh world and the Windows/IBM world. The difference between the two choices is in how the computer deals with data and software.

Macintosh was designed from the start as a graphically interfaced computer; you talked to the computer through a graphically driven operating system. Anyone who is familiar with the two types will tell you that the Mac is much easier to learn on and is much more user friendly in its basic operations. In the development of DI, Macintosh has been the leading computer of choice. IBMs (and its clones) run on an operating sys-

tem called MS-DOS (Microsoft disk operating system). This system did not originate with a graphic interface. This was added later in the Windows application. IBMs are generally regarded as better business machines. They are also capable of running graphics, and most of the programs currently on the market for DI can be obtained in Mac and IBM versions. As we speak, the two types are trying to grow together. The newest Macs can run DOS software, however not as efficiently as programs written in their "native" language. It may well be that in five or ten years there will be little or no difference between different brands of PCs.

Currently, I would recommend the Macintosh line for a number of reasons. Mainly, it is much easier to use initially, which means that you will use it sooner and more efficiently in your business. An excellent, unbiased article on basic choices appeared in *Consumer's Report*, which recommended the Mac as the best machine to learn computing on. Right now the Mac is a superior DI machine and offers a wealth of accessory items. Nobody can tell you which machine will be on top in five years, so don't believe anyone who talks like he/she knows all of the answers. Remember, the computer companies introduce new and improved machines about every eighteen months! Five years is three model changes away.

Using a Macintosh approach, here are some basic terms. The screen image in Adobe Photoshop (the leading DI program in use today) is a geometric arrangement of a layer of dots of different shades or colors on a rectangular grid. Each dot, called a pixel (for picture element), represents a color or shade. There are a number of color systems. The most familiar one is the additive system of RGB (red, green, blue) and another is the subtractive printing system of CMYK (cyan, magenta, yellow, and black for density). The number of levels of sensitivity is a function of memory space. To store the red data in one bit, it would either be red or not red (i.e., on or off in computer terms.) If we use more bits of storage, we can define more levels of red. For example, 256 levels of color would require 8 bits of storage. Today's programs store information in 24 bytes. They can reproduce 16.7 million colors for each dot or pixel.

The amount of information to be stored about an image determines its file size. Memory is measured in units of bytes, kilobytes (1024 bytes = 1 kilobyte [1k]), megabytes (= 1 Meg) and now gigabytes (1 billion bytes). Computers "read" and "write to" memory files with a given speed, so the larger the file, the longer it takes a computer to handle it. Many of today's major improvements in computer technology involve the speed with which they can store and manipulate data. The amount of storage in computer memories is increasing exponentially with each new model. The first Macintosh in 1984 had an internal memory capacity of only 128k, hardly enough space to store a four- or five-page letter, never mind a digital image. Most DI files are more than 1 Meg, and some can go up to 10 or 15 Megs. Basic computers today come with 4 Megs of RAM (random access memory) and internal hard drives that can store hundreds of Megs.

Computers have different kinds of memory. The software and data are usually stored in a memory consisting of a hard disk, or hard drive, or on small portable floppy disks that are inserted into the computer's disk drive. This information can be accessed by the computer and added to as needed. To actually manipulate the data and software, the computer needs RAM. This is the area inside the machine where the work is done. A rule of thumb is that one needs about three times your file size of RAM. If you are using 10 Meg files, you'll need 32 Megs of RAM. RAM costs about $50 per Meg at this time (and is coming down in price), so big files cost you more money in hardware.

Read-only memory (ROM) devices are disks that store information that can only be read and not written to. The most common device is the CD-ROM, which stores infor-

mation on a CD. For example, you can buy a phone reference for the entire USA (91 million names, addresses, zip codes, and phone numbers) stored on only four CDs. CDs are probably the best way to store DI files. It requires a very expensive machine to write to CD, so home computers only read them. You can have your negatives or slides transferred to CD at any number of labs for a nominal fee.

Many times in DI you need to transfer the data files you have created to a service bureau to have prints or negatives made. There are high-density disks that can hold up to 270 Megs called Bernoulli, Syquest, or Zip drives. These are separate drives that your computer can read and write to, but their medium is portable.

There are a number of ways to get DI to work in a computer. You can use a digital camera to take the initial image. For example, Kodak makes a back for the Nikon N90 body to adapt it to a sensor chip instead of film. Each exposure is recorded by 1.5 million sensors that are recorded on a hard drive. These images can be dumped directly into a Macintosh and used immediately. There are backs now being made for 2¼ cameras and 4×5 cameras. They are currently very expensive, but the prices are dropping quickly. There are also simple digital cameras, such as the Apple Quick Take 100 for $699. They don't have the resolution of the Kodak, but they cost a fraction of the price. I expect to see a lot of major changes in this area in the next five to ten years. I fully expect to be doing wedding photography with a digital camera within ten years.

Another method is to scan a regular photograph, negative, or slide. There are a number of devices which digitally scan your photographs and convert them to computer files. They range from under $1,000 to big bucks. Usually, the higher the resolution, the greater the cost. A flatbed scanner is designed to convert flat art to digital files. These scanners range in price from about $400 for black and white up to many thousands of dollars. The better ones come with the software needed to use DI (mostly Photoshop) and other software to read printed images. Some flatbed scanners have transparency attachments to scan slides. From my experience, you get a much better DI file when scanning from original negatives or slides than from prints. The print is already a second-generation image, and scanning the original eliminates many problems.

A third approach is to have your negatives/slides converted to CD files. There are a number of labs that write your images to CD. These files then can be read into your computer and manipulated. There are many stock image files available. I recently received an advertisement for 22,000 images on 100 CD disks for about $800. All of the images come with full releases and can be used for any purpose.

Output

The real weakness of DI for the portrait/wedding photographer today is the quality of the output devices. When you are in the reprint business, as most portrait/wedding photographers are, there are not a lot of good answers. You have two choices. (1) Have a negative made of the DI file, and then have regular prints produced at your lab. (2) Use a DI output device. Making a negative has the drawback of being another generational step in the process. However, the prints produced are the most stable medium we have and you can then sell frames, do any finishing required on the print surface, etc. Negatives are made on film writers. Film writers can write up to one thousand lines of data on a 35mm film or a 120 film format, and up to two thousand lines on a 4×5 format. A 120 negative for a DI can only be enlarged so much before the lines start to show. The biggest you can go from a 120 negative at present is about 20×24.

Then there are the DI output devices. There are a number of direct digital color printers on the market. Some have the quality of color laser copiers and are of little use to a por-

trait photographer. The best output devices are gas sublimation printers. Kodak produces some of the best. In these machines, a laser heats a thin film of color dye that is "sprayed" onto a paper support. Each primary color is put on in a layer, and they all melt together. The prints that come out of a Kodak 7700 printer are almost photographic in their brilliance and surface character. Unfortunately, they only go up to about 10×11 inches, and they are not very stable. They would be acceptable for a commercial job, but not to a portrait client.

Service Bureaus

Making negatives from DI files or scanning negatives requires some fancy and expensive equipment. As most photographers cannot afford to have all of this hardware on the premises, a new type of business that is springing up is the service bureau. These companies service DI clients in input, output, and specialized skills. They make the files and the negatives, and offer the expert services, such as restoration and retouching, that photographers need. Many of the larger commercial color labs are opening service bureaus to keep their printing business. They also employ people to do the complex restorations and retouching—for a fee, of course. Communication with a service bureau, if you have your own computer, is via portable hard drives and/or a modem over phone lines. This is a very new area of business, and there are a lot of standardization procedures to be worked out. I expect the relationship between you and a bureau will be very similar to your relationship with your color lab right now. It will range from great to terrible.

Where's the Market?

The market where DI will make money for you now is copy and restoration (C&R). You will need a flatbed scanner, a computer with appropriate memory and monitor, and a portable drive system to transfer the files to a service bureau. With very little experience you can scan images, improve the image contrast, color, and density as the client watches. With some experience and some "touch" you can learn to fix cracks, tears, stains, etc. This technology still requires a sense of color and a delicate touch with the mouse (instead of a pencil or brush) to do corrections. The advantage of DI is that if you make a mistake, you can erase it and try again. Making a mistake on a copy print with a wet brush usually means you have to start over from the beginning. Even a klutz like me can do some delicate work in DI that I couldn't do with the traditional tools of the restoration artist. However, even with a fancy computer, I still can't draw in an eye that was missing from an old photograph. That still requires the hand of a skilled restoration artist.

You can use DI to fix things for which you once had to pay an airbrush artist. In commercial work, you can fairly easily modify backgrounds, fix blemishes, and combine images. In portrait/wedding work, you can fairly easily do corrections such as change the background, hide something that shouldn't have been in the photo, and transplant faces from one pose to another. DI can save those sittings that didn't go exactly as you had hoped. There are special effects you can create for commercial and portrait/wedding clients that can make you unique in your marketplace. If you have the knack and the time to do creative DI, you may make a niche for yourself more quickly in your market.

Equipment

I don't want to make any recommendations about equipment—other than stick with Macintosh—as things change very quickly. Shop around and interview various computer outlets. Check to see if training is offered, what kind of technical support is available, and how long the store has been in your community. Buying computer equipment is just like buying camera equipment. You can always get it cheaper through the mail, but can you get the service you need when you need it? I think it is important to establish a relationship with a good computer supplier who also offers repair and teaching facilities to aide you. You may pay more for the initial equipment, but you will have an investment in a relationship in addition to the equipment.

Today, you can get a good midlevel Mac with a monitor and ink-jet printer for about $2,500 to $3,000. A system capable of DI, with a laser printer and a flatbed scanner, Syquest drive, etc., will run about $8,000. Many suppliers offer lease programs so you don't have to put all of the money out at once. Don't go crazy buying software until you learn a bit about the machines. You will also find out that there are computer groups in your community and on the World Wide Web that love to share information about programs and support items. Get involved and you'll learn a lot. Don't be afraid to sign up for an introductory course at the community college. You can learn a lot quickly.

Marketing and Selling

To succeed, you must be better than your competition. To be better, you must be different. . . . Your market offering is better only if your target market considers it to be better. . . . If you can't sell all of the people something, then sell a lot of something to some of the people.
—Stephen Harper in *Starting Your Own Business*

The best single idea I've ever heard about marketing and selling is this: You have a sale when the price equals the value! I would like you to remember that statement for the rest of your life in business. Think of how you look at any product or service you purchase and evaluate it in terms of that statement. When was the last time you bought a car or a house or other major item? What was the mental process that you needed to arrive at the final decision to say yes to the purchase? What did you value in the item? Did you use logic or economics to determine if this was the best possible price for the item? Or did you respond to the item's emotional appeal after determining you could afford it? Value is a combination of price, quality, and desire.

Most people have a limited income and cannot buy all of the things that they might value. I would like a ninety-foot yacht to sail around the Caribbean for nine months of the year. I cannot afford this dream. However, I can pay for a ten-day cruise on a cruise ship with all of the amenities. The cruise will cost me about $300 a day, which would seem crazy if a hotel asked me to pay the same amount for a one-night stay. Again, my dream is part of the value. The price was affordable and almost irrelevant after that fact.

Affordability is an important consideration. Even if someone desires your services but does not have the money to cover what you charge, he or she can't pay you. On the other end of the spectrum are people with millions of dollars in the bank who don't value anything except more money in the bank. They won't pay you, or anyone else, a price no matter how much they value the service or product you offer. There are many wealthy people today who came from poor backgrounds and have earned every cent they have. They accumulated their wealth by a combination of hard work and frugality. Now that they have the money,

they have forgotten how to enjoy it. Cheap equals good to these people. Not a good prospect for any merchant.

An equally powerful idea is: "The aim of marketing is to make selling superfluous." (Peter Drucker). As I will explain in the sections below, selling and marketing are different skills and require different amounts of labor on your part. The least efficient method is to work at both selling and marketing. Many studios succeed by being better in one area or another; seldom in both at the same time. You must realize this at the beginning of your business life to save yourself time, labor, and heartache. As you develop your selling and marketing skills, you will someday be able to choose which path is best. Another way of saying this is: "The role of marketing is to create the right conditions for sales to take place" (John R. Graham). In my view, marketing is different than selling in the sense that selling is mostly done face to face with a customer. Marketing is generally used prior to the customer's contact with you to help enhance your value and to interest the client in using your services.

When you are in a small room with a client, you are usually trying to sell them something—a specific product or service. You used marketing to make them aware of your existence and to get them to come into your studio in the first place. The two areas are very different and require different skills. It depends on your personality and skills as to which area you may be best at. Some people thrive on the confrontational aspects of selling, while others are best reaching out to potential clients through marketing schemes.

The easiest sale is when a customer walks into your studio and requests the service or product you most want to sell them, at the price you wanted to charge. There is no need for any additional sales effort; write the invoice and collect the money. In my mind, good marketing practices produce the type of customer who will ask for what you want to sell at the price you want to charge. This is what is referred to as the win-win sale. You win because you get your price, and the customer wins because he or she gets the product or service he or she wants at a fair (in his or her mind) price.

Sales- or Marketing-Oriented Studios

In my experience, there are two very different approaches to promoting photography studios and to structuring their sales and price lists. I will call the two extremes sales oriented and marketing oriented. In reality, most established studios offer a mix of the two ways of operating, but there are certain lecturers who will emphasize one or the other to the exclusion of its complement.

In a sales-oriented operation, the goal is to get a client into the studio to be photographed, and then sell them up to the level desired. Some studios will use a low sitting or creation fee for a wedding or portrait session just to get the clients in the door. The sales plan is to use all available (ethical) techniques to get the most money out of them after the photography is done as possible. In some studios, all sittings are complimentary and done on pure speculation of the potential total sale. This requires a very selective offering of the "free" sittings to a carefully chosen clientele to be successful. Not an easy trick.

In a marketing-oriented studio, the goal is to create the idea of value in the potential client's mind that the product or service being offered is worth the price being charged for it. In this second type of studio, sitting fees and wedding prices are usually higher up front, but with less selling pressure after the fact to increase the total sale. Most of the marketing work is done before the photography.

Which way is the best? There is no clear-cut answer. Both approaches are legitimate and each will have their strong advocates. I run a marketing-oriented studio and feel it

works for me, but I would not denigrate a sales-oriented studio. As stated in the beginning of this chapter, selling and marketing are skills that we exercise with varying degrees of competency and comfort. Most successful photographers combine some of both skills into a whole that produces the most profit with the least effort.

The Intrinsic Value of Photography

Value, to quote the popular cliché, is in the eye of the beholder. Value is the key word in all of the following discussion. The perceived value will vary tremendously from individual to individual looking at the same product, whether it's an automobile or your photography. Mercedes-Benz has spent a lot of time selling its car's "value" as opposed to Subaru, which markets its cars as the least expensive. What is the real difference between these two cars? Is it really $8,000 to $45,000? Obviously, Mercedes is selling very well, so a large number of people believe with their dollars that there is a difference, and the difference is worth it.

What value does a photograph have? What do people want when they take or purchase a photograph? What determines that individual's perception of what is valuable in a photograph, or a photographer? A lot of photographic portraits are taken in conjunction with special times in peoples lives: weddings, graduations, birthdays, anniversaries, family reunions, confirmations, awards, new baby, etc. The events themselves have high value as memorable times in our lives, so the photographs that are taken of them are memories, if nothing else, and have an intrinsic value to the people involved regardless of the quality of the image in the photograph. Grandma's Polaroid, in this sense, is as valuable as an Ansel Adams's 8 × 10 negative to the person in the photograph.

Many people conceive of their lives as a series of important milestones, and documenting them with photography is an insurance policy that the events will be remembered by future generations and the subject's place in history, no matter how small, will be immortalized. We, as photographers, tap into the emotional value associated with the events to produce our photographs and sell them back to the subjects. What is your value here? Again, this will vary from person to person. One father and mother may think that a 99¢ 8 × 10 is just fine to record the growth of their baby, while another couple will pay $1,000 for a sitting with the best photographer in town for a sensitive, artistic child's portrait.

What factors generate this range of values in the typical consumer? (1) The importance of the event in their lives. (2) The importance of demonstrating to other people (family, friends, peer group) the event that has taken place. (3) Perception of photography as an art form. (4) Recognition of the photographer's ability to make better photographs than the participants could. (5) Ethnic conception of the visual image as important in recording events. (6) Financial resources (least important factor).

At bull sessions among wedding photographers, you always hear about Italian or Greek weddings in glowing terms. For old country, traditional Italians and Greeks, the wedding is *the event* in a woman's life, the day deserving all the money they can earn in a whole year, or more. It is a religious, family, and social event all wrapped up into one. They will love to share the day with others for the rest of their lives, thus they need lots of photographs, and hang the expense! If the images are in focus and reasonably exposed, they will love them and buy them. The photos themselves have a value. If you can produce better, more varied photographs, the value, and therefore the price, can increase.

Given that some photos (minimal quality assumed) have an intrinsic value, does a photographer have an intrinsic value? Yes, but subject to a great range of price. Most

people know that good cameras cost a lot of money and that film and processing have a cost and that the minimum wage is X dollars per hour. How much for a wedding coverage—$100, $500, $1,000, $10,000? How do you get to the upper end of the scale, not only in wedding photography, but in portrait work, commercial work, or any area of photography? This is the most important problem you have to consider in business, and solve to be successful.

Creating and Increasing Value as a Photographer

To increase your value, you must achieve three things in your chosen market: (1) recognition, (2) reputation, and (3) position. It is difficult to get a reputation without recognition unless you are a terrific salesperson, in which case you should sell insurance or real estate. You'll make a lot more money than you will in photography. Recognition is getting the market to know you exist. Gaining recognition will vary tremendously from market to market. A "market" in this context is any target group to which you would like to sell your services. This could be anyone within twenty miles of your home, all high school seniors in the XYZ high school, or corporate executives of companies that earn over $100 million a year. Recognition is gained primarily by repetition of exposure in a target market. This can be done by media advertising over a long period of time and/ or many repetitions per day, as with ads on TV. This a terribly expensive way to gain recognition.

You can gain recognition by getting your work into the public eye in any way possible, by getting your name mentioned by the most people for any positive reason, and by working for the most people possible in your target group. There is also an element of luck in being in the right place at the right time. Robert Farber, one of the top fashion photographers in the tough New York City market, got his break standing in a sidewalk craft show with a display of his "art" prints. An advertising executive was walking by, saw the work, liked it, and gave Farber his first break. He, of course, had to follow up the luck with a good job, but he had his initial recognition, and his skill carried him to the top quickly. Ansel Adams is often quoted on how he captured his famous *Moon Rising over Hernandez* photograph, "Luck favors those who are prepared to receive it."

Position is where your reputation fits with the other photographers in your market. It is not always the best and the second best. Position may involve a degree of specialization or freshness. Jane might be the best at school photography, while Joe is thought of as more artistic, but not very efficient. Sometimes being newer can be a plus in the eyes of consumers. Different clients may value different aspects of your skills, location, price range, or efficiency. This is why a number of different studios can service the same market and all do well.

Position is the consumer's conception of differences rather than real differences between competitors. Look at some of the national advertising campaigns: 7-Up is the "uncola," Avis is #2, but trying harder. There are many products that can coattail on the established reputation of larger competitors by focusing on their minor differences, rather than on their great similarities.

Jeff Blackman puts it well, "Always deliver more in 'perceived value' than you take in cash value."

Free or Speculative Sittings: Value and Pricing

The tendency for many new photographers is to price their work incorrectly for their market. The "what the market will bear" pricing technique is very dependent on estab-

lishing a market position and product recognition factor. I can remember when I first opened my studio I thought I would do the department store photographers one better and offer a free sitting with an 8 × 10 for all babies under two. I had visions of lines of mothers streaming into my studio and coming back to buy hundreds of dollars of my obviously better baby pictures. I invested $1,000 in TV advertising (which was effective in that market area) over the month of May. Net result: zero, zip, nothing! Not even one phone call about our baby special.

Why? I was very new in the market area, had no name recognition, and the price equaled the value, that is, nothing. No mother was going to have a valueless photograph taken of her baby. Later, after gaining a share of market recognition (the old-fashioned way, I worked for it), the baby promotion would have brought in many sittings, but by that time I did not need to give away sittings.

At the same time I was running my baby special, a photographer across the street from me was running a promotion for his anniversary. The deal was, "Buy a 20 × 24 canvas portrait, and get two 8 × 10 copies for free." Big deal! I sold no free sittings and he sold twenty-four of his specials for big dollars. Where was the value? The other photographer was well known, produced a consistently fine product, and worked hard at selling it. His customers knew a value when they saw one, and got a bonus of two 8 × 10s, not for free, but in addition to something well worth owning.

Are free sittings always valueless? No. Many studios run promotions which are based on free sittings of many varieties, but usually in connection with something that adds value. An important promotion run by studios in the high school senior business is to give a complimentary sitting to the family of a senior purchasing a higher priced package. The people have already had to spend money to get the "free" sitting, and they are familiar with the photographer's prices and the idea of the senior about to leave home makes the family sitting more valuable. Studios run this promo in the spring when things are slow, and with good salesmanship they can make a profit in March and keep their people working. I used to run a free-sitting promotion to couples on their twenty-fifth, thirtieth, etc., anniversaries. These people, for the most part, would not have come in to the studio on their own for a sitting, so I didn't lose any business. Once their sittings were completed and they had seen the photographs, they realized that their whole family would also value them. As a result, they purchased a good number of reprints, which we would not have sold without the promotion.

Bill MacIntosh is a well-known speaker on the circuit who uses the complimentary sitting extremely well in the high-end markets. His skills as a photographer are great, but his marketing is even better. Read his articles and go hear him speak to learn more about this approach.

When you offer a free or very inexpensive sitting, you also attract the bargain hunter. These people come to you because of the cheap price and many times that is all they will want and no amount of salesmanship, hard or soft, will budge them. You will also attract people who have no knowledge of what a photograph of themselves or their family can mean. They are uneducated consumers and you, the photographer, have no value to them. Once they are in your studio, however, if you do a proper job of selling the entire experience of the sitting, they will perceive the value, and the dollars will follow. So, be prewarned, with special promotions using low prices as an incentive, you will get as many zeros as good prospects, but you'll get prospects.

The Uneducated Consumer

It can be one of the biggest mistakes in your career to assume that everyone knows about professional photography. The average consumer has some terrible misconceptions about what professional photographers do, based on their limited experiences with what they consider to be professional photographers. Most consumers have just never stopped to think about it at all.

A major part of building any successful business is creating a need for your product or service in your market area and then satisfying that need. (For more on this, see the coattailing section in chapter 2.) To use an example unrelated to photography, look at the personal computer market. We have had large mainframe computers since the late fifties, but only in the last decade have we had PCs. Today, many homes and businesses in North America have PCs. In 1976, the Apple Computer Company was three smart young men with a great idea in a garage in California. Today, the company earns billions of dollars annually and has given the long-established IBM a run for its money. To sell that many units took a lot of marketing and careful consumer education about the value of owning your own computer. Apple, IBM, and the other manufacturers created a market, and then filled it.

Most people's experience with professional photographers are the school photographer; the baby photographer in a department store; the person who took their driver's license or passport photo; if they are older and married, their wedding photographer; the person at the old-fashioned, dress-up studio at the mall; and if the people are in their forties, fifties, or sixties, they were probably photographed as children by "kidnappers," photographers who went door to door with a set of hot lights and a portable background or a pony.

The Photo Marketing Association (PMA) did a survey of households that had had a professional portrait taken, by location. The results were that 38 percent of households surveyed had had a portrait taken. The portraits were taken at the following locations: at school, 18.9 percent; at a chain portrait studio, 14.8 percent; at church, 6.1 percent; at a professional studio, 5.9 percent; in an outdoor setting, 4.3 percent; at a day-care center, 2.1 percent; at the home, 1.3 percent; at a studio in a one-hour lab, 1 percent; and other, 5.6 percent (multiple responses were allowed, so the total is greater than 38 percent).

The uneducated consumer's opinion of professional photographers is based on how they were treated by the above photographers. Over a long period in our society (at least the last thirty-five years), they were probably treated poorly in terms of good photography and good service. Eighty to ninety percent of the buying public in a typical North American town have never been inside a real photography studio. Ninety percent have never seen (to the best of their knowledge) a 30 × 40 photograph of a family. Seventy to eighty percent of North American families have never been photographed by a true professional in any manner whatsoever.

When a potential client calls up and asks what an 8½ × 11 costs, don't feel superior because he or she is ignorant of your technical jargon. Take it as a challenge and go to work on educating your customers on a one-to-one basis. If a person is totally ignorant about what it takes to make a good photograph, how can he or she place a value on it? Most people own some kind of camera and know that for $8 to $10 they can get some out-of-focus, poorly composed, poorly printed photos. How can they know about how wonderful a 30 × 40 fully retouched canvas portrait looks, unless you show them?

I would like to relate the following true story. A good friend operates an art gallery that sells oil paintings that she paints. The paintings are of excellent workmanship and

quality, selling for $800 to $1,500. One summer morning a Mercedes-Benz pulled up and a middle-aged man walked in and started looking at the paintings. He walked up to the first one and exclaimed "$1,000!" in disbelief. My friend walked over and said, "Yes, $1,000." The man replied "Well I just bought one *just like it* for $39.95 across the street at the flea market." In the car he had a sofa-sized Mexican oil painting of a seascape scene similar to the junk you see being sold in malls and on the side of the road out of the back of big trucks. He had liked the image and bought it. My artist friend proceeded to show and explain the difference between cheap art and real art. She talked about technique, use of light, colors, quality of materials, etc. Those were things she worked very hard at doing well. The result was that the man bought her painting for $1,000. No one had ever told him the difference before! He was neither stupid nor poor, and when she took the time to create the *value* in his mind, he paid the price.

What Do We Do with the Uneducated Consumer?

Part of our problem is to get the uneducated consumer into our studios so that we can show them our value. It is not easy, especially with the department stores selling sittings with packages for $19.95 in their very highly visible locations in the malls. We, as studio photographers, cannot beat the chains and department stores on price, and if we cannot get them into our studios to show them quality, how can we get business?

Simply, you must take every opportunity to expose the public to good photography. You must go out and get them. You cannot sit in your studio waiting for them to come to you! I feel that good studios should be in the school photography business and produce good school photographs. You are training your own (and also my) future clients. You may be charging much more for your family or wedding work, but you have created a more receptive potential market by doing good volume work. The idea is still good photography.

THE 80/20 RULE: If one hundred uneducated consumers came into your studio through some type of promotion, 80 percent of them would probably buy nothing or the minimum possible. To a lot of people, our work has little meaning or value other than recording moments in their lives. To many people, a snapshot of their daughter's wedding is adequate. You won't do much business with those type of people. But the other 20 percent will provide you with your living, if you do your job well. Moral: Be considerate of people. Don't ever look down your nose at an uneducated consumer. To quote Bruce and Sue Hudson of Renton, Washington, "Don't ever underestimate the potential of any single customer." The 80/20 rule has been around since the fourteenth century when an Italian economist first wrote it down. The extension of the 80/20 rule is that you will make 80 percent of your income from 20 percent of your customers. This holds true even as you move up the price ladder into the higher markets. It does not mean that you can just eliminate 80 percent of your customers and still make the same income. You have to have warm bodies to work with.

The Five Steps to Marketing a Service or Product

These are my keys to thinking about photography and how to market it to my clients. (1) Identify a market. (2) Identify or create a need within that market. (3) Identify a product or service that will fill that need in the market, and make you a good profit. (4) Make the market aware of your ability to fill the need that exists. (5) Produce and deliver the product. It seems so simple, doesn't it? Yet, large companies spend billions to find out the answers to the above questions. There are markets out there that nobody has

identified, and markets that produce millions of dollars quickly for those smart enough or lucky enough to discover them.

A simple yet profitable example was the hula-hoop in the late fifties. The market was there, and there was a new material, plastic, which enabled the manufacturer to produce this simple toy for very little money. Kaboom! It took off. The Pet Rock enjoyed a six-week boom in sales and then died. Someone came, saw, and made a killing. The fashion industry is constantly looking for new styles that will appeal to the various segments of the market, and it is constantly trying to create new needs through advertising. The computer industry had to create the need for home computers before it could sell you one. It has done a excellent job in creating a need in the consumer's mind. In photography, the boudoir market seemed to appear out of nowhere in the late seventies. Very few legitimate portrait studios would have thought about offering such sexy photography to their mainstream customers. Someone tried it and discovered that there is a large and quite respectable market with a need for this type of photography. Who knows what else lies in wait out there?

Brand Versus Concept

One major problem when marketing or selling a product is to separate the idea of the product from the brand, or specific name of the product. For example, an automobile is a concept and Chevy, Ford, and Mercedes are brands of that concept. More important for a photography studio is for you to realize that you are not selling pieces of paper, but something better: ideas, memories, and emotions. You must also realize that different studios represent different brands of the same product in the eyes of most consumers.

An illustration that I think applies to photographers is one told to me by a representative from a large PR and marketing firm from the Chicago area. Some years ago there were a number of dairies in the Chicago area. They would all advertise "My milk is better than their milk, because my cows are brown (black, contented, white, etc.)." The net effect of all this advertising was nil. The dairies were only stealing customers from each other, and were not creating new customers. They were selling the brand rather than the milk. Someone finally got smart and realized that the real competition for selling milk is not other dairies, but soft drinks, orange juice, wine, coffee—any other drink products. The dairies formed a marketing board, pooled their advertising dollars, and ran ads that said; "Milk is healthy," "Milk is cool," "Milk makes you beautiful and strong," etc. They were selling an idea (i.e., that milk is a healthy alternative to soda or coffee) rather than brand. The end result was that all of the dairies did more business, and each dairy made more money.

This story illustrates the difference between selling/marketing a concept rather than a brand. While there may be differences from one brand to another, they are less important than the differences between milk and soft drinks, as far as consumer acceptance is concerned. Consumer acceptance or awareness is the critical factor in marketing and selling.

Some other examples of selling the concept rather than the brand is the F.A.O. Schwarz Company—the largest toy store in the world, located in New York City. It does not sell toys, according to its president, it sells fun! A construction company does not sell buildings, it sells either profit centers for its commercial clients or homes for its residential clients. What does a marketing or PR firm sell? There is only one product, success for its clients in their chosen fields of endeavor. When you promote or advertise, do not try to sell your difference with the studio down the street, sell professional pho-

tography as a concept, and increase the value of what you do for the consumer. If you can make your product more valuable, you can then charge more dollars for it, and make more profit.

Marketing: Advertising, Public Relations, and Self-Promotion

One of the toughest aspects of opening a new photography studio is getting the public to know you are alive and well in your chosen location, and that you can supply all the photographic services that they will ever need. The three basic ways of building knowledge of your business within your chosen consumer market, all of which constitute what is generally referred to as marketing, are: (1) Self-promotion, or those activities you do to announce your own achievements to the public. These may include direct displays of your work, direct mail to a select client list, publishing a newsletter, giving lectures or other public service. (2) Public relations, or those activities which will get your name mentioned in the media, such as news stories about yourself or your studio, feature articles by or about yourself, and by-line articles (such as a photo-tips column) in your local media. (3) Advertising, which is the use of paid media, either print or electronic, to broadcast your message to your marketplace.

It is a lot easier to promote yourself if you are well known in your community for reasons other than your photography. It's like the story that any bank will loan you money if you have so much money that you don't need the loan. Unfortunately, when we start our photography businesses, most of us are not as well known in our communities as we would wish to be. It would be easier to start a business like a photography studio if you had been the mayor of your town, as almost everyone in town would know of you already. You would just have to let them know that you are now a photographer. Some of the various marketing schemes listed below are specifically intended for a new studio. Many of them cost little or no cash, but may require a lot of your time. At the beginning of your business, you probably will have more time than money, so these schemes may be the only path for you to follow.

A Basic Vocabulary of Marketing Terms

There are a number of general things to consider when evaluating any marketing scheme.

REACH is the number of people who will actually be exposed to your promotion or advertisement during its lifetime. This number is not easy to determine accurately. If you take an ad out in a newspaper with a circulation of 50,000, the paper will claim that it is actually read by 75,000 to 100,000 people. How many of those readers will actually see or read your particular ad? The answer is only a fraction. The smaller the ad, the greater the chance it will be overlooked, unless there is something special in the ad layout or graphic content that will attract the viewers' eyes. On radio, it is the audio content that will attract their ears instead of their eyes. In radio or TV, a million people may listen to the radio during a day in your area, but how many will actually listen/watch the station carrying your ad at that particular moment? How many went to the bathroom at that very precise moment you paid for?

AIM is the target market or group of best potential customers to whom you wish to sell your services. If you are a wedding studio, you don't want high school seniors and vice versa. If you charge $1,000 for a sitting, you don't want the same person who wants a $19.95 baby special at the department store. A wedding specialist has a narrow market—brides-to-be and their families. A senior studio is only concerned with students between seventeen and eighteen years old. A high-priced, carriage-trade studio is looking

for affluent people with a great deal of money to spend. The major point to remember is that very few promotions of a good portrait/wedding studio are aimed at the general consumer population. Sears and Olin Mills do aim at the general population using low price as an incentive. You cannot afford to advertise in the expensive medias that Sears does, or to make a living at the prices they charge. You must be more careful to choose media/methods which are aimed more precisely at your target markets.

First, you must identify your target market. Then, you must determine what they read, what they like to watch/listen to, where they shop, play, workout, or entertain themselves. This is not always easy, and it is not always obvious. Determining what the aim is for a product is the function of a marketing and research agency, to which large companies pay huge sums of money for its knowledge. An example of a national marketing scheme that seems odd but worked is on your TV every Saturday. A popular TV sport is motor racing. Advertisers sponsor cars hoping that they will be on National TV with their logo emblazoned across the hood or trunk. The best cars are usually on TV the most, so the better drivers get the best sponsors and the most money. If you are selling motor oil or auto parts, the typical viewer of motor racing is probably a good prospect—the stereotype being a redneck, Marlboro-smoking, Bud-drinking, all-American male. Some smart ad exec also realized that the guy's wife/girlfriend was also watching the race with her hero. All of a sudden you started seeing L'eggs pantyhose and Tide detergent sponsoring 450 HP racing cars. It works.

Another example is professional golf on TV. Golf is one of the lowest rated sports shows, but they get plenty of willing advertisers because the people who watch have much higher average incomes than those who view baseball or motor racing. Typical golf sponsors are American Express, expensive cars, stockbrokers, and jewelers. While golf has a smaller reach, it has a more specific aim than baseball. For many advertisers, golf has more bang for the buck. Similarly, if you want to aim at teenagers, MTV is a direct pipeline to their eyes and ears. MTV is not a great medium for reaching senior citizens, but *Modern Maturity*, the magazine of the American Association of Retired Persons, would be.

Another thing to consider is that the best market for your services is those people who have already used your services. Your past customers are very likely to be your customers again, and they respond more strongly to your ads than other people. Notice your own reading habits. When going through a magazine don't you tend to look longer at the auto ad for your make of car, or at the ad for the new model of your own computer? Most large corporations realize this and target past owners of their products with special ad campaigns. They realize that they don't have to sell you on their value, only on their new features—a much easier job than getting you to buy a product on faith alone. Most auto companies have expensive magazines that they give to anyone who buys a new model. This is good marketing as the material is going directly to the best potential customer. Cruise lines will send former passengers special full-color newsletters with special discounts. They know they have a better chance of selling a former client another cruise package than in advertising to the general public with that expensive print media.

PENETRATION: Assuming you have a well-defined target market and have found the correct media to reach them, how well known is your service to the members of that market? The degree of recognition within a market is your penetration of that market. I live in a small town and am very active in local government and in local business groups. I also do a lot of promotions. My studio is on the main business street in town, right across from the post office. Even with all of these factors, I still meet local people who ask me, "Do you work here in town?" It isn't always easy. Don't assume that just be-

cause you have a good campaign aimed at the right market that you will reach every-one. This is why you must keep promoting and advertising, even when you become more established.

COST: The important point to consider is cost per contact in the right market. This may seem obvious, but you must be careful. A million dollars in the wrong media at the wrong time is a waste, while a few hundred dollars in the right place at the right time may make you a lot of money. You will be bombarded by hundreds of requests to place an ad in the newsletters of civic or charitable groups. While they may only cost a hundred dollars, they are usually not effective in producing new business. Cost can be broken down into cost of production, cost of distribution, cost of space/time, and cost of your time.

An effective and good-looking TV ad usually costs a great deal to produce and a great deal to run. A radio ad's production cost is usually included in the time charge at most small stations. Most papers will help you with graphics and layout for nothing as long as you buy space. Selling by direct display costs you money in setting up a booth or display and then manning the booth. Even giving a lecture to a civic group costs you in time and preparation materials. Remember, your time has a value. In most direct media, such as direct mail and direct display, the major cost is the distribution of the information, not the production of the promotion. Anytime you can piggyback your message with another organization's distribution network, take full advantage of a golden opportunity.

FREQUENCY: Generally, a single ad run only once is almost useless in any media. The same (or similar) ad must run over and over to be most effective. How frequently to run the ad (and how many times in total) is a hard question to answer. Some of the large corporations will run a specific ad so many times it becomes ingrained in your memory. If this is so, you have gotten their message. Even in the most direct media, cold calling, frequency is most important. In a study published by a sales management organization, it was determined that an average sale (these were large-ticket items) required five cold calls to instigate. In other words, the good salesperson kept going back even after being rejected four times. Those who didn't go back, failed.

IMPACT: How noticeable is your ad or promotion relative to the other distractions in the media environment? There is so much advertising in our day-to-day lives that most people tune it out. We watch TV, but when the ad comes on, we pick up the paper or go to the bathroom. When reading the paper, we skim the pages looking at the headlines for the news and sports scores. Many of us by habit and lack of time don't even look at certain sections of the paper unless we have a specific interest in that section, such as classified ads, sports, or the entertainment section.

Impact is the power of the graphic or audio of the ad to attract the viewer/listener. In this sense, you are lucky since you deal in a visual product. Most people will look at a photograph in the paper or a magazine first, before they read the caption or the headline. That is why publications such as *Time* or *Life* spend so much on good photography. If you have a print ad with one of your photographs in it, people will look at the picture first. That means you have gotten their attention. Your copy must then hold their attention and communicate your message.

TIMING: If you specialize in outdoor photography in northern Alberta, November is not the time to start a special promotion. May or June, just before the busy season, is the best time to start building interest in what you are doing. When going for high school seniors, it is imperative to promote before the official yearbook deadline and not after it.

The three primary motivators for having a family portrait taken are Christmas, Christmas, and Christmas. A good promotion in October for families is much more effective than one in January in most areas of the country. People really don't think Christmas

until it snows or until Thanksgiving. In Canada, Thanksgiving is on October 12, which left lots of promotion time to get families into the studio for Christmas gift giving. In the USA, most labs have their cutoff date right after the Thanksgiving holiday, making it very difficult to market to families with all of the other retailers. Many retailers generate 50 percent of their profit between Thanksgiving and Christmas; why not get on the bandwagon?

Very few studios do what is termed *institutional advertising*. This is a term for the "keep your name in the public eye without necessarily trying to sell them anything" approach used by some very large and prestigious companies. They are willing to pay not to sell you a specific product or service but just to keep their name in your mind. Most of the advertisers or sponsors on public broadcasting stations are of this nature, as they are not allowed to sell anything, yet they reach a very specific audience. Good studios do work to keep in the public eye as much as possible, but usually not through direct advertising in paid media.

Most products have some kind of season associated with them, and you must capitalize on the season in planning your promotion and advertising calendar. Bigger weddings tend to be in the warmer months, but they plan and book the main components involved six to nine months in advance, so November through February are good months to promote your wedding photography in media such as bridal fairs. Running an ad in June while the brides are walking down the aisle will do you little good. School work is seasonal, as is most portrait work. If you are in commercial photography, your clients have seasons. If your potential client needs a catalog of plumbing supplies, there is usually a certain time of year when plumbing companies traditionally come out with their new lines. You must be aware of these times if you are calling on a potential client. If you do a cold call a week after the catalog went to press, you have wasted a call. If you call just when they are starting to plan to produce the catalog, you have a much higher chance of getting the job.

POSITIONING: Not all products or services can claim to be the best. Not all consumers are necessarily looking for the best. Many companies use the large advertising budgets of their bigger, better known competitors to increase their own impact. The classic ad campaign is Avis Car Rental, which for years would advertise "We're #2, but we try harder!" They played off of Hertz's superior market position and profited by it. A brilliant campaign was run by 7-UP claiming that it was the "un-cola." The company used Coke's and Pepsi's powerful ad reach to springboard its product.

In studio photography, you can use the fact that you are newer, younger, more flexible, and more available than the established studios to attract more business. You do not have to say you are better or more professional or cheaper. Stress the differences and not the similarities. Most consumers dwell on the small differences between products rather than on their great similarities.

Media Review

Below is a list of various media or methods of promoting yourself and your business. I have tried to rate them for their effectiveness for a new photography studio.

PAID MEDIA	REACH	AIM	COST
TV, general	broad	general	high
TV, local cable	broad	local	moderate
Radio	broad	local	high/moderate
Newspaper, general	broad	general	high/moderate

PAID MEDIA	REACH	AIM	COST
Newspaper, local	broad	general	moderate
Newspaper, specialized	narrow	high	moderate
Magazines, local	broad	general	high/moderate
Display boards	small	general	high
Business directories	small	general	high
Yellow Pages	broad	general	high
Ad books	none	general	high
Outdoor display	broad	general	high/moderate

INDIRECT MEDIA	REACH	AIM	COST
Cross promotions	specific	specific	low
Direct mail	specific	specific	moderate
Direct display	local	specific	moderate

UNPAID MEDIA	REACH	AIM	COST
Direct presentation	specific	specific	low
Cold calling	specific	specific	low
Civic associations	narrow	specific	moderate
Professional associations	narrow	specific	moderate
Word of mouth	specific	specific	free

TV: The TV market today is broken up into the general-station and the cable-distribution networks. The cost of TV time will vary tremendously with the market being served. A minute in New York during prime time costs much more than a minute of time in Fairbanks, Alaska. Very few studios can afford or can benefit from general TV ads. Local cable distribution is another matter. Here the rates get more reasonable, and the reach is within your local market. TV works best for more established studios with a good client base who want to keep their name and image fresh. I would not recommend TV advertising for a new studio. However, if you can arrange a guest appearance on a local TV talk show, you will get tens of thousands of dollars in free publicity. Try to make yourself available and interesting to local talk shows. One of the reasons boudoir photography has taken off is that local TV shows pick up on it. It makes an interesting half-hour show for the viewers. The photographers chosen to display their work attract a lot of sittings from these appearances.

RADIO: Again, the larger the market, the more expensive the time. If you live in a smaller town, the local station is probably more significant if it is aimed at the right market. If the local station plays 1940s swing as a format, not too many teenagers are going to be listening. Be careful of the format and the mix of the station. A good rule of thumb offered by Jeff Slutsky in his book *Street Smart Marketing* is that you should choose the third most popular station in your market to get the best deal. He also suggests that when you try to make a deal for a package, give them a set figure you are willing to spend and haggle for more time for the money. If you have a set amount of time and haggle over the money, the salesperson will lose commission income and won't be motivated to help you. Setting the budget will encourage them to give you more for your dollar than the other approach. Slutsky's book includes many other helpful tips on dealing with media.

Another great idea is to tie your advertising in with a local on-air personality. If your community has a popular talk-show host, for example, contract for your ads to run on that program. Also request that the ad be read by the host instead of another voice. Do a complimentary sitting of the host so that he or she can get to know you. Do a great

job. Impress them. What will happen is that you will pay for a thirty- or sixty-second spot, and the host will read your copy and add to the copy from his or her personal experiences with you during the sitting—a great way to get extra miles out of your media money.

NEWSPAPERS: Most areas have one or two general papers that cover the entire market area. These generally are not a good investment for a new studio as they reach too far. You do not want to sell your wedding services to a bride one hundred miles away if there are enough brides within ten miles for you to sell to. If you live in an isolated community, then the general paper may be a good buy. If there is more than one good paper in a market, it will have split the advertising reach in half, but usually not the price.

Most markets have smaller newspapers aimed at more specific local areas or groups of people. In large cities, there are foreign language papers for ethnic communities. If you are part of that community, these papers are an ideal place for you to advertise. There are other newspapers aimed at the business community, the arts community, the golf community, as well as specific neighborhoods. In tourist areas, there are publications aimed at the tourists, which can be very effective. These smaller papers have a better aim, both in area and in demographics than the general newspaper, and are usually a better investment for a new studio.

In my particular market, I have one general paper, ten different weekly papers, and one paper that prints twenty different editions for each of the small towns on the Cape. The last one also mails the paper to each household for no charge, so you can be sure that every household in those specific towns gets the paper—a very good way of doing business from my point of view.

MAGAZINES: Here I am only concerned with local magazines. Very few photographers can make effective use of an ad in *Time* or *Life*. There are many local magazines. The problem is that they are usually monthly or semimonthly, which means that you have to be very careful about what you promote. The space is usually expensive, and you can't change your ad easily. Some of these magazines have a good reach and a good aim. An established studio can do better in these than a new studio, but they are not the best way to spend your advertising dollars. It is possible to trade photography for ad space with some of the magazines. This is a good way of doing business. On the Cape, we have *Cape Cod Bride* magazine. It would cost me $500 an issue for a quarter-page ad. Instead, I give the magazine photographs from my weddings and ask for a byline. I also write articles for the magazine, which gives me great name exposure at no cost. I get a lot of good leads from these small efforts.

If you want to service a specific market that has a magazine devoted to it, then that magazine may be the media for you. If your specialty is dog or horse photography, there are very specialized journals for breeders and owners of the various breeds. If you are into cars or bikes or whatever, and want to photograph these toys in your area, the specialized magazines may be a direct pipeline to your potential customers.

DISPLAY BOARDS: When you walk into the supermarket, there is usually a display board of some type with ads for local businesses. These displays are virtually a total waste of time and money for a photographer. Avoid them.

BUSINESS DIRECTORIES: For only a few hundred dollars, the purple pages directory will make sure your studio name is seen in every house in Smallville. Again—a total waste of money for a photographer.

YELLOW PAGES: Here I am referring to the real Yellow Pages, which are published in your local phone company's directory, which is given to every phone customer in your community. There are a lot of imitations out there and, in my personal opinion, they are a waste of money. The phone company has a unique monopoly. The real Yellow Pages

are used by many people to find services and products in a given area. It is essential for you to be in the Yellow Pages under Photographers. The question is how big an ad. Once you have committed to a Yellow Pages ad, you have to pay for it for twelve months. There is no changing it or taking it out. My advice is to go with a moderate-sized ad in your early days and plan on going smaller every year in the future. Use professional association logos in your ads to help build your image and try to keep the ad simple. If you are going into business, try to time your opening with the publication dates of the Yellow Pages. Check with your local phone company as to when these dates are. In my area, the ad copy has to be in by April 15 to be in the books which are delivered in late June.

AD BOOKS: Many local church groups, school groups, police and firefighter groups, civic groups, choral groups, and the like produce annual programs or directories. They will call you and solicit an ad. These are not ads; they are donations. If you wish to donate to the group, do so, but do not expect any advertising results. Limit your donations.

OUTDOOR DISPLAYS: These are usually in the form of billboards along the roadways. Billboards are effective in getting a product exposed to a lot of people who drive on the highways. They are effective in that many of those people will drive the same highway every work day, so you get frequency and high impact because of the size. Billboards are becoming an endangered species as many people in the public sector feel that they are visual pollution and work to get rid of them. They are effective, however, especially when located near your studio on well-traveled streets.

We used billboards one year in Canada and were very impressed with the attention and business it brought us. The billboard company found a Kodak-produced color photographic portrait (10 × 8 feet) that we could use with our message, so the boards looked very professional. When the boards went up, we got calls from old customers congratulating us on our success. We were in the same league with the big national advertisers, and they thought that this meant we were doing very well. People who were not our customers also gained a new respect and knowledge of our business from this display. We got our money's worth.

CROSS-PROMOTIONS: In cross-promotions you tie your business advertising into the distribution of another business's or organization's material. For example, you produce a handout piece that the local McDonald's will give to every customer who buys a burger during a special period of time, offering a discount on your sitting fee for a senior or family portrait. The beauty of cross-promotions is that the production cost is only the cost of printing up the pieces to hand out and that both businesses benefit from the promotion. The McDonald's in this case gives its customer an added-value coupon to enhance the value of its product. From your point of view, you had to pay next to nothing to distribute your advertising messages. Cross-promotions are a very powerful and inexpensive form of promotion, especially for a new business.

The important point to consider is the potential clientele of a cross-promo partner. If you are going into boudoir or glamour portraiture, lingerie shops and beauty salons are a natural place to seek clients. If you are seeking teens for senior photography, solicit the businesses they frequent. Make your offer advantageous to the other business. Use their reputation and drawing power to distribute your material for free. You will also gain stature by association with another successful business.

Another area where you can get good results is to cross-promote with a charity or nonprofit organization. For example, when the Girl Scouts are out selling their cookies, they could also hand out a discount coupon from your studio. I recently saw a good cross-promotion from a chain of pizza stores. The coupon came in the Salvation Army's envelope, which I opened and read. Papa Gino's would discount each pizza you bought by $1, plus give $1 to the Salvation Army during the month of November. The pizza

chain gets both new customers and a good public image by supporting a worthy cause, all at minimum distribution cost.

Dave Newman of Salt Lake City tried this cross promotion. A local high school team was trying to raise money to go to Europe. They asked for a donation. Instead of giving them cash, Dave gave them coupons worth $25 for a special sitting at the slow time of year. The girls could keep the entire $25. Net result was they went out and sold a ton of coupons door to door. Dave got a lot of clients and made his profit on the reprints. I tried this idea with the parent groups of the schools I do the undergraduate photography for. They sold one hundred coupons in two weeks. I did very well on the reprint sales, and they think I am wonderful for "giving" them $2,500.

DIRECT MAIL: Direct mail is mailing your message to the potential client in his/her home or office. Look at your mail next week and see how many direct-mail pieces you get. If you direct mail, your piece has to compete with all of that other stuff in the mailbox. I have days when I go directly from the mailbox to the garbage can and dump 75 percent of what I just got without even opening the envelopes. The trick to direct mailing is first to get your piece looked at, and then to communicate your message. The four keys to a good direct-mail campaign are a good piece, a good list, good timing, and frequency.

Another key to a good direct-mail campaign is a good mailing list. If you want to get the local high school seniors into your studio, it is great if you can get your hands on the school list. This is a very specific group of people that are ready and willing to receive your promotional pieces. Where do you get lists? You can make your own list, which can be a lot of work; you can buy a list from companies that sell them, which can be moderately expensive and not totally accurate; or you can try a general mailing to a given area, which also can be very expensive. If you know that your best potential clients live in certain neighborhoods, there are directories, available in your local library, which list addresses by street rather than alphabetically. Using a personal computer, you can enter the lists and generate your own labels easily. You can create a mailing piece at a local printer or invest in a full-color piece.

Direct mail is one of the best media for photographers, especially in the commercial, senior, and wedding business. Here you are dealing with specific markets with specific names and addresses. You get your message directly to the people ready to receive it. Marathon Press has developed a wonderful collection of color postcards that you can put your own photographs on for a very reasonable fee. (See chapter 12.) Postcards make effective mailing pieces because they are colorful and easy to read. Don Feltner has many wonderful ideas and pieces for high school senior mailings which he will sell you at a reasonable cost. (See chapter 12.) For an established studio, the best mailing list is your customer list. You should mail to your past clients twice a year to keep your name in their minds and generate repeat business and word-of-mouth referrals. Even if a client has only recently used your services, he or she can pass along any promotions you send to friends and relatives. Former clients are your best sales force if you keep them stirred up and interested.

DIRECT DISPLAY: I will admit to a strong bias; this is my favorite marketing scheme. I have built my business around the use of direct display and have found it to be the most cost-effective media in the arsenal listed here. Direct display is displaying your photographs in public. Displays can be in a trade show, a bridal fair, a craft fair, a shopping mall, in a public lobby of a hotel, bank, airport, public building, art gallery, almost anywhere. It means showing what you actually do, which is to create large, beautiful, color wall photographs in nice frames, where people can see them. A newspaper ad does not do justice to a 30 × 40 canvas portrait of a family on the beach. A 24 × 30 of a loving

wedding couple against the sunset will wow the majority of people who see it in person. A potential bridal customer can get a better idea of your value if she looks at your sample album rather than at your ad in the Yellow Pages. Photographers sell color photographs, preferably large color photographs. When you can show people what you sell, this product will help sell itself.

The key to good direct-sales marketing is getting into the places where the best potential clients will be. This requires some beating of the bushes to get the lobbies and the malls to allow you in, and it requires some investment in large sample prints in good frames, and the mounting and hanging supplies needed to create a professional display. Direct display also requires a lot of personal involvement and time in manning booths or displays. Your presence is actually a plus because, in addition to selling large color photographs, we are in the business of selling our personalities, especially in the portrait and wedding business, and to some extent in the commercial business.

Jim Rawlinson of Plymouth, Michigan, told this story. Jim started in wedding photography like most of the people reading this book. Eventually, he quit his "real" job and went full time into photography. He relates how little response he got for his initial efforts: no phone calls and no bookings. One day he got fed up and could only think of one thing to do. He took his one and only 16 × 20 wedding sample, put it under his arm, and spent the afternoon walking around the local shopping mall. During that afternoon many people came up and said, "That's a beautiful photograph! Who took it?" He replied, "I did." From that afternoon at the mall he booked a wedding and got two more wedding interviews. This approach was far more productive than sitting in an office waiting for the phone to ring. You will generate very little business by sitting in your studio doing nothing. Get out of your studio and go find the work.

DIRECT PRESENTATION: This is where you are invited (or you have gotten yourself invited through suggestion) to present a program to a group of people on some area of photography. It may be a direct-sales presentation of a commercial photography idea to a board of directors, or it could be a lecture on the history of photography and the care and preservation of old photographs to a retired citizens group. It may be a travel program on your latest vacation, or a talk on the best way to take pictures with your automatic camera. Remember, that you are selling your personality and your skill as a photographer. While you may not be selling your products directly, the audience is forming an opinion of you as a person and as a professional. They are all potential customers. Direct presentations are usually an inexpensive but time-consuming marketing approach. It is very a good media for newer studios to increase their community exposure.

COLD CALLING: Cold calling is walking into a potential client's office or home and asking for business. It is what the old door-to-door salesman did, and it works. Many times you will get the door slammed in your face. However, many times you will actually get a new client. When you have only a very limited number of potential clients, such as a small town commercial market, you must call on all of the potential clients. Even a portrait/wedding studio should go out and hit the bricks if there are no phone calls coming in. Most photographers are repelled by the thought of cold calling, and it costs them business. See some of the ideas on cold-calling techniques detailed below. For many areas of photography, cold calling is the only effective marketing tool. All others are a waste of money. This is especially true when you are new. That's the bad news. The good news is that cold calling works and will get you jobs to pay your bills.

CIVIC ASSOCIATIONS: Many speakers will recommend that you join various civic and service associations to help promote your new business. This can work in the sense that you will get to know a lot of people (usually from the business community) quickly, and

you will establish a network of contacts in your community which helps establish your reputation. The problem is that these worthwhile groups require a lot of your time and some money to remain a member in good standing. If you are a bad member, you will get negative word of mouth for your half-hearted effort. Only join those groups which you can personally support with your whole-hearted effort. These groups could be church related, civic groups, service clubs, youth programs, etc. Follow your interests, but be a professional in all respects.

PROFESSIONAL ASSOCIATIONS: In groups like the PPAs and your local chamber of commerce or other business groups, you can work for the betterment of your business community, and, in the long run, you will gain respect and business from other members in your local community. In the PPAs, you will gain knowledge and self-respect. Again, be professional and devote sincere efforts to bettering your community.

WORD OF MOUTH: If you ask established studios where they get most of their wedding referrals, they will say, nine times out of ten, word of mouth. A good reputation is something you earn. With time and good work you will get it. You can speed up its growth by direct advertising, community involvement, and personal contacts in your community, but it is usually not something you can specifically focus on developing other than by never letting an unsatisfied customer leave your studio. A wealthy and well-loved older businessman once told me in my early days in business: "A job well done will generate a new customer. An unhappy customer will lose you six jobs." That advice has been a credo of my business life and one which I hope you'd adopt in yours.

Where to Spend Your Initial Promotional Dollars?

The exposure of your studio name is more important in the long run than the sale of specific products in the short term. The tendency for a new studio is to spend a lot of their start-up money on newspaper or radio/TV advertising doing specific product campaigns, often with results that do not even cover the cost of the advertising, never mind overhead, materials, or profit. Don't. It is simply too expensive to help most new studios attract customers. I want you to spend those promotional dollars on large samples for direct display, on acquiring rental spaces for commercial direct display (such as a bridal fair or a home show), on direct mail in areas where you can get a good mailing list, and on good brochures and promotional pieces. The only exceptions are in a single media town where one ad will reach most of the marketplace. Otherwise, you may as well stand on the corner of Main Street and throw your money up into the air.

Some Basic Rules of Marketing and Promotion

There are two basic types of marketing approaches, sales driven and market driven. A sales-driven approach stresses the price of the product. Supermarkets stress price to attract you. They all sell essentially the same products, and the only way to attract you to their store is to offer you a better price. In a market-driven approach, you promote what you know (or feel) the consumer wants or needs (or you create a need). There are many people to whom price is not the most important aspect of a particular product. A gourmet food shop sells food, just like the supermarkets, but they market quality, variety, uniqueness, flavor, haute cuisine, etc. They never advertise price as a major factor in consumer consideration unless the price is the highest possible for a particular item, to increase its appeal to customers for whom price is not a consideration.

Which approach is best for a photography studio? Unless you can offer packages cheaper and better than Sears, Kmart, or Olin Mills, you cannot underprice the compe-

tition. You must out-market them. The major point to remember is that all consumers do not want the cheapest. Most people want something that is better than the cheapest, while others want to know that what they buy is the best possible product, regardless of price. This is why you can go into a jewelry store and see a $29.95 Timex watch in the display case next to a $3,500 Rolex. To different people they are the watch of choice and worth every cent. Yet, in fact, they both tell time fairly accurately, and functionally they are the same. The other factor in the business world is that you will probably sell one thousand Timex watches for every Rolex. Most businesses are more dependent on the low end of the pricing scale unless they are skillful enough to only attract the Rolex lovers to their store. That is the key to marketing.

You must realize that you are not selling pieces of paper with images on them. That is what Sears and Kmart are doing. You must market your quality, service, personal involvement, availability, flexibility, skill, and material differences, and then produce a product worthy of the difference in price that you must charge to make a good living in photography.

Lilley's Laws of Advertising and Promotion

(1) In all of your marketing efforts, your studio name is what you must ingrain into the consumer's mind in your market area. It must be the most prominent part of all your advertising or promotions. When they think photography, your name should follow in their mind.

(2) Remember, you have a sale when the price equals the value. Don't promote price as the only factor. Promote the value of yourself and the concept of your photography as something valuable in the client's life.

(3) In a one-newspaper market area, people read the ads if they are big enough. In markets served by more than one newspaper, your reach is diminished, but not your cost. Radio stations have had their markets fragmented by the proliferation of FM stations. Most areas have too many stations to be cost effective in reaching your target market. Even in a small town, a lot of people tune into the big-city stations. Cable has totally fractured the local TV advertising market. With twenty or thirty channels to choose from, how many people will be watching a specific channel when your advertising comes on? Remember, do not take the audience figures the stations present at face value. They are usually derived by dividing the total population of an area by the measured market share, i.e., they assume everyone listens to the radio or TV all the time. This is obviously false.

(4) A news article about you in a local newspaper is worth $1,000 in paid advertising. Every time you do anything of note, make sure you send press releases to the local media. Write the news release exactly as you would like to see it in print. Many small papers don't edit releases unless they are poorly written, and will run them exactly as you write them as long as they are not too self-serving. Sometimes you can get an interview/article on your new business included if you purchase an advertising package from a newspaper. These articles are worth a fortune in exposure. Most smaller papers have some kind of New Business column, and people read them.

(5) Ads in service-club programs and/or directories are not ads, they are donations and should be treated as such. If you wish to support a given organization with your money, do so, but do not expect any return to your business from these types of ads. The easiest way to escape feeling guilty about not donating to a good cause is to set a budget each year for donations. When it is used up, say so and believe it. The first few years this budget should be modest and should be aimed at areas you are involved with personally or professionally.

Donating sittings or scenic prints to an auction by a charitable organization can produce a lot of good name exposure. As long as your name gets mentioned in front of a lot of people in connection with photography, it can be worthwhile. Check on how many people will be attending the auction, and if there is pre-auction advertising. One of my best promotions was the local Rotary Club Auction, which ran for two nights on all of our local radio stations as a simulcast. If the donation was big enough, they mentioned the name of the business over one hundred times in the two nights. Not a bad deal!

(6) Do not join a civic organization or a service club with the idea that you are going to get business out of your membership. At least one speaker on the lecture circuit promotes this as a good way to establish a name in a community. I tried it and found out that these groups are full of other businesspeople waiting to pounce on you. I think I had twenty insurance salesmen knocking on my door calling me Brother Ed and wasting my time selling me their wares. Do not join fine groups like Rotary, Kiwanas, Lions, or your chamber of commerce unless you personally believe in the goals and purposes of these organizations. Do not be false in your intent. For the most part, these groups are service oriented and take a lot of time and effort on the part of a good member. If you can't be a good member, don't join. It will make you look unprofessional to a group of mostly professional people.

(7) Business cards: Joe Girard, "the world's greatest salesman," passes on this bit of knowledge. Never stop saying "Hi!, I'm Joe Smith, and I have a photography studio on Main Street." Say this to everyone you meet; to your barber or hairdresser, to the person pumping gas at the service station, to the checkout person at the supermarket, to the person you sit next to at the movies or are standing behind in line at the bank. Give them your business card. Joe says that he would go through five hundred business cards a week! Everyone he met knew he sold cars. Some salesmen wouldn't use five hundred cards a year. Give them out with enthusiasm. They don't do any good sitting in your drawer.

(8) Bulletin boards, phone-book covers, local directories, etc., are of little value to a new studio. They are profit makers for the producers, not for the advertisers.

(9) Yellow Pages are a necessary evil when you are getting established. The ads do attract uneducated consumers calls, from which you must mine your good 20 percent. In the wedding business, a typical Yellow Page call is "How much?" Later, when you have established a reputation and you are drawing on word-of-mouth advertising, the first question is usually, "Are you available?" Yellow Page ads are expensive, and once you have committed, you must pay for a whole year. In my semirural area, a quarter-page costs over $300 per month. In my area, I also have to be in two different Yellow Pages to fully cover my market. If you live in a larger community, the cost goes up proportionally.

Keep your Yellow Page ads simple. Do not claim to be able to do every type of photography under the sun or claim to be the "best." Sell your name, location, and let the people phone for the details of your skills and abilities. People don't read the verbiage in Yellow Page ads; they do react to photographs. If your book can reproduce photographs well, run one. When you are new, choose a larger size. In each successive year, plan on scaling down the size of the ad as your reputation grows. Don't buy red! Studies have shown that it actually decreases the number of callers to those businesses that pay extra for the color.

(10) Learn proper phone techniques. The phone is your lifeline to customers, so learn how to use it properly. It is amazing how some simple techniques can transform the phone into one of you most powerful sales tools. Don't leave the phone to chance.

Proven Promotions for a New Studio

Some of the best promotions for a new studio are relatively cheap (in terms of cash).

Become the photographer for a small local paper, preferably one that is distributed free to your market area. Exchange photography services for advertising space and articles about you and your studio. This approach means a lot of work, but the exposure is great. Not only do you get free ads, but you also get assignments to photograph local celebrities, craftspeople, and businesspeople for the paper's articles and ads. All of these people are potential customers. Do a good job. Make sure the clients know your name, and that you are an independent person working under contract for the newspaper. Write a photo advice column for your local paper, or teach a course at the local evening school. Get your name associated with photography in your area.

Display photographs anywhere you can. Constantly look for public places where you can display big color prints—scenics, creative portraits, special effects, family portraits, anything that is good. Some ideas about places to solicit for displaying your photographs: (1) Doctors' offices. GPs or clinics with a large business in young families. Not much good in a geriatric clinic. The new small walk-in clinics have a lot of empty blank walls to fill up. Make sure your name is prominent on all displayed prints and that you have model releases from all the people in the photographs. (2) Restaurants. Again, look for family business. Try a McDonald's or Burger King with an Employee of the Month, or a Senior of the Month promotion, which can be mutually beneficial.(3) Bank lobbies. A display of scenics or local personalities. Try a Clergy of Smallville, or Business Leaders of Smithtown promotion.(4) Theater lobbies. (5) Hospital waiting rooms. (6) Hotel lobbies or any public buildings. (7) The post office lobby. (8) The local airport or transportation center. (9) The local tourist information center or chamber of commerce office. (10) Bridal and tux shops or other businesses with a mutual interest in weddings, families, fashion, or other areas. (11) Beauty shops and hair salons attract woman, who are the prime buyers of family photography.

Anywhere you see a blank wall that is in the public eye, see if you can fill it up with a photograph. One famous big-city photographer keeps his eye open for empty stores in his downtown area. When he sees one, he contacts the owner and offers to decorate the empty window for free until the store is rented. He argues that the empty window detracts and that a handsome display of photographs will increase the value of the store to a potential renter! He gets prime locations for his displays for free.

Artist/craftspeople copy day is another good promotion. Most areas have a number of local artists/craftspeople who need photographs for publicity and promotional pieces. These people usually have small budgets, are not really professional, and are not able (nor do they need) high-quality photography. Set up a specific day (or days) when they can bring their work into the studio for either black-and-white shots, or for color slides. Offer the prints or slides at a very cheap rate. Don't try to make money, just to meet costs. Keep the time you spend on these copies to a minimum and do not try creative photography, just good, clean, basic copies. These people are the artists in the local community. By associating with them, you become one of their community. They can be a source of a lot of portrait and good creative commercial jobs at a later date.

Craft fairs are magnets for middle-class consumers looking for cheap art on weekends. A display booth in most areas is usually very reasonable ($75 to $150 for two days) and craft shows draw tens of thousands of people, if well advertised. Getting into an established craft show may take some time, as there is usually a waiting list. These people can be fussy about who they let in, which is good, because they keep out the hucksters and poor products. The usual requirement is that everything you sell or display must be

your own product. We started in craft shows by selling scenic photographs and displaying some portrait work. We found that selling the scenics interfered with the portrait display. We currently only display our portrait work in our craft-fair booths, with both short- and long-term benefits. You get to meet a lot of good prospective portrait clients at these affairs. Many malls are now running their own shows, for which they charge you a relatively high booth rent. They are usually worth the cost if the foot traffic is there.

Create your own show! We have also gone to a mall as a local professional photographers' association and organized our own show featuring all of the local studios. It didn't cost us much, and the exposure was wonderful. An individual studio has a small chance of getting into a big mall, but a group show has a much better chance. (See the section on local PPA organizations.)

Become the photographer for a beauty pageant or other major community event. You probably will not make much money on the sale of the photographs, but you can get good name exposure in local malls, banks, and other public spots with displays of work from the pageant or festival. Insist that the organizers make arrangements to get you into these places. The benefits are community exposure and getting to know the people running the pageants. Often they are community leaders and will help spread your name. I have been associated in the past with the America's Junior Miss, Massachusetts State Program. It was a very valuable business builder for me. We made enough money on the sale of photographs to meet costs, and since the pageant took place in January, a normally slow period, we could afford to spend the time. The jobs we got from other workers in the early days were worth thousands to us. Don't get involved in commercially sponsored pageants. They don't get the local media coverage since many of them are scams to make money for the sponsors. Approach only legitimate pageants.

Community service can also be a worthwhile promotional venue. If a local nonprofit group calls up looking for photographs, offer to do them for a very good rate (a nuisance fee) in return for recognition. Again, look for display walls to hang your work in the group's meeting areas. Give talks to camera clubs. Amateur photographers are always being asked by friends to "do our wedding." Most of the smart ones won't touch a wedding with a ten-foot pole, but will pass on your name as "the new pro on the block" to friends. This is a good source of early wedding and portrait business, if you can impress them with your skills, knowledge, and personality. Remember that your skills are probably superior (I hope so), and that they look up to you. Don't get a fat head, and don't talk down either. Some of the club members may be better photographers than you.

Teach a photography course at your studio. For a modest fee, give a four- or five-week course in the evening. This gets people into your studio, and they become your sales force to the general public. Don't hold back. They are not going to steal any secrets from you. Charge a fee that will just meet your costs and expenses. You can also have a series of both educational and entertaining slide shows prepared, and make yourself available to local groups for social-hour entertainment. You can do shows on your travels, local scenic areas, on how to take better photographs (for a strictly amateur audience), or on some area that interests you. Make the evening fun and professional, and sell yourself as a professional in a very soft manner. Always have your business cards and brochures ready.

Lecture on copy and restoration. Prepare some talks (with or without slides) that you can give. There are usually local genealogical associations that are interested in old photographs and restoration. If you are aiming for the copy and restoration market, it is a good way of selling yourself. Include a History of Photography section where you explain the evolution of photographic techniques and how this can be used to date old photographs. Most people don't know the real difference between a tintype and a wet plate—study your photographic history.

Sponsor a photo contest/judge photo contests. Sponsor a contest for local photographers. Have classes for all age groups, as well as for novice and advanced photographers. Try to tie in the contest with some other local activity, such as a festival week or other annual celebration in your community. Supply some cash prizes and lots of fancy ribbons. See if you can cosponsor with a local camera store or a color lab.

Don't forget cross-promotions with other businesses. Gary Silber wanted to attract a very well-to-do clientele to his new studio. He offered a complimentary sitting given by other businesspeople in his community when someone bought an expensive item, such as a fur coat or a fancy automobile. The sitting was not free, in that the person had to pay out many thousands of dollars. It was a true, complimentary sitting, which included no prints, only the photography.

Other potential commercial cross-promotion partners would be engagement sittings for a bridal shop, young adults with new automobiles, families who have just purchased expensive homes from a local real estate agent, makeovers with a beauty shop, etc. The beauty of cross-promotions is that the cost of distributing your information to a group of potential clients is very small (the cost of printing the coupons or flyers). The other beauty is that you can control the aim and area of the cross-promotion. Geographically, you don't want to cross-promote with a firm next door, but with one across town.

Speculative sittings are when you ask prominent members of your community to come in for a free sitting, in return for being able to use their portrait in your displays. Ask people who can help you in other areas of your business, such as clergy for wedding referrals, school personalities for the school business, and the head of the local chamber of commerce for the business community. Don't be too generous with free sittings; they do help get your foot in many doors. Do sittings where the proceeds of the initial sale go to a well-recognized charity. This may enable you to get exposure on expensive media, such as TV and radio, at no cost. See if you can get on a local talk show to explain how this promotion will benefit the charity (not you). The more well known the group, the better your chance of getting the free publicity that will help you get your name established in your community.

Special!

What is the difference between a promotion and a sale? Pick up the Sunday paper and somewhere among the flyers you'll find some news articles. Every Sunday Kmart, Sears, Woolworth's, etc., have a special or sale. Observe them carefully. Some weeks there are no sale prices. Other weeks there are discounts, limited offers, or extra-low prices. Observe the technique. A special does not necessarily discount merchandise. People react to *Special* in the same way as they do to *Sale, Bargain,* or *Discount.* No one would read your ad if you said *Promotion* at the head of the ad.

In creating any promotion, use the following rules: (1) Sell what you want, not what the customer wants. (2) Set the price high enough to avoid the worst of the bargain hunters, but low enough to appeal to the uneducated consumer. (3) Keep it simple. Do not confuse the uneducated consumer. (4) Make it a complete product. Don't bait and switch. (5) Don't give away photographs. Give frames, sittings, or something else. (6) Key the promotion to some other event for added value: Valentine's Day, Mother's Day, graduation, engagement, anniversary, and the like.

Wah Lui of Seattle has a permanent special. When anyone phones up to inquire about a sitting, he will always say, "We've got a special on now, a sitting and the first 8 × 10 for only $39.95!" It is his Mother's Day Special, Valentine's Day Special, Christmas Special, or any-other-reason-you-can-think-of special.

Our most successful promotion since coming to New England has been our Family Summer Special. We created a package plan for large family prints, a plan consisting of the sitting, a large portrait (16 × 20 or larger), and a wood frame. I price the package from my regular price list and add the frame as a bonus to create the special package price. This special is not cheap, i.e., it costs a reasonable amount of money up front, so we don't get many bargain hunters. However, it is still a special, and we do attract the un-educated consumer who really wants our product once they have seen our large display prints. We force the big print idea by not allowing substitutions of smaller sizes on the special. As a result, we get a good average reorder from the smaller prints for the rest of the relatives.

Selling and Wealthophobia

Selling, oh what a fearful word! The most common phobia in the world is fear of public speaking. I think the second is fear of selling, especially when you are selling yourself. I'll call it *sellophopia,* or *wealthophobia,* because it is also the fear of becoming wealthy, or even reasonably well off. Like most phobias, you can overcome the fear of selling. You can do it yourself, slowly and painfully, or seek professional help and learn from others. Selling is a skill, much like your photographic skills. There are people who learn more quickly than others, and some people with more inherent ability than others, but any-one can learn to sell well if he or she can overcome his or her fears and practice his or her skills. "You must do what you fear most, otherwise you will never overcome your fears, and they will control your life," says Tom Hopkins.

Selling is a set of basic skills that must be learned and mastered before any results can be expected. All the talent and technical skill in the world will not do you any financial good unless you can sell it to someone and get paid for your time and talent. In photog-raphy, talent in the technical aspects of our craft is about third or fourth on the list of important skills one needs to succeed. Many new photographers get a false sense of their own value when they see the works of successful studios that are not that good in a tech-nical or creative sense. The new photographer will say to himself or herself "I can do bet-ter than that!" and think that being better is a semiautomatic guarantee for success. How wrong! What you do not see in the mediocre studios is the ability of the owner/staff to sell what they produce. There are more successful average photographers than success-ful brilliant ones in this world. The average photographers took the time to learn how to sell what little they had, and the bright ones withered on the vine because they did not know how to sell. To quote Tom Hopkins again, "So stop excusing yourself from the hard work of learning how to be competent in your sales career. It doesn't matter whether you think you're a wonder or a nonwonder, you still have to pay the learning price."

What Is Selling?

Ethical selling is not using tricks to make people buy something that they neither need nor can afford. Selling is not painting word pictures to dupe people into buying junk. There are hucksters and charlatans in the world willing to fleece the public for every penny it has. However, most people in the selling business are honest and ethical. In fact, if the merchant class of the Middle Ages had not sold the world on the pleasures of silks, spices, and other worldly treasures, we would be doing our photography in some mud hut in Europe with a quill pen by firelight. The salesmen of the Middle Ages opened up the trade routes and these helped to open up peoples' awareness of themselves and the world around them.

Selling is making clients aware of how much better off their lives would be with your product and services. Selling is helping clients make rational buying decisions based on the potential value the sales item could have for them. If you believe your talent and ability can enrich your fellow humans' lives, then you had better be prepared to convince them of your belief. If you do not believe in your own value, then you are a charlatan, and you should go to work in a factory. If you believe you have a real value, that what you do has a positive influence on other people's lives, that you deserve to be paid a good wage for your efforts and talent, then you must learn how to sell.

Selling is often broken down into tangibles and intangibles. A car, house, or any specific product is a tangible item; something real. Life insurance, stocks and bonds, or investments are intangibles. They are ideas and hopes to be fulfilled at some future date. Selling intangibles is much more difficult than selling tangibles, and the salesmen of intangibles usually get paid more than the salesmen of tangibles. Selling photographs, especially portraits, crosses the line between tangible and intangible. You will be selling a physical item, the print, but what you are really selling is a future memory, a future image of the client at the present time. Twenty years from now, an individual's memory will be the image that you created. Most forty- or fifty-year-old people's image of their physical appearance is based on their high school senior portrait or their wedding portrait.

My mother and father were married in 1929. My father was forty-four when I was born, and he died when I was fourteen. I knew him as an overweight, older man. My mother contracted polio as a child and walked with a severe limp and was also overweight. As I grow older, my memory of my parents is becoming their wedding photograph, which has been beautifully restored and hangs in our home in a prominent place. My children's image of their paternal grandparents, whom they never met, is this vision of youthful health and vigor that the photograph represents. Would I sell that photograph to you for any price? Not on your life.

I once heard a hard-line sales pitch that has a ring of truth to it. If a bride's mother is complaining about price (i.e., she does not think your photographs have any value), offer to give her a $100 trade-in on her wedding photographs (assuming she is not divorced). Not too many women will take up the offer. *The One Minute $ales Person*, by Spencer Johnson, M.D., and Larry Wilson, is one book on selling that you should read. It is only about one hundred pages and can be read in a very short time. It contains some nuggets of knowledge that can make selling a nice occupation for you, and earn you a lot of money. The basic premise of the book is "I will have more fun and enjoy more financial success when I stop trying to get what I want and start helping other people get what they want." This simple sounding concept is the key to effective, ethical selling. The book goes into many other aspects of this low-key and nonstressful approach to selling. I strongly recommend you buy and read this book, which is usually sold with its own audiotape, so you don't even have to read it!

Another master teacher of selling technique is Zig Zigler. He has developed his own version of this philosophy which he says is the basis of good selling. Zig says, "You can have everything in life you want if you will just help enough other people get what they want!" Tom Hopkins expands on this idea (in chapter four of *How to Master the Art of Selling*) Tom stresses, "Don't sell what you want, sell what they want." But, you ask, how can I sell them my product? Tom says, "Neatly. People want more than they can get." Use your professional expertise to show them what is best for them in emotional and lifestyle terms, not in dollars and cents. Demonstrate how your photography will enhance their lives.

The Six Steps of Selling

There are six simple steps to selling a product or service. You have to learn to do them efficiently, if you are going to be successful. They may be simple to express, but they may not necessarily be easy to perform. They are: (1) prospecting or marketing, (2) making contact or the call, (3) qualification and/or credit check, (4) the presentation (or pitch), (5) handling objections, and (6) closing the sale.

PROSPECTING: This word brings to mind an image of some grizzly western character with a burro in the harsh wilderness looking for the lost gold mine of the Incas. It is not a bad image. The harsh wilderness is your marketplace, the burro is your studio, and the lost gold mine is that particular client who cannot wait to give you money for doing what you love to do best; take photographs. The trick is to find the real gold mine with the least amount of searching!

Prospecting takes many forms. I like the terms *marketing* and *promoting*. These are your efforts to reach out and find potential clients who need your services. The techniques differ for different types of businesses, but the practice of constantly looking for new clients is one of the hallmarks of a successful business. Even when you are so busy that you can't conceive of looking for new business, you must be thinking six months down the road when you may not be so busy.

Almost all new businesses run into a little brick wall about six to twelve months after they start. Most new businesses start with a lot of energy and little work. They go out and get the work. They get enough work to keep busy working all day, and they don't dedicate any extra energy to getting more work. Most new businesses have a false impression that work produces more work automatically. There is a relationship, but it is not an automatic one. All of a sudden, after two or three busy months the work slows down (as well as the cash flow). They have to start all over again. Achieving and keeping a reasonably steady flow of work is essential for a successful business and very important in keeping your business life in order. Peaks and valleys wreak havoc on your nervous system as well as on your bank account.

MAKING CONTACT: Once you have created potential clients, through advertising or other promotions, you must make contact with them, either in person, on the phone, or through written communications. Once you have made contact, you switch from marketing to selling techniques. You must start selling as soon as you pick up the phone or greet the customer. See each specialty section for specific ideas on making contact with clients. Remember that the initial contact is to establish need and value. Most contacts have a need and want a price. You must always work on the value before setting the price.

QUALIFICATION: A lot of salespeople waste their time talking to people who really can't make the important decision to buy, or who simply cannot afford the product. In the wedding business, you do not want to waste time talking to a potential bride if your minimum is $1,000 and her maximum budget is $500. You may "sell" her, but she can't pay! It is often a waste of time to talk to a bride when the decision will be made by the mother of the bride. Often you have to repeat your whole sales presentation when the other party comes back for an interview.

You might also be unable to fulfill the specific requirements of a client, and you should not waste their time or yours. If a commercial job technically requires an 8 × 10 original and you do not own or have access to an 8 × 10 camera, don't try to sell them on something they don't need. If a job requires you to jump out of an airplane and you are not willing to, end the conversation. It does you no good to sell the boss's secretary on a commercial job if the boss will make an independent choice. You must seek out and find the true decision-maker, before you start selling your services.

Qualification may involve some intuitive sense that you and the potential client might not get along. You may get some very negative vibes about a potential bride's personality and tastes, or from a commercial client's seemingly impossible demands. You may not wish to book the wedding or do the commercial shoot in the above cases. Then you must stop selling and start backing out of those types of jobs. Unfortunately, you only develop this intuitive sense with experience; often after getting burned a number of times. Welcome to the school of hard knocks.

Qualification, especially in commercial photography, also involves some credit checking. If clients have a history of not paying their bills or taking a very long time to pay, you may not want to do business with them. Proper credit checks should be done through your banker if the amount of the bill will be very large and you must extend a lot of expense money before getting paid. Other credit information can be obtained through the local grapevine, including your chamber of commerce or local service clubs. Good relationships with other photographers in your area also help to avoid some of the worst of the bad credit risks, but some care is always required when granting extensive credit.

Ask your banker for advice on how to extend credit. He or she knows what should and can be done to protect yourself. No credit granting system is foolproof, but there are pitfalls a novice can learn to avoid. Don't be afraid to seek professional help in areas where you lack experience and expertise. You have to remember that giving credit is a gamble on your part which might result in a job that you would not have gotten otherwise. Sometimes taking a risk in the short run will pay in the long run. Just be aware of the risks and the potential rewards, before you stick your neck out too far.

THE PRESENTATION: Once you have the qualified client in the studio, you have to determine his or her needs by asking questions and listening. Once you understand his or her needs, you must present your products and services in such a manner as to fill those needs. A good sales presentation requires a physical place and equipment. You must have your presentation area organized so that your sales materials and any technical reference materials are easily available to show to the client. This includes price lists, policy statements concerning your work, and samples of past work. Since we deal in a visual product, you should have the appropriate sample photographs readily available to show the client.

The physical environment of the sales presentation is very important. It is best to be in an area where you will not be disturbed during your presentation, so you can concentrate on the client. There is nothing more bothersome than being waited on by a person who constantly interrupts you to talk to other customers or answer the phone and wait on other phone clients (my personal pet peeve). Your presentation area should have good lighting for your photography and should be designed to make the client feel comfortable. Presentations will vary with the nature of your studio and the type of clients you are dealing with, but the principle is to make them comfortable so that they will concentrate on your photography and what you are saying.

If you use technical devices to aide you in your presentation, such as slide projectors or video recordings, make sure that they are working properly and that you are familiar with their controls. It is very distracting to prepare a customer for a slide presentation and realize that the slide trays are in another room. You will look like a fool, and the time you take to get the trays and fix them up will detract from your presentation. Be prepared, when you go into a sales room, to work smoothly and efficiently. Don't waste time, motion, or words!

HANDLING OBJECTIONS: The easiest sale is when a client say yes on the first presentation. That's it! Sign them up. More often the client responds, "Yes, but . . . ," or, "Well, I don't know, what about . . . ?" These are objections—reasons why they won't say yes to

a sales presentation. Some objections may be simple technical questions like, "Do we have to use those lights at the wedding?" or "Can I return it if I don't like it?" To these you provide the appropriate answer. The tougher objections are "Well, I'm not sure," and "Well, I'll have to ask my husband." Many times these are smokescreens to cover up the person's real objections. The most common objection is price, but seldom will a client come out and say that directly. People will say things like, "Well, I don't like blue, therefore I don't want to buy your product," when they really mean, "$100 is too much for me to pay for your product." The key to handling objections is to find the real objection so that you can either explain that the product you are selling does fit his or her needs or that the price equals the value of the product. Finding the real objection involves asking questions to help the client admit the problem, to himself or herself, as well as to you.

There are specific training courses to teach you how to respond to any level of objection for any reason, from friendly customers to clients who don't even want to talk to you and are taking out their fear by being hostile. There are also numerous tapes available for you to listen to while you are working in the darkroom so that even while you are doing the drudge work in the studio, you can be honing your selling skills. See chapter 12 for books by Helen Boursier on selling in a photography studio. She details many objections that you will hear, and suggests appropriate answers that you may wish to learn and incorporate into your sales technique.

Here are the steps you should take in order to handle objections. (1) Hear the customer out. Many times the initial few words are not the real objection, and the second or third sentence will give you a better understanding of the customer's true objection to the sale. (2) Feed the objection, as you perceive it, back to the client as a question. "We don't like blue!" You respond by asking "Would you like it better if it were red?" They will either mention another color or tell you the real objection to the sale (such as price). (3) Question the objection. Test to see if it is the real objection. In the example above, you would ask, "If I can get it in red, would you buy it?" If there is another objection, it will come out here. (4) Answer the objection. If it is technical, get the correct information. If it is price or availability, answer the objection with a trial close answer: "The price is $66.99. Does that fit into your budget?" (5) Confirm the answer with a question which requires a specific commitment to a course of action. "Well, if we can get it in red, will you want to take delivery of the product on next Wednesday?" (6) If you can't finalize, go back to step one to find the objection and repeat the procedure all over. A sales presentation or sales interview can take from thirty seconds to many hours. One of the other skills you have to develop is knowing when to stop selling and to start closing the sale.

CLOSING: Closing is when you have answered all of the objections of the client and have received a yes to purchase the product or service. During a long selling session, such as a wedding interview, you use trial closes, such as "Well, what do you think so far?" If the answer is yes, stop selling and start closing. If the answer is "Yes, but . . ." keep selling. Closing is the finalization of the sale. It may involve filling out a contract, writing out an invoice, booking an appointment or collecting a deposit. At this time, you reduce to writing the conditions of the sale: the where, when, who, etc., plus how much, when the money is due, and any other special conditions. Sometimes you may get all the way to the payment policy and the client will come up with another objection. You must return to selling to overcome the objection before you can continue to close.

Remember that good selling creates a sense of ownership in the buyer's mind. Once people own something in their minds, it is theirs and they feel good about it. People can spend weeks deciding to spend money on an item, debating all the pros and cons in their minds. Once they have decided to buy, they usually only remember the pros and can justify the purchase to themselves or anyone else. There is seldom any buyer's remorse

for most people after a purchase, unless they later feel they were deceived by improper or unethical sales techniques. Most consumers consider high-pressure sales techniques improper, even if they were not dishonest or unethical. If your client goes home and later regrets being pushed into his or her purchase, you will probably never see him or her again, or any of his or her close friends. This is why it is important not to trick or pressure people into buying something. Good selling creates a positive feeling both in the customer and in the seller.

Cold Calling

The toughest and probably the most effective method of marketing or selling a product or service is cold calling—picking up the phone or knocking on the door of a potential client without any prior invitation, and trying to sell your product or service. In cold calling, the client is not motivated to welcome you. In fact, he or she is usually afraid to talk to you. Many people react with a lot of negative energy to a cold caller and may respond by slamming the door in your face or by calling you some unfriendly names. From these experiences comes the classic image of the Fuller Brush door-to-door salesman. The clients may question your pedigree and heritage. Ouch! That hurts. This is rejection in the worst sense of the word.

Why make cold calls to potential clients? Simply because there may be no other way to approach them. They won't read your ads, they won't listen to your TV spots, they won't even know the good you can do for them, and they don't care. You must confront the bear in his cave and get him to at least look at your work and give you a fair consideration. Commercial accounts in photography require more cold calling than your typical portrait business. In a given locale, there are only so many potential accounts for a commercial studio. You must go to see them because, when you are new, they usually won't be looking for you. You must overcome your fear of rejection and replace it with a more realistic attitude.

Tom Hopkins has a great mental aide. Let's say that you make $1,000 on a certain type of job. Let's also say that you must make five cold calls to get one job. That means that each rejection is worth $200, isn't it? So every time someone tells you to take a walk, say thank you, because they just gave you $200. This is not rejection, this is making a good profit. The point is you will not get any jobs if you don't go and look for them when you are new. Later, as your professional reputation grows, people will call to hire you. But, at the beginning, you have to make cold calls! In a survey by the National Association of Sales Executives, it was determined that it took, on the average, five cold calls to sell a potential client on the product or service being offered by the salespeople who participated in the study. If you give up after the first or second call, in all probability you will never get the job. Persistence is the key to using cold calling as an effective sales tool. Don't give up on a potentially valuable client just because you have been rejected once or twice. Keep trying.

You can soften the coldness with some specific pre-call selling. Send a neat, short letter addressed to the person you will see, introducing yourself and stating that you would like to meet them and show your photographs. Then state, "I will be calling your secretary at 11:00 A.M. on Tuesday to arrange a convenient time for us to meet and discuss your photographic needs. Please tell your secretary if next Wednesday at 10:00 A.M. fits into your schedule." Make sure to include some of your good-quality sample photographs with the letter. Do not overdo the number of samples. Keep it reasonable and specific to the needs of the client. If the client is a steel mill, do not send baby photographs. Make sure that you do call the secretary at 11:00 on Tuesday, just as you said you would.

The cold-calling method takes time and lots of emotional energy, but it works. If you are sitting at your desk waiting for the phone to ring, you are wasting valuable time. You should be out looking for work and making cold calls. A little research is required so that you don't call on people who really have no need for your services. If a company or a potential client has not used a photograph in years in its advertising or PR work, it is not a good prospect for you. It needs a new creative ad agency, not a photographer. Look in the various media to see who uses photography before you try to get their account. Al Gilbert, of Toronto, goes after large corporations to do portraits of their executives. Step one for Al is to get copies of the last two or three annual reports of a potential corporate client to see if it uses photography at all, and how well it uses photography. If there are no photos at all, it is not a good prospect. If it uses photos, but of low quality, it is a poor prospect. If it uses good photography, it is the ideal prospect and worth more effort because it will appreciate what Al can do, and be more willing to pay his fee.

Some Thoughts on Selling: Tricks or Techniques?

Selling is not order taking. The art of selling is stimulating the client to buy more than he or she would have if left to his or her own devices. Different people have different talents when it comes to selling, but some of the best salespeople were shy introverts who learned to become outgoing, positive people who can sell anything to anyone.

DON'T ARGUE: The old adage is true; "You can never win an argument with a customer." Customers may not always be right, but proving they are wrong does you no good if you lose the sale.

DON'T ATTACK THE CLIENT: When a wedding client says, "I don't like formal photographs," don't start a tirade about the wonders of formal photography. You are calling the customer an ignorant fool, and you will not win his or her trust that way.

DIRECT SELLING: When you pick up the phone or sit down with a client in your studio, you are direct selling. Your tools are your words, voice, appearance, body language, and personality, as well as your sales aides (e.g., samples and price lists). The first thing you must learn is to be comfortable with people face to face. I know many of you are inwardly shy and do not enjoy speaking in public and feel uncomfortable dealing with clients face to face. Half of the reason you like photography is that you think you can hide behind the camera all day. You must learn to overcome this fear of human interaction or you will be poor the rest of your life. The best way to overcome the fear of face-to-face dealings with a client is to be prepared with all the answers before you begin. Great salespeople have answers prepared, rehearsed, and neatly cataloged in their minds for most conceivable objections. They can recite these answers by rote.

Knowing your product is essential as well as knowing your price list. If a client asks "How much is a 16 × 20?" and your response is, "I'm not sure, I'll have to look it up," you have just given a value to the print—zip. It wasn't important enough for you to remember. You should go into any sales situation fully prepared to answer any questions or objections that the client may present. How you deliver the answers is the art of selling. Most direct selling is perceived as a confrontation by both client and salesperson. Both expect certain arguments and certain defenses against the arguments. The most important part of selling is to defuse the confrontational aspect of the meeting and replace it with a consolatory role. Your purpose is to help the client fulfill his or her desires.

Let us think of a bad sales example. You are walking down the street and a guy in a bright red suit jumps in front of you, grabs your lapels, and asks in a garlic-scented whisper, "Wanna buy a Rolex for $25?" Every defense mechanism you have springs into ac-

tion and also your sense of greed at hearing of such a crazy bargain. You have been physically and verbally accosted and confronted. You are uncomfortable, insecure, and you want to run away. You don't care if the watch is cheap, and you are afraid for your physical well-being. Or, you go into a sales room of a car dealer. You walk in the door and there is a group of salespeople chatting in the corner. They all look up at you, and one strides over to you and says, "Hi, can I help you?" Like hell! He really wants to make you buy something you didn't want and steal your money. Let's get out of here!

If a car dealership has any smarts, it doesn't act in the above manner. I bought a new car a few years ago from a dealership about fifty miles from home. Sue and I walked in, and an attractive woman walked up to us and said, "Welcome, did you know about our contest? You have already won at least $5 and possibly $50! Come on over, play the multiple choice game and have a cup of coffee. We will give you your prize in cash right away!" She then gave us a crisp $10 bill along with our cup of coffee. She asked us if we wanted to look at the cars and said she would get a salesman to help us. All of our defenses were down. She gave us money, not tried to take ours. She was sociable and friendly, and really seemed to be wanting to help us make a good decision. A terrific sales approach. Then the salesman went to work on us!

CREATE A SELLING ENVIRONMENT: When clients walk into your studio (or call you on the phone), make them feel comfortable. Be friendly, make them feel welcome and do not immediately say, "What can I do for you?" Sell yourself as a nice person by being just that, a nice person. Have all of your sales aides ready so that when the questions do come, you can answer them quickly and efficiently. Do not make clients stand up. Seat them at a table or on a couch where they can relax a bit. This is why I recommend that you don't build a counter in the front of your studio. You place and take orders at a counter, you do not sell things at counters. The counter becomes a barrier between you and your clients.

Good selling means creating an image of the product or service in the client's mind, so that it becomes real. You must use all of the client's physical senses that you can— sight, sound, feel, smell, and taste (use coffee or soft drinks). You must create in the client's mind a belief that he or she already owns the product, and how much better life is now that he or she owns the product. Once clients have seen (in their minds) how beneficial owning is, buying becomes secondary.

The single most important factor in selling is to gain the clients' trust. They must believe that you are not lying or playing tricks on their emotions just to take their money. When you are selling your own photography, I must assume that you are proud of it and that you think it is worth your price. You must convey confidence and assurance. You must be friendly and trustworthy before you can discuss the product with any client. Again, it is a skill that you can learn by practicing, and by studying the great salesmen. You may not need all of the tools that a real estate agent needs, but you should study them.

The biggest single obstacle to overcome is fear of rejection. Every time a client says no can be like a slap in the face. You don't like the pain, so you stop asking. The pain goes away, so do your profits, and you go broke. Rejection is part of selling. Nobody sells something to every sales prospect all the time. You must simply realize that a no is part of doing business and not take it personally.

USE GOOD SELLING LANGUAGE: Sometimes it is advantageous to employ less aggressive words that will make your client feel more comfortable with you and what you are selling. (1) Sell to people who can buy, not to nonbuyers. (2) Don't sell logic. Arouse emotions. (3) Use go-ahead terms, not rejection terms when talking to clients.

- cost or price = total investments
- list price = values at, or worth
- down payment = initial investment
- monthly payment = monthly investment
- contract = agreement
- buy = own
- sold/sell = acquired through me, worked with me
- pitches/deals = presentations/arrangements
- sign = OK, approve, authorize

PASSIVE SELLING: Passive selling is what your sales aids do without your physical presence. Sales aids are your price lists, product descriptions, brochures, flyers, mailers, print displays, business cards, and the samples on your walls. Passive selling is done more subtly than direct selling because you cannot vary the presentation to the specific client, but must use a general approach that will appeal to the average consumer of your product in your area. The same rules apply in passive selling as in direct selling. You are trying to create a feeling of ownership on the part of prospective clients. You want them to feel that owning your photography would make their lives better and that ownership is easy to accomplish. Don't confuse the client or make ownership seem difficult to achieve.

We, as photographers, are lucky because we sell a product that is visual. We can show samples of our work in public. A father sees a beautiful family portrait of someone else's family and can easily imagine his family in a similar setting. If you can stimulate such thoughts with your samples, you should have printed materials by the display that will explain how easily he can achieve the same effect. Do not try to sell him commercial photography in a family display. Sell him what he is looking at and thinking about. Passive selling should avoid reducing products to price alone. In the case of the father looking at the family portrait and imagining his family in the same setting, he should be more concerned with the procedural difficulties of achieving the dream than with the price of it. Cost will be a consideration, but only after he realizes that his dream can easily come true. Once he realizes that the dream is attainable, how much is a dream worth? A lot more than a piece of paper.

With any direct display presentations you design, or in any brochures and other promotional pieces, do not discuss the nitty-gritty of pricing details. Quote a price for a complete service, and encourage a phone call or a visit to the studio. If the wishes of the client imply additional costs, you can explain pricing more carefully in person. If you have a two-page price list with different finishes, different types of sittings, and all kinds of options, you may scare off potential clients by making the decision-making process too complex. Keep it simple.

Your passive selling aids should create the feeling that you are an artist and a nice person. You should always sell yourself more than specific products in your printed materials. If you have certain accomplishments that you feel will help you win the potential client's confidence and trust, use them in your promotions. I used to use the various titles I have earned on my letterhead and business card. Most of my potential clients have no idea what they mean or what I had to do to get them, but they sound impressive and they help establish a positive image.

Be biographical in your brochures. Establish yourself as a person who the potential client would want to meet. Talk about your background, other career if you had one, education, travels, professional involvement, community involvement, and even your future plans. Be a real person to the people reading your materials instead of just a technician for hire.

Be succinct in any printed material you produce to help you sell yourself or your products. People do not take the time to read three or four pages of information if they have not yet imagined that they own the product involved. A long blurb will actually turn people off, and they won't even read the large print. Again, be concise and precise in your language. If you are not good with language, hire someone to rewrite your ideas.

In his book *How to Sell Anything to Anybody*, Joe Girard has formulated his Law of 250. After asking funeral directors and wedding halls how many people, on average, attend a funeral or a wedding, he concluded that most people know 250 people in their life important enough to invite to these special events. The implication is that if you satisfy a customer, on average, they will tell up to 250 people they know well of your service or product. On the other hand, if you don't satisfy them, they will give you bad word of mouth. Considering that most people like to trade bad stories, the negative will outweigh the positive. The point is to consider each client of the moment as a direct pipeline to 250 more potential clients. This kind of thinking will help you keep a reasonable temper and do your best to keep the customer satisfied.

The Bargain Seekers

When selling to the general public, you will meet all types of people. Most people are not forceful or demanding and are a pleasure to work with. There are a few less-pleasant types who will upset you so much that you will want to do foolish things. For example, out and out dishonest crooks. There are people out there who will try to steal your proofs, albums, or portraits. They are dishonest and have no empathy for the businessperson. They will come into your studio to pick up a wedding proof album and say, "Oh, I forgot my checkbook and credit cards. I'll send you the money tomorrow." They walk with the book, and you don't get paid.

There is a simple solution. Nothing leaves the studio unless it is paid for in full or paid for with a valid credit card. With experience, you might bend this rule for old trusted customers, but not with any customers not known to you. In my experience, don't trust well-known local people who try to use their position to avoid paying. They are the hardest to collect from because they use their position to thwart you. This also applies to very wealthy people living in fancy houses. You will appear cheap and foolish to others and must expend a tremendous amount of emotional effort and time to collect money owed to you. So, don't allow a product out of the studio unless it's paid for in full. The only exceptions are on frames that you are trying to sell with a portrait order. If the client is not sure it will fit his or her decor, let him or her take it home for a week. Use credit card slips as a security deposit when products leave your studio. Not a bad gamble. Don't allow the portraits out without being paid in full.

Another character you will encounter is the "How much off for me?" type. This type of person believes that price lists are for other people and that he or she is entitled by birth to a discount from everyone. This person will generally want a discount on all services from the sitting fee through the final frame order. Most of us are not very good at dickering over price. If you let clients create a climate of doubt over prices, you'll be at a distinct disadvantage. The people that ask you for a deal do it everywhere they go and they have experience. There are two points to consider when dealing with this type. (1) Many of them will not buy from you unless you give them some type of consideration, no matter how good your product is. (2) How large is the order and have they earned a legitimate discount? We have found this stock answer to a request for a discount to work for us. We say that we have built our discounts into our price lists (first print, additional

print, proof policy, etc.) and that everyone is treated equally. In other words, try to show them that they are already getting a deal.

When the request is on a smaller than average order, be firm. Never offer a price discount. The reasons not to offer a price reduction are: (1) You have just sold your soul at a discount. (2) You have just overcharged all your regular customers who paid the full price. (3) You have just risked the possible ire of the regular customers if they learn about the deal. Most discount-seekers like to brag to their friends about their conquests. If any of your regular customers hear the boast, they will feel slighted.

Another type is the faultfinder. This type attacks your work for being inferior or technically poor, in the hope that you will offer them a lower price in order to satisfy them. These are some very nasty people to deal with. The real question is—assuming that the photography is of good quality—do they really want it? If they are using the faultfinding to get a price reduction, offer them a total refund of all fees paid for the return of the proofs. If the complaints are bogus, they will not take you up on the deal. This type of customer will be speechless when you offer them all of their money back. They never expect that and have no response. Give them their money and bid them a cheerful good-bye! Don't call them names or offend them. They will leave a satisfied customer, and you will retain your pride. Don't lower yourself to their level of name-calling.

Weddings

ow big is the wedding market? In 1992, there were 2,351,000 marriages in the USA, a rate of 9.2 marriages per every thousand people. If you know the population of your community in thousands, multiply by 9.2 to get an estimate of how many marriages there were in your community, on average. The other statistic of interest is the median age at which people first get married. It has been creeping upward with time to twenty-six years old for men and twenty-four years old for women.

The number of marriages includes all marriages, i.e., first, second, third, etc. It includes marriages of teens and of people in their eighties. The divorce rate is about one half of the marriage rate, but divorced people are still prime candidates for wedding photography. Second weddings run the gauntlet from very large to very small, similar to the first wedding spectrum. I have observed that once couples get into their forties, they tend to have smaller weddings without the expense and trappings associated with larger weddings. One of the trappings they do without is full wedding coverage from a professional photographer. These older couples will often use a simple portrait session in the studio instead of a candid coverage, so they are not to be totally ignored. Older couples tend to be married on days other than the busy Saturday afternoons, when you should be booked with large weddings.

The other number of interest is the median age at first marriage. Many modern couples wait until they have completed their education and have started their careers before tying the knot. I do very few teenage weddings, which is fine by me. Teens tend to be much more price conscience and certainly less mature in deciding what they want from a photographer. I personally find the teen brides' immaturity difficult to work with when trying to get any meaningful photographs. If you can smell the bubble gum going down the aisle, you are in the wrong place.

There are great regional variations for the age of first marriages, with the ages

lower in the South and higher in the Northeast. Check with your local government to determine these average ages in your area. It is important to tailor your promotions and advertising to media which appeal to the age you want to attract. Teens and college-age people listen to different types of music, read different magazines, and have very different buying habits, so you will have to determine which approach is best for your market area. The place to go for your local statistics is your town or city clerk's office. This information is public record and should be easily available.

The Most Important Principle

The price you charge is equal to what you can expect to earn. You must analyze yourself as a photographer in terms of both technical talent and personality. Can you sell those qualities you do possess to a bride and groom? To get the "good" weddings, as a photographer you must be able to sell the potential clients on your unique ability to provide everything they expect on their wedding day, both in terms of technical skill and personality. You must radiate the type of personality that the couple would want close to them on their wedding day. What that personality type is will vary with the ethnic, financial, social, and educational background of the couple, so no one type will satisfy all.

First, define your own personality, and then find the market for it. Second, realize that not all weddings are the same as all couples are not the same. Bargain-basement weddings only want "some pictures" taken, and could care if a robot took them, as long as they were cheap. People willing to pay good money for a wedding photographer want a personality as well as technical skills. They want a companion, a wedding consultant, and a little bit of a showperson who can also create beautiful photographs. Some couples may want a strong director of events, while others may want a more laid-back attitude. Some want humor, others want stoic solidarity. Do not prejudge every couple that walks through your door. You must determine what each couple's real and imagined needs and desires are.

Styles in Wedding Photography

There are many different ways of photographing a wedding. Experienced photographers develop their own style after a few years in the trenches. Style is usually broken down into *candid* or *formal* approaches. This is not really a division in technique, rather an attitude toward how one procedurally photographs a wedding. A better distinction, in terms of how you mentally and physically approach a wedding is posed (or controlled), and unposed (not necessarily uncontrolled). One extreme approach is a purely photojournalistic one. In this approach, you record the events and the emotions of the day without influencing them. The opposite extreme is where every shot taken is controlled by the photographer. I know experienced photographers using both extremes exclusively. Most experienced working wedding photographers use some mixture of these two approaches.

Types of Wedding Photography

I think formal and candid are incomplete descriptions of the photographic styles popular today. The following terms are more helpful in understanding what you have to learn to produce at a wedding: (1) formal, (2) semiformal, (3) candid, (4) semicandid, (5) documentary, (6) special effects.

FORMAL: All conditions are under your direct control, the location (to a major degree), the lighting, the posing, and the timing. With correct portrait techniques, you can control the expressions of the subjects, make sure the subjects are correctly lit and placed. Formals include the bridal portraits taken at the home before the wedding, and the group and bridal photographs taken at the altar, park, or studio before or after the ceremony.

SEMIFORMAL: Usually the place and time are not fully controlled, but you help set up the poses and the lighting to create your desired effects. For example, cut the cake, getting into the limo, bride in mirror adjusting veil, pinning the flowers on mom and dad. I call these semiformal because they do not naturally happen. You have to help create them. They are not necessarily part of the couple's wedding day, but are part of a preconceived idea about what a wedding day should be.

CANDID: A candid is a naturally occurring (i.e., unposed or controlled by you) event which you capture. You may control the lighting (e.g., with double lighting and good technique), but you usually do not control when, where, or how the action takes place. You can influence some candids by your presence and give them some extra significance. A lot of the dancing shots at the reception and a lot of the receiving line are candid, but with subtle influences, you can control the flow and direction of the action.

SEMICANDID: You set up a sequence of events to duplicate what should have been a candid sequence. It is also when you ask people to do things which you think should happen at a wedding in a candid manner, such as dad turning his pockets inside out, the best man holding the bride's bouquet, the flower girl admiring the bride's ring on the dance floor. For example, when the couple starts their first dance, you can get them to look at you instead of just looking at each other.

DOCUMENTARY: These photographs are records of events as they happen. You have very little control over the timing, the place, or the pace of these events. For example, coming down the aisle, the entire ceremony, entering the hall, throwing the garter, throwing the flowers. You have to know where to be and have the technical skills to capture these events. You usually have little influence on how these events go, you just do your job.

SPECIAL EFFECTS: These are the creative photographs you take to bring some feeling into the wedding coverage. They may be available light shots of the ceremony, double-exposures, filter extravaganzas, or close-ups of the rings. These are usually your concepts, and you are totally responsible for creating them as additions to the couple's wedding coverage. These are usually the most interesting photographs of the day.

Growing in Wedding Photography

What will work for you? That depends on many factors: your clientele's likes and desires, your personality, your ability to deal with complex and stressful situations, and your level of experience. Most of you reading this book have done a few weddings, and maybe a few of you have done a hundred or more. I will outline a pattern of growth that I feel will help those of you with only a few weddings under your lens cap.

When you first get involved in wedding photography, you are usually a photojournalist, mainly because you don't know much about posing or handling people. You follow the flow of action on the wedding day, scurrying around looking for the best angles, the peak of action, the decisive moment, etc. You don't interrupt the sequence of events. You try to do some group and formal shots of the couple, which come out looking pretty stiff and posed. Your candids lack freshness and interest and look like a catalog of the backs of people's heads.

You shoot a few dozen weddings, see some lectures, read a few books, and suddenly you start to direct the course of the wedding day. You begin using window light, im-

prove your posing, arrange for group and formal photography, and are not afraid to ask the couple to stop what they are doing and pose for some "candid" photos. You start to tell the bride where to stand for the bouquet toss, and how to hold the knife in the cake shot. Your proofs are starting to look better, with more setups and formals, which your couples usually appreciate.

You do some more work, hear some more speakers, maybe attend a few week-long courses. You learn to shoot pose sequences at the home, to bring studio lighting to the church or home to get good portraits of the principles of the wedding party. You now instruct the couple in many aspects of the wedding day. Indeed, you begin to use some persuasive skills to get the bride and groom together before the ceremony, so that you can get those formals done before the chaos of the actual wedding. You learn to shoot every possible combination of every important person at the wedding day in a two-hour portrait session in the church basement. You buy a couple of portable backgrounds and add a second lighting unit to your on-camera flash, which an assistant uses to double-light all the candids. At the reception, you make sure all of the right things happen at the right time, and are correctly lit so that all of your proofs look like you shot them in the studio. Your proof book has 150 surefire selling shots that the couple can't resist buying. Every shot is skillfully crafted to show your best talents as a photographer. You also come home exhausted, and usually can't stand the thought of going to another wedding.

Don't laugh! The above sequence describes the stages that most experienced wedding photographers go through, and which most new wedding photographers must go through. The last step is when I didn't want to do weddings anymore. I spent all of my time fighting the couple's wishes in order to produce what I thought were better photographs. I would come home on Saturday night feeling frustrated, abused, underpaid, unappreciated, and tired.

I am still doing weddings today, and I enjoy photographing them because I realized that the strictly structured approach is wrong for me and my clientele. The more structured approach may be perfect for someone else, and would be perfect for me with a different clientele, but not here and now, for me. I deal primarily with yuppies and preppies, couples in their late twenties and early thirties with advanced university degrees, who are already active and successful in careers in law, medicine, computers, retailing, etc. They know what they want, and what they want (and are willing to pay for) is a professional who understands them and respects their desires (even if the professional does not think the desires are practical, proper, or reasonable). I have stopped trying to pose every shot, but try to work within the flow of the wedding, to control it without dominating it. This approach is harder to predict, but produces a happy couple and a happy photographer at the end of the day.

Many photographers burn out and no longer want to do weddings. They feel energy spent to produce the perfect picture is not worth the frustration of partially met expectations. No matter how much money they are getting, they feel they are not getting enough for the stress. There are types of clientele and certain traditional situations where complete control is both good for the photographer and necessary to produce what the couple expects. But this is not true for every locale and every photographer. I think that if you want to enjoy weddings, you have to learn to relax, learn to anticipate where the good candid shots will be, and not take it personally if you fail to get every shot you think is possible under the best of conditions.

Regional Differences in Wedding Photography

We have been in business in both the East and in the West. We have worked in farm country, in the big city, and in a resort area. From experience, we can say that there are major differences in what people want from a wedding photographer in different areas of the country. If you hear a speaker or read a book that trumpets one approach to wedding photography over another, do not automatically assume that that approach will work with your clientele in your area. Many of the approaches touted by the speakers on the lecture circuit are linked to their particular personality and to their well-developed selling and shooting skills, as well as to the traditions of their region. Californians have a different approach to staging weddings than do their New England cousins. City folk have a different attitude to wedding photography than do farm folk. To be successful in life, you must find out what the people in your area expect traditionally, and work within that context. Don't try to make them like something you heard was popular at the other end of the country and you think is impressive. You will wind up frustrated, looking foolish, and losing business.

In Canada, working in a rural setting, 60 to 80 percent of the photographs in our wedding albums were the formal group and bridal couple photographs we took during a one-hour portrait session after the church portion of the wedding. This session was photographed in our studio or in a park location of the photographer's choice. In New England, I am lucky if I can arrange for thirty minutes for formals, and I have never had a couple request coming back to my studio for formal photography on their wedding day. Our New England wedding albums contain only 20 to 30 percent formal or posed photographs. I have done weddings where there was no formal photography at all, at the couple's request.

In some parts of the country, the typical wedding reception is a punch-and-peanuts affair in which the bride gets dressed at the church, goes through the ceremony, and has a short reception in the basement with only light refreshment and no dancing. In the East, people pay $25 to $90 per person for two to three hundred people to sit down at a large meal, followed by an expensive band, dancing, and an open bar for hours. In the West, most of our weddings started at 4:00 P.M., but in my part of New England, they are mostly scheduled at 11:00 A.M. or noon.

In Texas and the Southwest, you had better get the "penny" shot. In doing over a thousand weddings in Canada and the East, I have taken this shot only five or six times. It wasn't until I heard a speaker from Texas mention it in a lecture that I was even aware of the custom. It is a tradition in some parts of the country for the bride to put a penny in her shoe—the older the penny, the better the luck—with people buying old English pennies from the seventeenth century. It is a custom not practiced too often in New England or Alberta. In Canada, after the vows in the church ceremony, the couple and the entire wedding party leave the sanctuary to go to the minister's office to sign the official documents. This is a British tradition (or a practice of the churches in Commonwealth countries). The photographer follows along and records this official event. In the USA, I have only seen this done a few times in the Episcopal Church. You must always be aware of both local custom and what are really culturewide traditions or superstitions. Most couples and their parents don't know the difference. You should know.

Know Your Clients

If you can convince prospective clients of your ability to provide the personality and technical skills they desire, you have earned whatever you are going to charge for your services. Most wedding markets have a spectrum of prices.

CHEAP: Cheap dress, cheap food, cheap booze, cheap photographer.

MEDIUM CHEAP: Move everything up one notch, still price conscious.

NOUVEAU RICHE: Best place, best dress, best whatever. Here "best" equals most known or most expected to impress. Tough people to make a buck on, because they usually want the "best deal" from the photographer. Unemotional stock wedding, get your money up-front if you deal with this type of clientele.

THE BEST: That's what they want, and that's what they are willing to pay for. The best wedding couples are those who really value photography and what you produce. They respect you as a professional, and cooperate with you whenever necessary. They are also planning to have a fun and loving wedding, and want you to share the day with them. Your price is irrelevant to their desire to have you there.

In wedding photography, the 80/20 law applies very strongly—80 percent of your income comes from 20 percent of your potential customers. To work less, filter out the 80 percent, and keep the 20 percent through higher prices. But you still need customers. It is not as easy to do as it sounds, but it's a noble goal.

Wedding Albums: The Quality Difference

One of the big differences in wedding photography between a real professional and a part timer is the actual presentation of the finished product. The most important product in wedding photography is the bride's album. I have seen reasonably good photographers deliver their weddings in a Kmart magnetic album. The photography was OK, but the total package was tacky.

If you work hard to produce good photography at a wedding, you should work a little harder to make the presentation look as good as the photography. Invest in good-quality albums, and pass that cost along to the customers in your fees. Don't think you have done your couple a favor saving them $100 by putting their photographs in a box. They probably will spend $100 every ten minutes of their wedding day. Why should they keep their memories in a box for the rest of their lives? After you have done a few dozen weddings, you will find that putting a wedding album together properly takes a lot of work and organization. You must build the cost of this time and skill into your wedding fees.

Packages and Packaging

An important distinction is whether you will be providing full or partial wedding coverage. Full wedding coverage on Cape Cod is typically six to seven hours of contact time: one hour at the bride's home, an hour at the church, and then four to five hours for the formals and reception. In some parts of the country, full coverage may take twelve to fifteen hours of contact time, while in other parts weddings may be four-hour punch-and-peanuts specials, so local custom will dictate your "full coverage" time factor. There are always requests from couples that only want to hire you for part of their wedding day. This is especially true for smaller weddings with less than one hundred guests, or garden weddings where everything (dressing, ceremony, and reception) takes place at one location. Up until recently, I had a small wedding coverage, which included four hours

of time and a smaller album than my full coverages. I have also come to realize that a four-hour wedding is as much emotional work as a full wedding, with only a fraction of the return and a less-than-satisfactory album.

Many wedding studios actually prefer to do two- or four-hour coverages rather than full-day coverages. They will argue that while the up-front money isn't as good, the average reorder is usually just as big as a full wedding, and they can do two or three in a day instead of just one full wedding. If your packaging and pricing is based on getting reorders, it makes financial sense to schedule more weddings in a given day. When I had my studio in Alberta, we photographed many "studio only" weddings where the wedding party would come to our studio right after their ceremony just for formal photographs. We did no candid photography for these couples at all, and I loved them. I could do four different weddings on a Saturday afternoon, and still be home at 5:00. Since these western couples wanted more formal photography than people in the East, our sales from these one-hour sessions averaged $700 (in 1978). Not a bad hourly wage. And all of this without leaving my camera room except to go to a park setting if the weather was good.

When first starting out, you should offer a partial package. When pricing a small wedding coverage, remember that it still involves as much of the lead- and follow-up work as a full wedding, as well as the same travel time. You will have to work harder to get all of your photography done, and you will be forced to adhere to a deadline, which is not always easy. If your full wedding involves eight hours and your small wedding involves four hours of contact time, I would price the small one at 65 percent of the full wedding and give them 50 percent of the amount of photographs you include in the full coverage.

You will discover in doing a partial package that there is never enough time. When it comes time for you to leave, the bride and groom suddenly remember twenty more group photos they want taken. The three to four hours become four to five hours. One way to avoid this is to structure your price list so that it is clear to the couple that extra time means extra money. An excellent price structure is offered in the book *Wedding Photography—Building a Profitable Pricing Strategy*, by Steve Herzog. Steve offers many samples of wedding price structures for you to blend into your business. Steve also understands the concept that you have to start out with lower pricing. He discusses how to start low and work your way up quickly. I would highly recommend this book for your library.

On your price list you should also include a "social function other than a wedding" package for anniversaries, banquets, bar mitzvahs, etc. This could be two- or three-hour coverage with a small album with thirty or forty of the proofs included, and not available during prime wedding time. It has been my experience that I can book a large fiftieth wedding anniversary party as a full wedding package. A large fiftieth usually has a church ceremony and a reception. The nice thing about a fiftieth is that there is usually a lot more family involvement. Many times the children of the couple will pay for my services as a gift for their parents. There are also the potential for many more family group combinations, which are very salable. In Jewish communities, bar and bat mitzvahs are usually treated the same as wedding coverages in terms of packaging or pricing. The way you shoot a bar mitzvah is quite different from the way you photograph a wedding, but the packaging concepts should be about the same as a wedding.

Elements of Wedding Packages

What can be included in a wedding package? (1) your time, (2) the bride's album, (3) the prints in the bride's album, (4) the parent's album(s)—usually sold with prints in them, (5) the proofs, (6) gift prints for the wedding party, (7) folio for the gift prints, (8) large

prints, (9) frame for the large prints, (10) black-and-white prints for newspaper announce-ments, (11) reflections slide programs. I have seen packages advertised where all of the above were included plus a discount on the reception hall's fees, the flowers, and limo rental! In the beginning, try to stick to including your time and the bride's album with prints. All of the other items are good postwedding sales items. You don't want to pack-age them at a discount before the wedding.

Types of Wedding Packages

There are seven general types of popular wedding packaging systems in the market to-day, with an infinite combination of features from all of them: (1) the straight package, (2) the time-only or à-la-carte package, (3) the "minimum purchase" method, (4) the "no proof" 8 × 10 finished print package, (5) the "no proof" album, (6) the transproof or videoproof wedding, (7) the designer album.

THE STRAIGHT PACKAGE: For a fixed price, the client receives a fixed amount of photographer's time and a fixed number of albums and/or prints. Typically, a proof set is delivered to the clients from which to select their album package and, hopefully, to order additional prints and albums. Proofs are either included or sold in addition to the initial package. Many new photographers make the proofs themselves.

Pros: Simplicity in telling the client, "you get this much for so many dollars"—a com-plete transaction. The trick is to keep your package at the minimum in terms of content and charge your best for it. Most newer photographers shoot themselves in the foot by including everything they can think of in their package, leaving the client nothing to purchase afterwards. The key is to price your most popular package at the amount you wish to average on each wedding. When you are dealing with couples who live out of your area, straight packaging is the only way to go, in my opinion. I have a studio in a resort area and most of my wedding clients are yuppies with successful jobs in big cit-ies across the country. We never see many of our wedding couples again after the wed-ding day. It is difficult to sell them much if you can't sit down face to face with them, so we like to package everything and sell it in advance to them. We have to depend on pas-sive sales techniques for reorders after the wedding.

Cons: People who use the other packaging systems claim that by straight packaging you have created preconceived notions in the clients' minds of the number of prints they are going to buy. This then reduces greatly the resale or additional sales potential of the more open-ended systems. They also think that you appear inflexible on the initial con-tact with the couples and that you lose wedding bookings because of your lack of op-tions. Another problem is that you may be competing with other studios who offer similar packages which lose money. You try to beat them in the giveaway department, just to book more weddings. If you do this, you have allowed the client to dictate the packages by comparing your offering to that of your competitors. Don't allow this to happen. Never have exactly the same package contents as your competitors.

THE TIME-ONLY OR À-LA-CARTE PACKAGE: The photographer's time is sold by the hour or for a full coverage, just as in a commercial job. Any prints or albums are purchased afterwards. Typically, a proof set is delivered (or transproofs used) and various album packages or à-la-carte print selections offered to the clients after they return from their honeymoon.

Pros: A flexible system because you can do very small weddings or very large wed-dings within the same system. The hourly rate is usually low, not covering your expenses or paying you much for your time. Along with the time charge, there is usually a mini-mum order required if any order is to be placed at all. A great variety of wedding album

sizes and qualities can be offered, and the photographer's postwedding selling skills can be applied to increase the total sale. A substantial deposit is required before the proofs are taken out of the studio, or else you will probably lose everything. One photographer who uses this system successfully charges $150 for a full-day coverage but collects an additional $500 to $1,000 deposit on the wedding day to take the proofs out of the studio. À-la-carte is consumer friendly, offering flexibility to the customer and low initial investment to get a photographer to the wedding. It is a good method to book a large number of weddings. Most couples on a budget only see the initial fee as an expense to include in their planning and do not think about the ultimate total cost. Since they are only getting time, your price will look better than the package photographer, on the surface.

Cons: The trick is to make sure the couple understands that they will probably have to spend a lot of money after the wedding to get any photographs at all. The possibility also exists of not selling anything after the wedding. Many couples spend a lot more on their weddings than they budgeted, and they are broke. Most photographers who use this approach attest to high average resales and claim that the risk of an occasional deadbeat is well offset by the high average sale. This technique works best with a clientele that is reasonably well-off, where there is sure to be some money left after the honeymoon. If your selling abilities are not strong, you are not going to get a good average with this system.

THE MINIMUM PURCHASE METHOD: Here the couple contracts for a minimum purchase of so many dollars worth of prints for whatever amount of time they wish to book. There is no fixed number of prints or size distribution of the prints offered. The price of the different sized prints are on a sliding scale. Usually the album covers are extra.

Pros: People who use this system swear by it. It does not predetermine the number of prints in the couple's album, and it encourages greater reprint sales by offering a sliding discount scale for those who buy more than the minimum. It allows different print sizes to be used, but encourages same-size print orders (which save you time and money at the lab) through the sliding price scale discount system. Albums are usually sold in addition to the prints in this system. However, parent's album prints, reprints, etc., all come under the sliding scale. The sliding scale gives a financial incentive to get all the reorders along with the bride and groom's order. Another strong point is that you can offer what appears to be a less expensive package to a couple, with the strong assurance that you will be getting a good average through the additional prints and the sale of the albums. You charge a higher fee to pay for your time and materials, in case you get a deadbeat, than in the time-only system listed above.

Cons: Requires a lot of selling after the fact, and it can be a bit confusing to many people. In my opinion, it has a touch of "bait and switch" to it. Some people think (even if they were told differently) that they get a complete album for their money. They sometimes get a little upset when they realize that they have to pay $200 extra for the album cover itself in which to put the photographs. To get your average out of this system, you usually must sell at least twice the initial minimum. Most practitioners of this technique sell better than that. Again, your clientele had better have some money left after the wedding.

THE "NO PROOF" 8 × 10 FINISHED PRINT PACKAGE: The couple and their parents book a minimum number of 8 × 10s. Two to four weeks after the wedding all of the principles are asked to return to view the proofs, which are actually finished 8 × 10s, usually 70 to 120 of them. They are asked to choose which of the prints they want. The photographer hopes to sell additional 8 × 10s to the original package for additional profit. The album itself is usually extra.

Pros: Saves the photographer the cost of a set of 4 × 5 proofs ($100 to $200). Cuts down

on the time wasted with couples who come back without choices made for their album. The couple and their families view finished prints, cropped and retouched if necessary. The important trick is to have all important photographic purchasers there at the viewing. These normally would be the couple and both sets of parents. The second trick is to put all 100 to 120 8 × 10s in a pile, out of sequence, and have them start to try to sort and make sense out of them. When they look confused, the photographer makes the intelligent offer of "why not buy all of them?" for a good price (e.g., about two to three times the original booking minimum). Those who practice this technique say it invariably works. You get a big album sale plus a big reorder because the parents must then order their sets and the peer pressure is there with the in-laws watching. The other advantage is that if the couple is broke, the parents are there to foot the bill.

Cons: This technique is weakened if you can't get all parties back to the sales room at the same time. The clients must be fairly affluent to be able to plop down the big bucks required after the wedding for all the additional prints. The photographer must have the complete trust of all the parties and have completely explained the procedures before the wedding. The photographer must have the sales skills to pull off this technique smoothly. There is also a lot of work involved in choosing, cropping, and retouching the 8 × 10s. This technique is slower in getting the photographs to the customers after the wedding, which can reduce the amount of the potential reorder.

THE "NO PROOF" ALBUM: In this system, the couple contracts for a completely finished wedding album containing a minimum of X 8 × 10s, Y 5 × 7s, and Z 4 × 5s. (If a square format is used, 10 × 10s, 8 × 8s, and 5 × 5s are offered.) The couple does not select the prints; the photographer selects the prints, their size distribution, and their sequence. The numbers usually allow for enough prints so that almost every important or fun shot taken by the photographer at the wedding is included in the album.

Pros: The photographer saves the time taking the album orders after the proof set is returned. The couple never sees proofs but finished (cropped and retouched) prints, in a complete album, which they then show around to friends and relatives. This looks much classier than a 4 × 5 (or 5 × 5) proof book. Other relatives and people can order from the couple's album. In selling this album, you include a lot more prints (in the album, not on the side) than in the conventional, straight packaging techniques, and charge accordingly. This system allows the photographer a lot of creative control in telling the wedding story. Using the new Futura Album insert system from Art Leather Co., the photographer can organize the album quickly.

Cons: Many couples balk at the idea of not having control over the content of their albums. The photographer must deliver the finished album by a specific deadline, which during the busy Christmas season can be tough. The studio loses the potential sale of the proof set, which can reduce the overall sale significantly. Albums take six to ten weeks to produce. Reprint orders are usually smaller because of the longer time delay in delivering the album.

The Texas variation: Doug Box of Texas uses this variation of the "no proof" album. After shooting a wedding, he has his lab make two proof sets. He has a deal with his lab so that he has the proofs back in one week. He sorts the proofs and selects so many to be made into 8 × 10s or 5 × 7s and fires them off to the lab for reprints, again with one-week delivery. He now has two sets of 4 × 5s of the best shots (i.e., the ones he chose for enlargements) and a set of enlargements. He then assembles the bride's album using a mixture of 8 × 10, 5 × 7, and 4 × 5 proofs and also assembles two parents albums from the 4 × 5s of the best poses. He delivers all three albums to the bride on speculation. Doug says it produces excellent resales and dramatically reduces his workload. The key is to get fast and dependable turnaround from your lab.

THE TRANSPROOF OR VIDEO PROOF WEDDING: Some wedding photographers are converting to transproofs (slide proofs) or video proofs instead of print proofs for both wedding and portrait work. This system affords complete control of the proofs, and, most importantly, allows the photographer to exercise his or her skill in selling more prints than the couple had initially booked.

Pros: The couple and their parents come in for an evening viewing of the proofs. The lights dim and, to soft swelling wedding music, life-sized images of the wedding day are projected with dissolves and effects. Wow! The lights come back up, and the people are now asked to choose their package (or booking minimum) of twenty-four or thirty of these images, or (as in the 8 × 10 system) why not buy them all, letting the photographer select the sequence and distribution. The couple may wish to eliminate some and get certain images bigger than others (i.e., control of content). The couple can also buy a videotape of the show they just saw for $XXX. Reprint orders are easier to get from parents and the couple. (More on selling by projection in chapter 8.)

In the video proof method, the negatives are developed at a lab and then videoed on a light table using the pos/neg reversal setting. The proofs can be electronically numbered, and can be color corrected. Each image is on the TV for about five seconds and then fades into the next image. A soundtrack can be added in some systems. The completed tape can be shown on a good-quality monitor in the studio and can be taken home by the couple. The tape itself is a valuable item to offer for sale in place of a proof book.

Cons: It requires all important buying parties to be present at the showing to be successful. It will meet with objections from people who think it will be strange to watch slides (or TV) instead of looking at paper proofs. You loose the potential of a proof album sale. Requires A/V and video equipment to be on hand for duping procedures.

THE DESIGNER ALBUM: The couple books a package that contains X images in the bride's album. The images are chosen from a proof set, but the photographer will design the album using various sizes and page combinations to create a beautiful story.

Pros: User friendly. The couple gets content control, and the photographer gets control of the layout and formatting. Most couples have absolutely no idea of how to lay out an interesting album. When we do this type of album we often add additional photos above and beyond the package number in order to create an album we are proud of and that will bring us referrals when seen by the couple's friends. Always give them more than they expect. This allows the photographer to use creative skills to make interesting looking albums that will generate word of mouth.

Cons: Same as in straight packaging.

Which Way to Go?

All of the above systems work for photographers in all parts of the country. When you have not yet established a solid reputation, I would avoid the "no proof" systems unless you use the Texas variation. I would recommend either the straight packaging, à-la-carte system, or minimum purchase system. I would also try to avoid using the same system as other studios in your area. If all studios use the same packaging system, then couples calling around from studio to studio get to compare apples and apples. If you all use slightly different systems, the couple has to compare apples and oranges, and you stand a better chance to use your personality and selling skills to best advantage. At the least, you should design your packages within the same system substantially different from the other studios' packages. In other words, you force the consumer to make a buying decision based on something other than price.

Pricing a Wedding

How much to charge? There is no simple answer to that question in any area of photography. The best answer I can give you is to charge enough to make a good profit on your time and materials and to compensate you for your talent. The time and materials are things that we can account for; your talent is a variable which you will have to judge for yourself. As you start out, it will be a modest fee, but as you mature and realize your value, you will start to charge more.

First, let us calculate how many hours of labor are in a typical, full-coverage wedding. I will try to be reasonable, and must assume that you can work with some degree of efficiency. I will also assume that you do all of the good things that good wedding photographers do for their clients in terms of service and production. If you do not offer some of these services, deduct the time required to do them from the total. I am also assuming a traditional proof book type of packaging with some type of bride's album as the final product. I will also assume that you only book about two-thirds of your interviews.

Wedding Labor Calculation

JOB	TIME (HOURS PER WEDDING)
Price list preparation	.25
Phone calls for information	.25
Booking interviews	1.33
Engagement/pre-bridal session	.75
Film to lab, proof number, etc.	.25
Prep. time for wedding day	.5
Drive time	.25 to .5
Contact hours (full wedding)	6 to 9
Drive home/unpack time	.5
Film to lab	.2
Edit proofs and number (240)	.5 to 1.0
Assemble proof album	.25 to .5
Develop and print B&W for paper	.25 to .5
Proof pickup	.25 to .5
Proof return	.5 to 1.0
Sort and order album prints	.25 to .5
Sort and number print order	.25
Finishing work on album prints	.25 to 1.0
Assemble bride's album	.5 to 1.5
Album and reorder pickup	.25 to .5
Filing and misc. time	.25 to .5
TOTAL	13 TO 20 HOURS

Wedding costs

Assume your package is a bride's album with thirty 8 × 10 prints in an Art Leather Futura Album. Assume you shoot eight thirty-exposure PMC220 rolls of film.

ITEM	COST EACH	TOTAL COST
Film, Eng. sit. 1 roll	$ 7.00	$ 7.00
Proof, Eng. sit, 1 roll	15.00	15.00
Film, PMC220 (8 rolls)	7.00	56.00
Proofing 8 rolls	15.00	120.00

Proof books, 2	30.00	60.00
Futura Album with inserts	125.00	125.00
Price lists, contracts, etc.	5.00	5.00
30 8 × 10 reprints	2.50	75.00
TOTAL COST		$463.00

Note: These costs do not include any extensive retouching or special finishing to produce good professional quality photographs. They also don't include your auto expenses, or any travel, meals, assistants, depreciation for use of your equipment, or any share of your overhead expenses. I have included a lot of film, but I personally believe in shooting a lot of photographs at a wedding. I usually come home with fourteen to eighteen thirty-shot PMC220 rolls.

What I have described above is not an unreasonable figure. To do a full wedding, you will spend about $475 and invest about thirteen to twenty hours of labor. If you put a value on your time of $30 per hour, that is $390 to $600 in labor, for a total cost value of $800 to $1,000. In reality, you can and must separate contact hours from busywork hours. When you are just starting your business, you had better not be numbering wedding proofs in the middle of the work day when you should be out prospecting for new business or working on assignments. The proof numbering should be done after hours in front of the TV or by a high school student you can hire at minimum wage. Even then, there is a cost, and a value to your time as a manager of your business.

If your cost and value is $800 to $1,000, what is your talent worth? What about a return on your investment in your studio and equipment? What about the wear and tear on your physical and emotional self? What about the time away from your family? What about the interest on the debt that financed your equipment? What about a respectable profit to keep up your self-esteem? Your price should reflect all of these factors, as well as some realistic evaluation of your place in the market and other potential income areas (such as reprints and parent's albums) from the wedding. Whatever you value yourself, no intelligent person should be doing a full wedding coverage with professional quality materials and finishing for under $1,000. If you do, you are only subsidizing the labs and the album companies.

Another major observation from twenty years in the wedding business: the less you charge, the less people respect you. When you do weddings for $500, you won't get much voice in planning the wedding. When you charge $2,000 in advance, the wedding party and families respect what you say and go out of their way to assist you. I greatly prefer to have the client's respect and money rather than fighting for my place in a line with the band, the florist, and the limo driver.

Booking Weddings: How to Sign Them Up

The crux of the wedding business is the booking session or interview. All photographers to some degree use an interview to establish wants and desires of the couple, show samples of services offered by the studio, and to book the wedding, i.e., fill in contracts and collect deposits.

STEP 1: FINDING THE CUSTOMERS. Step one for the new studio is to find prospective brides and make them aware that you exist. Most well-established studios rely heavily on referrals by former customers or word of mouth to find their brides. You will have to work a lot harder at getting clients in the beginning. Where do you find new brides? Here are some ideas: (1) mailing brochures from engagement notices in local newspapers, (2) cross-promotions with local bridal shops/tux rental shops/florist shops, (3) cross-promo-

tions with reception halls/restaurants and caterers, (4) through portrait and other clients, (5) at bridal fairs, (6) through referrals from other photographers, (7) through referrals from direct advertising (newspaper, TV, etc.), (8) through referrals from ministers of churches, (9) through Yellow Pages ads. (In a recently published survey of over a thousand bridal couples who booked with legitimate photography studios, less than 2 percent indicated that they chose their wedding photographer from a Yellow Pages ad.)

Visit all of the wedding professionals and businesses listed above in your immediate area. Leave your business cards and some background information on yourself. Do not attempt to bribe another business by offering a kickback, and do not get suckered into being forced to discount for referrals. Some reception halls like to package weddings, i.e., the meal, the photos, the limo, the flowers, etc., for a single price. They like to hire new photographers at a discount so that they can make more money on their packages. They make the money, you do the work. Bad news.

Make sure that any wedding business that you work with in the first few years gets a complimentary 8 × 10 of their contribution to the wedding (e.g., photos of the flowers to the florist, photos of the food tables to the caterer, and prints of the dress to the bridal shop). Deliver the prints in person so that you can get to know the owners personally. At first, as a new studio, you may not get into the better florists, dress shops, and reception halls. Keep trying. Show samples. If you do book a wedding serviced by the better shops, prove you are a professional by your behavior. After you do a wedding, make sure to show the bridal shop, florist, and caterer photographs of their work to show how well you can take photographs. They will be slightly flattered, and they can judge scenes with which they are familiar (i.e., their handiwork) better than shots of the altar or posed groups in the park. If you have an opportunity to get a display in a popular reception hall, florist, or dress shop, invest in a professionally prepared poster with 11 × 14 color prints and a place for your business cards. Be willing to make properly finished 16 × 20 prints of that establishment's services in return for the display area. Keep the samples fresh.

Bridal fairs: Most bridal fairs are organized by businesses that are trying to make money. In many areas, they are run by radio/TV stations, and participation in the fair is tied to the purchase of a media advertising package, which can be expensive. You must also be aware that bridal fairs tend to attract real shoppers, i.e., the types who want to compare prices and get the best deal possible. For a new studio, these people are good potential clients, but for an established studio, they are not much use. At the last bridal fair in which I participated, I was amazed to see a number of my previous year's brides in attendance with their mothers. I asked around and realized that 25 to 33 percent of the people in attendance had been married within the last year and had come to the fair to see if they had done their wedding "right." Obviously these are not good wedding photography prospects.

If there is not a bridal fair in your area, you can organize one yourself. When I first came to the Cape, there were no bridal fairs. I worked with three other businesses (bridal shop, florist, and a jeweler) to start one. By the fourth year we had over 1,500 people attend our fair. By producing the fair ourselves, we kept our costs down and were able to keep a high quality level of business participation. The key is to get a popular reception area to provide the room and food at no cost and to get a bridal shop to put on a fashion show. With these two major businesses, you can then charge other wedding businesses to rent booths to help pay for advertising and other expenses. Putting on a bridal fair is a lot of work, but can be a source of a lot of business to the new studio. Schedule a fair in January or February when many couples are planning their summer and fall weddings.

If you prospect all of the above sources you will start to get some phone calls.

STEP 2: THE PHONE CALL. It has been my experience that there are two types of wedding phone calls: "How much?" and "Are you available?" When you're new and have few word-of-mouth referrals and little reputation, most of your calls are the "How much?" type. The "Are you available?" calls come from those who find that their first four choices are booked, and they are getting desperate. Let's concentrate on the "How much?" calls. Many platform speakers say they don't give prices over the phone. That's OK if most of your business is word-of-mouth referrals, but if you are new, you have to say something. Show interest in their plans, ask questions: What date is the wedding? (and check your appointment book to see if you are available), Where is the wedding? What time? Where is the reception? Who is the caterer? The band? How many guests? Then say, "We have various plans (packages) ranging from $X to $X. Our typical full wedding coverage is $X. Would you like to come in and talk about your wedding day and view our work?" This information gives the caller an idea of your minimum and an idea of your maximum. It also allows you to qualify the caller.

Qualifying the caller: It is a waste of time to interview anyone who cannot afford your rates. If your price range is beyond a couple's budget, you do not want to waste time talking to them for an hour in an interview session. Most reasonable people are on some kind of budget, the majority (80/20 rule) of the people you get at a new studio are on a relatively small budget, and they won't call the well-established studios because they are too expensive. If the couple is reasonable, they probably will be turned off by the "we don't give prices over the phone" approach without some previous knowledge of your skills.

STEP 3: THE INTERVIEW. I am assuming that you have done some wedding photography before, either in your prestudio days as a freelancer or for a more established photographer. You must have at least two sample albums of weddings you have photographed available in your interview room. One should be an 8 × 10 (or 10 × 10) with either mixed sizes (if that is what you are selling) or one size showing your best wedding photography. The photographs may be from different weddings, but should show all aspects of a photographic coverage. The second should be a single complete wedding, either in an 8 × 10 album or set of proofs (4 × 5 or 5 × 5). In your sales area, you also need some good formal and candid wall prints (16 × 20 or larger) and some sample special-effect prints. You also need a well-written, concise price list with all the facts and policies, and a contract form (such as the one from NEBS) ready to fill out.

In my opinion, if you want to start off booking weddings at a good price, you also need two slide projectors, a tape player, and a dissolve unit to prepare a slide show to show your wedding photography. Have a good sample wedding you have shot converted to transproofs and pretape a slide show with traditional and contemporary wedding music. (For a home or prewedding sequence, use the *Chariots of Fire* theme or "Going to the Chapel"; at the church use the "Wedding March" or Paul Stukey's "The Wedding Song"; for the reception use "Celebrate" or "Love Is Like.") The more senses you can involve in the presentation, the more emotions you can generate in your clients. Remember, you are selling emotions, not photographs. Have the couple touch the albums, hear the music, smell the lacquer and the leather, and feel comfortable with you.

Interviews should run as follows. (1) Greet the people, exchange amenities (weather, season, etc.). (2) Get seated in the wedding room at your round table with sample albums on the table, contract and price list in front of you and not readable to the couple (i.e., upside down to them).

(3) Ask questions. Where? When? Who? What? Show concern with all details of their plans. Listen for positive and negative clues: "We don't like formal poses," "I was at a

friend's wedding and I did (or didn't) like what the photographer did." Until you've been to a hundred weddings, you are not a wedding expert, so don't make any comments on the correctness or properness of a couple's plans or procedures. However, read all the wedding custom books and know the rules. Read *Bride's* and *Modern Bride* magazines to learn what's new and trendy. You should be able to answer basic questions about procedure, dress, sequence, and local custom. If you don't know, say so. (You will also realize that the people who write for the bridal magazines do not go to many weddings.)

(4) Somewhere in the middle of the question/answer period, offer them a sample album to look at while you continue to talk. Mix chit-chat about the sample album in with questions about their wedding. If they see a photo and say, "We like that," make a note of it. If they say, "We don't like this," make a note of that also. Listen. Most wedding couples will give you many clues about what they are looking for, or trying to avoid. Adjust your sales presentation accordingly. After twenty-five years of doing wedding interviews, I have concluded that 80 percent of the brides and their moms viewing your sample albums are not looking at your photography. They are checking out the other bride's gown, flowers, place settings, etc. You need to have some photographs that really stand out to grab their attention.

After they have looked through the two sample albums, show your slide show if you have one. Be quiet. Let the music and the images blend in their minds. Let the music set the mood. It will help the photography. It is also critical to keep the slide show under about eight minutes in running length. Too much longer and you will put people to sleep. At the end of the show, or after viewing the albums if you don't have a slide show, get out your price list and give it to the couple. Discuss your packages and what will suit them (and you) the best. If they have additional questions, answer them, and don't be afraid to say, "No, we don't do that." Don't offer to do something you haven't done before and are not sure you can do. Be honest with them.

STEP 4: THE CLOSE. Periodically during your interview use trial closes to see if the couple is ready to book. Ask them, "What do you think so far?" If they have questions, keep on with your presentation. Let us assume you have convinced the couple that their wedding day would not be complete without you. Now take out the contract and start getting the details of the wedding day in writing. Where, when, who, etc.—all the questions you asked before, except you are now asking them officially and are writing them down. Parents attending? Are they divorced and are they still talking to each other? What special photos do they want? How many in the wedding party? The ages of the flower girl and ring bearer? Never go to a wedding without a signed contract or not knowing what the couple wants.

Your contract: Don't leave home without one. Fill in the contract, and have the couple sign it; explain clearly what they are to get, and when the money is due. Collect a deposit of at least one-third, and require that the balance be paid in full seven days before the wedding.

How to handle objections about the money: You'll get some objections about paying all the money up-front. First, I tell people that if they really didn't like all the photographs, I would give them their money back. I have even put that in writing, and I have never had anyone ask for their money back instead of the photographs in twenty-five years and over 1,900 weddings. Customers will not ask for their money back if you are at all competent, even if inexperienced. However, you have the money. Once people have paid you and own something, they don't usually complain about it. Ninety percent of the problems in wedding photography come when you try to collect a balance after the wedding. The couple may be broke, or in debt, because they overspent and the parents are out of the picture, etc. When they are broke, and the only person they owe money to is

you, guess who they find fault with? If you allow them to pay the balance when they pick up the proofs, they will often send a parent who is not aware they still owe money and asks you to trust them. Don't. In the past fifteen years, I have only bent my pay-in-advance rule once, and it took me over a year to get paid, even though it was one of the best weddings I ever photographed. They were simply out of money.

Tell them how unprofessional it is to discuss money on the wedding day, and how convenient it is to get these details out of the way before the wedding day. Don't give in on this point, even to the point of losing the wedding. Calmly stand your ground. That's professionalism. You'll have the comfort of knowing you'll never get stiffed by a wedding couple. You will also gain respect and value from the couple and their families. Since they have already paid you, they are usually more willing to cooperate to see that they get their money's worth. You become a valuable or costly asset of the wedding day.

When you have finished filling in the contract, make tentative appointments for engagement sittings and/or pre-bridal formals or a love story sitting. The more times you can photograph the couple before the wedding day, the easier the wedding day photography becomes, and the more you can sell them.

If the couple does not book at the end of the interview, make sure that they leave your studio with a brochure or information with your name on it, so they remember you as opposed to other studios they may have visited. Remember: you can't sell everyone. Don't take it personally if you can't close every sale. If you think you can't do what is asked of you, don't offer. You'll get in far more trouble than you can imagine by nonperformance than by admitting weakness in an area of expertise. If your lowest price is too high, you don't want them. Politely end the presentation. If they want to dicker, you don't want them. This is especially true if the wedding is at the most expensive country club, the fanciest church, and the couple is hiring a new studio and wants to get the cheapest price possible.

STEP 5: THE FOLLOW-UP. Immediately after the couple leaves your studio, write them a thank-you note for the booking, and get it in the mail so that they get it in the next few days. Include album information. Use mailers furnished by the album companies and any other materials you may have, or send brochures with your own photos. At the booking you should have made arrangements (if possible) for an engagement sitting. If the wedding is a long way in the future, it is usually more practical to wait before doing the engagement sitting. When the appropriate time is approaching, write or call the couple to set up the sittings. At the sittings, review the arrangements to see if anything has changed. Stay concerned. If the balance is due seven days before the wedding, fourteen days before send out a statement gently reminding the couple that the check is due and asking them to update you on any details that may have changed since the last time you talked to them. Keep in touch as much as possible. It makes the couple feel that you care about them.

The Wedding Story Concept

Many years ago, most wedding albums were a series of staged or posed photographs showing the highlights of a couple's wedding day. There were few true candid photographs. The typical album was twenty-four or thirty-six 8 × 10s. In the sixties, better candid photography became technically possible through the development of better strobes and faster color films. There was also a shift toward more location formal photography and away from studio formals. In the seventies, Rocky Gunn from California introduced the concept of the "wedding story" for creating interesting albums. The idea

is simple to state, but was not so simple for most established photographers at that time to put into practice. The concept is to use all of the tools you have available to you as a photographer to tell the story of the couple's wedding day, from start to finish, in a creative and beautiful way. This includes both the traditional highlights and the more spontaneous candids, as well as some special "love" photographs to set the mood of the album. Rocky would show couples in beautiful, dreamlike settings (usually photographed on a day other than the wedding day), which set the tone of the rest of the album. Most couples think that their wedding day will be dreamlike, so why not help them realize their dreams? Most real-life weddings are a rush of procedural events which leave little time for dreaming or even having fun. In many ways, you, as a photographer, can help the couple capture something that only existed in their minds, a true wedding story.

The concept required photographers to let go of their set-shot concepts of posed groups and posed candids and to let themselves get involved with a couples dreams and wishes. As couples become more sophisticated and better educated, they do not want the more mundane albums that their parents have from twenty to thirty years ago. They want the excitement of MTV on their wedding day, even if they don't know how to physically accomplish it. That is why they are willing to hire a professional for a substantial amount of money, to help them achieve a dream.

Within the wedding story concept is the idea of the "love story session." This is a photography session scheduled away from the bustle and confusion of the wedding day, when you can create stunning photographs of a loving young couple in beautiful settings. This is dream-making. The love session may be of the couple before the wedding on a picnic, going for a walk in the park, or at the beach. It may be the couple in your studio in more adult and loving poses than you would use for an engagement sitting for publication. The love session might be the day after the wedding, where the bride puts on the wedding dress again, at dawn or at sunset, to catch the beautiful light in a scenic area. It is a time when the couple, in all of their wedding finery, can concentrate on each other and express their love to each other in front of the camera. What a start or finish to a wedding album!

It isn't always easy, but, to paraphrase a routine by comedian George Carlin: If it was easy, it would be hard. Because if it was easy, everybody would be doing it, and you couldn't charge much for it, so it would be hard to make a living!

The Candid Page Concept

A few years ago, we shifted a good part of our wedding business into a new direction. First, we had observed that in our market, the majority of the income (profit) for 80 percent of our weddings was in the bride's album. We mostly deal with yuppie couples who are paying for their own weddings. There is not a great deal of parent involvement in the financial end of our weddings. We also observed that wedding reprints, additional album photos, and parents' albums orders were not as good as we had had in our Alberta studio. We decided to concentrate on the bride's album as the major product in our marketing strategy. To add value, we wanted to expand the size and also increase our control of the number, size, and sequence of the photographs in the bride's album.

Even though our wedding clients are primarily well-educated professional people, we had observed that when it came to selecting an interesting album from a proof book, they were rank amateurs. The albums we were asked to assemble from clients' proof selections were uneven, uninteresting, and lacked the feeling of the fun and excitement of their wedding day. We might have taken 240 to 300 photographs and the couple would reduce

this to thirty or forty images. Often we would try to help them flesh out a better album by including extra prints or proofs. We found that we were taking two to three hours during the proof-return interview with our wedding clients helping them arrange an interesting album. Even after all of this work, the albums seemed empty and shallow.

What we now offer to our couples is a finished album containing 120 to 150 different images (or almost all of the photographs I take on the wedding day, allowing for multiples) in various sizes. We specify a minimum of ten 8×10s, twenty 5×7s, and ninety smaller images. We promise to deliver the completed album in six to ten weeks from the day of the wedding. There are no proofs, and there is no chance to look at the photographs before we put the album together. We discuss extensively with each couple what they would like to see in the album in terms of special photographs, family and formal groupings, and things to avoid. We are sensitive to their wishes and desires. We also offer a regular package that includes proofs and selection for those couples who cannot put their trust totally in us. We offer a lot more photographs in a much more interesting format to those couples who do trust us.

One major element in this type of album is the candid page. These pages are collages of images instead of the standard format pages the album companies offer. We start with an Art Leather Futura album and use blank pages instead of the formatted pages. The concept is to get the 90 to 120 smaller images into an album that is not a foot thick. This requires that we put more photographs on a given page and still keep it interesting. I personally think the Futura is bulky enough without adding any more pages than absolutely necessary.

The candid page concept has affected my way of shooting a wedding. I no longer think in terms of "Will they buy this shot?" Instead, I think in terms of the events of the day and what sequences I will be showing the couple to best capture the feelings of this unique day. I may show the "cut the cake" sequence with one photograph or with eight photographs, as the conditions dictate. I have no preconceived idea of what a particular page will look like, but I have the concept that the major events of the day deserve their own page. I know I need a "leaving the house/arriving at the church" transition page. I know I need a "toast" page, and a "cut the cake" page. I photograph what I feel is important at that particular wedding and think of the editing process I will go through afterward. I never worry about the couple liking a particular photograph before I take it. I do worry about getting great photographs that will make the album a striking presentation. I do concern myself with getting a consistency of style and feeling in my photography that will translate into a coherent and interesting presentation. I am more concerned with the whole album than with any single photograph in the album.

In the older system, when couples would select their own album photographs from a proof set, they would hardly ever use the good candids that I worked so hard to capture. While most of my clients would specifically ask for lots of candids, they would not select them, because they were not as important as the single shot of the first dance, cake cutting, wedding party formal, coming down the aisle, etc. In the new system, the couple gets all of the fun shots and transition shots in smaller sizes on candid pages.

Physically, a candid page consists of a collage of photographs mounted directly on the blank surface of the album page. We use mostly 4×5 prints, but sometimes we will mix in larger sizes on a given page. Each image is first trimmed to whatever actual size suits the image. We may cut a one-inch circle of a smiling face out of a 4×5 or cut an 8×10 down to a 3×10–inch strip if it suits the subject. All the trimmed prints are gold edged with a Pilot gold liner pen and then mounted on the page with an adhesive material, such as 3M Repositionable Mounting Tissue or Coda mounting tissue. We may overlap the

images or we may stagger the images. We may have ten or twelve images on one page and five or six images cut in odd shapes on the next page—whatever we feel will enhance the story we are telling.

The centerpiece of our albums is the panorama page, a 20 × 24 print trimmed down to 12 × 24 and mounted across two blank pages (which have been stitched together by a shoemaker). I like to get a shot of the couple walking hand in hand through some scenic area, looking at each other and not at the camera. I compose the image so that the couple will be on one side of the double page, and the sweep of the scene spreads across both of the pages. It is a lot of work, but the expression on the faces of the couples as they view themselves in the beautiful setting is worth it. I do not guarantee a panorama in every album we deliver, as we must have a special place and mood to create the composition required. The couples understand the special requirements and work with me to plan a panorama. If weather does not allow us to go outside and get a good scenic view, I will do a panorama of the ceremony in the church. I may superimpose some close-ups of the ring exchange inset (using the mounting tissue and gold liner) if the larger overview has a blank area.

The bonus that comes from producing panorama pages is that our sales of 20 × 24 reprints from weddings has skyrocketed. We had sold few large prints, other than formals, from weddings in all of the years we have been in the wedding business. Now we suddenly are selling copies of the panorama photographs that parents and friends see in the album. People remember our "pans" more than anything else. The end result is an album that contains all of the ideas we felt we captured on the couple's wedding day. Almost everyone who has viewed our samples agrees with us.

Wedding Equipment

CAMERAS: The wedding photographer's equipment has to be reasonably portable, of good optical and mechanical quality, and dependable. The most popular camera systems are the 6 × 6 and 6 × 4½ formats, the 35mm and 6 × 7 formats being too small and too large, respectively, for most working wedding photographers. The 35mm format is handy, and offers a lot of advantages in flexibility, zoom and fast lenses, ease of use, etc., but does not look professional and leads to difficult enlargement problems when cropping or retouching is required. The 6 × 7 format is, in my opinion, the ideal studio format, but the cameras are a bit heavy for shooting a wedding all day, and the cost of the film is 33 percent to 50 percent greater than the 6 × 6 or 6 × 4½ formats. I personally like the 6 × 4½ format for shooting weddings. I used to shoot some candids on 35mm, but the use of two formats leads to difficulties in proofing, filing, and printing. Stick with one format at a time.

Ideally, the wedding camera should have interchangeable backs for special-effects shots and for ease in reloading in a hurry, and also for changing film types when needed, e.g., black-and-white for newspaper or higher speed film for a poorly lit church altar. Two camera bodies are desirable, even though only one needs a prism. At the bride's home, one camera on a tripod with a portrait lens can be set up while the second camera with the prism is used with the on-camera flash for candids.

The wedding photographer should have at least the three basic lenses. In the 6 × 4½ format that is a 50mm or 60mm, 75mm, and a 150mm; in the 6 × 6 format, 50mm or 60mm, 80mm, and a 150mm; in the 6 × 7 format, 65mm, 100mm, and a 180mm. The portrait lens should have a professional lens shade, and the normal and wide-angle lens should have rubber lens shades. Pro lens shades serve many more purposes than keeping the light off the front of the lens. They serve as filter holders, vignetters, montagers,

and matte-boxes for special effects. They also look professional. Somehow a big lens shade impresses the clients more than the quality of the lens.

THE TRIPOD: A sturdy, yet reasonably lightweight tripod is a must. It should be one that can be set up quietly in the church and must have quickly adjustable legs. There are hundreds of tripods on the market and few fit the bill for weddings. Always check them out before buying them. I prefer the Bogen 3221 (black) with the 3285 pistol grip ball head.

THE CAMERA BAG: When you need a piece of equipment at a wedding, you need it in a hurry. Deep, soft-sided camera bags are better for protection and easier to carry. Tamrac has designed a camera bag which is both soft sided and laid out well enough to be easily accessible. The Model 695 holds my complete 6 × 4½ system. The flat aluminum or fiber cases are very good as everything is laid out in plain sight. You can also stand on them in a pinch to get a higher angle, or seat members of a large group shot.

PORTABLE STROBES: The on-camera strobe is the real workhorse of the wedding photographer. Even a second-rate lens is sharp at f/8. Conversely, a fine lens without enough light is a piece of junk. A wedding strobe must have the power to fill-flash groups outdoors (f/5.6 or f/8 at twenty-four to thirty-six feet). It must be adjustable enough to do the close-up of the rings or a close-up of the couple and still have enough battery charge to last all day with quick recycling so you won't miss any action shots at the end of the reception. Quite a bill to fill.

There are two popular types of strobes available, the nonautomatics and the automatics. The nonautomatics, such as the Normans and Lumedynes, offer plenty of power, changeable reflectors, adjustable power settings (quarter, half, full), and lots of battery power. However, their light output is fixed within a given power range and you have to adjust the f-stop of the lens based on the distance from the flash to the subject on every shot. That or keep the distance the same, which is difficult to do. In a rush of action photographs, you have many things to worry about, other than the exact distance to the subject. Photographers who use nonautomatics will swear by their consistent output, the better quality of the light from the reflector-type heads, and the ability to bare-bulb when necessary. They claim better control, with experience, with nonautomatics.

Automatics come equipped with a sensor that measures light reflected from the subject, shutting off the unit when enough light for the settings is measured. This type of strobe eliminates the worry about distance during action shooting. The ability to shoot a bridesmaid at three feet and the wedding party at twenty-four feet without adjusting anything takes a lot of worry out of technique. I have always used the Metz strobes. They are solid, dependable workhorses. My 60CT-4 did two full weddings (six hundred shots) in one day and just started to run out of juice at the end of the second. They are more reasonably priced and not as heavy as the nonautos. They have adjustability over a range of six stops, and are accurate from three feet to ninety-four feet with VPSIII. In my experience, the Metz units produce f/8 when set on f/8; some of the others on the market are grossly overrated with regard to their power.

A new feature is the ability to place the light sensor inside the camera so that the sensor becomes a through-the-lens (TTL) system. This system is called *dedication*. The Bronica ETRSi can be connected to a dedicated flash through a module, while the ETRS cannot. In the Hasselblad camera, the 503CX model can be dedicated without a module directly to some Metz strobes. Many of the professional automatic strobes can be connected to the more modern cameras through an accessory module. The results can be better balanced than before TTL. However, it has been my experience that TTL does not solve all exposure problems. Dedication does not work well in strong backlighting situations. Be careful.

One thing to remember about an automatic strobe is that the light sensor is just like a reflected light meter. It wants to see a gray world. Point the unit at a white wall, and it will be underexposed by two stops, i.e., gray. Point it at a black wall and you'll get an overexposed negative, i.e., gray. A little common sense is required, but with experience, one learns to make these adjustments quickly with the flip of a finger on the power scale.

DOUBLE LIGHTING FOR CANDIDS AT WEDDINGS: A more professional looking candid wedding photograph can be produced if you use two strobes to light your candids. Double lighting requires an assistant to hold the second light unit, and it is not an easy job that someone can just do without some training and coordination with you, the photographer.

Generally, the second light should be exactly the same light unit you have for your on-camera strobe. The sync of the second light is controlled either by an optical slave or an infrared slave, or by a radio slave. The optical slave is cheaper and easiest to use, but it is subject to the flashes from other cameras at the wedding, especially during the most important events of the day, such as coming down the aisle or cutting the cake. The infrared slave cannot be fired by regular light and avoids this problem. A radio control costs about $200 to $300 and connects the second light to the sync terminal of your camera by radio transmissions. This allows you to sync up to 250 feet away (which very few optical or infrared slaves will allow) and around corners of buildings for some interesting side- or back-lighting effects.

Always use the second light as an accent light. If it does not go off for any reason, your on-camera strobe should give you a proper exposure. You have to learn to position the second light relative to your camera position it a quick and quiet manner. It doesn't help your communication with a bridal party if you are constantly telling your assistant where to move. Work out a series of hand signals so that you can move them around without having to talk to your assistant. Assistants also have to learn to anticipate certain amounts of movement of the subjects and to follow the action without direction, allowing you to concentrate on the couple and not on the second light. As I said, it takes a good deal of teamwork to make double lighting work well.

When first using double lighting, you must make sure that you are not creating double shadows. The second light is an accent, and shouldn't be mistaken as a substitute for a studio main light. When doing groups or full-length formals at a church altar, I get better results using the second light as a background light, creating a separation between the groups and the background. Even outdoors, when I may pose the couple one hundred feet away and use a long lens for effect, I can have my assistant behind the couple rim lighting them for a dramatic panorama shot.

BACKGROUNDS FOR INDOOR FORMAL PORTRAITS: It is often advisable to bring a portable background when you are not sure of the type of background you may find in the bride's home or in the area in which you are taking formal photographs. This procedure will assure you of a good-quality image in the worst of conditions. You must also remember that your background is a foreign object in the couple's world and has little or no meaning other than covering up an otherwise ugly wall. It is preferable to find a pleasing background in the home environment or church on the wedding day that suits the couple's personalities. A familiar background is preferable to an artificial one to most people. Do not overstress your use of portable backgrounds in your interviews, unless the couple expresses a concern with the ugliness of the areas available in which to shoot their portraits.

PORTABLE STUDIO LIGHTING EQUIPMENT: If you are going to do an extensive series of portraits using a portable background, or if the weather does not allow you to use a planned outdoor area, it is advisable to have a portable studio lighting unit ready to use.

By studio unit, I mean a strobe with a modeling light and enough power and control to do good group portraiture. Please refer to the list of recommended equipment. Either the Ultra 600s or the Photogenic Powerlights fit the bill perfectly. With two of these units equipped with umbrellas, you can do the largest of groups in a church or reception hall area with a minimum of shadows and good depth of field. Again, portability and ease of setup are the key factors to look for in a portable studio lighting unit.

REFLECTORS: When you do any amount of window-light photography or light with one portable studio lighting unit, you need to bring a portable reflector to use as a fill light. The spring-loaded, twist-fold reflectors are a good investment. They are light, compact, highly reflective, and easy to use. The Larsen Reflectsols are a good tool to have, and I often carry the 3 × 6–foot, full-length model with me. They fold up fairly well and can be mounted easily on a light stand to free your hands for the camera.

Preplanning with Your Wedding Couples

The most important part of shooting a pleasing (to the client and to yourself) wedding is preplanning. It is crucial for you to understand the exact desires and wishes of the couple. It is then necessary to plan the time and location you require to fulfill the couple's wishes, and to communicate these plans to the rest of the wedding party. We use a form called "Where and When" to help the couple and ourselves plan the time required to do group and formal photography. We spend a lot of time in the interview talking about the couple's wishes with regard to candids, formals, family, groups, special friends, etc.

One of the most important aspects of preplanning wedding photography is encouraging the couple and their families to think about what they really want in photographic coverage. Most wedding clients have little idea of what kind of photography they want. Most of them want "some pictures." That is what they tell you because they don't know how to express it any better. You must take the time to show you care and to help them decide what they want from you. You must educate them in the various photography styles, offer them different options in timing formats, different locations, and different techniques. If you get the couple and their families to think, then they can make reasonable requests which you can fulfill. If you don't convince them to think and tell you what they want, they will often get upset after the wedding because you did not do something they had assumed that every wedding photographer in the world did as a matter of course.

You must also persuade the couple that any wedding is an emotional roller coaster and that the best photographs are taken when they are at the emotional highs. Most weddings peak emotionally at the exchange of the vows and the coming down the aisle. The further away from that peak you schedule your photographs, the less emotional energy the couple will have left in their expressions and feelings. If you wait until the end of the reception to do the formal photography, you will get a bunch of tired, drained people who can hardly stand up, never mind look happy. In short, try to anticipate all of the problems that could happen after the wedding day is over, and solve them in advance with the couples. They will appreciate your help.

IMPORTANT POINTS TO GO OVER IN PREPLANNING: The important points to impress upon the bride and groom.

(1) You cannot start doing the groups until everyone is at the chosen location. If a bridesmaid goes off to the bathroom, or a groomsman stops along the way to buy a beer, everyone must wait. Your scheduled time starts when all of the parties on the "Where and When" sheet are present and accounted for (with their flowers and formal clothing all in place). Tell the couple that you can start the couple sequence first, but it won't be

as nice as when it's done in the proper sequence, as all of the rest of the wedding party will be watching them.

(2) Specify how much time each group of photographs will take. The larger the wedding party, the longer it takes to get everything done.

(3) Tell the wedding party not to drink until after the photos, as often they spill the booze on their formal wear, as well as become unruly.

(4) Unless the reception area has a separate posing area removed from the rest of the guests, avoid doing the formals at the reception. The guests will be everywhere, making the couple nervous and slowing down the entire process tremendously.

(5) Doesn't it make a lot of sense to do all of the formals at a beautiful location before the wedding?

I have done all of the shots listed below in ten minutes. The father of the bride was very concerned with keeping to a time schedule. The part that made it easy was everyone in the wedding party and both families left the church in a decorated double-decker English bus (what a ball we had inside). We had chosen a scenic area on the way to the reception, and we pulled up right on time. The father organized all of the groups (he was president of a Fortune 500 company, and no one argued with him), while I posed and photographed twenty different groupings. We were all back on the bus in ten minutes with some good photographs and everyone very happy. I would have liked more time, but I was able to do a good job under very stringent conditions because of good organization.

I think it is most important that you take all of the essential photos as quickly as possible, even if you are rushing and not making every one perfect. In my early days, I had couples just leave for the reception before I got to the close-ups of them alone because I had spent so much time fussing over the wedding party and family photos. Most bridal couples have a limited amount of patience and want to get to the party. It is important to keep a smooth flow to your work and to maintain a constant banter to keep the wedding party focused on you. As soon as someone else takes control of the emotions of the group, your job is ten times more difficult and much slower. Never lose control. Don't let outside events or influences take over the control of the wedding party's attention. If the weather, traffic, schedule, some drunk groomsman, or the parents take over control, you will have to work much harder to get a result half as good.

The trick to keeping control without losing the positive goodwill of the wedding party is to keep the whole experience fun or humorous. You must learn to make light of any of the tensions of the wedding day, to make jokes about the bad behavior of unruly wedding party members without offending them, to get people to laugh with you or at you for the period of time you need to work. You cannot be fiddling with f/stops or concentrating on fixing lights at this time. You must maintain eye contact and vocal control of the party. You must also focus most of the energy back to the bride and groom.

One of the biggest distractions at a wedding party formal shoot are small children in the wedding party. Often a bride and groom will want their young relatives in the party because they think they are cute. Most children under two or three years old are cute for about fifteen minutes, and then they get restless, especially if they are not the center of attention. Small children know how to get attention, they cry, have tantrums, and make life miserable for adults. If everyone responds to the tykes to keep them happy, the wedding couple is deprived of the emotional attention they deserve. Don't you lose your focus. Keep the wedding couple in the center of your attention. If you have done a lot of children's photography, you will have learned to handle them, but don't do it at the expense of the couple. Make sure you bring toys and surprises with you. I always have squeakers or Chinese yo-yos in my wedding camera bag for those moments. See FWI's catalog for some great items for children.

Wedding Party Photography Rules

(1) Have all of the groomsmen and groom pull up their pants. Rented tuxes usually don't fit well, and tend to bunch up at the ankles. Also, have them adjust their cummerbunds/vests and ties.

(2) Don't allow the groomsmen to hold their hands in front of their crotches. Have their hands at their sides or behind them. Tell them it looks like they have to go to the bathroom.

(3) Have the bridesmaids hold their flowers at the proper level. I tell them to think "fig leaf" and then adjust the heights to make them even. The tendency of bridesmaids is to hold the flowers like a flagpole and extend their elbows out like a majorette. Keep the elbows in. Have them keep their weight on the inside foot, with the front foot pointed back toward the camera. The camera should only see the front leg if they are standing properly. Tell them that this is the "skinny pose," and they will cooperate. Show them.

(4) Have the groom hold the bride in a comfortable position. For the groups, have the bride's back to the groom so that they can snuggle. Watch out for the groom's back hand coming around the bride's back and showing underneath her far arm. Make sure the near hand gently holds the bride's arm, and doesn't hold it like a baseball bat. Watch that the veil flows between them and isn't caught on the groom.

(5) When doing the full-length shot of the couple, remember that the veil and the train are as much a part of the portraits as the feet and the hands. Make sure the dress is fluffed up and spread out to show the back of the train as much as possible. Arrange the veil carefully.

(6) The flowers are part of the composition, but should not dominate. Make sure that the bride holds them gracefully. Do not push them up into the face in the close-ups in an unnatural way, but keep them at the bottom as an accent. Use the veil to create leading lines in the close-ups. Have a bridesmaid or the groom hold the veil off to the side for effect. Shoot through the veil for effect.

Taking the Formals Before the Wedding

Many experienced photographers put a lot of effort into persuading the bride to take the formals before the ceremony. The advantages are mostly for the couple as well as the photographer, but you are fighting the superstition of not seeing the bride before the ceremony. That has no real meaning in most Western European cultures. This is not a tradition, but a superstition based on nonsense stories told by grandmothers to their young granddaughters. Ask if they would cancel the wedding if they broke a mirror? What would they do if a black cat walked across their path? Same nonsense.

Pros of prewedding formal photography are: (1) Much less nervous energy rushing to fit in the formals between the church and the reception. (2) More time with their guests. (3) Better photographs. (4) A much more romantic time for the groom to admire the bride in her beautiful wedding dress away from the bustle of the wedding day (this is oh-so-true!). (5) All the photographs are taken with the hair and makeup and clothing in perfect conditions, before the stress of the ceremony and all of the hugs and kisses. (6) The couple gets a lot more control over the choice of a location.

There is a good deal of resistance to the idea, but after a couple tries it, they will realize how smoothly their wedding day runs. They will give you written references to help you sell the next couple on the idea. After you have shot before-the-wedding formals, you will realize what a great idea it is and sell the idea from true conviction, not from your business perspective.

Wedding Shot List

The last thing you want to show a prospective wedding couple is a shot list. There are some real cheap studios that hand out a sheet of paper with "One Hundred and Fifty Fantastic Fotos For Fabulous Wedding Days," and ask the couple to mark off what they want. There are two reasons you do not want to show such a list to a couple. (1) If you allow them to select a number of poses in writing, you are obligated to provide every shot they mark. If you miss one, you may be held liable for failing to complete your contract. (2) You have given creative control of the wedding photography over to the couple, who generally doesn't know what they really want, and you become just the cameraman for the day. Thinking of the poses and their sequence is your job, and you should have to work a little bit for it.

The list below is for your use only and is to give you some ideas for what you might shoot on the wedding day. I have organized the shots into sequences that go naturally together. Once you've started doing the window-light portraits, do them all. Don't run around doing different types of photography as you will waste lots of precious time.

Abbreviations: B=bride, G=groom, M=mother, F=father, BM=best man, MH=maid (or matron) of honor, BrMs= bridesmaids, GrMs= groomsmen/ushers, WP = wedding party (couple, bridesmaids, and groomsmen), GPs=grandparents.

SHOTS TO TAKE BEFORE THE WEDDING: Engagement of B and B&G, either in the studio or in outdoor setting. Special-effect shot of B&G, such as sunset or silhouette. Photo of invitation against flowers or fancy background. Double exposure of couple with invitation. Rings on fancy background.

PRE-BRIDAL: Full-length and close-ups of B with lots of detail of dress. Try moody shots. Use high- and low-key styles.

THE BRIDE'S HOME, GETTING READY: Lots of candids of B and BrMs getting dressed, doing hair, fixing veil, etc. Use mirrors, different angles. Look in the bathrooms; there is usually a lot of action in there. Shoot faces and interaction of different WP members. Watch M and F for details of expression. Try to catch F off-guard. Get flowers on table and table of gifts, if they are present. If there are any fancy decorations, document them. If there are any children in the WP, shoot with their parents, if possible. Look for family groups of the B's brothers and sisters, especially if the smaller children are not going to the wedding.

Set up a window-light area for formal portraits. If there is no window light, find an area you can set up good artificial lighting or find an outdoor location for bridal portraits. Do series of B, B with M, B with F, B with MH, B with M and F. Do the BrMs individually. Do B close-up and soft focus. Get in rings and flowers as much as possible. Don't forget GPs.

Set up area for full-length portraits. This area may be in the living room or some other nice area of house, or perhaps outside in the yard or other prearranged spot. Do B full-length, both front and back views, B with WP, B and WP and M and F, B with any children in party, GPs if they are there. Don't forget the family pet. Get ready to do the going-away sequence—getting ready, going through the door, getting into the limo. Try to get a series of different views that will tell the story.

AT THE CHURCH: If you can get there early enough, go to back and get G and BM waiting. Include clergy if they are available. Take fun as well as straight shots. Get B arriving. Get F helping B out of limo into the church. Get candids of the crowd milling around. Get Ms going down aisle, get WP performing any official duties. Be sure to get all of WP as they go down aisle. Position yourself so that you get the nicest background possible for each shot. Look for stained-glass window or interesting feature of church. Get B and

F as they come toward you, as they pass you, and as they come to end of aisle near G. If you can, get the B meeting the G. If the B kisses F good-bye, get it.

Switch to available light camera setup. Go to balcony, if there is one. Get all altar formalities, the vows, the rings, the readings, the offering, the candle lighting, etc. Use soft and normal focus. Use double exposures with stained glass if possible. If you have a magazine back, do a shot to double with a portrait of the couple later. If you have preshot the couple, do the altar shot now. If in the balcony, go down and shoot from floor angle or from the side of the church, wherever you can position yourself without disturbing the ceremony.

Switch back to the strobe camera. Get the kiss at the end of the ceremony, as well as the smashing of the glass in a Jewish ceremony, and then the B and G coming down the aisle. Get the rest of the WP if possible. Get the B and G coming out the door and then concentrate on the kisses and hugs. If the receiving line is at the church, help set it up and do some candids of guests and WP.

After the receiving line, do the formals, either at the church altar, a preselected location, or at the reception area. Do full WP, WP with parents and GPs, B and G with all parents, with his, then with hers, with brothers and sisters if they are present. Do G with GrMs, do B with BrMs. Do B full-length, do B and G full-length, straight and moody, do close-up of B and G. Make sure you get a newspaper picture using black-and-white film. Do any special shots of the couple. Use the church or any scenic area, and use your imagination. Do any family photographs at this time, if feasible.

AT THE RECEPTION: If the receiving line is at the reception, get candids. Get shots of the food layout, the cake before it is cut, any special decorations in the hall, and the band. Start concentrating, on faces of guests and WP. Be prepared for the formal part of the reception, which would include: (1) the grand entrance, (2) the toast, (3) the cake cutting, (4) the first dance, (5) the father's dance, (6) the garter/bouquet toss, (7) the going-away dance, (8) the going-away sequence, and (9) any special event which the couple has arranged for their wedding day. In between, keep your eyes open for any candid shots. Watch the dance floor for GPs and parents and other members of the families and WP. Do any informal groups the couple may have requested, such as friends from work or school. See if you can arrange a few moments alone with the B and G to take some informal mood and/or fun shots, especially if there is a scenic area close to the reception hall. If possible, do an "everybody shot," where all of the guests can be in one photograph together. If you can find a high position, this is a great shot to get.

Some wedding couples want "table shots" taken. If previously arranged, do them during the meal service, as that is the best time to make sure all guests are at their tables. Table shots are a hangover from the past and are not as popular anymore, but you will still get requests for them. Most food service people hate having you work when they are trying to serve a meal, so make sure you coordinate with the mâitre d'. I personally hate doing table shots. Very few couples actually use them in their albums if you have provided good candid coverage of other parts of the reception. They are a lot of work. One way of avoiding and/or making a profit at table shots is to tell the couple and families on your price list/contract that every table shot must be an 8×10 in their album. If they have a thirty 8×10 package and twenty-two tables, the wedding album will be very thick or pretty boring.

Formal Posing

The posing for bridal portraits, individual, couple, or groups, requires that you work quickly and efficiently. Most weddings are photographed with severe time constraints, which leave

you little time to experiment or change poses. The best way to organize the formal pho-
tography is to think in terms of sequences of poses and to do similar things together. For
example, I work the sequences listed below, based on some basic rules of procedure.

Rule #1: Start with the largest group and work down to the couple/individual por-
traits. There are two reasons for this. The first is that it gives the bride and groom time
to relax before you get to the close-ups of them, and, secondly, it allows the parents and
families to go on to the reception or the church to get the other events under way. Rule
#2: Family takes precedence over wedding party in shot priority. Do family groups first
before going to wedding party formals.

FAMILY SEQUENCE: (1) Entire bride's family, including in-laws, cousins, or anyone else
present. (2) Bride's immediate family, i.e., mom and dad, brothers and sisters, and groom.
(3) Bride with brothers and sisters. (4) Bride and groom with mom and dad and grand-
parents. (5) Entire groom's family, repeat above sequence.

WEDDING PARTY SEQUENCE: (1) Wedding party (i.e., all bridesmaids, groomsmen, ush-
ers, flower girls, ring bearers, etc., with bride and groom. Can be posed two ways. Girls
on one side, boys on the other, or by couples, i.e., alternate boys and girls. (2) Wedding
party with parents (and grandparents, if there). (3) Dismiss attendants and do couple with
all parents and grandparents. (4) Do couple with bride's parents and grandparents. (5)
Do couple with groom's parents and grandparents. (6) Do couple with best man and maid
of honor. (7) Do the bridesmaids with the bride. (8) Do the groom with the groomsmen.
(9) Vice versa of previous shot. (10) Do fun shot of entire wedding party. (11) Dismiss
wedding party.

BRIDE AND GROOM SEQUENCE: (1) Full-length of bride, front and back views. (2) Full-
length of couple, straight at camera and looking at each other. (3) Close-up of couple,
straight. (4) Close-up of couple, moody. (5) Moody shot of bride. (6) Black-and-white of
couple for paper. (7) Special-effect shots of couple. (8) All done.

In most weddings, you have ten to sixty minutes to do all of the above. Sixty min-
utes with a large wedding party with a lot of family is not a lot of time, so you still have
to keep to your sequences and keep moving. If the bride and groom feel that they are
missing out of some of their wedding day, they will start fighting you, and your pho-
tography will lose its impact.

Photography in the Church During a Wedding

The amount of photography you can do in various churches will vary considerably with
denomination and local custom. I used to work in one Catholic church where the priest
would make me stand next to him during the vows and would stop to point out good
shots for me to take! I also had one wedding at a church where photographers were not
allowed inside the building, and I had to sit on the outside steps after the bride went in.

The really hard-nosed clergy became that way because of abuses by photographers
in the past. Some of our colleagues have no respect for the solemnity of the ceremony
and the religious aspects of the sanctuary where the ceremony is taking place. I know
of one documented case (the priest who did it told me) where the priest stopped the
service, jumped off the altar, grabbed the disrupting photographer by the neck, and physi-
cally threw her out of the building. The key to establishing a working relationship with
your local clergy is to establish communication with them. If I am working in a new
church, I will either call the day before or make sure I get to the church in time to intro-
duce myself to the clergy and to find out their rules. If you are dressed like a professional
and act like a professional, they will usually cooperate with you, but it is their church.
Play by their rules.

Most Catholic and Orthodox churches are fairly liberal with where and when you can photograph with strobes. Generally, as long as you are reasonably quiet and respectful, you have the run of the church. Most Protestant churches do not allow flash photography once the couple is down the aisle and the religious service is under way. Most will allow available-light photography from the back, balcony, or sides of the church. Jewish synagogues are subject to the wishes of the local rabbi, so you must check ahead. My local rabbi told me the first time I worked with him that after a certain point in the ceremony, "Either I work or you do! Not both of us!" He was quite clear in his concerns, and it was easy to comply with his rules and do my job well. When rules of behavior are given in very specific terms, obey them. You do our profession no credit by being a jerk, and you will probably lose business from that church by getting a bad reputation.

I prefer to be seen as little as possible by guests at the wedding once the bride has gone down the aisle. Using ASA 400 film in conjunction with a long lens, I get good close-ups of the altar, ring exchange, etc. I use a tripod and try to be as quiet as possible. I explain my approach to the couple, and they understand the differences between the strobe photographs and the available-light ones. Some fine wedding photographers I know continue to shoot with flash (and double light to boot) throughout the ceremony. As long as that is what the couple wants and the clergy will accept, it is OK. It is really a matter of personal style and preference.

Wedding Price Lists and Contracts

A wedding is probably the most significant event in many people's lives. Anything that causes it to turn into a disaster will release anger seen nowhere else in our culture, and this anger is usually followed by legal action. The damaged wedding consumer usually has the sympathy of the courts. If there is something you did wrong, you will pay for it dearly. There are two kinds of legal errors: errors of omission and errors of commission. Errors of omission are such things as: you didn't write the appointment in your book and you didn't show up at the wedding, or your lab destroyed the film in processing. The average settlement for such cases that reached the courts was about $5,000 in 1985. You cannot argue that the lab destroyed your film. Handling the film and making sure it is processed safely is your professional responsibility.

An error of commission is more subtle. The couple says that you promised to give them 400 8 × 10s in a mink-covered album, and you say you promised twenty-four 8 × 10s in a leather album, but you have no written contract with the couple. It is your word against theirs. They also claimed that you did not perform all of your duties and didn't photograph every relative that they had asked you to. Grandma Smith has since died, and your lack of care has caused them hardship, pain, and suffering, and you should pay them $100,000 to make them feel better! Again, you don't have a written "Where and When" sheet to prove what they told you and what you did.

A wedding price list and your wedding contracts should be very specific about the following items, detailing exactly what is included in a wedding coverage by your studio. The areas to be detailed are: (1) Amount of time you will be at the wedding and when you will leave. (2) Number/sizes of prints and/or albums that are included in the coverage. (3) Dates, times, and places where the events of the wedding are to take place, and who is to be included in the photographs, including any special requests the couple or family may have. (4) Payments and payment schedule. (5) Cancellation policy. (6) Limitation of liability in case there is a problem and the film is destroyed, either through negligence or by accident.

Don't assume that you can do weddings with a handshake. First, it is unprofessional, and, second, it is dangerous.

DISCLAIMER STATEMENTS: Most commercially printed wedding contracts have a statement such as "in case of loss of film, for whatever reason, the photographer is responsible only to return any moneys received." This statement may not hold up in open court, but having stated it clearly will keep you out of court eight out of ten times when a disaster does strike. You should have a discussion with a lawyer about what you should and shouldn't say in dealing with any client, especially with wedding clients. Verbal contracts are binding if either party can prove that they were made, but that usually involves a lengthy court battle over who said what! Reduce everything to writing. On your price list, specifically state something to the effect that, "The studio is not legally bound to perform any photographic function which has not been requested in writing before the wedding." Get a lawyer to word this idea properly, and stick to your guns!

A typical area where you can get into trouble is grandmothers. Many times, they will leave the church and not go to the formals session. When you get to the reception, they have planted themselves in some corner; they don't move from their seat to the dance floor, and they leave right after the meal. If the couple asked for photographs with grandmother, and you waited, you are in trouble! This is why the "Where and When" form is so important to establish wishes and reality with the couple. If you had planned to photograph them at the formal session, and they did not come as arranged, it is not your fault that you missed them later, in a legal sense. Make sure that you try hard to get them at the reception if they didn't show up at the formals so that you can include them in the album. This is good business sense.

THIRD-PARTY CONTRACTS: Another area where you can get into deep trouble is dealing with three parties about details. A third party may be a parent or grandparent who is making arrangements for the couple, or a reception hall if you package your photography with its services.

This story illustrates my point perfectly. A mother of the bride came in to book a small wedding coverage on short notice in February. I was free and signed her up. I did not get to meet the couple, but that is not unusual because I work in a resort area where many of my couples live at the other end of the country and their parents are making all the physical arrangements for the wedding. On my wedding contract, I wrote down all the special shots that the mother asked for, mainly that I should get a lot of family photographs of both sides of the wedding. This was not an unusual request, and the mother and I both signed the contract, and she paid me in full for the coverage.

The wedding was a festering cesspool of hate and spite. The bride was high on some medication, and the two families despised each other. We got to the reception area where I was supposed to do the formal groups, and I did the wedding party formals and then the groom's family with the couple. I then started to ask the bride's family to gather around, and the bride started to walk away. When I asked if she would like photographs with her family, she said no (quite strongly) and walked off. So much for the family shots. I left the reception soon after this, and when I got home the phone was already ringing. It was the bride's mother; "How dare you not take those family photos! I have a contract with you!" etc., etc., for an hour. She was right. She did have a piece of paper signed by me agreeing to provide her with a certain number of specific photographs, and I could not deliver.

I had made a contract with a third party which depended on the cooperation of the second party (the couple) to accomplish. It all worked out in the end as tempers settled down, but I learned a lesson. I always consider that I am working for the bridal couple no matter who pays for the coverage or signs the contract. If the desires of the couple

are different than those of the parents, it is the couple I obey, and I make this point quite clear on my price list's policy section.

SPELL OUT MARITAL CONDITIONS OF THE PARENTS: In this modern world of short-term marriages, it is not uncommon to have one set, and often both sets, of parents divorced at a wedding. The best policy is to openly discuss this situation with your wedding couple at the contract signing and figure out how best to handle any situations that may arise. Most divorced couples will act decently, but not all! I have done weddings where we had to keep mom and pop in separate rooms so they wouldn't see each other. It was kind of hard to do the family shots, but we managed. There are also new spouses, "friends," or live-ins to deal with. Don't get stuck in the middle. Ask the couple to tell you how you are to behave, and who they do and do not want in their wedding album (especially if you use a no-proof system). The same may apply to other problem guests. Ask if the couple expects any unusual behavior from any of their guests. If there is an uncle who always gets drunk and starts a fight, you want to know about it in advance, and whether or not to take photographs of it.

At the formal session, you must control the posing to facilitate the couple's wishes. If you have divorced parents and there are strained feelings, *you* must handle them. I have found humor to work. I have also found that you must keep things under control. If a divorced dad, who is footing all the bills but not getting the center stage, starts to act up, especially after a few drinks, you have to try to keep him involved and feeling important. My best line in recent years was in a situation like this. I had done the big wedding party shots and wanted (at the request of the couple) the family shot. I asked dad to stand next to mom. He looked at me and said, very strongly, "I'm not married to her anymore!" I replied, quite loudly, "I didn't ask you to kiss her, just stand next to her!" They all laughed, and we got the shot. I didn't attack, and they all realized how silly the situation was becoming. I won, but, more importantly, the couple won.

UNCLE HARRYS AND AUNT MATILDAS: Wedding photographers rant and rave over those most disgusting of subhuman creatures, relatives-with-cameras, at their weddings. Many pros experience a real fear that these people will actually steal a sale from them by copying one of their set poses during the formal section of the photography. The standard wedding contracts all have statements such as "this studio will be the only photographers allowed to take photographs during the wedding day." I have heard of photographers actually enforcing this rule and forcing an uncle or friend to put away the camera after a dramatic confrontation in front of the bride. How professional!

I take the position that the guests are just that, guests of the couple. I am not going to worry much about losing any sales, and I don't want to look like a fool chasing grandmothers out of the church. Ninety-eight percent of the time the relatives are not trying to steal your thunder, but are doing their own thing with their own camera. They do get in the way sometimes, and they do slow things down, especially if you are on a tight schedule.

I have a simple, positive solution. I will get the first formal group almost ready to shoot (i.e., I have not adjusted the hands, heads, or fine posing details within the group), turn around, pretend to just notice the relatives with their cameras and say, "Why don't you folks take your photographs first, and when you are done, I'll take mine!" in a friendly tone of voice. I then go and sit down in a pew, if I am in the church. The relatives start flashing away and after about thirty seconds the bride realizes what a waste of time this is and she will kick them out. You don't have to say a thing! You are Mr. Nice Guy, and she is in a hurry. It works 95 percent of the time.

The other 5 percent are the real problems. When a relative shows up with a 2¼ camera with a professional strobe and then stands two feet behind you and won't leave under

subtle pressure, you have got a real problem. Again, it is not the lost sales as much as your lost timing and rhythm with the couple. If the person is really obnoxious and is bothering the couple, the couple will usually find a way of getting rid of them. For the really persistent ones, I get physically abusive (not verbally), suddenly backing up into them and stepping on their toes, etc. But I am a large man, and this technique wouldn't work for everyone. You must always remember that they are still guests. In the worst cases, take the couple and the parents aside and tell them how difficult it is to work with the distractions of the person, and something has to be done. Do not make a public scene. I was photographing a wedding where the videographer was having difficulties with an uncle. During the bride's dance with her father the two actually got into a fist fight on the dance floor. This is not professional behavior! You'll lose far more in reputation with anyone connected with the wedding with abusive behavior than you will gain in print sales. Behave in a totally professional manner at all times.

I have more problems these days with the amateur video types. They tend to get in the way of everything, especially in the church. I make a point of standing in front of them until they get the idea that they are in the way, if I can't be more subtle. I sometimes have to have the couple or the parents tell them to not bother me. The worst offender is the "professional" videographer who brings hot lights into the church. There is not a whole lot you can do if you don't know about it in advance. Once the ceremony gets under way, you can't correct the situation. I did a wedding where the video man (hired by someone other than the couple as a wedding present) had two 750 watt quartz lights facing the audience in the church. No one could see a thing, and I couldn't take any good available-light shots! Needless to say, the couple was as upset as I was. Not getting good ceremony shots did not reflect on my work at all, but the quality of my album suffered.

Working with Videographers

Many couples are hiring both photographers and videographers. It is my observation that video, especially at good weddings, is decreasing in frequency as we move through the nineties. What you do as a photographer is vastly different from what a good videographer does. As a photographer, you are trying to get "inside" a wedding to capture emotional highlights and the spontaneous interaction of people in emotional situations. A good video person takes an overview of the wedding day, looking for the sequence, flow, and motion associated with the events of the day. I find that when I work with competent video people, I get in their way more often than they get in mine. I usually am talking to the bride and a good video person can't talk and videotape at the same time. I also don't care because typically I am charging four or five times as much as the video person, and I feel my work is more important than theirs.

I also feel that there are different turfs where you should take right of way and also give right of way. The home of the bride is my turf, especially during the formal posing sequences. At the church, you have equal rights, but usually different points of view so that you don't get in each other's way. The one major exception is coming back down the aisle after the ceremony. To me, this is one of the best and most valuable photographs of the wedding day, with the couple looking radiant and relieved that the formalities are over. I claim the center aisle and will not yield to anyone.

When I do my formals, I invite the video person to come and record the events, but not to interfere. I am very confident that I can keep the flow of the session fun and interesting enough that the couple will enjoy watching it in future years. The video person must realize that they are there to record, not to help or get their own shots. At the

reception, the video person has more right of way. On events, such as the first dance, cutting the cake, it is usually easy enough for you to move to a different angle so that you don't interfere with what they are doing. The good video people work hardest at the reception, while your job becomes a little more documentary. When working with good people, it is easy to help each other keep out of shots, or to get the good candid sequences.

The problem is that many times the video person is not a professional, this is his or her third or fourth wedding, and he or she doesn't know what to do. I do not worry about him or her, but concentrate on what I have to do to earn my fee. I am not above telling a novice video person to back off or to act properly. You will soon get to know the good ones, and they usually have the same sense of professionalism you have. You should work together to the benefit of the couple. The nonpros are a problem, and I think they are going to be around for quite a while. I have a number of videographers I strongly recommend to my couples for their skill and professionalism, not to mention my ability to work with them in a professional manner.

Many of the good video people use small lights for better lighting. I have found that the small 100 watt lamps do not affect your photography at all; in fact, they make focusing in dim reception halls easier. I strongly protest if a video person brings in heavy-duty lighting of over 250 watts. Most guests and the families also protest because the heavy lights ruin any atmosphere the reception area may have had.

The "Where and When" Form

Below is a copy of my "Where and When" form. Be sure to use it as outlined above.

Where and When

To insure that we get all of the photographs of yourselves, your family, and the entire wedding party in the least possible time, it is important to think about where and when we will do your formal photographs. By organizing everyone involved, I can work efficiently and return you to your guests in the shortest amount of time.

Some basic planning ideas:
1. Plan for bad weather, and hope for good weather.
2. Most reception areas (with a few notable exceptions) do not have good backgrounds for large groups. Most churches are better for the group photographs than reception areas.
3. When going to a special location, it is essential to have everyone well informed and to stay together.
4. Plan to photograph the largest groups first (parents plus whole wedding party), parents groups next (with grandparents, if desired), then the wedding party, and, finally, the couple. As each group finishes, they can go to the reception area to get the party started.

FORMALS: Check poses desired.

Rain location _____

Good weather location _____

WEDDING PARTY WITH PARENTS
Where _____ *When* _____
BRIDE AND GROOM WITH PARENTS

Where _____ When _____

BRIDE AND GROOM WITH GROOM'S PARENTS

Where _____ When _____

BRIDE AND GROOM WITH BRIDE'S PARENTS

Where _____ When _____

GRANDPARENTS? ☐ YES ☐ NO

WEDDING PARTY

Where _____ When _____

GROOMSMEN

Where _____ When _____

BRIDE ALONE

Where _____ When _____

GROOM ALONE

Where _____ When _____

BRIDE AND GROOM, FULL-LENGTH

Where _____ When _____

BRIDE AND GROOM, CLOSE-UP

Where _____ When _____

BRIDE AND GROOM, B&W FOR PAPER

Where _____ When _____

FAMILY GROUPS: Family groups can be done (1) the night before, or the morning before the wedding, (2) at the church, (3) at a special place, and (4) at the reception.

BRIDE'S FAMILY

Where _____ When _____

GROOMS' FAMILY

Where _____ When _____

Please fill in, sign, and return to the photographer at least one week before the wedding.

SIGNED _____ DATE _____

High School Seniors and School Photography

After wedding photography, the high school senior market is one of the most easily accessible markets to the new photographer. The high school senior portrait is a long-standing tradition in North America. Since someone has to take that portrait, why not have that someone be you? Unfortunately, the senior portrait is also associated with the yearbook, the people who administrate the school, and the school photographer. The idea of being forced to get your portrait taken is a negative one for many seventeen and eighteen-year-old students. Part of the challenge of doing senior photography is to overcome the negative images that people have and to produce good, salable photography.

The High School Senior Photography Market

Some statistics will give you an idea of the market. The number of high school graduates in 1992–93 was 2,461,000 (public school only); in 1979–80, was 3,058,000; and in 1969–70, 2,896,000. Enrollment in private high schools (grades 9–12) was just under 10 percent of the public school figures, so one may add about 240,000 for the number of graduates in 1992–93. There are also a number of students who start their senior year but who don't graduate. These students are also good senior photography prospects, even if they are not good academic ones. I would estimate that you could add another 10 to 15 percent to the population figures. There are also college and university graduates (undergraduate and graduate), nursing schools, and many other postsecondary schools which have some type of graduation ritual.

If you live near a military base, I would classify portraits of soldiers/sailors in the same category as high school seniors. It is an area in which I have no personal experience, but if I were near a military base, I would figure out how to

market package photography to the troops. Since most military bases are closed environments, it would be easy to advertise your services to such a captive audience.

The population coming through the upper school systems in the late eighties decreased dramatically, but it has since rebounded. There is a second-generation, baby-boom coming though the elementary school systems now, which will show up in six to ten years in the high school senior population. The decrease in the number of seniors meant increased competition among photographers, and I think it has affected the large outfits more than the local studios. There are also large local variations related to the average age in your area and to your local economy, which may drastically affect the number of high school seniors and what they spend on senior photographs.

There are also regional differences in senior photography. When I had my studio in western Canada, we did almost no senior photography as it is done here in the USA. In western Canada, we promoted graduation portraits in the spring, when the students were about to graduate. We did almost none in the fall for inclusion in the yearbook. I did some nursing schools, and some university students, but they were for graduation, not for their yearbook.

Do You Like Teenagers?

The first thing you should decide is how good you are with seventeen- and eighteen-year-olds. Do you hate rock-and-roll or think that Bon Jovi is a high-powered sink cleaner? Do outlandish outfits, green hair, foul language, giggles, and rudeness disturb you? Do you tire of insecure people with big egos? If so, don't try photographing high school seniors, especially on contract. However, if you do like teenagers, if you relate to them, their dreams, their fears—go for it. If you have not had much contact with teens, get some experience before you start trying to get high school contracts.

ABOUT SENIORS: THE BAD NEWS. Seniors spend hours on their hair, but never seem to be happy with how it looks. They spend hours on their hair and clothes and then smile and show off $2,000 worth of wire, which they hate. They have the bodies and wardrobes of soap opera stars and yet are shy. Most of them do not want to see what the camera is about to see, because they are afraid it will show them as ugly, or at least unstylish. Some of them are absolutely convinced their physical appearance is not worthy of anyone's attention (this feeling has no correlation with their actual physical attractiveness), while others think that they are the most beautiful thing since Brooke Shields went to college (again, this feeling does not correlate with the facts all the time).

ABOUT SENIORS: THE GOOD NEWS. What's good about seniors, for photographers, is that, for the most part, they are young and beautiful, or as beautiful as many of them are ever going to be. They are malleable, and are willing to put their looks into your hands. When you do your job well, they love you and will give you lots of money. It is very satisfying to show a shy teenager that he or she looks absolutely normal, and to watch him or her come out of his or her shell to a more mature appreciation of his or her physical appearance.

The School Photographer: Your Main Competition

I have photographed a number of local high schools on contract. At one of my schools, about half of the seniors would come to the studio for their portraits, and I would do the other half in the school. One year, during the in-school period, we got a phone call from a mother of a senior trying to schedule a sitting at the studio. We told her to schedule a time at the school. She informed us that she "didn't want that school photographer to

take her son's senior portrait, but wanted a real photographer to do it." When we told her we were one and the same, she didn't believe us! Perceptions are more real than reality to many consumers. Don't assume they know everything, and don't assume they value what you do. There is a stereotype of the school photographer. He is a guy (sorry ladies) with a white shirt and wide tie who stands behind a big camera and says "smile." He has no face, no name, no personality. His photographs are "school" photographs, craftsmanlike and mass produced.

Most high school seniors (especially in the sixties and seventies) were photographed by large firms with many staff photographers who would go to the high schools and photograph a class of three hundred seniors in a couple of days. The proofs were "passed" by a trained proof passer who would return a few weeks after the shoot to take orders. The sports and activities were done by stringers or specialists who did nothing but the black and white. Some of these outfits would photograph at hundreds of high schools in a given year. They would usually hire photographers right out of photography school or the service, give them a few days of training, and ship them out. The key to mass-producing packages is consistency in exposure, so the lights were measured into position and never moved during any of the sittings. Again, the photographs were not bad, but there was certainly not a great deal of variety or creativity offered to the seniors. Most local studios were too busy doing weddings, babies, and families to bother to compete. The large outfits owned their own labs, were able to control their costs, offer packages at cheap prices, and still make a good living. Seniors and their families certainly got their money's worth.

These outfits are still around. They have a lot more competition than they used to have, and they have improved their act. The one and only major advantage you have is that you are small, and that you, not someone else, is going to do the photography. That is the weak point of the biggies and your ace in the hole. With the advent of more competitive color labs, you can produce packages for not much more than they can. With the increasing awareness of photographic styles, the impersonal corporate touch is losing its appeal. This is where you move in. You cannot compete with the big outfits in giving large kickbacks or in giving many free services to the school just to get the contract.

These firms stay in business because they do deliver what they say they will deliver, on time. They don't promise the world, and they do produce a pretty acceptable, if boring, photograph. Most school officials can't tell the difference between a school photo and one produced with good lighting and a good shooting style. As long as the service is good and there are no complaints from the parents, they are happy. School photography outfits know how to keep school officials happy.

In the past ten years, quite a few local studios have broken the grip of the contract outfits on local high school seniors. They have done so by offering better photography to the seniors through direct advertising, bypassing the contract option, and also by not doing the support photography the schools demand. Other local studios (including myself) have gotten the contract by outphotographing and servicing the big outfits. You can also do it, but in your first few years be careful that you can keep your promises.

To Contract or Not to Contract?

There are two types of seniors. One type is the contract senior. A single studio is awarded the contract by the school administration or senior class vote. The school then promotes the studio as the official photographer for the class. In many cases, the yearbook will only publish photographs taken by the contract studio and will reject any other submis-

sions. If you are the contract studio, you are given the inside track to the senior class in return for services to the yearbook staff.

The other type is the noncontract senior, whom noncontract studios attract through various direct-advertising methods to come to their studios instead of going to the contract photographer for his or her senior portrait. In some areas, because of increasing consumer awareness, many high schools do not have a contract studio, allowing the students to go where they please for the sitting. In most (not all, and not enforced well in some) states, even if the school administration awards a contract, the school cannot grant exclusive rights of access to the yearbook to a contract studio. If a noncontract studio submits a technically correct print to the yearbook editor, it must be accepted for publication. I will review the pros and cons of the two arrangements in one of the following sections.

If you get the contract to photograph an entire senior class, you usually will have to provide a whole range of services to the school and the yearbook, in addition to doing the seniors portraits. These services may include providing film and black-and-white paper to the photography class at the school, photographing sports and activities, taking an ad in the yearbook, and, in some cases, giving the school a percentage kickback of your sitting fee and/or gross sales.

Kickbacks: A Polite Term for a Bribe

There are various levels of kickback. Most are either a per head fee, or a fixed percentage of your print sales. In the worst cases, to get the contract you also have to grease a few official hands under the table. I know of cases where the yearbook advisor got $500, the principal got $250, and the school got 15 percent of the gross sale plus all kinds of free services by the contract photographer. Because of the amount of potential profit, there are many outfits willing to play this game to get the contract for the whole class. Fortunately for you, most schools are honest and bribes are not necessary, but kickbacks on sales may still be part of the deal.

I won't debate the morality of kickbacks here. When you are first starting out, I recommend you solicit contracts by offering yourself and your services. The money is good, and you'll get a lot of customers with less effort than through direct advertising. You'll have to evaluate whether or not you can pay the kickbacks, both financially and morally. Be sure that you are aware of the laws of your state in regard to paying any amounts to a public official. If officials ask for under-the-table bribes, they can be put in jail, and in some jurisdictions, they have been.

How Much Money Is Involved in a Senior Contract?

To give you an idea of the dollars involved, the average sale to a typical high school senior (1994) will run over $150. Well-run studios specializing in high school seniors can average up to $500 for every senior they photograph (e.g., Larry Peters of London, Ohio). I am concerned here with volume (over one hundred seniors) operations and true averages that reflect the buying habits of the typical senior. If you take a local high school with three hundred seniors, you are talking about a so-so photographer grossing almost $45,000 and a good studio grossing $150,000. Not a bad piece of change. Let's do a brief cost analysis to determine the profit involved in the above gross figures.

Costs

300 sittings (film, proofs, mounting, promo materials, mailings)	$4,500
Printing packages (8 units @ $2.00 per unit)	4,800
Mounts, etc.	1,000
Miscellaneous support costs	4,000
TOTAL	$14,300

Gross Income (300 seniors)

AVERAGE SALE	$100	$150	$200
Gross	30,000	45,000	60,000
Costs	14,300	15,000	16,000
PROFIT	5,700	30,000	44,000

The Pros and Cons of Contracts

When you are just establishing your photography studio, your most difficult and important job is getting any customers. Getting a high school contract will give you an inside track to hundreds of paying customers. Not all seniors will go to the contract studio, but many of them will go without a second thought since they want to be included in the yearbook. The price you pay for the captive customer list is becoming a captive servant of the yearbook advisor and staff. Typically, you will be obliged to spend a lot of time at the school photographing activities, sports, drama, and staff. For a high school of three hundred seniors, I estimate that you would spend a total of one to two full months of your year in order to fulfill your obligations with any degree of professionalism. I include in this estimate time spent doing both the portrait sessions and the activities photography. A lot of the service work is not interesting. Photographing the JV girls' basketball game on a snowy winter evening is neither fun nor photographically interesting. You must maintain your professional demeanor and do a decent job. If the profit is substantial enough, and the spin-offs are good, I think that contracts are the way to go, especially for a new studio.

An established studio, with a good community base may not wish to invest the manpower in the activities photography required by the school. These studios can elect to attract the seniors by direct mail, by newspaper advertising, and by any other means available to them. These studios usually have to pay more per senior in advertising than a contract studio spends in services offered to the school. What the noncontract studio saves is the amount of labor involved in the activities photography. As a newcomer, your time and labor are what you have to offer to the client.

Getting a Contract

If and when you are ready to go after the contract, follow these steps outlined below.

1. Learn the name(s) of the yearbook advisor and the principal.

2. Find two juniors from that school, one male and one female, who are photogenic and offer them a complimentary sitting. Use all your skills to produce a great sitting with lots of proofs of lots of poses. Don't skimp. Make sure you get both traditional and nontraditional poses, lightings, and backgrounds. For the use of their images, pay the juniors a modeling fee of $25 and get a signed (by them and their parents) model release for use of the photographs in a public display and in media advertising.

3. Go to a school event, such as a basketball game or school play. Photograph it in

black and white. Get good shots that prove you are a real pro. If you can't do sports or activities, you will have to hire someone who can. Sometimes a local newspaper photographer will moonlight for you in this area at a reasonable rate.

4. Your portfolio. Have a complete package made up of one pose from each of the sittings, showing all sizes offered. Make sure that the negatives have been retouched and that all print retouching has been done to enhance the portraits. Put all the prints in folders. Put the proofs in folios. Print the black-and-white activity photos into 5 × 7 glossies. Blow up a couple of great activity shots into 8 × 10s. Make sure you have included good action shots.

5. Prepare a price list of services to be offered to the seniors. List packages, à-la-carte prints, sitting fees, and all other charges you will be offering. Use your lab's price list to determine the best packaging. Your lab should be able to help you here. They may even supply you with some promotional materials that you can use to explain your packages.

6. The toughest part is getting an appointment to see the yearbook advisor. If the advisor won't return your call, be politely persistent. If he or she won't call back, go to the school to make an appointment for a future date in person. Don't lose your cool. Most advisors get dozens of bids each year and throw most of them out. Show that you are a professional, and that you are interested by being persistent. The decision for the next year's yearbook is usually made well before the end of the current school year. January or February is the time to talk to the advisor. If the advisor is really good at avoiding you, send one of the proof folios along with a request for the interview. If you can't get in the door with this, you have two choices. Give up until next year, or go over his or her head. If the school is in your town, you can write to the administration (superintendent or the head of school committee) claiming that as a local, you should at least be considered for any contract, and that you are being denied the opportunity to present your case. If you do this too harshly, you'll never get the job from the advisor, because you got them in trouble with their superiors. A little political subtlety is required. If you have photographed or know any faculty or staff people from the school, ask them to help you get the appointment.

7. If you have done your job and made an appointment, prepare yourself. Ask to have some students present (especially the editor of next year's book). Know your price list forward and backward, and know what you are willing to offer. Be prepared to answer any questions about kickbacks, free services, free cameras, etc., if they arise. Have all your facts and figures written down, as well as some background material on yourself. Have minimums ready to offer, but also prepare your maximum offer. If you are not willing to pay a kickback, you must be prepared to sell yourself and the amount of service and quality you'll be bringing to the advisor to make his or her job easier.

8. Keep your presentation short and sweet. Do not badmouth the current contract holder. Don't mention the studio at all. Sell yourself. Show what you can do, and explain how available you will be to them. Remember that your strong points are your availability to meet their needs more readily and your enthusiasm. Have your folios to hand out and your sample packages ready. If the students in the photographs are available, have them there to support you. Teenagers believe each other more than adults. If one of their own says you're good, they will usually accept that, assuming you didn't choose the class nerd for one of your models.

9. Don't take too much time—fifteen to twenty minutes is maximum. After your presentation, ask the advisor, "Are there any questions?" If he or she has none, create questions by asking about the yearbook. Ask to see copies. If you have yearbook experience from school, share your experience. Talk shop. If the advisor has had problems in the past, he or she will bring them out. Help solve their problems.

10. Ask how you're doing, but don't push it. If he or she is undecided, leave it. Conclude the interview. Leave your card, your price lists and bids, and some of your samples (this will give you a reason to come back again in about a week).

11. Immediately upon getting home, write a thank-you note to the advisor, thanking him or her for the time, and offering your services whenever he or she needs a photographer. Will this approach always work? Of course not. It will depend on how well the current contract studio is doing. If you are going against a good outfit (it could be another local studio) that is doing everything the advisor wants, is experienced, and provides the school with good service, you have a tough job. If, on the other hand, the advisor has not be been getting what he or she expects, you have a foot in the door.

12. Follow up and be persistent. I have a sign over my desk that says, "You have not failed until you've stopped trying." I worked for two full years on my main school contract. I finally got it. I beat out a good contract outfit, which paid big kickbacks, and my contract was for no kickbacks. Also, in some schools, the advisors change from year to year. You have a better chance of breaking in during a switch. Keep your name constantly in front of the advisor and the principal. If you get a ribbon at a state or regional convention and/or a news article in the local paper, make sure they get a copy and a small note. Never give up.

Let's go back to step 10. What if the advisor says yes, I want you to do the book next year? This is why it is absolutely necessary for you to have your offer in writing. The answer is usually in the form of yes, but. . . . The advisor will then start to negotiate the freebies and ground rules with you. See the checklist below.

Points to Cover in a Contract with a High School

1. Exclusive "official photographer" status. You will be the only studio allowed to sell, promote, and photograph in the school. This restriction usually applies only to seniors, as the underclass photography contract is a separate issue.

2. Establish what the yearbook photographs will be: (a) black-and-white or color, (b) head and shoulders or other types of poses, (c) standard background or free choice accepted in yearbook, (d) size of print required (and head size), (e) deadline for delivery.

3. Establish where and when you will start shooting the seniors. Reserve the right to shoot some sittings in the school building and have an appropriate room reserved for your time.

4. Get a mailing list of the class—very important. Do not depend on the school to promote you effectively. You must still do most of the work to get the seniors into the studio on time.

5. Establish how much time you will spend doing sports, activities, and other support work. This is your main negotiating point, so try to keep your time under control.

Some schools (especially the larger ones) will want you "available on twenty-four-hours notice" for any reason, and will place no limit on how many times they call on you. If you agree, you are a slave to the school. Try to negotiate five- to seven-days' notice and limit (ten to twenty times) the number of special events you'll cover, in addition to sport, clubs, and general-activity photographs. Define the number of days you will spend on clubs and activities. Sports is a separate arrangement. You should negotiate a "team day" for each season, when you would do all the team photographs in one afternoon. You should deal with the athletic director of the school on this point. It is not as easy as it sounds. You will also have to photograph at least one game from each sport to get the candids required by the yearbook. It is important to plan to do this as early as possible in each season because weather can be a factor.

With small schools, it is wise to tie the amount of activity work you will do to the number of seniors you actually photograph. If there are one hundred in the senior class and you only photograph seventy-five of them, it is not fair to expect you to do all of the activity work for the yearbook. One method is to credit the activity account with a certain dollar value for each senior photographed, and then to charge out your time and materials at your regular commercial rates to that activity account. This exchange is all done on paper, and no actual money changes hands. When the account is used up, you are not obligated to do any more work. This practice will encourage the yearbook advisor to use any and all pressures to get the seniors into your studio. Don't be stingy, especially when you are trying to break into the field. Give your time as freely as possible. After you have established your credentials, you can get a little stricter.

6. Establish other services. Some schools want you to provide film and paper for the students as well as a simple camera for the students to use. Some schools will want you to develop and print student film for use in the yearbook, which can get expensive. Make sure you understand your lab's prices. It is not easy to find a lab that does 35mm black-and-white cheaply. Establish how many custom-cropped color photographs you will furnish for the color section of the yearbook. The yearbook printers want all color prints printed to the exact size of the layout. Try to get the yearbook staff to use the standard 4×6 or $3\frac{1}{2} \times 5$ formats from 35mm negatives. Shoot your candids tight so that they don't need any cropping. If you are willing to teach some of the photo classes, or perform some other service, such as prepare a slide show for a yearbook promotion, include that in the contract.

7. Negotiate any other freebies, and try to limit them as much as possible.

8. Try to get the junior and senior proms tied in with the contract. It is to your advantage to get the proms. The proms can be very lucrative, and the junior prom is a good place to start promoting next year's seniors (even if you don't get the contract back). Some yearbook advisors like to tie the proms in with the seniors, others do not. Try. If you can't get the tie-in, find out who is in charge of the proms and contact them. Use the same steps as outlined above in getting the senior contract.

9. Obtain the right to use a prominent display case in the school in May/June and in September/October for promotional materials. Also, get permission to put up posters in the school.

SIZE OF THE SCHOOL IS IMPORTANT: There is a huge difference in going after a school with one hundred seniors and a school with three hundred seniors. It takes almost as much work to do the small school in terms of activities, sports, etc., as it does to do the large school, yet the only compensation you receive is the fees you get for the senior portraits. In simple arithmetic, one-third of the seniors means one-third of the gross income. The good side is that the large school outfits don't want the little schools as much. It is easier for a new studio to get these little fish! If you can get a small school, it will increase your chances when you go after the larger schools again. It makes you appear more experienced talking to the large-school advisor if he or she knows you have already photographed another school in the area. Sometimes it is feasible to go after two or three smaller schools in a given area, especially if they play each other in sports. Photographing one soccer game can cover two schools' requirements, cutting your time involvement considerably. However, I would much rather have one school of three hundred than three schools of one hundred.

What If There Are No School Contracts in My Area?

As previously mentioned, there are some areas where the schools have no contracts with any studio. Seniors are free to go where they wish for their senior portrait. In this type of market, it is critically important to get a mailing list of the seniors. Sometimes the school will furnish a list. In other markets, you have to buy it from a mailing service (see chapter 12) or create it yourself (see below).

In noncontract communities with other aggressively marketing studios, you have to compete for the seniors with either your photography and/or your price/convenience. The seniors will be receiving many mailings from different studios. Your photography has to stand out as well as your packaging and other services. Seniors like to see way-out or different styles of photography, such as the urban landscapes of Greg Barkholtz, the posing of Nancy Bailey, the glamour of Larry Peters, or the many different backgrounds that Wah Lui builds into his senior sittings. The seniors *want* to be photographed in way-out styles, but they do not necessarily buy them! Make sure that you get the traditional head and shoulders in all sittings. Seventy percent of the seniors will still buy the traditional poses, even though you would not have attracted them by just showing traditional poses.

One way of getting an inside track is to enter into a working relationship with a school. This is an informal arrangement in which you will do some of the service work for the school and the yearbook in return for a chance to advertise within the school. One Michigan photographer has two schools where he can go into the auditorium with a slide show to entice the seniors into his studio. He is allowed to have a display case in the schools. He gets most of the seniors from those two schools, even though he is not the official photographer, and these seniors are swamped with mailings from the other studios in town. The amount of service work to this photographer is much less than the cost of advertising to get the same seniors to come into his studio via the regular means.

Getting Noncontract Seniors from a Contract School or Getting Your Contract Seniors in on Time

If you cannot get a contract in your community, and you want to try to get some of the senior business, here are a few ideas to help. If you have the contract, you will have to work at getting the seniors into your studio as early as possible, and these same techniques will work.

1. It is paramount to get a mailing list of the juniors before the start of the summer vacation. You can get it by: (a) Asking for it (although the school may not be able to give it out by school board policy). (b) Buying a list for your whole area from a label company. (c) Making up your own list. If you can get the junior prom, you will have two-thirds of the names and addresses. To make up your own list, it is necessary to find one or two active juniors. You pay them one dollar for each name and accurate address of the members of their class. Don't pay them the full amount until after the first mailing, and then don't pay anything for letters that come back! Sometimes you can offer the one dollar per name in trade for your photographs of their own senior sittings.

2. With your mailing list in hand, make up a set of labels. If you have a computer, enter the list into your filing program, and generate the labels you need. You will need at least four to six sets. If you have purchased a list from a label company, make sure you get four sets of labels. I have found that for my geographic area, I can get four sets for the minimum that the company charges. The number of seniors in the minimum order (which is only $150) will vary dramatically with your location.

3. You must now create a mailing piece. You have a number of options. (a) Make a color brochure using some of Paper Direct's (or similar company) preformatted papers using color wallet prints from your demo sittings. These are taped into the final brochure by hand. Figure out how many prints you'll need, and have your lab print that many wallets of four or five different poses. Keep the photos interesting to teenagers. This is a lot of hard work, but the results look very professional. (b) Have a color postcard made by Marathon Press. The company has a number of preformatted cards specifically aimed at seniors. One advantage of a postcard is that it gains more attention in the initial mailbox pickup because of its color and your photography. Another advantage is that you can use a lower postal rate without dealing with permits and bulk-mailing procedures. (c) Using your own photographs, have a nice black-and-white flyer or brochure made up by a local printer. (d) Don't use other people's photographs unless you can recreate them exactly. Some labs offer preprinted color flyers that have other photographers' photos on them. While they are a good deal, they can get you in trouble if you can't match the posing, backgrounds, and quality of the originals.

4. Mail the piece. The best time for the first mailing is a month before school lets out for the summer. This is the time when the contract studio is starting to schedule sittings or starting to promote their services to the new seniors. At the start of the summer, plant your name in the senior's minds as a viable option.

Another important part of the mailing is an incentive to induce the seniors to come in early to avoid the rush. Seniors actually look better in the summer, and have more free time to schedule sittings. They don't realize the advantages in scheduling early, so you have to provide an incentive, either financial or in terms of a product or free gift. This also is true when you have the contract. In the past, I have found that the following incentives work: if they come in before the end of June, they receive $5 off the sitting fee, eight extra wallets, and last year's prices with any package, if the package is ordered before September 15. (Note: specify a cutoff date to give them an incentive to order early also.) If they come in before the end of July, they receive the $5 off and the eight extra wallets. If they come in before the end of August, they receive the eight extra wallets.

How to Get Seniors from Noncontract Schools: the Ambassador Concept

Another way of getting seniors into your studio is through an ambassador or studio representative program. This technique is taught best by Nancy Bailey of Anderson, Indiana, and has worked wonders for her over the years. Here are some of the main points that you may apply to your community. The idea is to find a photogenic, popular member of this year's junior class (usually a girl) and invite her in for a free sitting at your studio. In this sitting, do every background idea you have, and allow the junior to change clothes many times so that you have her in different outfits. You want to produce a set of thirty to forty proofs with different styles, clothing, and backgrounds. Display the proof set in a four-by-five Art Leather Futura wedding album, with the rep's name on it. The reason for the album instead of a folio is that the album is easier to see and to hand around to friends. Students tend to stack the folios under books they carry, while the four-by-five album sits up on top of their stack of books in plain sight.

Tell the rep that she can earn the proofs in the album and extra wallets on any order she may place by getting referrals for your studio from her classmates. Give the rep some business cards with her name and a place to fill in the name of the referral. Anytime you book a senior from a given high school, ask who referred him or her so that you can properly credit the rep. The key is to get the girl to show her proof book to as many of

the other juniors at school before the end of the current school year. You want to get them into your studio during the summer and early fall, as they will be bombarded by the contract studio and other noncontract studios during the summer. Kids trust other kids. Hearing that you are a nice person from one of their own is far more valuable than receiving a fancy mailing piece. If they also see good photographs and a large variety of poses and backgrounds while hearing how wonderful the session was, they will book a sitting with you.

To use this program effectively, you'll need a rep in each of the high schools in your area. Finding a rep the first year is the most difficult. You must invest some time in asking students from that school who is the most popular, not the best looking. Sometimes the most beautiful girl is not well liked, and students won't appreciate seeing her photographs because they know that she's beautiful to begin with. If you can take a less attractive girl with a great personality and make her look better, you will impress her friends more. Does this work for every studio? Of course not, but it is a tool you can use.

Shooting a Senior Sitting

Seniors are a different breed of people than the rest of humanity. I once saw a bumper sticker that said, "Hire a teenager, while they still know everything!" or another one in a principal's office that said, "The mental activity of a human peaks between four and eighteen. At four they know all the questions. At eighteen they know all of the answers." If I had to sum up seniors (at least as a photographer sees them), they are: (a) self-conscious, (b) worried about their appearance, and (c) conscious of style, even if they don't practice it.

The most important consideration in shooting a senior sitting is a variety of poses. You will earn a great reputation in your area if you give your senior clients more poses than your competition. You must also work at making the poses different and interesting to teenagers. When you are just starting in the business, you can usually afford the time to create for your young subjects different settings and environments, and these will help you get their business. It is also important to remember that a majority of your sales will be from the "straight" traditional poses which everyone does, so don't ignore them! As you build up a volume of business in the senior market, you will find that doing a lot of running around with each senior may be unprofitable and time consuming, and you will have to change your approach and shooting techniques. When having too much of one type of business becomes a problem, you don't really have a problem, do you?

When photographing seniors, you can use way-out backgrounds, either through set construction, scene-projection systems, or background projectors. Seniors like lots of props. You should encourage them to bring their own, such as a favorite instrument, their sports paraphernalia, their costumes or uniforms, their autos, or other treasures. You want to show some shots of the seniors trying to be models, with full-length and strong, dynamic posing. You want to allow the seniors to change clothing to reflect different aspects of their personalities, but only after a clothing consultation about the affects of clothing on their final images.

Some studios build elaborate sets to enable them to create unique settings for their seniors (and other clients). Ed Matuska of Rapid City, South Dakota, has plans for his "Circle of Fashion," which is a dynamite posing device. Go to conventions and get circulars from labs that specialize in seniors to obtain some good ideas. The fun part about seniors is that they love to try something different, even though their parents may not agree or like the results. Remember, it is the thought that counts, not the actual result.

Make sure that you have those boring traditional head-and-shoulder poses in the can before trying the more creative and fun stuff.

Senior sittings are usually sold by the number of changes of clothing that are included. The more changes a senior wants, the longer a sitting is going to take. I figure that it takes at least fifteen minutes per outfit to do a good sitting, after the sign-in time. Thus, a sitting with four changes of clothing will take at least an hour. If you do outside photography where you have to travel to a good location, add the travel time.

Make sure that the first part of the sitting is the traditional head-and-shoulders poses in conservative dress. Almost make a joke out of it: "This one's for mom!" You will also make mom happy, which is money in your pocket. There is one excellent book on the market, *Senior Portraits* by Larry Peters, that will show you many background and posing ideas for seniors as well as how to market these ideas. Larry is an excellent marketer and superior photographer, and he offers a wealth of ideas on every aspect of senior photography.

Senior Packages

Senior photography is one area where you must have some type of packaging system in place. Very few seniors will come to you unless you do. When designing a senior program, you have to keep the sitting fees for the "basic" sitting low if you want to attract the less than enthusiastic senior, who also happens to buy as much as the more photogenic ones, in my experience. See a sample of my sitting list for some ideas. Do not give anything except the yearbook glossy required by the school.

Most labs have special print packages for high school seniors. They are standardized around the 8 × 10 unit, which consists of one 8 × 10 or two 5 × 7s or four 4 × 5s or eight (or nine) wallets, all of the same pose with the same cropping. Labs which specialize in package printing will have different cropping masks available, as long as all of the prints in the packages require the same cropping. Some also offer 11 × 14 prints as well as the 8 × 10 units. Because the cost of package printing is so much less than ordering individual prints, it is critical that you build your senior packages around the unit. Consult your lab's price list for how it prints packages for minor variations. All labs charge more for the first unit in a package and less for each additional unit. Also, each negative should be retouched, which usually costs about $4. Some packaging systems allow seniors to use more than one pose in a package if they pay a "change of pose fee," usually about $5 to cover the additional costs involved.

Most senior price lists have two sections: the packages and the à-la-carte sections. In the à-la-carte section, all prints are priced individually, usually at a much higher rate than in the package section. The à-la-carte section is for those who must have one 5 × 7 of a different pose. It is designed to make them pay for the right to do so. There are three major types of packaging systems in operation today. I will outline how they work and how they differ.

THE STRAIGHT PACKAGE: In this system, a number of packages are detailed and offered for sale. Such as: Package #1 includes one 11 × 14, two 8 × 10s, four 5 × 7s, eight 4 × 5s, and forty-eight wallets. Package #2 includes two 8 × 10s, two 5 × 7s, four 4 × 5s, twenty-four wallets. Package #7 would include one 8 × 10 plus eight wallets. As you can see, all of the packages are built around the 8 × 10 unit and only come in even units, i.e., you cannot have one 5 × 7 or two 4 × 5s. All packages are priced so that the client gets more photographs per dollar the more money that he or she spends. Usually, seniors can order extra wallets of the package pose for a small additional fee. I have also found that allowing people to rearrange the units within a package has a marketing value, e.g., they

can trade two 5 × 7s for four 4 × 5s. The only confusion is that no matter how clearly and strongly you state it, many people want to trade one 5 × 7 for two 4 × 5s, which is not allowed under the unit concept.

Typically, for the higher one or two packages, you may allow the package to be split between two different poses at no additional pose charge. This option makes the higher profit package more appealing, and the small additional lab charges are more than off-set by the larger order.

BUILD A PACKAGE SYSTEM: In this system, the client can mix any combination of units based on the table below. This approach appears to give the customer a large degree of freedom, including the option of buying one 5 × 7 at a high rate, if he or she really wants to. (These prices are for illustration only and are not intended to be used as an example for you to copy!) The wallet units interest seniors the most, so the trick is to keep the price high for the small amounts and build a large sliding discount with increased volume to encourage the larger orders.

11 × 14	8 × 10	5 × 7	4 × 5	WALLET
1 @ $90	1 @ $40	1 @ $30	1 @ $12	8 for $15
2 @ $80	2 @ $35	2 @ $20	2 @ $11	16 for $25
3 @ $75	3 @ $30	4 @ $15	4 @ $10	24 for $40
4 @ $70	4 @ $25	6 @ $12	8 @ $ 9	32 for $45

The client chooses so many of each size to suit his or her needs, and there is a sliding scale built-in to favor whole units and more of the same size prints.

OPEN UNITS: Here the client can decide how a package is made up and all the packages are based on open units.

Package A = 8 units @ $_____

Package B = 7 units @ $_____

Package C = 6 units @ $_____

Package F = 2 units @ $_____

Some photographers who offer open units only include the larger sizes in the open packages and place wallets on a separate list. Wallets cannot be ordered unless a regular package has been purchased. I include wallets along with the larger sizes in my pack-ages because they actually increase the apparent size of the package. In reality, they cost me less (from a lab) because wallet units are usually priced lower than the 8 × 10 units.

In any of the systems, the minimum package price is about $50 and ranges up to about $250 to $300 exclusive of sizes 16 × 20 and larger. The national average for a three-unit package is about $90 to $125. The national average for a single à-la-carte unit is about $28 to $35. In addition, there should also be a choice of finishes for each package. We use *economy* and *custom*. Other studios have three and even four different finishes, which I think adds more confusion. When you confuse the customer, you usually lose sales. Our custom prints are mounted on a cardboard backing, lacquer coated, textured, and have some print retouching in addition to the negative retouching done before printing. The economy prints are negative-retouched only and come in a less expensive folder. We price the custom about 20 to 30 percent higher than the economy. In our business, over 70 percent of our seniors buy the custom package even though they all do not need the additional retouching offered. They think they do. Good negative retouching will conceal 75 percent of the typical senior's blemishes.

Underclassmen and Elementary School Photography

I refer to underclassmen (all classes other than seniors) as *littleheads*. Most high schools negotiate and award separate contracts for seniors and for littleheads. Littlehead photography is package photography and should be attempted only by those who can do up to five hundred sittings in a day efficiently. It is relatively boring photography, but highly rewarding financially. You must price correctly and buy your printing carefully, so that you can make a lot of money. The competition in littlehead photography is fierce, and you usually have to compete with large, well-equipped outfits with lots of money to promote. Littlehead work usually involves kickbacks to the school of between 15 and 20 percent of the gross sales. However, the money is good and well worth the effort.

HOW MUCH MONEY? Let's take an elementary school, K–4, with five hundred students in twenty classrooms (four classes of each grade). Seventy-five to eighty percent of the students will buy your packages, or, in this example, about four hundred of them. In 1994, we averaged (net after commission) $16 per package. This gave us a gross income of $4,800. My costs were:

Promotional materials	$100
Order envelopes and forms	$150
Delivery envelopes	$150
Film and processing	$225
PACKAGES: Average 4 units*	$1,740
Group shots (400 @ $1 each)	$400
TOTAL COSTS	$2,765
GROSS PROFIT	$2000
LABOR: Shooting	1 day
Packaging and delivering, etc.	1 day
TOTAL	2 days

Not a bad gross profit. Or not a bad net profit either. I was also home by 3:00 P.M. and could still shoot six senior sittings before dark. This example is not out of line. I did almost $100,000 in littleheads in the past few years. I have two schools where I bring home $10,000 gross income for one day's work! On a dollar-per-hour basis, it is the best money earner that I do.

Almost all littlehead photography today is done on a prepay basis. It used to be that a photographer would go to a school, photograph every student, produce a package, and send them home to the parents on speculation. This method put a heavy workload on the teachers to collect and account for the money. The schools didn't like handling all the money. The prepay system works well since the parents now have multiple packages to choose from and multiple backgrounds to select. The prepay system improves the collection of money.

EQUIPMENT: The large-school outfits use long-roll cameras which hold one hundred feet of film in 70mm (6 × 7 format), 46mm (6 × 4½ format), or 35mm. With these cameras they can, in many cases, shoot an entire school with only one change of film. Some of these long-roll cameras are equipped with periscopes, which allow an informational data strip to be exposed on the film just below the image of the student. The name and

*In my operation, I do my own package printing so that the actual package costs me less than $1 to produce. I used a lab's price for this example. I would have had a gross profit of over $3,000.

package the student wants can be coded. Some can be read by a computerized automatic printer so that the whole one hundred feet can go through the lab without anyone ever looking at the film. This is the most efficient printing method known to the photographic industry.

If you get into littlehead photography heavily, I recommend that you consider buying a long-roll camera. Some of the manufacturers are Camerz, Nord, and Photogenic. These cameras run about $3,000 to $5,000 fully equipped, and there are hundreds of options. You can also get a long-roll back for a Mamyia RB67 camera. There are also some labs which will rent you the long-roll back for the RB67 for a nominal fee in order to get your printing business. Check your labs to see what they have to offer. If you only do littlehead work occasionally, you can use your normal 220 format camera and work a little harder at the bookkeeping and tracking the names and packages. The 6 × 4½ format is ideal for this type of work as you get thirty shots on a 220 roll, which will usually do one grade in a typical school, with some reserve for multiples of a few children for eyes shut, etc. In addition to your regular camera, you will need a second camera setup to take the group photographs (at the nursery, elementary, and middle school levels). You can do this with simple on-camera flash, or you can set up a couple of lights on stands.

Lighting should be good, solid portrait lighting. You should use at least a four-light setup with umbrellas or soft boxes for the main light for soft lighting. You should have a main, fill, back, and hair light in your setups. Good lighting is one area where you can beat the big outfits. Most of the school outfits have not changed lighting styles in twenty years. You can use more contemporary lighting styles, with umbrellas or soft boxes. You will need to have 600 to 800 watt-seconds of power to get an effective working f-stop. Most studio lighting equipment is adequate. Cheap amateur units will not consistently put out light quality over many exposures in a short time. Beware of cheap lights.

If you do any amount of littleheads, I would recommend you buy a Photogenic Photo-Master 800 powerpack with three PM 10-6 heads and one PM12 head as a backlight. I would use two Eclipse umbrellas as main and fill lights. This outfit is lightweight, powerful, and consistent over many years. A good investment. If you only do a limited number of schools, use the Powerlights or Ultras that I recommended in chapter 4.

The key to volume package printing is that your lighting and exposures must be exactly the same on every frame. The lab will not adjust the printer to compensate for a change in exposure if you move your lights. Good lighting equipment is essential. In senior package printing, each negative is individually analyzed before printing, allowing for more freedom in lighting styles. In littlehead package printing, only the first negative on a batch of film is tested, and the rest of the entire job is printed at those settings. If your lights stopped putting out full power halfway through the day, you will get half your packages back poorly printed, and the lab will not be sympathetic. It was your fault!

Lighting for school photography should be fairly low ratio with good bright backgrounds. I try to keep the ratio at 1.5:1, or lower. Shadows will give you printing problems and complaints from parents. In addition to lights, you need a background system. I use one (homemade) that holds three backgrounds on window-shade rollers (made out of a 1 × 8–inch board and window-shade hardware). This allows you to offer multiple background colors and change them easily. We offer a white (actually a very light gray), a green, and a sky blue. Denny Manufacturing is an excellent source for these backgrounds and holders.

I have a personal preference for posing people in a standing position with the aide of a Photogenic Pony posing table, which is a sturdy, adjustable-height table. Posing people standing up is more efficient and saves a lot of time, especially in volume school pho-

tography. If you can save ten seconds with each of the five hundred kids, it mounts up to a huge time savings over the course of a day.

You will need a supply of combs to groom your young clients. We buy them by the thousands so they cost less than two cents each (five cents with our name on them). See the listing for Cardinal Comb Company in chapter 12. It is unsanitary to use one comb on more than one person, and the school nurse will be upset if you try. Some schools do not want the students to keep the combs, so we use one to comb the hair and then throw it away. In elementary schools, you will need help with the grooming. Make contact with a parent's group to see if you can get some mothers to come in and help you with the grooming, especially with the younger children. Above the fourth grade, the students are more conscious of their appearance and can partially take care of themselves. You should have a mirror available so that the students who care to can do their own grooming quickly. You should also be aware that some parents do not want you to touch their child's hair at all. Stress grooming in your promotional literature.

One vital piece of equipment for group photography is a name board with movable letters, so that you can include the year, the school, the grade, and the teacher's name in each group photograph. These boards are available from most office-supply houses. My assistant fills in the teacher's name while I am photographing the individuals so by the time I am ready to photograph the group, the name board is all prepared. I have one of the students in the front row hold it for the photograph.

ORDER ENVELOPES AND PROMOTIONAL MATERIALS: To properly sell your packages, you must prepare four levels of promotional/ordering materials. The first step is posters that can be put up in school two weeks before you are due to shoot, telling the school "Picture day will be _____," with some basic samples of your photographs attached. These serve to remind the students and the faculty over and over that you are coming. About ten days before you are due to shoot, send a flyer to parents' homes annuncing when you are coming to the school, what your packages are, and how much they will cost. You should also include some basic information about grooming and clothing suggestions. Also inform them that order envelopes will be sent home two days before the scheduled shoot day. Review the prepay policy and your guarantee policy.

Two nights before (or on Friday if you are shooting on Tuesday), send your order envelope. The further away from the actual photography day you send this order envelope, the more likely it is that it will get lost. Avoid scheduling shoots on Mondays for that very reason. The parents might forget on Monday morning and send the kids off to school without the money. Also, Mondays are one of the higher absentee days, which cuts down on your efficiency. Fridays are also days with higher absentee rates, so avoid Mondays, Fridays, days after holidays, or teachers' conventions.

If the order envelope goes out two days before, then the day prior to the shoot send out a simple $2 \times 8\frac{1}{2}$–inch slip containing a big happy face, and the message "Tomorrow is school picture day—don't forget your smile." The order envelope is the key piece of communication you have with the parents. Use a #10 envelope so that the parents can put the money into it and seal it at home before giving it to the child, especially with the youngest children. On the envelope you must list your packages and provide the ordering information. For elementary and middle schools you will need: name, grade, teacher, package ordered, group shot ordered, extra wallets, choice of backgrounds, payment policy, and guarantee policy.

For junior and senior high school students, you will not need to offer group shots, but you can offer negative retouching as an option. You will also need to ask for homeroom number and grade. One additional feature of doing the high school littlehead work is that you usually have to photograph students who do not wish to buy a package in or-

der to be included in the yearbook. You have to offer a no-charge, yearbook-only op-
tion on the envelope.

HOW IT WORKS: Set up so that the children can come in a line up to a table (your con-
trol point) about ten to twelve feet from your shooting area. Set up your background
system so that the child being photographed is not looking at those waiting in line. Each
class will come to you in a line with the teacher at the head. Stop the students and make
sure that they have their envelopes with them. If some do not have them, instruct them
to sit in the group shot area. Separate the rest by background choices, whatever they
may be. Start shooting. You need to stand behind the camera, and you will need an as-
sistant to control the flow of students. You must keep moving. You should always have
a child in the "on deck" position, but you don't want five kids there making faces at the
one you are photographing.

Your assistant and any helpers should take care of grooming, making change if re-
quired, etc. As soon as you finish shooting a student, direct the student to the group shot
area to wait. Have the teacher control the group while you shoot the individuals. Have
your assistant keep track of the color groups and tell you when to change backgrounds.
With the Denny window-shade backdrops it takes a second to do this. Keep an eye on
the student's envelope just in case your assistant missed one in a color group. Kids are
like eels, and they slip in and out of your groups easily. You should also keep some combs
in you pocket for last-minute hair repairs. Again, if you use a comb, throw it away or
give it to the child.

As each child approaches, take the envelope from him or her. When dealing with very
young children, I use a hand puppet and I tell them to give the envelope to the puppet.
The puppet helps warm them up. Check the background color selection, and take the
child to the posing table area, helping him or her up on the box, if assistance is needed.
Write the roll and frame numbers on the envelope.

I use a very simple technique. The first child I photograph holds up a card that says
the "XYZ school, roll one." I shoot the first frame of the roll with the child holding the
card. I then photograph the child and he or she becomes R1-1 on the envelope. If I take
two or more shots because the child blinked, or I just didn't like the first shot, I mark
the envelope 1½ (i.e., roll one, frame 1 and 2 after the ID frame). At the end of each roll
of film (frame 19 with 6×7 format, frame 29 with $6 \times 4\frac{1}{2}$ format), I bundle the enve-
lopes and mark the 220 roll of film. Sometimes it is easier to use an $8\frac{1}{2} \times 11$ envelope
and put the order envelopes in with the roll of film and seal it. I then ID the next roll
with a card held by the next student and proceed. If you shoot $6 \times 4\frac{1}{2}$ format, you may
want to change the film at the end of the class group (a typical class is twenty-four to
-six students plus the teacher) to save a few minutes.

When the last student in the class is done, take the teacher's photo (usually for free).
Then go to the group area and do the group shot on a separate camera. When photo-
graphing the group, try to get at least three rows and four if possible. Sometimes you
can borrow a set of choral risers from the music classroom for this purpose. Choral ris-
ers are sets of steps used for singing groups, and are ideal for group photography. Make
sure you fill up the frame with the group to maximize the size of the faces in each pho-
tograph. If you seat a row on the floor, make sure that young girls with skirts are either
sitting in or standing behind chairs to avoid any embarrassing poses. Have the teacher
stand to one side at the end of one of the rows of children. Take at least two shots to
ensure a good expression. Watch for kids making obscene gestures at the camera or oth-
erwise fooling around.

The photography of the individuals should be consistent and relatively straightfor-
ward. You do not have the time to fine-tune every pose, and you must never move the

lights. You should concentrate all your energy on relaxing the child and getting a good expression. You must learn and then discipline yourself to work quickly and efficiently. I figure that if I have five hundred students to photograph that I have about ten to fifteen seconds to spend on each one, allowing for the group shots. Some children will take a little longer, and you must make up that time with the better children. I have found that the kindergarten and first-grade classes take longest because the children are more afraid of you, and you have to take more time to win their confidence.

If you get a real problem child, one who starts to cry or is really withdrawn, pass him or her by. I let them watch me photograph the other children and have the teacher help me. You cannot take ten minutes like you would if you were doing a portrait sitting in your studio. If a child will not cooperate with you by the time you are ready for the class shot, return the envelope and suggest to the parents that you try again on makeup day. If the teacher feels that perhaps later in the day would be better, shoot the child out of sequence. I try hard to do the best by each child, but you cannot take too long with any one child without affecting the quality of work for the rest of your students. You cannot get them all.

In most schools today, there is a special needs class. These children are mentally retarded, physically handicapped, or both. Try your best to do the best portrait possible under the circumstances. Allow some extra time for this class, and work with the teachers to get the best expression possible. Also remember that not all parents want their child to look like Shirley Temple. Don't try to force a smile if one is not natural. Not an easy task, but an important one. I ask the school to schedule this class first or last as it may be necessary to move your lights to accommodate wheelchairs.

I prefer to work with the students standing. I use my Pony table which I cover with a white, furry cloth. I bring a sturdy wooden box (made out of two-by-twelves) that is about a foot high for the youngest students to stand on. By fourth grade most of the kids are tall enough not to need the box. Using the box helps me cut down on the number of times I have to raise and lower the table or my tripod. Exercise caution when getting the children up and down onto the box. Three reasons I like to work standing are: (1) I feel it is much faster to get the people into a comfortable looking pose, (2) most people slouch when they sit, and their posture and clothing do not look the best unless you take more time to fix them, (3) it is easier on me (and my back) to work standing straight up instead of bent over the camera all day.

Most school photographers point to a stool and have the kids plop down. The typical school photograph taken by the large outfits would be 100 percent better if the children were standing. If you prefer to work with your subjects sitting on a stool, make sure they sit up tall. It is not easy to make people do so and not look stiff. It takes time, and that is what you usually have the least of in littlehead photography.

Getting good expressions out of children quickly and consistently is another key to good littlehead photography. The trick is to get them to focus all of their attention on you and ignore all the other noises and lights in the room. I use word cues because I have learned that most people have a very predictable physical reaction to certain words and phrases. Adults react to different stimuli words than children. My favorite phrase with young kids is "say spaghetti." They look at you, smile, and then try to say it, usually incorrectly. Most children are a little afraid of that word and the smile is the "OK, here it goes, but you better watch out" variety of anticipation and embarrassment smiles. The trick is to shoot before they say the word. Other words are "rotten socks," and "you turkey." I also try to get them to talk, "Do you have a dog (cat)?" if so, "What is its name?" Any question to which they can give an easy answer will get you a quick smile. I often work at the elementary school level with a stuffed green frog on my lens shade, or my

"frogtographer," as I tell the children. I will ask the children, "What's a frog say?" They will say "ribbit," and smile. It works most of the time. With older children I ask them to say "boys" or "girls," which usually gets some reaction. Use what you are most comfortable with, but develop the ability to get those smiles quickly.

I work with a relatively low lighting ratio (about 1.5:1) and keep my backgrounds well lit. Over the years, I have gotten more returns for dark backgrounds than for any other reason. This is not creative studio portraiture. A good hair light is also essential for good separation, but do not overdo it. If you set up your fill system properly, you should not need a huge amount of power to backlight. You want to create good separation and an even density across the backgrounds.

GETTING THE JOBS: The person who makes the decision about school photography is usually the principal, who often has complete control or who may pay heed (or delegate this authority) to a parents' group, or to the school superintendent.

Principals are most concerned with: (1) Service. How soon the photographs will be back; how efficiently you shoot while taking the least amount of time possible from the school schedule; how much support you give the school in preliminary promotion and subsequent delivery. (2) How do you intend to handle complaints and/or problems? How much of his/her staff time will be spent on school picture problems? (3) How good are your photography and your prices? (4) How much are you going to kick back to the school? (5) Your reputation on delivery.

When selling to a principal stress service, the "I'm local and I'll be there" philosophy. Show concern for the school staff and make sure you do as much as possible to relieve them of any jobs or responsibilities. Also stress your community involvement and be willing and able to help the school with any service work, such as hallway displays, photographing a visiting dignitary. This year I am having the fifth and sixth grades at my local elementary school photograph "A Day in the Life of Harwich Elementary." The students will take all of the pictures using their own cameras. I will provide the film, support service, and edit an A/V program to show the rest of the school and parents. All of the above at no charge.

If a group of parents is choosing the photographer, they will be more aware of quality and price. They will want some service and support for their programs and goals. I think parents' groups are slightly easier to get work from because they are more concerned with the human aspects, rather than the business aspects of the photography. Another influence on parents' groups is to offer to do a fund-raiser for them in the pre-Christmas season. One that has worked well for us is our holiday family special. The parents' group gets a coupon for a special ten-minute sitting including an 8 × 10 print. They sell the coupon for $25 and keep all the money. You schedule a limited number of pre-holiday Saturdays (with a partial Sunday afternoon) to shoot the sittings. Keep the number of shooting days limited, and pack in the sittings ten minutes apart. This past year I photographed one hundred families in two and a half days. We used package printing and offered preprinted packages. We averaged about $75 additional sales per family. Not a bad promotion.

Read the section on getting a high school senior contract. Many of the steps are the same, except you have to find out who is in charge and adjust your selling accordingly. It isn't always easy. If a big outfit has been doing the school for a number of years, the principal has had no complaints and the work has been satisfactory, why change?

You can work your way into an elementary school through the back door, so to speak. A good place to start in the littlehead photography business is in nursery schools and day-care centers. These children (and their parents) become the elementary school students in a year or two. If you can do a good job with decent portrait lighting and good

expressions, your nursery school parents will start asking for you at the elementary school. Principals do listen to parents and will give some credence to parents' wishes in these matters. Solicit help from nursery school parents you have served. They can pave the road to future work.

DELIVERY: The single most important thing you must control is delivering the packages to the school. If you are dealing with a lab, get a written promise of the delivery date for the packages. Word the question to the lab this way, "If I deliver the film on October X, when will you get four hundred (or whatever) packages back to me?" You must specify the dates you will be sending the film so that the lab can't say, "Well, it is our busy season you know." If you are told two weeks, promise the school three weeks. Account for various holidays, and leave yourself a margin of error. Typically, you must deliver in the three- to four-week range to be competitive in public schools. This is what the big outfits promise and they do, for the most part, deliver on time.

A lab cannot be held responsible on a promised delivery date if your film was not exposed correctly or consistently. If you moved the light or if you grossly under- or over-exposed your film, it will not take responsibility for late delivery. It is essential that you establish the lab's requirements for good exposure and lighting ratio by doing a test roll using the light meter and camera you will be using at the school. You cannot afford to reshoot four hundred sittings! You'll lose your shirt. School photography requires that you be more careful than creative.

RESHOOT AND MAKEUP DAY: About a week to ten days after you deliver the packages to the school, you usually must schedule a makeup day to photograph the students absent on the first day and to reshoot those students whose parents were unhappy with the original package. When you use a prepay system, you must always guarantee a refund or a reshoot to any unhappy parent.

If you photograph four to five hundred students in one day, you are bound to get some blinks, some really weird expressions, and some expressions which are not pleasing to the parents. You also will get some kids with long or unkempt hair that no amount of grooming will help and other children who wore a dirty T-shirt to school instead of the nice clothing their parents would have preferred. The question is how liberal you want to be. Some people will try to stick it to you. Generally, I reshoot any package for any reason, as well as refund anyone who requested it, no questions asked. I felt (and was correct) that I got the jobs by servicing the customers better than the big outfits. Arguing with customers is not giving service. But I did get upset when students would bring back perfect packages with little notes like, "You didn't catch Johnny's perfect smile just right, please try again," or "Jane just had her hair redone and we would like her pictures with her new hairdo."

When I deliver the original packages, I indicate the ones that I think should be retaken. It still amazes me that some parents will accept a shot of their child with the eyes half shut. It is my job to get a decent expression on a normal child's face, and I will reshoot any photograph where I feel I failed to do so. Generally, parents have to accept the second package as long as both eyes are open and it is technically OK. The reshoots do not get the automatic refund policy nor do they get any more reshoots. In a large enough group there are always a few who will try to take advantage of you. Expect it, but don't let it affect you.

PAYMENT POLICIES: Accept cash or a check at the time the photographs are taken. No exceptions. You are in the middle of shooting four hundred students. Little Mary comes up to you and says, "My mom will send you the money tomorrow. She forgot to give me the envelope." If you photograph her and wait for the money, you'll waste fifteen to thirty minutes just trying to find her envelope. For a $12 sitting, it is not worth it. Don't

shoot the package. No money in the envelope, no photo. Tell her to come back on the makeup day. In every school there are a few deadbeats who will try tricks like sending you the wrong amount of money (too little of course) or other cheap tricks. You do not have time to open and check each envelope as you shoot the children, so you must check the contents later. You must also look for people who overpaid you, and return their money.

I have a policy of giving the school up to ten gift certificates for my basic package. In every school, there are some children whose families truly can't afford even $9. I don't want these children to be deprived of their school photograph. I give the certificates to the school staff to distribute. I do not want to know who gets them, and I can usually depend on the staff to give them to the children who really deserve them. It is a small investment in human happiness that I do not mind making.

In doing school photography you get a lot of checks (seven inches worth on my biggest school). I have more bounced checks from school work than anywhere else in my business. The average value of the bad checks is about $12, not enough to spend a lot of time worrying about it. If my time is worth $300 per hour, I cannot spend any time chasing these small checks. I write it off as part of my expenses. I also do not deliver the photographs if I can find the package. One of the problems in doing school photographs is that often the child's name is not the same as the parent's name, and unless you write the package number on the check, it is hard to match up.

Also, remember when you price your packages that most banks charge a ten to twenty cent service charge to clear a check. When you deposit three hundred checks you will have to pay $30 to $60 in service charges. These are costs of doing business and must be built in to your package costs. One year I asked for cash only on the order envelopes because of the above problems. That request was greeted with a storm of protest by the parents. Most modern families don't have a lot of cash around the house and pay everything by check. You can't get cash only in my neck of the woods without losing a lot of sales.

FAMILY DISCOUNTS: For a couple of years I offered family discounts. In my local schools I photograph all the children from day care through twelfth grade. What a disaster! The deal was that the oldest child paid full price, the next got 20 percent off, the third child got 33 percent off, and the rest got 50 percent off. Those years I had four packages to choose from and when I finally tallied up the deposit slip, I had checks with seventy-three different values. What a bookkeeping mess. People took whatever discount they felt like, did their math poorly, and I got the short end of the stick all the time. It wasn't worth it. I try to keep my prices fair to everyone. To offer a family discount, you have to raise the overall prices to keep the total dollars the same, which penalizes the families with only one or two children, who make up a greater majority of the student population today than in the past. I discontinued the family discount and kept my prices the same for the following year. When I explained all of this to the principals and to the parents who called, they understood.

HIGH SCHOOL VARIATIONS: Doing the underclassmen at a high school is the same as doing them at the elementary level except in three major regards. (1) You usually have to provide a black-and-white print of all students and faculty for the yearbook, so you have to have a yearbook-only option on your order envelope. (2) You generally do not do class group photographs. (3) You can offer negative retouching as an option. We usually charge $5 for this service and carefully explain that retouching corrects pimples and blemishes and is not for braces, hair, or clothing. We provide a black-and-white contact print (from either the 6 × 4½ or 6 × 7 format) of each frame we shoot for use in the yearbook. Most labs have a volume department and they will splice your 220 roll together

and make color or black-and-white contact strips of the entire job. The film and contact strips come back in a roll that you can easily label.

Nursery School and Day Care

By 1990, there will be six million children in day-care centers and nursery schools. To-day, most of these establishments are privately owned and managed, or part of an in-house corporate program or a nonprofit group. The typical day-care center has between thirty and one hundred children, with about sixty being the average in my area. These preschools are stepping stones for getting into the school package business. They are small enough for the novice to handle efficiently, and they are more accessible to the local studio photographer because the large-school outfits don't want them. Most day care centers are locally owned or managed, and the managers are willing to use local business over out-of-towners as long as you provide good service and competitive prices. This situation is much different than the large, public elementary schools where there is a lot of fierce competition.

GETTING THE JOBS: Check your local Yellow Pages and make a mailing list of all day-care centers and nursery schools. Also check to see if large corporations, universities, or government institutions have day-care centers. Prepare an introductory mailing. To be fully prepared, you must contact your lab, get all its information on school packages, design the various package plans you will offer, and price them. Be sure to include group photographs as an option. Some labs specialize in sales support material and have very clever gimmicks, such as special mounts just for preschoolers. Ask your lab to provide you with whatever sales aids it has. You should have some photographs that you have taken of children two to six years old to show as samples. You should try to show backgrounds similar to what you will be using. If you can do outdoor photography consistently (so that it can be package printed at the lab), you may offer to do the children in an outdoor setting. Check with your lab first before offering outdoor photography.

Send a letter introducing yourself and your studio, and tell the day-care manager that you will be calling in two or three days to make an appointment to show your portfolio. Set a specific time and date, and follow up with the phone call. You will get one of three potential responses: (1) they do not require your services, (2) they are currently using someone else with whom they are very happy, or (3) come on over and let's talk. Follow up on the last one. Go after the smallest of the day cares at the beginning. Even if they only have ten children, it is a job which will provide you with samples and contacts to bid on the larger ones the following years. The people who run day cares know each other, and if you do a good job for one, the word will spread. Use the small jobs where the competition is not bidding, and develop them into bigger jobs.

PACKAGING AND POLICIES FOR NURSERY SCHOOLS: The packages and policies should be exactly the same as for the littleheads in elementary and high school work with only one exception. You cannot afford a reshoot day. It just does not pay. Tell them that you'll refund anyone who asks, but you cannot spend hours for a few reshoots or makeups. We also have a minimum of twenty children to come out and offer our special prices. There are a number of small schools who come to our studio to get the special rate. One is a religious school with only twelve students. They don't mind coming to the studio, and it only takes me about thirty minutes to do the job instead of the hours required to go to their school with my whole setup.

One other major difference is that most preschools are on a two-day cycle. They have some kids Monday/Wednesday/Friday, some Tuesday/Thursday, and some all five days.

To fully shoot a large day care, you may have to go two different days (usually Tuesday/Wednesday or Wednesday/Thursday). You may also have to go in the morning and in the afternoon. I have a number of day cares that I shoot for an hour in the morning and return at 1:00 P.M. for another hour with a different group of children. I usually can leave my equipment set up, so it is not a lot of extra labor to shoot both A.M. and P.M. Be flexible; it is your major strength.

Shooting a day care is very similar to shooting an elementary school except I seat the children. I use a small heavy stool (tip-over proof), and I kneel behind the camera (bring a pad for your knees). I find the little preschool kids don't stand well, and my box and table setup at the elementary schools scares them. I get down to their level. When shooting preschoolers, I have hand-puppet helpers who come with me: Tommy the Turtle, Wolfgang the Wolf, and Beaufort the Frogtographer. When the children come up to me, Wolfgang takes the envelope out of their hands, not me. Beaufort sits on the lens shade and gives them something more interesting to look at than me.

You have to be very patient with the little people. You do not have the time pressures at the day-care level than you do at the larger elementary schools, so you can take more time with each individual child. I love these little people, but you must win their trust. This job is the best training in the world for a portrait photographer. That is why I feel it is a very important area for you to explore if you want to grow. If you can learn how to deal with these little people in a school situation, you can do a much better job in your studio sitting with full-paying customers.

As with elementary schools, day-care faculty and staff are usually photographed at no charge, and the school gets copies of the group shots for its records. The packages should be exactly the same as you would offer to an elementary school. Check with your lab to see what it offers and what you can easily shoot.

Proms

I love proms. I probably make more money in less time with less effort than anything else I do. I like that. Almost all high schools hold proms in the spring. The larger schools have both junior and senior proms. In my area, the kids spend between $300 and $500 per couple on prom night. The girls buy beautiful dresses, the guys rent tuxes, they hire limos to drive them around, and pay $25 to $35 a plate for food service. When they arrive at the prom, I am there to record their finery for them. Typically, 80 to 90 percent of the couples want to be photographed at the prom when they are looking their best.

At my large school, between 100 and 150 couples attend each prom. I usually have from about an hour before the start of the meal service until the crowning of the King and Queen to do all of the photography. This gives me about three to four hours of hard shooting.

PROM PACKAGES: Packages are absolutely essential for prom work. Most labs have some type of prom printing packages available. Typically, you would offer two 5 × 7s plus four wallets for one package, and two 8 × 10s plus eight wallets for a second. Remember to have everything in any package divisible by two, as the couple may not be going steady and each may want their own share of the package for their parents.

If your lab only offers two packages, and will only print one package from a given roll of film, you have to be a little creative to make it look like multiple packages are being offered. If your lab has two different packages, but only one from a given roll of film, you need to have a camera with a magazine back or two separate cameras. One magazine (or camera) is for package A and the other for B. You can also offer "Get the second package for one-third off!" and shoot two packages (A or B) of a couple as they wish. In

this way you can get the most out of a very simple setup. Just make sure to clearly label your rolls of film A or B as you take them out of the camera.

I like to offer five or six packages with many options to my students. There are labs that will print multiple packages from a single roll as long as you record them properly. They will provide the recording forms to make it easy. I do my own color printing, so it is easy for me to keep track of my packages and to vary packages within each roll. If you do use a lab, you must find a lab that will help you in this area by being very flexible in creating various packages. Proms usually occur during the slow season for most color labs, so they should be willing to go the extra mile. Check around.

I have observed that the students tend to buy my biggest package more frequently than the small one at the proms. Do not underestimate the buying power of teenagers today, especially on prom night. They seem to try to outdo each other and actually brag about buying the most. Use this peer pressure to your advantage. I average just over $25 per couple with my packaging. On a good night I will take in $3,000 in four to five hours of work. My material costs (if I bought the packages from a lab) would be about $500 to $600, leaving a net of $2,400. That is a net of $500 per hour. Not too shabby! I also do small schools with fifty couples so I don't quite make the same hourly rate. I still make a great deal more than my typical wedding photography per hour.

HERE'S HOW IT WORKS: I set up my lights and backgrounds in an area that is easily accessible to the couples. If it is out of sight, I have "Prom Photos Here" signs made up and placed in the main area with arrows pointing the way. I also place cards at each table reminding the couples that I am taking photographs. A week before the prom, I distribute prom order envelopes with a prom promotion flyer to all the couples at the school. The students can pick up these envelopes and have them all filled out when they arrive at the prom. This it the most efficient method. Make sure your prom order envelope asks for the address of both individuals and their class (junior or senior). A couple might be a junior and a senior, or a sophomore. You want the junior's names and addresses for next year's senior work. Make sure you get both names on the envelope. If one of the names is from another school or is a sophomore or graduate, make a note so that you don't waste money mailing them senior information.

If the prom starts at 7:00 P.M., I am ready to shoot at 6:00 or 6:15. The couples will start arriving that early if it is a dinner/dance. The majority of the couples arrive around 7:00, and I will have a line waiting while I shoot. Typically, I must stop shooting while the meal is being served, by the request of the caterers. It disrupts the food service to have the line in the way and too many people missing from their places. I will take some candid photographs of the couples and chaperones eating, so the hour is not totally wasted.

After dinner, I shoot couples until they are finished or until the King and Queen are chosen and crowned. I get the crowning on black-and-white film (35mm) for the yearbook. I usually am finished with the couples by the King and Queen part, so I start to pack up and head for home to count the money. With a smaller school, I might be finished shooting before dinner is served and can get packed up before the crowning.

Rene and Joan Genest of New Haven, Connecticut, gave me a new idea. During the meal service time when they couldn't shoot, they went into the ballrooms and did table shots. The kids bought a ton of them. I also offer something new. Since I have to photograph a set of candids of the prom for use in the yearbook, why not offer a duplicate set of the candids to the kids? I found out from my lab that I could get twenty or more sets of proofs from a thirty-six-exposure 35mm roll for about $4 a set. If I shoot two rolls, my cost is $8, and I will offer a set of fifty color candids for $20.

KEEPING TRACK OF WHO'S WHO: As each couple comes up to me, I take their enve-

lope (so I can read their names and call them by their right name) and pose them. I shoot $6 \times 4\frac{1}{2}$ format and get thirty shots on a 220 roll. I ask the very first couple on a roll to hold up fingers (one, two, three, etc.) and I use that shot as a roll ID#. I then write on each envelope the roll and shoot number for each couple; R1–4, 1–5, etc. If I take two shots because I thought I got a blink, I would write, for example, 3–12/13 (roll three, shot twelve and shot thirteen). In the many years I have been doing proms, I have found that this system works very well for keeping track of people. You can also have an assistant write down the colors of the couples clothing as a safety check (red dress, blue tux). One lab suggests that you put each finished roll of film in a large envelope with the order envelopes (mark each order envelope with the sequence number as you shoot the couple) so that you can mark the rolls clearly for the lab later.

If I go through a roll and have a number different than twenty-nine at the end, I know I have a mix-up somewhere. Usually the mix-up occurs because I forgot to write down when I took two shots instead of one, or I had a blank shot because the lights didn't fire for some reason. At the end of each roll, I bundle up the order envelopes with a rubber band and put them in a safe place. I also write the roll number on the exposed film wrapper and put it in the camera bag.

I always have an assistant with me who has blank envelopes for those who forgot them and change for those who need it. It really slows down the line if everyone has to fill in the envelope at the prom. I have also noticed that when the students fill in the envelopes at home, they buy more. The parents (both sets) want the photographs, and they are the ones who write out a check for the biggest package (or two of the biggest package). If you can't distribute your envelopes at the school, make sure to put them at every table so that the students can fill them out before arriving at the photography area. Also make sure to bring plenty of pens.

I also offer group photographs of friends in addition to couples. I will do up to five people on my regular background and will have an area to one side of my regular background set up for groups of up to twenty, usually just a row of chairs against a plain wall or curtain. Groups are popular, especially at the senior proms. We charge $3 per person and they each get a 5×7. It is a lot of fun but can get confusing, unless you have your assistant directing traffic for you. I also shoot the prom chaperones at no charge. These are usually the principal, the class advisors, and other distinguished guests. It is a little perk that will help get you the job again next year, and help you to keep your senior contract.

BACKGROUNDS: Depending on the decor at the prom location I will vary my setup. If I have a room with nice drapes and a nice rug, I will bring a butterfly wicker chair or a stand with some artificial flowers or with some candles. In some cases, I will create a scene with balloons. I like using ten-foot-wide muslin because it doesn't seem to be affected by high heels walking on it. I have a number of different shades so I can vary my backgrounds for different dances. I like to stick to middle tones of gray as they clash the least with the color of the customers' clothes. They cost about $150 each and are well worth it.

POSING: The purpose of the prom photo is to show off the dress and the tux. I prefer to have the girl stand in front of the guy in a proper posed position so that the front of her dress is fully shown. I place the guy slightly behind her (he rented his tux and it is not as important as the dress the girl purchased) and instruct him in how to hold her in a proper fashion. You have to show the couple quickly how to stand and how to hold each other. The other easy option is the dance pose, in which the couple has their inside arms around each other. I do not like this as much because you can't see the dress fully and you get a lot of shoulder showing. It also looks squeezed if not done carefully,

and you don't have a lot of time to be too careful. I will also do a seated pose if requested. I usually have a chair handy, but again, it does not show off the dress very well, and I tell the girl that. She is usually the one making the decision as to which pose they will use. You have to work quickly and efficiently posing prom couples. The guys usually start messing up their tuxes after about an hour, and the girl's hair looks better earlier. Don't chat, don't waste time. Work.

DELIVERY: I deliver my prom packages fourteen days after I shoot them. The juniors are always in school, but the seniors may not be. I deliver the packages alphabetized by the girl's name so that the secretaries at the school office can find them easily. The seniors are told when they can pick them up at the school. (You must have a specific date; if you use a lab, allow yourself some leeway.) If you cannot deliver to the school, you will have to mail the packages, which involves a lot of work, plus the expense of the postage. Every year I have some problems with people stealing others' packages. The secretaries at the schools try very hard to prevent this, but it does happen. I will either reprint or refund any such claim.

All my packages are fully guaranteed. In fact, if I see a couple with their eyes shut, I refund their money and give them their photographs. Other unsatisfied clients must return the package to me. I have a return rate of less than 1 percent. We do not offer reorders. That is clearly explained on all of our promotional literature. Most requests for reorders are for eight more wallets or one more 5 × 7, neither of which is worth the effort unless you charge $30, which would make you look like a crook. Do not take reorders. Make sure that this policy is clearly stated on all of your ordering and promotional materials. If you deal with a school where the students leave (such as a prep school), you may have to mail the package to them after the prom. You must build in to the cost of the package the cost of the packaging materials and the postage and the time required to prepare the mailing. This costs would add about $2 per package. You must check to make sure that the envelopes have the correct addresses recorded on them.

THE PROM BOOK: A number of years ago a competitor forced me to add the prom book to my packages, and I think it has turned out to be one of the most positive things we do. It also makes money. The prom book contains all the couples that I photographed, a lot of the candids of the prom, plus a copy of the prom program or any other information I feel is of interest to the students. I make a black-and-white contact print of all of the shots, and we glue the trimmed prints to plain white paper (8½ × 11). My wife arranges them so that a page has ten couples and some candid photographs. We will fill the center spread with the King and Queen ceremony and dancing candids. We will include all the group photographs I took. I take all this to my local printer who prints them up for me. If the prom had an official program, I use it as a cover design. I use the printing inside the program to create inside pages. If there wasn't a program, I make up a cover on my Macintosh computer. There are no names or any other typesetting inside the book. It is simply a picture book. If you did any typesetting, you would add greatly to the cost and the time required to produce the book.

We sell the prom book for $8.00 (including mailing costs), and it costs us about $2.50 to produce. We sell 100 to 120 at a large school prom, and 50 to 60 at a small school prom. It is not a great profit, but it is great PR. We have picked up some new school proms specifically because of the prom book. The trick is to find a printer who will do it quickly for a reasonable cost. We mail the book because it usually takes longer than the packages, and we don't want the secretaries at the school to be working double on prom pick-ups.

GETTING PROMS: If you photograph the seniors at a school, the prom is a natural add-on. When you get a senior contract, try to tie in the prom. If not, start working on it right

away. If you do not have the senior contract, you get proms in the same way as you get littleheads or seniors; you find out who is in charge and get an appointment to see that person and sell yourself. Review the senior section for a step-by-step detailing of this process. Proms are usually run by a prom committee of students and the class advisor(s). You must contact all these people to do an effective selling job. Start sending out information in September, but concentrate your efforts in December and January.

KICKBACKS: Typically, at a noncontract school, the prom committee gets a 10 percent kickback. This is standard. Contract school proms are covered in your contract. If you sell books, exclude them from any kickbacks. There is not enough profit margin in them.

Portrait Photography

portrait sitting usually starts with a phone call, which is typically worded: "How much do your charge for an 8 × 10?" The proper response and follow-through, from start to finish, should follow this format.

Anatomy of a Portrait Sitting

1. Ring- Ring. "Good Morning! This is the ABC studio, John speaking. How may I help you?"

How much do you charge for an 8 × 10?

2. Ask the following questions first before you quote any prices: (a) Who will be in the photograph? Yourself, your family, a child? Determine who is in the portrait. (b) Why? Is there a special reason for the portrait? Christmas, birthday, anniversary, or just because? Or perhaps one of your promotions has stimulated an interest? Find out which one. (c) How big? Try to establish preliminary wants and needs of the customers. "Is this going in your husband's/wife's office, or somewhere else?" (d) When? Establish any time constraints, such as, does it have to be done by Christmas or a birthday, or is time not important?

3. Keep asking questions. What style is he or she looking for? Indoor/outdoor, formal/informal, traditional/unusual, special clothing (uniforms or favorite outfit), special location (at home, a park, the beach, some local scenic spot)? Write down all the responses as the customer feeds you data.

4. Discuss the key of the portrait. Does he/she like light or dark backgrounds? Where in the recipient's home will it hang? What is the complexion of the sitting subject?

All the above are important questions which tell the person on the other end of the phone that you care about him or her and care about producing the best possible portrait. It shows you value what you are doing, and you want his or

her portrait to be the best possible. If your first response was, "A sitting is X dollars and your first 8 × 10 is Y dollars," the customer has little information other than price to consider. Remember, you have a sale when the price equals the value, so make what you do more valuable.

5. Now quote your fees for the sitting, and quote a range of prices for your reprints, from wallet to 16 × 20 prints or larger. Do not try to quote your whole price list on the phone, as this will only confuse the caller. Pick out what you feel are his or her major interests in regard to size. Quote your lowest or economy prices, not your higher levels. You should not try to explain the differences on the phone. If you have a special in effect, quote it as such, a special price for a limited time.

6. Immediately after quoting prices (don't pause between words), ask when it would be convenient for the caller to schedule the sitting, and then suggest a time that would be convenient for you. "How about Wednesday at 3:00 P.M.?" This time will either be acceptable, not be convenient (and then you can arrange a convenient time), or end the conversation (Well, I am not sure, I'll phone back later [i.e., the price is too much]). Continue until you book the sitting time. If it is a woman and she says, "I'll have to wait until my husband comes home," suggest you book the time, and she can call and change the time if her husband does not concur. Try to get her to commit to the sitting.

If you only do three sittings a week, try to schedule them all in one day right after one another with proper spacing. This timing is easier on you emotionally, and when customers see other customers coming and going they think you are busy and therefore must be pretty good. It is a cheap trick, but it does make good use of your time and helps your developing image.

7. It is then critically important for you to book a clothing consultation with the primary decision-makers of the portrait session. In family and children's portraits, 90 percent of the time it is the mother who is making all the planning decisions and the one you want for the clothing consultation. Ask, "Are you familiar with our work? Can you come in for a short visit to discuss the clothing your family/child/self/etc., will be wearing? Can you bring in the clothing you were thinking about? How about Monday at 3:00 P.M.?" Again, suggest a time and book it. Some people are very busy, but showing interest in what they will be wearing indicates that the portrait is really important, that you care, and that they should take the time to come in for the clothing consultation.

8. At the end of the conversation, get the name, address, and phone number. Immediately send a thank-you card for booking the appointment (Make sure it is not a surprise for someone at the home address.), and include any promotional materials you may have. Write up the data on a sitting card so you will remember the information during the consultation and the sitting.

9. The clothing consultation. When the client comes in, start by looking at samples of your work on the walls. Watch his or her face for indications of likes or dislikes. Get a sense of what appeals to him or her. The client may have indicated that he or she wanted a formal studio portrait on the phone, but now really seems to like your outdoor work better (or vice versa). Discuss it, show concern for his or her wishes, and change the sitting if necessary.

Establish the policy of collecting the sitting fee and the proof deposit (discussed later in this chapter) at the clothing consultation. We have found that this policy makes the sitting more valuable to the clients, and they will show up. Without a financial investment, you can expect to have a 10 to 20 percent no-show rate on scheduled sittings. If they have paid for it up front, 99 percent of people will be there, even if there are some other distractions. I strongly recommend that you adopt this policy at the start of your studio operation.

10. Start to discuss key and clothing. Ideally, your samples will show good clothing selection. Create a small album that illustrates both good and bad clothing selection so that you can show the client visually what you are talking about. Discuss color families, color harmony, and color coordination. This is where we start to run into a problem. Sometimes our view of what is tasteful and harmonious is not shared by the client! You'll hear lecturers stress solids and dark colors with long sleeves on woman, etc. The lady at your interview may have just paid $800 for a zebra-striped evening dress because the dress shop told her on how wonderful it made her look. Now here is a photographer who charges less than the cost of the dress telling her it will make her look fat and won't blend! Guess who is going to lose that argument? This is why I stress "show them" rather than try to tell them. Let them make up their own minds.

Try to show how colors create a key, and determine what the family or individual likes. If red is really their favorite color, red it should be. You must develop the technical skills to adjust to all shades of color. One thing to stress is that once a key is established, everything (and everyone in a group shot) should be coordinated within the same general color family: warms or cools, pastels or brights, whites or darks, etc. Have samples ready to show what you are talking about. If you don't have your own samples yet, use photos clipped from magazines.

Before he or she leaves, provide a "Who Needs What" form and a set of *size templates* to assist in predetermining what sizes will fit best in the client's home. Ask the client to consider the size and quantity needed for gifts. Plant seeds of sales here. These are two of your best passive sales tools. If you are using transproofs, book a proof presentation appointment at the clothing consultation.

11. The sitting: The first fifteen minutes of any sitting should be spent talking to the subject(s). It can be any type of chit-chat, but should focus on them. Again, ask questions about jobs, school, vacations, clubs, anything to get them talking. If it is a family, make sure you include everyone in the conversation, even the smallest of them. Don't leave anyone out. I like to joke and kid with the children, but usually not with adults. Suit your own personality in this regard. (Note: even in a ten-minute senior sitting, I will spend the first five minutes talking and watching, as Victor Avila taught me.) While you are talking, watch the subject closely. Look for physical idiosyncrasies. Does he or she stand a certain way or sit a funny way or hold his or her hands in a certain manner? How does he or she smile in normal conversation? Make mental notes.

In the meantime, the subject is evaluating you. Are you nice? Are you mean? Are you funny? The subject should see you as a caring, warm person. I usually start the conversation in my reception area, but move into the camera room (for a studio sitting) while we are talking. If I am outdoors, I have them stand in the general posing area where I will start the sitting. I keep talking. Let them look around (have the lights already turned on) and let them get used to the room or the outdoor posing area. There is nothing as disturbing as going into a strange room and having no time to look around before having to perform a task that is not pleasant. The next time you go to the dentist's office, observe how they let you get acclimated to the room while sitting in the chair, before they actually start working on you. If there are children, have toys available for them to play with. Not too many and not too big.

Do not touch the lights or camera for at least five to ten minutes. Have the subject(s) in the general posing area either seated or standing, as you prefer to work. All the time, as you talk, go through various poses in your mind that you may want to try. Predetermine the first pose. With a family group, you walk a thin line between conversation and boredom. It may take more time to get grandma to relax. In the meantime, the teenagers have lapsed into a bored state. It isn't easy all the time.

A major exception to the talk-first rule is portraits involving small babies and very young children. If they come in happy and smiling, go right to work. Often small children will get bored waiting for the adults (you and mom) to have their chat, and you will lose them emotionally. With a little experience you will learn to sense if the child is ready to be photographed, or if he or she requires a little coaxing to get into a good mood. Always try to get some insurance shots when a child is in a good mood and then try more complex poses. If you are planning a sitting with a complex prop setup, do some simple poses first so that you have some good expressions. I have often had children's sittings where the first two or three shots were just wonderful, and then suddenly the child took a great dislike to me, the lights, the whole studio, then burst into tears and was beyond recovery no matter what I tried to do. At least I had some nice photographs to sell the parents.

12. When you feel they are sufficiently relaxed, go to work. Work as smoothly and quickly as possible. Do a variety of poses. Try one of your ideas. If you don't like it, adjust it or say, "No, this won't work." Try to avoid changing the very first pose. It does not look very professional to be incorrect on the first try. Start with a safe pose. Build up some excitement in your voice as if you think things are going beautifully. Always say something positive after each shot: "That one's great!" or "Wow!" If someone makes a funny face at the instant of exposure, make a joke out of it. Never chide a client in the middle of the sitting. Get your emotional momentum going. Try safe poses first, then try experimenting with different poses. Involve the clients in the process of creating a pose. Show your interest in them and the look of the sitting. Remember, you are on stage and your demeanor is reflected in their faces. Don't let up on your energy or you will lose control of the sitting. Never let your lights or camera get in your way. Do not focus behind the camera any more than is absolutely necessary for technical reasons. Try not to lose eye contact with the subjects. Keep their attention on you and off of the camera and the lights. If they start worrying about the equipment, they will start to get that "fear of the unfamiliar" look on their faces. Give them something very human and friendly to focus their attention on—you and your smiling face.

When photographing a family, divide them into subgroups after doing the poses with the full group. Do the children and the parents separately. Do as many separate groups as you see fit for making future sales. Don't be cheap with the film. You can't sell photographs that you have not taken. Make sure that you have good expressions on all of the people in all of the groups. Be careful not to focus all your attention on just one person. Try to sweep the groups with your eyes as you fire the shutter to see the most expressions possible. Train your eye to wander constantly over the subjects during the exposure, even though your mouth and your mind have to be worrying about other things.

13. When you are finished photographing, escort the subject(s) out, make more chitchat, and bid them farewell. Let them know when the proofs will be ready, and make sure they have an appointment if you use transproofs.

To Proof or Not to Proof

After any portrait photography session you must produce something for the clients to view in order for them to make a buying decision for prints. Very few people will give you absolute control over the selection of the final image for their print order. There are three choices today: paper proofs, slide proofs (also called transproofs or transvues), or video/electronic proofs.

First, you must decide what you will call the proofs; *proofs, previews, poses, studies, or*

originals are various terms used by different photographers. Photographers will argue that calling them something other than proofs somehow makes them more valuable to the client. They feel that people expect poor quality in a proof and that they are not willing to pay for them later. If they are shown "originals," the proofs will have more value.

What you call them will depend on how you plan to show the clients the proofs and on how you wish to market them. Some photographers cover their overhead by selling the proofs, and the sale of the proofs is critically important to their financial well-being. Donald Jack, of Omaha, Nebraska, believes that a good proof set, mounted handsomely in a folio, is one of the best forms of advertising available, and one of the most readily marketable items you have to sell. He argues that the client will show that proof set to many other friends and create more clients for you, and then pay you in order to keep the folio. Other photographers feel that selling the proof costs them the sale of a small reprint and that it hurts their ultimate average sale. Bob Stevenson of upstate New York feels that proofs are just that, proofs: incomplete and unfinished, and he does not want them circulated as examples of his work. He will cut them for cropping guides or use a marker to indicate burning and dodging. He does not want the customer to keep the proofs. Others feel that if you try to increase the value of the 4×5 or 5×5 proofs, you are making the sale of larger wall prints more difficult, costing you large prints sales which represent many more dollars than the small prints. There are legions of photographers who will argue the correctness of any of the above positions. You must decide where you stand, and then periodically reevaluate your position.

When first starting a studio business, if you have elected to show paper proofs, I strongly recommend that you attempt to sell your proofs and call them either *previews* or *originals*. I also suggest that you use the sale of the previews to encourage the client to buy a larger order by using a sliding price scale. For example, each individual preview would be $25 (or the price of your 4×5 reprint) unless the client's total reorder (excluding proofs and sitting fees) exceeds $X, and then the individual preview would be only one half of that. If the client's order exceeds $X, then include the previews for no charge with the order. Make the latter figure what you want your average order to be.

Increase the value of your photography and the value of the previews by showing them in a proper way. Present all of the previews in a folio for regular sittings. A nice presentation makes them look more professional. Put a unit price on the entire folio, including the number of previews in it. You can use the incentive pricing discussed above to encourage larger orders. Never give the folio away unless you are getting at least $500 for the reorder. Typically, an eight-view preview folio sells for $65 to $125.

Many photographers are not allowing paper proofs to leave the studio. They feel that looking at the proofs in a proper setting is most important in selling large wall prints. They do not want their portrait clients viewing 4×5 pieces of paper on the kitchen table. They want them to view 30×40 projected images on a well-decorated wall in their studio. Read Helen Boursier's books on selling to learn how to use transproofs effectively. There is some client resistance to this approach. "You don't trust me!" is a feeling often expressed by clients told they can't take the proofs home. It offends their sense of honor and trust.

If you have your proofs in the form of slides (or the new video option), the client is usually more willing to accept the idea that they must be viewed in the studio with the proper equipment. With the Tamaron Fotofix II, you only need to have the negatives developed. You put the negatives on a light table, flip the positive/negative switch on the video camera, and there are beautiful images projected on a screen as large as you wish. Because of all the hardware, the client realizes how difficult it would be to take the proofs home.

The transproof photographers argue that an 8 × 10 print looks big after seeing the image as a 4 × 5, and, conversely, that a 24 × 30 looks small to a client after seeing the original image projected as 30 × 40. The transproof supporters also argue that allowing the client to take longer to deliberate hardly ever leads to a larger sale; in fact, the opposite is true. The longer people dwell on the price, the cheaper they become. They will mentally start saying, "Why buy a large print? This little 4 × 5 looks fine to me, and it only costs a few dollars." Also, involving other family members or friends in the decision-making process of pose selection usually only adds to their confusion. "Well Aunt Martha thinks my smile is better in this one, but Uncle Harry likes the other pose of my husband better." Net result, smaller sale.

On the other side of the argument, using transproofs requires a great degree of selling skill to make a correct presentation. If you have any kind of volume built up, transproofs take much more time and personal involvement than paper proofs. You generally have to spend one to two hours with each client to present the transproofs properly.

Kodak sells an electronic proofing system called the PRISM system. In this system, a second camera makes a video image at the exact instant your regular camera does. At the end of a sitting you can show the clients their proofs on a TV monitor. They can decide there and then that they like the sitting. Sometimes you missed something, like hair or clothing, which totally turns off the client. You can go back in the camera room and do more exposures to correct these physical problems. With good sales skills, the clients can place their order immediately after their sitting.

PRISM systems are leased directly from Kodak. There are other systems available, such as the one from Denny. I do not have any experience with these systems, but I have talked to a number of people who think they are wonderful. Three experienced master photographers I know very well, Ron Simons of Maine, and Dennis and Roberta Cloutier of Massachusetts, swear by the system. They claim greatly increased sales from family, senior, and regular portrait sittings in their studios. They feel that the lease fee is very reasonable compared to the increase in sales the system generates. Unfortunately, PRISM systems do not work well outside of the camera room. PRISM proofs or video proofs are best viewed on a monitor-quality, twenty-inch or larger, color TV. This means the client is seeing big prints instead of 4 × 5 proofs. This is a plus in the selling of large prints.

Which Way to Go? Recommendations

WEDDINGS: Use paper proofs for at least three years, and then consider a no-proof system or a transproof or videoproof system. Evaluate potential return against amount of labor involved and your confidence in your own selling skills.

FAMILY AND REGULAR INDIVIDUAL PORTRAITS: This is where transproofs, video proofs, or a PRISM would work best. Consider using them right from the start if you feel that you can learn to sell your photography properly. You will lose proof sales but get bigger orders. Customer acceptance is harder to achieve when you are new, and you must have all the answers ready. Be careful of strong customer resistance, especially before you have established your reputation. Don't lose customers over this issue.

HIGH SCHOOL SENIORS: If you do less than one hundred per year, transproofs may work. Paper proofs and folios do work well with seniors, as they do show their proofs to all their friends, which helps to get more people into the studio, especially if you are a noncontract studio. If you are doing more than one hundred seniors a year, transproofs would be too time-consuming for you unless you hire more staff just to do that, and that could wipe out any potential profits very quickly. In my opinion, paper

proofs are the way to go. Many seniors want outdoors sessions, which eliminates the PRISM system.

Note: When a seventeen- or eighteen-year-old picks up a proof folio worth $65 to $125, you should collect a deposit for the return of the proofs, and have him or her sign it out. The student's signature is worthless in court, as a minor usually cannot enter into a legal contract, but it does remind him or her that the proofs have to be returned on a given date. Do not let the seniors have the proofs for more than two or three weeks. Schedule an appointment to place his or her final order at the time of the pickup of the proof folio. The faster the customers view their proofs after the sitting, the better the sale.

A Transproof Presentation

Showing transproofs is very different than handing the customer a proof folio and waiting for his or her reactions. When you present transproofs, you have to help the client(s) along by creating a pleasant mood as well as showing your work. There is a sequence to follow. First, you need a projection room that can be completely darkened. It should be large enough to hold two or three comfortable chairs and long enough to project a 30 × 40 image with a normal projector zoom lens at full magnification.

1. Edit the transproofs into the sequence in which you want to show them. A single projector works very well and may be used successfully in making a transproof presentation. If you have two projectors, arrange them in two trays in the sequence in which you want to project them. Put your favorite pose in first, followed by your second favorite, and so on. You must use your best judgment. Oftentimes clients will dwell on small, relatively unimportant details, such as that their eyelashes were not done right, and ignore the overall balance of a particular pose. You are the professional, and you should help them reach a conclusion right at the start.

Load the projector(s), and play a tape of nice music. Prefocus the projector on the screen in your projection area. The screen should be a minimum of 30 × 40 in size, preferably 40 × 60. Some photographers mount a screen inside a 30 × 40 frame, which they mount on the wall on a turnable mount so that it can be flipped vertically or horizontally. Other people who use transproofs successfully argue that flipping back and forth takes away from the presentation and that a square screen with no frame works better.

2. When the clients come in for the viewing, greet them and chat for a while. Do not just rush into the room and turn on the projectors. If you have coffee, offer them some, or if it is late in the day or early in the evening, offer them a soft drink or other goodies. Make them feel at home.

3. Enter the projection room. Seat the clients facing the screen area, and explain how the presentation works. If it a husband and wife, seat them on chairs three or four feet apart so that they have to talk loudly to each other. This way you can be in on their conversations and they can't whisper comments to each other. Tell them that you are going to show them all the proofs, and they are going to love them. Explain that you will go through the entire set without comment and then go back to the beginning so they can eliminate the shots they don't like.

4. Turn off the room lights, and let their eyes adjust to the dark for about ten to fifteen seconds. Turn on the music. Either preprogram the projectors or manually fade in the first proof. If you are using a dissolve unit, let the picture come up on a slow fade in. Allow the first image to remain on the screen for about ten to fifteen seconds, fade to the second if you have two projectors, cut to the next if you have just one projector. Do not say anything. Let the music and the images speak for you. Listen for any comments

the customer might make. Choose soft, bright music for your presentations, songs with no words.

5. After the last slide, tell the clients, "Wasn't that wonderful!" If you have done your job well, they will love it. Now you go back to the beginning and start the editing process. Put the projectors on manual and go back to number one. Go back and forth between various poses asking the clients to eliminate those they like the least. As they eliminate one, remove it from the slide tray. Keep going through the tray(s) until you are down to their last choices. When using two trays, it is wise to have a third tray so that you can put the selected slides into it as the choices are made. Remove the initial trays and just use the third tray in one projector to facilitate going back and forth for the final comparisons. If they are having difficulty making a decision, help them. In a family group, one person may be better in one pose than another, but the overall balance of the family is better in the second choice. Offer your professional opinion in these matters.

6. Once you've eliminated the unwanted poses, review the final selections. They will usually represent the best of the different poses you did. In a family group, these should consist of the best of the overall group, an informal group, the best of the kids as a group, and the best of mom and dad separately. Now start discussing size, beginning with the primary pose. Remember that they are looking at a 30 × 40 projected image. Be ready with your prices. On the walls of your viewing room have samples of other sizes so that you can refer to them by pointing. Have a 24 × 30, a 20 × 24, and a 16 × 20, all in nice frames. With the 30 × 40 image on the screen, say "This size costs $X, and it would look wonderful over your fireplace" (or wherever else your sitting card indicates that they may wish to hang the portrait). If they object, saying "That's too much," use your projector's zoom lens to reduce the image to the next size down, a 24 × 30, and say, "Well, this one will only cost $Y." Keep reducing the size until they stop objecting. If you are down to a 16 × 20, it will look like a postage stamp. Zoom the lens back to the 30 × 40 size and back to the smaller size to show them the difference. They will usually wind up with either the 20 × 24 or 24 × 30 size. You can also use the zoom lens to indicate any cropping of the image which may be indicated to improve the final print image. You can also use your hands in front of the lens to do any burning of the corners of the image or to tone down a bright spot, which can be done with custom printing or retouching on the print.

Have some empty frames on the floor next to the screen so that you can frame the smaller sizes within the 30 × 40 screen area, so that they can visualize the final image within a frame. Make sure the frame is not too wide as it will fill more space and make the final image look larger, causing the client to go back to the next smallest size. Write on the slide mount what size they have ordered and any cropping information you need to give your lab. Repeat the process with the other poses. Typically, they will want smaller sizes for the secondary poses. Talk about (and have a sample on your wall) a cluster of poses in different sizes. Again, zoom in and out to show the different sizes.

7. Now that you have decided on the portraits for the client's home, you have to determine what they will be ordering for gifts. Hopefully, they have completed the "Who Needs What" form you provided them at the clothing consultation. Ask if they plan to give any portraits as gifts (also consult your sitting card for this information). Repeat the process until you have all the information.

8. Show them some sample frames and ask if they wish to complete the portrait with proper framing. Have samples ready of your stock, or of a framer's stock. Encourage them to decide on framing while they're in the projection room.

9. Total the order, and present the total to the client. Your price list should have clearly stated your payment policy. The minimum should be a 50 percent deposit on the total

order. Instead of saying, " I need a 50 percent deposit," total the order and matter-of-factly ask, "How do you want to take care of this?" Seven times out of ten the client will pay the entire balance, giving you a better cash flow. If the customer says any amount less than the 50 percent deposit, politely say that a 50 percent deposit is the minimum required.

This process applies to both individual portraits and family groups. When showing a family group, it is vitally important that both the father and the mother be present at the viewing. If only the mother is there, she will be saying constantly, "Well, my husband will have to have the final say on the selection." Do not book a viewing appointment unless all significant decision-makers will be present. If the client has indicated that he or she wishes to have another person there, such as a grandmother or boyfriend, for an individual sitting, make sure that these people are included in all the discussions. When doing a family group, it is not helpful or at all necessary to have all the children in the viewing room. It fact, it may be counterproductive. If one teenager dislikes his or her looks in general, he or she will comment negatively on all of the poses, destroying the overall mood of the presentation. Explain this problem to parents when booking the proof presentation. They will understand if they have teenagers in the family.

If you go through the whole process and the clients say, "We can't decide. Can we take the proofs home because Aunt Millie needs to help us decide? " they are trying to wiggle out of making a decision. Counter with, "Well if you cannot make up your minds, why don't we reschedule the showing and you can bring Aunt Millie here." Explain that there are no paper proofs, and transproofs require specialized projection equipment. Stand your ground. If you let the slides leave the studio, you have just cut your sale by 50 to 75 percent. I have heard both sides of the argument about allowing the client to take the transproofs home. Some photographers who allow it argue that the clients will still have to project the images through a projector at home, so that the size advantage is not lost. Other photographers will argue that the sale should be consummated then and there. Asking for more time is a ploy to stall the sale, which will usually result in a reduced sale.

Presenting Paper Proofs

If you are using paper proofs, it is very important to present them correctly to enhance your future sales. It is imperative for you to make appointments and to encourage people not to just walk in whenever they feel like it to pick up and return proofs. They may come right in the middle of a wedding interview or another proof return, when you cannot give them the attention they deserve. If you can't take the time, you will probably lose sales, and they won't have as much respect for you as you deserve. Insist on scheduling the return, explaining it is to their advantage to have your undivided attention. If someone walks in unscheduled and you are busy, explain and try to get them to come back at a scheduled time. You will have destroyed any continuity of presentation with the people you were interviewing and will lose sales because of the interruption.

1. When you get the proofs back from the lab, finish them as you would your economy prints. Make sure they are spotted and textured (texturing helps prevent copying by unscrupulous clients) and look as good as possible. If the proofs have been poorly printed, send them back to the lab. If does your image no good if you have to explain off-color or incorrect density to a client. Once the proofs are finished, mount them in a folio. Folios come in eight-pose options. If your sitting has more than eight proofs, either edit them down, or use a second folio (perhaps a four-pose folio). Once the prints have been inserted, wrap the folio in tissue and return it to the presentation box. Include any price lists or other promotional materials with the folio in the box. Put the customer's name

on the outside and place it in the pickup area. Phone the client, tell him or her the proofs are ready, and schedule a time.

2. When the client comes in, seat him or her at your table with good lighting before actually handing over the folio. Unwrap the tissue and make a bit of a flourish out of the presentation. Act excited, as if something wonderful is about to happen. Allow him or her to view the folio for a while. Encourage discussion after the first few minutes. If he or she has any questions concerning cropping, retouching, etc., they usually will occur at this moment. Answer any questions.

3. Explain the enclosed price lists and other information. Show him or her how to use the size templates and the "Who Needs What" sheet. Describe any specials which you may be promoting that month. Always tell the client to call with any questions.

4. Have your proof sign-out form handy, and have the client sign out the proof set (and pay a deposit if necessary). Indicate the due date and, if possible, book the return appointment on the spot. We used to wait until the proof pickup to ask for a proof deposit. We'd waste a lot of time explaining the deposit, collecting the money, and getting signatures on sign-out sheets. For the past seven years, we have collected the proof deposit along with the sitting fee at the clothing consultation. This policy has almost eliminated no-shows for appointments and has simplified the proof delivery system.

Out of every one hundred sittings, a certain number (four or five) will steal the proofs and never return them. If you allow this to bother you, you will probably overreact and hurt the honest 95 percent of your clients by being too strict with your proof-passing requirements. If the deposit is too high or the paperwork too formidable, you will hurt your regular sales. It is part of the cost of doing business, an unpleasant part, that you will get taken by a few dishonest people. There is no totally foolproof system of insuring proof return, so do not penalize your honest customers to spite your crooks.

5. Mark in your appointment book the indicated return date. If the client has not made an appointment by that time, a friendly phone call may be necessary to remind him or her. He or she may have a legitimate reason for the delay. Do not get huffy, but do try to book a return appointment.

6. At the proof return appointment, make sure that you have their sitting card and all of your sales tools ready to show the clients your various sizes, finishes, and specials. This is where preselling with the templates for the larger sizes is important. Clients need a realistic idea of how big a photograph will actually fit in the area of the home or office under consideration. Most people have absolutely no idea of how large a print is required to fill up the wall over the couch.

The Clothing Consultation

Every portrait subject must wear something (except nudes, which are not a big market in my area). What people wear will affect the final look of the portrait as much as your expensive equipment, carefully selected backgrounds, and skillful use of techniques. This is why you must control the clothing selection of the client to the best of your ability. Again, by control I mean passive selling more than pressuring the clients into wearing what they may not like. Years ago, Joe Zeltzman taught us that it is better to cancel a family sitting rather than to photograph them in inappropriate garments. Well, Joe was perhaps a little too harsh, but his point was that he had a certain low-key style that was destroyed if people dressed the wrong way. He was well established enough to demand that clients conform to his style. When you are starting up your new studio, you can't afford to lose a sitting over the issue of clothing, but you should help the people understand that it is to their advantage to go along with your suggestions.

How do you passively tell people what to wear? Simply show them good and bad examples of what you mean. You cannot write long descriptive brochures because 90 percent of your potential clients won't read them and 50 percent of the 10 percent who do will misunderstand the principles and do things totally wrong. If you demand total clothing control you will lose customers because you will appear too inflexible unless you have a unique and well-known style of photography. Very few photographers achieve this status.

What is proper clothing selection? First the principles:

1. CLOTHING SHOULD NOT BE THE SUBJECT OF THE PORTRAIT. The clothes should enhance the faces of the subjects. (a) Corollary: clothing and fashion date a photograph very quickly. Can you imagine your mother in a sack dress. Years ago she would have torn it up. Stress classic looks in clothing, things that never go out of style. Most people will understand this idea. (b) Clothing should cover the parts of the client's anatomy which are not of fashion-model quality, such as the upper arms (both men and women) and usually the lower arms. This is because most upper arms are heavy and lighter in color than the face and neck (to which the client usually applies makeup). Low neck lines can be flattering as long as the tan is even with the neck and face, and the weight allows it. If the upper chest is blotchy or light, it is better covered.

2. CONTRAST ATTRACTS THE EYE. The eye loves patterns and will look at them before looking at solid color, like faces. The eye is drawn toward the things that exhibit the most visual contrast. The ultimate in contrast are large stripes and large polka dots. The flowered shirts of Hawaii certainly stand out, don't they? That is OK on a beach in Hawaii, but not in your studio. The classic look is usually solid colors with no discernible patterns. By discernible I mean the pattern does not become dominant. A tweed jacket is more of a texture than a pattern and may be perfectly OK if that is the garment the subject prefers. (a) Corollary: the eye loves to choose contrast between colors or tones within a group. If one person in a group dresses differently than the rest of the group, in the final print he or she will stand out because the viewer's eye will be drawn to the difference. This difference often leads to an unhappy client, especially if the offending person weighs three hundred pounds and wonders why he or she looks heavy in stripes. (b) Corollary: the eye loves contrast between the subject and the background. If the subject has an absolutely beautiful body, you would use a contrasting background to emphasize it. If you have a body which you would prefer to camouflage, then you should use a complimentary color or tone so that it blends. This is what *key* is all about.

It never ceases to amaze me how people's minds work. A client may have spent an hour in front of a mirror getting her hair and makeup ready and then put on a garment which is too tight or doesn't cover her undergarments properly. I have concluded that when all of us look in a mirror in the morning we do not look at the whole image. We look at our eyes, at our hair, put on makeup or shave, and our eyes only see what is necessary and mentally block out the rest. Try it. Sit in front of a mirror and really look at yourself. Also see the section on self-image on the following page.

3. COLOR HARMONY. Certain colors blend with each other and certain colors clash with each other. What we would like to achieve in a portrait is color harmony; both within the subject and between the subject and the background unless we want to emphasis something. *Playboy* photographers don't use these rules because they are in the emphasis business. You, as a portrait photographer, are usually in the camouflage business, trying to hide things rather than displaying them. Boudoir photography is in the subtle-emphasis business. Model portfolios are different than portrait sittings in this regard.

Now you must apply these principles to your clients. The best way of getting your

point across is to show them good and bad samples of the points mentioned above and let them conclude for themselves what is best to wear. This is passive selling. You have to help them out by using samples that dramatically demonstrate what you wish to show, such as a heavy woman in stripes versus the same woman in solid colors. You need to show groups where everyone dressed differently and the family photo looks like a circus parade. If you have good samples you will find that some people like to stand out. Their idea of looking good is looking different. If that is what they want, then their wish is your challenge. Don't try to impose your standards on their wishes if that is their heartfelt desire. Most people want to look as good as possible in their portrait. The number one priority is making the subject look as thin as possible. This is your strongest argument to dress in key and to dress in a classic style; it makes bodies look slimmer.

The problem we run into is that you probably only have a limited number of backgrounds that you can use, so you must convince the client to dress for your backgrounds. It would be nice to have a proper background for every possible shade and tone, but that is not practical. The modern studio should be equipped for both high- and low-key portraits. In their purest form, both are effective at reducing body bulk and enhancing facial features. There are different psychological leanings which will reflect the client's choice of key. Once a key has been selected, then the client can easily see what clothing fits the setting, if your samples illustrate these points well.

When discussing color harmony, you should emphasize that all people in a group don't have to dress exactly the same. It means that if five people wear blue-greens and one person wears red-oranges, then one person will stand out. All members must stick to a color family, but can pick from the different hues within that family. A major exception are the pastels, which are popular in our part of the country in the summer months. We have found that the pastel tones go well with each other, even if they are not in the same strict color families. A lot of my photography is done on the beach, which, late in the day, is a pastel environment. The pastels blend beautifully with the pale yellow sand, the light blue sky, the gentle green of the beach grass. Nothing stands out, and it all looks so natural!

Self-Image in Portraiture

I firmly believe that most people in this world have a negative self-image when it comes to their own physical appearance. If a person really didn't care at all what he or she looked like, you wouldn't see them in a photography studio having a portrait taken unless forced to, e.g., a passport or a utility photo. By negative self-image I mean that most people think that their physical appearance is less becoming than it really is. If we use the childish beauty scale of one to ten, most people are fives, but they think they are fours.

This does not include studios in Hollywood, Muscle Beach, or studios that deal a lot with professional or aspiring models. People who want to be models obviously have a higher opinion of their looks than the average person. This also doesn't include people who are physically deformed. It has been my experience that people with severe scaring from accidents or deformities caused by disease or birth defects are better portrait subjects than average people. Usually they have accepted their features and they are comfortable with their feelings about themselves. They open up and let their true personalities show more readily than the average-looking person worrying about his or her appearance. This attitude makes for a better portrait.

Again, most people think they look worse than they actually do. What they fear the most is that you (the photographer) are going to confirm their fears, and prove with your camera (which most people believe produces an accurate copy of reality) that they are

as ugly as they think they are. This is also why you are in business. If people were as ugly as they thought, we'd be broke. Luckily, you can perform a positive human service and help people realize that they look normal. Better yet, make them look better than normal and they will like you and themselves better. In my mind, this is the primary mission of a portrait photographer.

The strength of this negative self-image is stronger in men than in women. Even though women spend more time and energy on their appearance, with makeup, hair-dos, clothing, jewelry, etc., men are much more sensitive about their appearance, although they remain aloof from the beauty technology. Men are more afraid of the camera and what it will see. They can't blame a bad portrait on bad makeup, a bad hairdo, or the time of the month. What they are is what they will see, or so they believe and fear.

Teenagers and senior citizens are also more prone to negative self-image, one from lack of knowledge, and the other from the ravages of time. The degree of negative self-image has no relationship to the person's actual appearance. In fact, the better looking the people are, the more likely it is that they don't think they are good looking. You must understand that you become a fearful truth-telling agency to the normal person. Many people are more afraid of having your camera look at them than they are of a pit of poison snakes. Fear ruins appearance. When people are fearful they get tense and tend to overreact to normal stimuli. In other words, they don't act normally, and their appearance is not normal. As a result, their photographs indeed do look worse than they really are, confirming their fears. To most people, their driver's license photo is a true representation of what they look like.

You must understand this fear when you start doing portraits. Your first job is to get people's minds off of the camera, then off of the lights, and to distract them from the whole mechanical process of taking a portrait. You must make people feel comfortable, feel secure, and get their mental energy focused on something other than themselves and their situation. There are many different ways of doing this, but the best one is for you to become the center of the client's attention, a focus for his or her mental energy. You must get out from behind the camera so that he or she can look at you, and not a pile of glass, metal, and plastic.

Negative self-image increases with the intelligence and power of the individual. A corporate executive is no better than a high school senior in this regard. In fact, executives are worse. The teenager is just afraid of the unknown, while the executive is worrying that he or she won't look powerful enough. Karsh tells of photographing both Churchill and de Gaulle. Both men strongly disliked being photographed, and both were extremely strong individuals accustomed to getting their own way in life. The famous portrait of Churchill by Karsh was taken after a speech to the Canadian Parliament during WW II. Churchill came out of Parliament into a room where Karsh had set up his lights and camera. Since Churchill had not been forewarned, he was surprised and uncooperative. Karsh posed Churchill, but Churchill kept his trademark cigar tightly between his lips. When Karsh was ready, he walked over and yanked the cigar out of Churchill's mouth. The resulting image is world famous, the bulldog fierce growl of the leader of the free world. In reality, Churchill was focusing on Karsh and his cigar. They had a laugh over it, and Karsh took some other poses with some smiles and the usual expressions. The real portrait was created when Churchill was focusing on something other than the camera and the process.

De Gaulle was so afraid of the camera that he gave Karsh exactly ten seconds to take his portrait. Karsh had set up everything with a stand-in, de Gaulle walked in, stood in the same spot, Karsh took one exposure, and de Gaulle walked out. The portrait is as stiff and lifeless as de Gaulle envisioned himself, not Karsh's usually sensitive and worldly

portraiture. A sitting should be a positive experience on the client's mental level, not a technical exercise. It should be enjoyable, not painful.

You, the portraitist, have a function; in fact, it is the major function of a portrait sitting: you control the subjects' expressions to create a pleasing appearance. They will respond and react to you as a human being, not as a mechanical device. The looks you get may not be the "real them," but at least they will look good. If you study the great photographic portraitists of the first century and a half of photography, you will realize that the only consistent factor is the person taking the portrait. A Karsh portrait of Churchill is a reflection of Karsh and is very different from an Arthur Penn portrait of Churchill or an Arnold Newman portrait of Churchill. There is more similarity between a Karsh portrait of Churchill and a Karsh portrait of Kruschev than between two portraits of the same man photographed by two different great photographers.

You must also remember that Karsh, Penn, and Newman were commissioned by an outside agency to photograph their famous subjects. They were not trying to please the subjects (who were not going to buy extra copies from them). Instead, they were trying to capture the subjects' very strong personalities. You, working with average people, have a more humble task, to please the client while trying to help him or her discover his or her own true personality. Don't confuse what you do on a day-to-day basis with what the superstar celebrity photographers of Hollywood or New York do for a living. The techniques and approaches are vastly different.

Posing People

The real difference between an amateur and a professional photographer is the ability to pose people quickly and easily. Most people feel and look awkward whenever a camera comes out. Powerful business executives suddenly look like third grade students in the annual Christmas play (in the executives' minds that is exactly where they are, reliving some dread past experience of embarrassment). In front of the camera, teenagers who swagger down the hall with the overconfidence of youthful vigor turn into the hunchback of Notre Dame. They look awkward because they feel awkward, and they have no idea of how to do anything about it. They are out of control and that translates into fear, which is very visible in their expressions. Terror destroys carriage. You have to learn to do three things quickly: (1) in your mind, create a comfortable position (a pose) that will make the subject look his or her best, (2) communicate that idea to the client, and (3) coach him or her in how to assume the correct stance and position in a comfortable manner.

Easy? Yes and no. Good posing is knowing where you are going before you start. It is starting at the feet and working your way up through the body to the head and shoulders, which carry most of the messages that we associate with body language. Where do you start? Get a full-length mirror. Stand in front of the mirror and practice posing yourself. The most fundamental pose, and one which you will use on 80 percent of day-to-day studio work, is what dancers call fourth position. Start with the body and feet slightly turned away from the camera, left or right, and the feet slightly apart (three to six inches). Shift all of the weight to the back foot (this automatically tilts the shoulders toward the back). Turn the front foot back toward the camera so that the front foot heel is a few inches from the back foot's instep. Finally, turn the head back toward the camera position and tilt the head either toward the high shoulder (which is the front shoulder) for a feminine pose, or perpendicular to the shoulders for a masculine pose. That's it. It works left or right. The degree of turning of the shoulders can be varied for different builds and different effects. To shoot a profile, start the pose as if the camera were

90 degrees from where it actually is. The body and head will then look very comfortable from the real camera position. When posing people, explain to them why you are having them shift their weight and move their shoulders and head. If you explain each step and its purpose, they will feel much more comfortable.

Once you have a person standing on his or her back foot, you only have a limited amount of time to shoot before he or she becomes physically uncomfortable. Ask him or her to move about every so often to relieve the pressure. Many times it is easier to show people a pose with your feet and hands rather than tell them how to do it. This is why you must practice on yourself so that you can show the client. Come out from behind the camera where they can see your feet, face the camera, and demonstrate the pose. This helps a lot of people pose more quickly and feel more comfortable. It will also get a laugh out of a bride to see a guy doing a feminine pose.

When you work with seated subjects, you still have to arrange the feet first in order to get their shoulders in comfortable positions. In addition, you have to have the posing stool or other chair at the correct height so that they can sit up straight without being uncomfortable. It isn't easy. The correct stool height is such that the back of the thigh is angled slightly downward toward the knee when the person sits on the stool. I have found, however, in creating head and shoulder portraits, that working with people standing up is easier than working with them sitting down. The two biggest differences are that the human body looks slimmer standing and that most clothing is designed to be worn standing up rather than sitting. The posture and position of the shoulders and upper body are more natural in a standing position and the clients are more comfortable. The difficulty is that you need a higher camera position to get the proper camera angle. I sometimes have to stand on a box, especially for a subject taller than I am.

THE CONVERSATIONAL ANGLE: Years ago one of my roommates in college had a psychology assignment about body language and how people stand when they talk to each other. Years later, after many observations and reading behavioral psychology books such as Desmond Morris's *On Human Mannerisms* and *Body Watching,* which deal with the subverbal levels of human communication and ethics, I developed a term that I find useful in telling portrait subjects what I am trying to achieve. If you are standing in a room and someone comes in and stands close and directly in front of you and looks you straight in the eye, your every instinct tells you to fight or flee. That stance is aggressive. People only stand square to each other and stare into the other eyes when they are mad, afraid, or flirting. When they are having pleasant social interactions with other human beings, people usually stand so that their shoulders form a ninety degree angle. When they look at each other their heads are tilted and they are not looking directly into each other's eyes. Next time you go to a cocktail party, observe.

I feel that a portrait of an individual should give the viewer the sensation that they are talking to the subject in a social and pleasant setting. This is why I pose the subjects in what I call the conversational pose, exactly the pose described above. If the sitting is for a boy/girlfriend, a more direct look is better since it is more sensual.

Some Posing Rules

You always hear that rules are meant to be broken. Break some of the following rules and you'll break your bank account!

In regular sittings, never position the body facing the camera squarely. This pose maximizes the body's width and makes it look heavier. Never turn the body past the point that the neck muscles will cord up when turning the head back toward the cam-

era. This angle is very unflattering, especially in women. Never shoot directly into the shoulder. The head needs some support and the shoulders need to be turned to some degree. This rule is especially true for thin people.

If you seat just one person in a group, it implies that he or she is physically disabled. Seat at least two people, or none. Don't be afraid to seat men and stand women. This pose works well if the woman is larger than the man, and you want to use a chair or his shoulders to mask some of her bulk. The woman will thank you. Use thinner bodies in front to screen heavier bodies in the back. Use youth to hide age. Use short to shield tall. Place small children in the front of large groups to cover knees, heavy thighs, etc. Place younger adults on the floor in seated poses to create a broader base for your composition. Avoid straight lines.

Hands should be doing something, e.g., touching, pointing, grasping, hiding in pockets, holding. They should never just hang there or be clasped in front, as if the subject were waiting to go to the bathroom in a standing pose. Avoid using the same hand position for everybody. Heads should lead to the center of the grouping. People posed in the standing position should shift their weight toward the center of the group. Never shoot totem poles or crosses, e.g., two heads directly over each other vertically or two heads on the same level horizontally, in a group. Never shoot into an open crotch of a man or a woman in slacks.

Put the tallest or most dominant person in the center of the back row. If the dominant person is not the tallest, make them look like the tallest by seating the others who would compete with them. In an extended family, always pose the youngest member in the group next to the oldest member and group the subfamilies together in the composition. Think pyramids and *V*'s.

Good posture takes about five to ten pounds off of a subject. Make them stand up straight. A heavy person should lean forward and look up. This position tightens the subject's neck, creating an illusion of slenderness in the face and neck. Use hands to create shoulder lines, hands at side, hands on hip, behind back, arms folded, hands in pockets, behind neck, in praying position, hands touching face, etc. When photographing hands, avoid fully turning the back of the hand toward the camera. (Of course da Vinci didn't read this book before he did the Mona Lisa, but what did he know?) Position the hand so that the side is visible, preferably with a little finger tip edge. Use a loose fist for men, hardly ever for women. Remember that hands are graceful. Avoid making them look short or awkward. Watch for chewed or broken (dirty!) fingernails. Hide these defects. Be very careful to avoid the feminine tilt (the head turned toward the high shoulder) when photographing men. There is an implication of femininity that is apparent, if not fully understand by the client. The pose will not be accepted and will cost you sales.

Soft Focus

Modern lenses have one major fault for the portrait photographer. They are too sharp! There are not too many people who want to see every pore, hair, and blemish reproduced with exact detail in lurid living color. The old portrait lenses, such as the Kodak Portagons, were very simple lenses with many optical defects. These defects caused a softness, which enhanced most of the portraits that were taken with them. For almost every portrait I take, I place some kind of softening device in front of the lens, the major exception being large groups of people where sharp detail is more important. There are three physical ways to create soft-focus effects.

1. Internally shift the focus of the lens. When the lens is designed, the manufacturer allows for one or more of the elements to be moved out of its proper optical position to

defocus the image on the film plane. By controlling the degree that this element is out of position, one controls the amount of softness. The Mamyia 645 150mm SF lens works on this principle. It has a ring that moves the element to create various effects. In my opinion, this lens produces a mushy softness, which is not acceptable to most clients. It looks out of focus rather than soft focus. It looks like the style popular in the forties and fifties, which actually defocused the camera to achieve softness, a look that is both dated and unacceptable to most clients.

2. The second technique is diffusing the image physically before it enters the lens. Diffusion means to scatter the light by introducing a translucent material into the beam of light. It may be some nose grease or Vaseline on the front element of the lens or a coating of clear nail polish on a skylight filter on the front of the lens. The overall effect is to blur an image that otherwise would be in sharp focus on the film plane. Diffusion can be done selectively on some areas of the lens and, when used lightly, can be controlled to a degree. The problem is that as soon as one tries to increase the softness, you lose control very quickly. The image becomes mushy and halos of light surround the highlights. In certain types of glamour and special-effect photography, these effects can be beautiful, but for day-to-day studio use they do more damage than good.

Vignetters are essentially diffusive devices. To darken or lighten edges of a photograph, place appropriately colored materials in front of the lens at various distances to diffuse the light selectively. Use a mat-box lens shade to control the distance and the amount of light falling on the diffusion material being used. Lindahl makes very nice sets of diffusion filters to fit its wonderful lens shade. I have grown to love the pearl diffusion filters sets sold by FWI of Salt Lake City.

3. The third type of soft-focus device is based on diffraction of light. Whenever a light beam encounters a small opaque obstacle, the beam does not form a sharp shadow; instead, the light diffracts around it. If a sharp edge blocks the light beam, some light energy (a small amount) will be diffracted into the shadow area. If a series of thin obstacles (a grate) blocks the light beam, the amount of light diffracted into the shadow areas increases and forms a regular pattern. If we create a grid of cross-hatched obstacles, each opening in the grid acts like a new light source creating the image. It acts as a source of diffracted light energy, which is added slightly out of register to the directly transmitted main image's energy. The net effect is the superimposition of many fainter images upon the main image. The greater the number of diffractive openings in the beam path, the greater the strength of the secondary images, hence the greater the softness of the effect. The big difference between diffusion and diffraction techniques is the ability to control the latter without introducing flare (i.e., unwanted scattering of the light by the material of the filter) and haloing (unwanted concentration of the light beam around highlights).

Making soft-focus diffraction filters is easy. Simply cut out a square of mesh cloth, mount it in some type of holder, and put it in front of the lens in a pro lens shade. The density of openings in the grid will determine the degree of softness, and the nature of the material being used will determine the amount of flaring you will get. The finer the mesh, the more softness you will get on the final image. In practice, you can make up a series of filters using different mesh densities to achieve various softness degrees.

Go to a cloth store and buy various sizes of netting. There are very coarse meshes used for hat-making or in crinoline garments, curtain materials, up to the very fine chiffon materials. Try to find cloth with a square grid pattern in solid black or deep navy blue. The color of the grid does not add color to the light beam as long as it is not illuminated from the side (that's why you need a pro lens shade). However, the black mesh is a far more effective diffractor than other color threads.

With simple cloth, you'll start to get some flaring when you use finer and finer materials, because there is some scattering of the light, or diffusive effects, occurring due to the nature of the cloth surface. To solve this problem, experiment with various types of materials or burn holes in the center of the filter to create a more solid image. Again, experiment with the amount of holes and the area they cover. As your grid gets finer, it will start to block light, and you'll need to increase your exposures to compensate for the filters. I have found that a coarse grid has little effect and that my finest chiffon requires about one half to one full stop increase in exposure. Experiment and mark each filter.

Combine various levels of mesh to create filters that both soften and vignette at the same time. By cutting out and overlaying ovals of mesh, you build up density on the edges. The more layers, the more vignetting. The cloth is cheap, and you can create all types of effects for very little money. I am still using a bag of cloth I purchased at a piece-goods store in 1973 for the unheard-of sum of twenty-nine cents! I have made lots of filters for myself and friends out of the material I bought way back when. The net cost per filter is a fraction of a cent.

The diffraction effect is used in the most expensive of the soft-focus devices. The Imagon lens uses metal disks placed inside the lens. These disks have many small holes scientifically located on them to create the secondary images needed to create the desired softness. The Imagon comes with different disks with different numbers of holes which create different degrees of softness—a beautiful and very expensive tool. I would not consider buying one of these lenses without first using it. They are very tricky.

The Hasselblad softar filters use optically ground secondary lenses in front of the main lens to create softness in the final image. The softars have little dimples (which are very carefully ground) in the filter, which act as the secondary light sources. The softars come in various degrees of softness, and create beautiful effects. Again, because they must be ground precisely, they are not cheap. The softars are now available in 67mm threaded versions for the Contax camera system, which are easily adaptable to most 2¼ camera lenses.

Another important point to remember is that soft-focus effects are greater when the lens aperture is wider. With diffraction effects, it is the number of openings that determines the strength of the effect. If you stop down the lens (i.e., decrease the size of the aperture on the lens), you use less openings on the mesh, thus your image is sharper. The same filter used at f/4.5 and at f/22 will produce very different results. It is critically important to test any filters that you make or purchase before using them on a client. You should also test each new filter at the various apertures that you commonly use. I have one filter set to use in my studio when I shoot at f/8 and another set for my outdoor photography when I usually shoot at f/4. Experiment.

I spent a lot of time looking for a material for the holders for the various mesh filters I make. The most readily available material I found is the plastic that they use to make 5.5-inch floppy disks for home computers. It is just stiff enough to support the mesh and thin enough to fit in any lens shade. I use double-stick carpet tape to attach the mesh to the plastic, and I usually get one to two years of heavy use out of one. I put them in my pockets, step on them, and otherwise generally abuse them.

To Touch or Not to Touch?

Photographers argue about whether it is proper to touch the subject to aide them in posing. Some argue that it is a violation of the subject's personal space and that it bothers some people. I (and most good portrait photographers) argue that touching, as long as it is firm and professional (with the fingertips), is a great means of establishing com-

munication on a physical level with a stiff or nervous client. To get the correct head angle, it is often necessary to adjust the turn or tilt of the head. The client can't see what is required, and it is much more efficient to place the head in the correct position. This is especially true with men. If I see a wisp of hair out of place, I fix it. If I see an article of clothing that needs adjusting, I will do it (except for ladies undergarments, which I tell them to adjust.) If nothing is out of place, I will adjust a tie, adjust a nonexistent wrinkle, and pretend to fuss a little bit. These little touches show them that I am looking for the details of their appearance and that I care.

Touching can give you a great sense of the nervous state of a subject. Sometimes you can feel the stiffness or sweating of a worried subject, and then you know to take more time relaxing them. I touch almost all my subjects in every sitting. I have never had anyone complain or comment about it in any way. There are a few people I do not touch because I sense their wish to keep a distance. If I sense their wish, I back off.

When photographing children, I touch them as much as possible. I really want to hold and hug (within limits of proper behavior) with the mother or father present. I feel that if I can get small children to hug and kiss me, I have won their confidence and the sitting will be much better for both of us. I do not force children to hug or kiss, but I work through play to get them to want to. I like kids, and I think that they sense this. I don't want to be "the photographer," but Mr. Nice Guy with the funny puppets. I still think the best reward for doing a good job in photography is a good-bye kiss from a three-year-old subject when he or she leaves the studio.

One thing to remember, if you are going to touch, make sure your hands smell good. If you work in the darkroom and have fixer on your hands, you will create a negative reaction. Have a fresh smelling hand soap (Neutrogena is excellent and won't dry your hands out) in the darkroom to remove odors before going back into the studio. Do not use your hands if you have just sliced up a big onion for lunch. Also don't breathe on your clients if you had onions or garlic for lunch. They literally will melt in front of your eyes. Also, wear deodorant and bathe regularly. If you use perfume or cologne, don't overdo it.

Working with Others in the Studio

Often when dealing with portraits of individuals, you will have clients who will come to the studio with a friend and often that friend (or parent, spouse, hairdresser, or whoever) asks, "Can I watch?" The answer is usually no.

First, remember that the majority of people feel very self-conscious about being photographed. If they know that their best friend is witnessing their self-consciousness, they will become more self-conscious and feel more embarrassed. For the sake of the client, keep the friends out of the camera room. Second, your most important job is focusing the subject's attention on you, so you can divert attention away from the lights and camera and control facial expressions. If there is someone else in the room, the subject will be constantly looking over at the friend for approval, and you will lose control. It makes life so complicated, so just don't allow others in the camera room, with the exceptions listed below. I even ask a spouse to leave the room when I am doing a sitting of a couple if I want to have separate poses of each.

EXCEPTIONS: Young children may feel insecure without a parent in the room with them. The younger the children, the more you need mom there to make them comfortable. What you don't need is mom, dad, and three grandparents. Keep it to the minimum. Play it by ear. Sometimes if you can get a young child to feel comfortable with you, have mom leave. You will generally get better photographs without mom there. If you see a look of uncertainty spread over the child's face, get mom back in fast. Parents

can sometimes get good expressions out of a shy child better than you can. It is important that you have the parents behind you. If they are off to the side, the child's attention is drawn away from the camera, and it usually does not look as good.

The other major exception is doing bridal formals in the studio. I have found that most brides, once they have the wedding dress on, want a small, appreciative audience. I allow the groom, the mother and/or the best friend (at a prebridal) to stay in the camera room with me. This is a very positive experience for the groom or the mother. They will say, "You look wonderful," helping the bride to feel that way. The groom will carry that image of his beautiful new wife in this perfect setting for the rest of his life. It makes your portrait even more meaningful to the couple.

Note: Allow only one or two other people in the studio for the exceptions, not a mob scene. Even on location I don't allow the whole wedding party to watch me do the full-length portraits of the bride and groom if I can help it. If they are hanging around, I will have them turn their backs so that they don't gawk at the couple. When I move in for close-ups, I don't need company. I want to be alone with the couple as much as possible.

Composition

When composing an individual's portrait, remember one major rule. The eyes, which are usually the focus of the portrait, should be about one third of the way from the top of the frame. This is true in close-ups, three-quarter length, full-length, or any other normal portrait. Getting the eyes (and thus the top of the head) too near the top of the frame gives a feeling of crowding to a portrait. Getting the eyes too low makes the person look childish or short. Learn to compose in your viewfinder. Even in a tight crop, when you cut off the top of the head, keep the eyes at the one-third level.

When composing groups of people, the strongest compositions are based on triangles and pyramids. Within any grouping you should be able to connect three heads together in a triangle (remembering the no-cross rule). The larger the group, the easier it becomes. The hardest group to pose is four people of equal size. I find that there is always someone left out of the triangular composition. Six is almost as bad. The odd numbers, three, five, etc., are easy because odd numbers lend themselves to triangles. The overall look of a group is strongest when you can create a pyramid, either upright or inverted. Position the strongest figure (usually the father in a family group) at the peak and the youngest at the base. If the family is all adults, you can form the base on the top and lead down to a single figure seated on the floor.

A very good photographer, Tom Shields, taught me a good rule in my early days. Once you have a basic grouping almost ready, squint your eyes out of focus slightly and check the edge of the grouping. If someone or something stands out from the basic grouping, build it into the main composition. Nothing should stand out in a solid composition unless you are intentionally trying to emphasize it.

Smile!

What is a smile? One thing it is not is a laugh. Most people open their mouth and close their eyes when they laugh. That is not a smile. The most pleasant smiles are formed when the eyes are open fairly wide (though not at their extreme open position) and the mouth is in an upturned position. The mouth can range from a little bit open to a lot open with the teeth just showing.

Why do people smile? I use the analogy that people use their faces and especially their smiles in the same way that a dog uses its tail, to communicate a message on the physi-

cal level. When you meet someone, and you are introduced, you smile, and say hi or hello. Your smile is saying, "Look at me. I am a nice person and I am not going to hurt you." When you are about to do something you are the least bit apprehensive about, you look around (for potential witnesses) and smile. Your smile is saying, "OK, here I go. Watch out for me!" When you do something stupid or embarrassing, you smile. Your smile is saying, "Excuse me for being stupid or clumsy!" When you call someone a name you usually look right at the person, smile, and say, "You ——!" We smile to greet people, because of apprehension, out of embarrassment, to project an emotion, and for pleasure and happiness. Mostly we smile because someone else smiled at us and we respond in kind. Smiles are infectious.

Most of us don't know how to smile. We smile by reflex in many of the above situations. Some of us smile more easily and quickly than others. Some people can learn to smile on demand, even if they hate the person at whom they are smiling. Most successful politicians have a wonderful smile to look at. They can turn the smile on and off at will, and it looks real. Well-trained actors can generate smiles on demand. Most people, however, have absolutely no idea of how to smile on demand. Never ask a client to "smile for the camera." The look you usually get is insipid or a caricature of his or her real smile. Most people think a smile is in the mouth, and they curl up their lips in the "cheese" expression which is not a real smile. Most people, even though they cannot generate a smile on demand, recognize a forced or fake smile when they see one. We are trained through life experience from the crib to recognize real smiles from false smiles, and we are usually pretty good at it.

A real smile is in the eyes. The eyes have be open for a good smile. Curling up the lips closes the eyes, the exact opposite of a real smile. The best way to get people to smile, especially when you are doing individual portraiture, is to have them mimic your smile. If you don't have a good natural smile, you should develop one. It sounds silly, but it is true. Learn not to worry about the technical aspects of photography or about what you are doing physically during the sitting. If you're concentrating too hard on the person being photographed, your smile disappears, and so does that of your client. You must look confident and assured, and you must look like you are enjoying yourself. If you don't look happy, they don't look happy.

I have found that word cues generate pleasant smiles on most people. I use "Say hi," "Say hello," or "Say good morning" (especially when it is in the evening). All of these generate a quick genuine smile in most people. You have to be ready because the smile is quick. Most of these cues only work once in a sitting. Once you have used it, you cannot get a valid response the second time. The client has learned the trick. People also smile when you give them an easily accomplished task or question, such as "What's your boyfriend's name?" They know the answer, and they will give you a smile of relief that you didn't ask them the cube root of 13,689. Be careful; don't ask the minister's daughter to swear at you!

Where the Portrait Business Is and How to Get It

BABIES: Baby photography (under one year old) used to be one of the mainstays of a photography studio. Every day mothers would bring their little bundles of joy into downtown studios for their photograph. One older photographer told me how he survived the Great Depression in drought-stricken rural Canada. As part of a major promotion, the studio would send a car every Wednesday to pick up mothers and babies at their homes in the city, or out on the farms, and bring them to the studio. People couldn't afford gas for their cars, but they would still buy baby photographs. After WW II, the "Kid-

napper" photographers would go door to door photographing the baby-boom babies in their homes rather than photographing them in the studio. One photographer who started out in this area says he learned to judge the age of the baby in the house by the diapers on the line in the backyard. He describes dragging lights and backgrounds up to third floor apartments, taking four shots of split 5 × 7 films, and proceeding to the next apartment down the street. A tough way to make a living.

Today, the ninety-nine-centers in the discount stores and the department store studios (mostly run by the same parent corporations) have killed the low-end baby market for regular studios. If you want to try to compete with the large outfits for the baby business, you can only do it by low prices, which is foolish. You cannot produce quality photography at the prices the chains offer. Don't try it. I remember when I first started my studio that I thought I could beat the chain operations. I could, but only for a loss—so why bother?

The baby business today is limited to those parents who want a study done of their child rather than a documentation of the child's features. Ninety-nine percent of people would rather pay ninety-nine cents for one 8 × 10, or pay $19.95 for a package, than pay $200 for something nicer. It is difficult to collect $200 for baby pictures, especially when they are less than six months old, can't sit up, and have not yet started to show their features through the baby fat. A better market for your profit margin is the "mother and child" photograph. This concept allows for more sensitive and meaningful photographs and is an area where the chains can't begin to compete, especially if you have some mothers in tasteful lingerie and a delicate high-key setting.

YOUNG CHILDREN: There is still a good potential market for photographing young children (one year old to six years old). The market is better than the baby market because the child has started to develop a personality and parents want to capture that as well as document the child's growth. The ninety-nine-centers do not do well with anything except the documentation aspect, at which they do an adequate job for the price they charge. To attract the children's market you must demonstrate that you can provide the parents with something other than a record of their child's growth. Your displays must show children at play, in natural environments, or in a creative studio setting. Just doing a straight portrait won't cut the mustard today. Some good speakers on this subject area are Robert Simms from Georgia, Ellen Bak from California, Patsy Hodges from Texas, and Bob Stevenson from New York. These people run very successful children's programs and can show you how to create and market good children's photography.

Photographing children can be the best and the worst sittings you do. The good ones are great and the bad ones will send you to an early grave. You must make a good profit on children's sittings to justify the amount of work and emotional energy expended on the sittings. Children of this age also provide a great training ground for your photographic and people-handling skills. After a cranky three year old, a crusty businessman is a breeze.

It is not uncommon to run a children's special during the normally slow times of the week, usually weekday mornings. These sittings and packages are usually discounted. Don't tie up your prime studio hours doing children's sittings unless you charge full price. Many families who can afford to pay you a good fee for your photography, and who appreciate good photography, also consist of two working parents. Many young mothers must work in order to support the expenses of the good life today. However, this factor makes it more difficult to offer promotions that don't include evening or weekend appointments.

SCHOOL-AGE CHILDREN: These are the school years (six to eighteen years old). Once children start school, they are photographed (usually) every year by the school photog-

rapher. Most parents are satisfied with the quality and price of these school photographs. Very few parents will take this age group into a studio for a good portrait unless there is some other angle to bring them in. You must be able to produce a photograph that has mood and feeling to justify the cost to a parent. (See chapter 7 for details on school photography.)

YOUNG ADULTS: These are prime years for the studio photographer (nineteen years old to parenthood). These are the years when most people look and feel their physical best. This age group is proud of their physical appearance and are also able to pay for good photography to preserve it. They are turned off by the baby factory in a department store, so they will come to your place of business more readily than parents of young children.

Young adults (married or single) are very style conscious. They want to be photographed in high-fashion clothes, in romantic settings, in natural settings, in boudoir or glamour styles, and with their expensive toys, such as cars and boats. These people are one of the most interesting challenges to a studio photographer. To attract these clients, you must display your photographs in areas where young adults will see them, such as health clubs, singles clubs, colleges and universities, postsecondary schools of all types, movie theaters, and special-interest clubs. The key is variety of looks and personal attention. This age group wants to be treated like adults, and they are willing to pay for it.

FAMILIES: Once a couple starts having children, their lives are tied up in the family unit. While they may have an individual portrait taken for some reason, their main interest lies in the family unit. Lumping families into one broad category doesn't work. There are families of three, families of fifty with three or four generations, "core families," and extended families with in-laws (which change). There are ethnic, religious, and regional differences in the importance of the family unit, and the consumer's desire to document it. In the USA in 1991, there were 66,990,000 family units, but there were only 52,635,000 married couples! There were also 89,479,000 households. The definition of a family unit is fairly broad, but as you can see, there are quite a number of single-parent families.

Family photography is the single most profitable area available to the studio photographer. You can earn more dollars per hour here than in almost any other area I know. It is not an automatic market. Families are not like seniors or brides. They are not necessarily looking for a photographer to take their portrait. You have to show them what you can do, and create a need in their minds to have the portrait taken. Once you have done your job well, families spend more money on prints, on average, than any other group of clients in this book. In my business, I value a wedding at three family sittings. The difference is that a wedding takes about 20 hours of total work, and a family sitting only about 1½ hours, on average. My dollar-per-hour return is much greater on families than on weddings.

The department stores and the chain studios realize the potential of the family market and are soliciting it with their usual sophisticated marketing techniques—cheap. Sears and Kmart say they will do a family sitting for $9.95. Most older families will not subject themselves to waiting in line with a bunch of babies at a department store to have an important photograph taken. They have a greater sense of their own value than $9.95. The department store appeals to a young family with a baby or two, but not to a mature family of any taste or sophistication. There are new franchise studios. Expressly Portraits is one that does a good job marketing to the midlevel family market. With highly visible locations in malls and one-hour service, they appear to attract a good number of families.

The real value in family photography is tradition, tempered with mood. I think that

the studio family-group photograph has little appeal to many (not all) modern families. They see themselves relating to the world in ways other than the muted antiseptic tones of the traditional studio backgrounds. They see themselves as a unit in the natural environment of their area, in their homes or yards, in their dream environments, or in some high-tech setting. (This is not to say that in five or ten years studio formal portraits won't be back in fashion in the same way formal weddings are back in vogue after ten years of being unpopular with the majority of young couples).

LIFESTYLE: A new concept is taking hold in the family photography market, the concept of lifestyle. I live and work in a seaside resort area. People come here from all of the Eastern USA and Canada for their vacations. They come to be near the ocean and walk on the white sand beaches. They come to spend their time off with their families in their dream environment, Cape Cod. What better place to have your family photographed? I photograph a lot of families because they see my work displayed, which provides them with a reason and an incentive to have their family portrait taken on the beach. These families see the beach as a symbol of freedom in their lives and they want to be associated with these symbols. The same is true for the sports types, who love to dress in their tennis/golf/yachting outfits. This is how they define their lives, and you can take a picture of it.

I have lectured in different parts of the country, and almost everywhere I go people say, "Ed, we don't have the beautiful beaches you have! How can we do lifestyle portraits?" Someone made one of these comments when I was lecturing in San Antonio, Texas. I had spent that entire morning walking in an area called the Riverwalk in downtown San Antonio, marveling at all of the wonderful potential settings for family portraits. Not one of the photographers at my lecture had looked hard at his or her own backyard. Every area has some natural or man-made beauty that locals love to look at. Go and find it.

Other families define their lifestyle by their home, especially if it is in an upscale neighborhood or extensively landscaped and/or furnished. Home settings have a great deal of appeal to many families and you should direct your marketing efforts in this direction. Home sittings take a little more work than outdoor sittings, but the efforts are usually worth it.

ADULT PORTRAITS: There are more and more unmarried working adults and more double-income couples with no children in today's world, especially in the large cities. These people usually have chosen professions over family, and they are usually earning excellent wages. They are a great potential market for studio photographers because they appreciate the finer things in life and can pay for them. To this age group, expensive equals valuable. Again, portraiture of these people can feature their homes, their clothes, their cars, or outdoor environments. Style is important to them, so do not just document their appearance when you photograph them. Stress mood and style, with taste. The boudoir/glamour look is one area that appeals to mature adults, especially women. (See the section following for a more complete discussion.) Adult portraiture is one area where the franchise studios exert a lot of competitive pressure. The Hot Shots and Hot Looks! chains are just two examples. These chains have good marketing programs and use mall locations to attract customers.

EXECUTIVE PORTRAITURE: Many people in the thirty-to-sixty age group need a portrait to document their success at some time in their lives. This portrait is different from the utility portrait described on the next page. Becoming president of a company, becoming a leader in a social, religious, or fraternal organization, becoming the salesman of the year, etc., are all events in their lives worth documenting. The purpose of this type of portraiture is to show that individual with the trappings of office or in the environment where

they have achieved success in life. This type of photography is termed *executive portrai-ture,* a market with a high degree of potential income for both the portrait and commer-cial studios. For a small-town market, expand the term *executive* to include any successful individual. The environment could be a wheat field, a barn, a skyscraper, a steel mill, city hall, or a small shop. Any community has successful people who are all potential portrait subjects. Good speakers on this subject are Al Gilbert of Toronto and Van Frazier of Las Vegas. Van has an excellent book on the subject. (See chapter 13.)

Many photographers approach the executive market through complimentary sittings. It makes sense to ask the mayor to pose for a sitting for public display for community and self-promotional interests. It is not unreasonable to offer the subject an opportunity to purchase copies of this portrait after it has been used in your public displays. When the sitting is complimentary, you can control the location and style of the portrait much more than when an individual is purchasing your services with certain preconceived notions of what they want. These photographs also make great display prints for your exhibits. People relate to successful people in their area, and your growing reputation can be tied to the subject's reputation and stature. An excellent speaker on this approach is Bill MacIntosh of Norfolk, Virginia.

SENIOR CITIZENS: When people reach the golden years (sixty and above), the need for a good portrait becomes greater because there are more people who love them and think they are important and worth remembering. The problem is that a person's self-image erodes with the ravages of time. This older group is a good market for a regular studio, because there is real need for high-quality photographic technique that the chains and discount stores can't provide. Also, older people won't stand in line in Kmart for a sen-sitive portrait.

All promotions should be aimed at making older subjects look as young and active as possible. Great care in proper retouching and proper background selection helps to hide the effects of age on face and body. You must pay a great deal of personal attention to these clients to alleviate their fears and to make them feel comfortable. Your promo-tions should be oriented to rather conservative settings and backgrounds (both indoors and outdoors) that show both senior citizen couples and individuals in dignified poses. People of this age don't go for the gimmicks that the high school seniors demand; in fact, the gimmicks will scare them away.

One great advantage that senior citizens represent is that they are available on those otherwise slow weekday mornings. You can use some of the promotional ideas appli-cable to children when promoting to senior citizens. Seniors citizens also live in concen-trated areas and congregate at social centers where you can promote relatively easily. Many times seniors are also the heads of families. When the family gets together next, you will be the one to get the family job, which is the most lucrative. Seniors citizens are a worthwhile market for you to pursue.

UTILITY PORTRAITS: There is a continuous need for people to have a portrait taken of themselves for newspapers or other visual promotions. There is always the constant need for passport or other ID type of portraits. I call this type of work *utility portraiture.* The use requirements rob you of any creative control over pose or lighting, and the legal or publication format requirements do not allow for a great variety of posing or back-grounds. The client's need is almost always the need of the moment. A great deal of this type of work should be done in black and white as the finished products are to be used in newspaper reproduction.

There are large studios that will shoot fifty to one hundred black-and-white utility sittings a week. These studios are usually located in the downtown sections of busy metropolitan areas with many business offices located within a short distance. The closer

you get to the center of industry or commerce, the more simple black-and-white business portrait work, passport, and ID work you have the potential for attracting. Even in small towns, people run for elective office, receive local awards, and need some of this utility work.

The drawback is that the money for this type of work is not that great. There is usually only a need for one or two 5 × 7 glossies from the sitting, and there is very little potential for reorders of any magnitude. I know of studios that will do the utility sitting, then put color film in the camera and shoot a few regular portraits of the subject and then try to sell them color portraits. I do not know of anyone who gets a great return, especially for the amount of selling required, to justify getting too excited over this form of portraiture.

If you do any utility work, you must set your prices to fully cover your time and material expenditures. A simple black-and-white sitting still requires a booking call, an appointment, a proof pickup, a proof return, and an order pickup, which all take up your studio time. The sitting also requires a roll of film, black-and-white paper, darkroom time for film and print development, and negative retouching. While none of the above is as time consuming as a family sitting, the time and expenses do add up, especially with little potential for large print reorders. If you do fifty to one hundred of these a week, you can organize your time and production schedules more efficiently. If you only do a few of these a week, they seldom will be profitable for you.

Passport photos today can be done on a Polaroid camera (it costs about $500 to $1,000). Many studios have a passport camera in a corner of the camera room with a simple lighting setup and a plain white background. Passport customers can be photographed by the photographer or by a receptionist with a minimum of training. Passport photos generally sell for about $10 to $15, and the film (with wastage) is about $1 to $2 per person. Once the prints are developed, they usually have to be trimmed to the legal size and delivered to the customer. Total time involved, about ten to fifteen minutes.

If you have a storefront studio on a busy street in a larger town, you may be able to pay your rent from passport photography. If you live in a small town, you may get one or two passport sittings a week. If you only have a few a week, or even a few a day, I do not think they are profitable for you, and you should not even bother offering the service once you have built up any type of volume. You cannot afford to tie up your time waiting for a passport and then take the time to do the sitting, prepare the photos, and deliver the prints. Some photographers will argue that the passport customers are potential portrait customers. I don't think so. I have had few passport customers come back for an expensive sitting. When they look at the passport photo, who can blame them? The legal requirements make the posing so unattractive, and the lighting so flat, that the subject looks terrible. They blame it on your photography, not on the medium. You lose. I once heard the expression, "If you look like your passport picture, you're too sick to travel anyway!"

MODEL PORTFOLIOS: The majority of people who come to a studio for a model portfolio have no chance of ever becoming a professional model working for a legitimate agency. The primary clients in this area are young adults who think (rightly or wrongly) that they are good-looking, who like to dress well, and to express their personalities through their hair and styling. They are proud of their appearance, and today that means looking like a high-paid fashion model. In the thirties and forties, it was the Hollywood starlet who filled that role. Today, the stars on the covers of magazines are the models of New York and California.

The model business is a multibillion dollar enterprise. There are modeling schools where young girls and boys are bilked out of large fees to learn how to comb their hair,

apply makeup, and do runway modeling. A lot of these schools only claim to be finishing schools, and not model placement or training schools. If you watch their ads and read their brochures, they use the word model about ever five or six sentences. The young people who attend do think they are going to be models. There are also model discovery competitions where, for a substantial entry fee, a potential model can walk up and down a stage in front of a panel of judges. If they win, they get the right to pay another entry fee to go to the next level of competition. I have yet to hear of a person actually getting a paying job out of one of these contests. There are as many scams as there are unscrupulous people to think of them. Be very careful when you are trying to get established not to become associated with anything that is an unqualified rip-off. Only associate with established businesses or new ones which are interested in real goals, and not in taking money for fluff.

A real modeling agency usually has a list of photographers to whom they send their people. Even when a person becomes a paid model, he or she usually has to provide his or her own promotional photographs to the agency for the *head sheet,* which is a photographic data sheet that agencies send to potential customers. Head sheets contain four or five photographs of the model in different fashions, with usually one close-up head shot. The head sheet also contains the model's physical measurements, clothes size, weight, shoe size, hair color, etc. The head sheet photography is usually done by the list photographers, but it is an area where you can break into real fashion photography or just get into real model photography. If you live in a larger town or city that has a legitimate modeling agency, you may want to become a list studio and do a lot of fashion work. Providing good photography for newer models (usually for gratis) can help you get your foot in the door.

A real model has a portfolio: an 11 × 14 briefcase with tear sheets of real jobs that have made it to print and 11 × 14 prints from their own or some photographer's promotional work. A strong portfolio shows the model in different fashion styles: formal, casual, sporty, country club, swimwear, etc. Different models have different strong points, and the fashions and settings should enhance their strengths. Most portfolios should include some close-ups, some body shots (not nudes, but swimwear or other tight-fitting or skimpy clothes). All shots should show some aspect of a personality to enhance the model's usability.

Back to your new studio and reality. The majority of people coming to see you about a portfolio have no idea of the work involved in being a professional model. They think it is just wearing nice clothes and standing around looking beautiful. That is what they want, and that is what they are willing to pay you for. The key words to use in designing a model portfolio are: looks, head shot, body shot, glamour, style, fashion look, and all of the fashion terms you see in magazines like *GQ* and *Seventeen*. Pick up a few copies of *Elle, Glamour, Vogue,* etc., to see what is in fashion.

When a person wants to be a model, he or she has to have a "look," such as sporty, preppie, evening wear, hip-hop, or formal. The look really refers to the fashion styles of the moment and the environment of your model's life, of which you should be aware. Unless you are very knowledgeable about fashion trends, let the client choose the look he or she wants. Let him or her provide his or her own wardrobe unless you have access to a fashion store which will help you out in return for promotional photos. Tell the model to bring a number of different outfits to the studio. He or she will usually arrive with ten or fifteen outfits and you have to help him or her decide. He or she likes clothes, so let him or her play dress-up in your studio.

A typical portfolio package would consist of a one- to two-hour shoot with four or five different looks, some in the studio and some on location. Real models carry their

proof sheets (contact sheets) with them, and it sounds professional to include them in your portfolio package, as well as blowups of the best shots. Scout out some environments that will make graphic backgrounds or that will fit one of the looks chosen by the model. If he or she wants to wear a tennis outfit, go to a tennis court and stage a game. If he or she has a business suit, go to a downtown area and frame him or her against an urban landscape. The two or three studio shots should include a close-up head shot and some hand shots. There should also be a swimsuit shot, or something in a leotard or very short skirt. Do not offer to do nudes. They are not part of professional modeling and are a separate type of photography.

Doing model portfolios is one area where you may use 35mm. In the big cities a lot of fashion work is done on 35mm so there is nothing unprofessional about it. The lightweight cameras with motor drives and zoom lenses make shooting a fast-moving model easy. Look at the popular TV image of a professional photographer and you'll see a Nikon buzzing away and the guy yelling, "Wonderful, give me more! Play the role. Work with me, baby!"

A lot of model portfolios are shot in black and white. Black and white is actually preferable to color for most applications. Go along with the perception and shoot lots of film and make sure you get every facial expression that they have. Don't be shy. Help them let it all hang out. If you can't let loose, stick to babies.

Model portfolios should be priced to pay for themselves. It has been my experience that these sittings do not generate resales. Modeling hopefuls will not invest in a high-priced portrait now because they think they are going to look better next year and they will wait until then. So charge like a commercial photographer and get your money up-front for your time, materials, and effort. Sometimes you can do a tie-in with a beauty salon and have a cosmetologist in your studio for makeovers and hair styling. This service will make the client feel better and could be a business builder for the person doing the makeup work. A tie-in with a high-fashion store which caters to upscale children or young adults can provide good leads and beneficial mutual marketing concepts. Check it out.

Model portfolios are fun because you can try out your new techniques on handsome, photogenic people. They love looking different and trying new things and will usually work with you. These sittings are a wonderful way to generate exciting samples for your displays and to create good competition prints. They are good ways of expanding your photographic horizons. You can also learn how to elicit more emotion from your regular sittings. A good book on photographing models and how to market to them is by Art Ketchum of Chicago.

BOUDOIR/GLAMOUR: The boudoir style of photography is an area that has grown greatly in the last few years, but I feel it has peaked. The style involves photographing women in negligees, in a style that is classier than "cheesecake" and not as frank as nude studies. The style reflects a changing attitude in women in their twenties, thirties, and older. These women are conscious of their bodies and looks, and want to be photographed in poses that are erotic but still within the limits of good taste. The portraits taken in boudoir sessions are usually not given out as Christmas cards, but are meant to be given to the special significant other in their lives, usually the husband or boyfriend. The most successful sittings are usually of the older women (thirty to fifty) as they have longer established relationships with their spouses or lovers and also have the money to buy good photography.

Boudoir teeters at the edges of good taste (in my opinion). I have seen boudoir shots of the highest fashion and taste, and I have seen them done in the most crude manner imaginable. Your taste as a photographer is the key factor. If your taste is a little more

crude than that of your market, you may injure your other business by offering and displaying boudoir photography. If your taste is in tune with your market, this style of photography can be profitable and should not detract from your other business. However, if you do a lot of school photography, you should be extremely careful about your reputation.

Helen Boursier has established a very good boudoir business in a small, conservative New England town. She is a woman of impeccable taste, and she promotes and sells her style of photography very well. For Helen, boudoir is exciting, creative photography which helps bring in the dollars, especially in the slower months of the year. Helen advertises, "Sensitive portraits of a woman, by a woman, for the man in your life." She displays her work in fancy lingerie shops, which are increasing in popularity. These shops sell high-priced lingerie mostly to middle-class women in the twenty- to fifty-year-old range.

Helen tells me that the key to making a good profit is preselling a large wall portrait and then selling an album of the different poses afterward. Again, the main purpose of the session is to give a gift to the significant other, and a wall portrait for the bedroom is ideal. The album idea is great for selling the other poses. Again, it is generally intended for the lover, and not for public display.

Another approach worth considering is fantasy photography in the glamour style. This is different than boudoir because the emphasis is on the hair and makeover makeup techniques and on the style of clothing (rather than on the lack of clothing). Instead of lingerie, you use hats, boas, scarves, and drapes to achieve a Hollywood look. The key to this approach is doing the makeovers with good hair and makeup stylists. If you have talent in this area, there are a number of tapes available which can teach you to do the makeup. Be careful to check your state laws concerning applying makeup without a license. The Perrins, of On Broadway Photography in Portland, Oregon, have a wonderful program on this area of photography, which can be very lucrative for the average studio. Pat Harrison also has a great tape on makeup technique that is well worth investing in.

PETS: A great market for a portrait studio is the nonhuman members of the family. I have had people spend more on their dog's portrait than on their children's portrait. Many people are more emotionally attached to their pets than to their spouses and are willing to have a nice portrait done of the animal. This is also a good market for a regular studio because the chains and department stores don't do animals. It is also harder for people to get a good photograph of an animal with their regular camera. David and Elizabeth Dame of New Hampshire don't like doing weddings and have replaced weddings with pet photography in their small town. They personally enjoy animals, and they are happier shooting four-footed bow-wows.

There are some excellent books available on photographing small animals and larger animals. The lighting equipment in the studio is usually all you need, with a few refinements of technique. The major technical point to remember is that you need to emphasize texture (the fur) of an animal, and you do not have as many specular highlight problems to deal with as you do with human skin. A more direct light source is preferable over a large diffused light source to create specular highlights on the fur and to establish texture. When you get a black dog or cat, you need a lot of light and a lot of kicklighting to get good texture and good separation from the background.

Animal portraits make some of the best wall samples you could have on display. Next to babies, no warm human being can resist looking at a photograph of a cute puppy or a kitten. In public displays, use animal and baby photographs at the ends of your booth space to get people to look. It never fails.

Large animals, such as horses and cows, require a lot of space. They are usually done in an outdoor setting. Use direct sunlight to create specular lighting on the hair, but make sure you keep your ratios under control with proper fill lighting. When photographing large animals, you must never use a wide-angle lens. The size of the animals will create severe distortion, and the owners will not accept it. When doing horses and cows, the correct stance and proper ear position are critically important. Study the various magazines, which exist for almost all major breeds of large animals, for examples of good stances and views of champion animals of the breed. A tin can full of pebbles, shaken gently by someone between you and the animal, will get the animal to turn its head and perk its ears forward. It works most of the time.

There is a difference between photographing animals for breeders and pets for regular people. When working with breeders who use the photographs in publications to sell the animal or its offspring, you must capture the important details of what makes that particular breed different from other breeds or individuals in the breed. For example, I photograph each new litter of cocker spaniel puppies for one breeder near my studio. It is always one of my favorite days, and I spend a half hour playing with these cute little puppies. To a cocker breeder, a good expression is a sad one. To me, dogs smile just like people. I have to fight my instincts to make the puppies smile to please the breeder's ideas. I usually do both and use the smiling ones for my studio walls.

If you have some knowledge of animals, there is a large market available in the world of animal shows. If you want to do horse shows or dog shows, you need to know the good and bad points of all breeds, and to work quickly and efficiently in the show format. There are photographers who do nothing but shows, and make a good living at it. If you are interested, you should try to get to do the local shows to see if you want to go after the larger shows.

A very important piece of equipment to have when photographing small animals in the studio is a sturdy table. If your table is shaky, the animals do not feel secure and they look unhappy and won't sit still. I have found that the dog breeders can get you a dog-grooming table from their suppliers. It is one of the sturdiest folding tables I have seen, and I use mine for children too, all the time.

Copyright Protection

A portrait photographer is lucky that the current copyright law is quite specific regarding who owns the rights to a portrait taken by a professional photographer. The copyright law automatically assumes that the ownership of the reproduction rights of a portrait photograph resides with the photographer. The copyright law is not this specific about commercial photographs. Read ASMP materials for an extensive discussion of commercial copyright issues. As a portrait photographer, it is essential that you mark your photographs properly to correctly inform your clients of your rights. The following is a PPofA handout designed to be attached to the back of a portrait photograph.

Important notice about copyright protection

The Copyright Act protects photographers by giving the author of the photograph the exclusive right to reproduce your photographs. This includes the right to control the making of copies.

It is *illegal* to copy or reproduce these photographs elsewhere without our permission, and violators of this Federal Law will be subject to its civil and criminal penalties.

We will try to accommodate all reasonable requests. Please feel free to discuss your needs with us so that we may have the opportunity to serve you better.

Or try this more wordy one:

Important notice about the reproduction of your photographs
(Please read carefully.)

As the creator of your photographs, this studio, under the protection of the Federal Copyright Law, owns all rights (copyrights) to these works. As the copyright owner, the studio has the exclusive right to reproduce your photographs.

Therefore it is *illegal* to copy or reproduce these photographs elsewhere without written permission from this studio. Violators may be sued for copyright infringement.

Your photographs are the result of our experience, creativity, and professionalism. We earn our living by providing you with this quality product. Frequently, our right to earn this living is violated when our work is copied or reproduced through other sources. And, just as important, the quality of the finished product is diminished, as is the reputation of our work.

Your desire for the best quality product and service available brought you to a professional photography studio. By reproducing your photographs from the original negative, our studio assures that this quality is reflected in the final prints.

And because we retain your original negative, you can order additional or replacement prints that will beautifully preserve your memories for years to come.

We appreciate your business and look forward to servicing all your professional photographic needs.

Outdoor Portraiture

In my present studio operation I do 80 percent of my family photography and about 50 percent of my children, adult individuals and couples, seniors, and wedding formal photography in outdoor locations. I have a backyard at my studio with the space and greenery to work quickly and efficiently with seniors and people wanting a wooded background without having to travel at all. I also live a two-minute drive from the white sand beaches of Cape Cod. I had a small camera room before I built my studio in which it was very difficult to shoot family groups. I like working with natural light, and I do more creative posing with all the space available to me in the natural settings. I have also spent years learning the light quality at different times of the day for various spots in my yard so that I can go to exactly where I know a pose will work without experimenting or searching. Natural settings are a popular part of the modern portrait market, especially in family and senior photography. There are some major technical adjustments that you have to make and some mental ones.

I find that working outdoors in beautiful, natural surroundings relaxes the clients more, and being relaxed makes for better portraits. The studio is a strange place full of hardware and mysterious objects which puts the average person on the defensive. Being out in a park or at the beach is a more familiar and comfortable place and easier to adjust to, especially for young children. From the client's point of view, the natural backgrounds are more real and not artificial (even though by the time you put them out of focus, crop and vignette them, and add soft-focus filters, they don't look anything like the client saw them).

Technically, outdoor photography is more demanding of your skills as you have less control over the direction and intensity of the light than you do in the studio. You often have to make compromises which are not perfect, leading to posing and/or printing problems. Light levels are often very low, leading to slow shutter speeds and/or low f-stops (with less depth of field for your focus), both of which require great care and skill on your part to overcome. Often the light is not daylight (i.e., 5500 degrees Kelvin), but tinted, requiring that you use appropriate filtration and exposure correction to get printable negatives.

POSING OUTDOORS: The best part of working outdoors is the increased variety of poses available. I think that a couple sitting on the studio floor with a canvas backdrop looks contrived, while the same pose looks very natural on a beach or on green grass in the park. I feel (and I think most clients agree) that poses should look natural, i.e., they must look like the subjects are doing something normal. Outdoors you have grass to sit down on, trees to lean against, rocks and banks for people to sit or lean on, all making for a great variety of body positions with very little effort. Such variety is most important in family photography.

The other advantage of outdoor photography is your ability to back off and reduce the size of the subject relative to the background. Many people look at a close-up taken in the studio and feel self-conscious about being so prominent. To isolate a figure in the studio looks contrived and actually increases the feeling of sticking out. Outdoors you can back off as far as the scenery will allow and it will still look normal. You can even reduce a figure to one twentieth of the portrait and capture a feeling that will please both you and the client. This composition is especially true and helpful with heavier (and older) people. They look smaller (or less wrinkled) in a reasonable way. When posing a group outdoors, it is handy to have a set of small folding stools on which to place people. If the grass is damp, it is handy to carry small patches of green carpet for people to sit or kneel on (out of sight of course) to protect their clothing.

OUTDOOR LIGHTING: The whole point of taking a sitting outdoors is to capture the feeling of the natural light and scenery. People know what they see, and to alter the natural look of the light too much will result in an artificial look, which should be avoided at all costs.

LOOKING FOR THE LIGHT: What do you look for when viewing a potential scene to be used for outdoor portraiture? (1) A good light for the subject. (2) A pleasing and well-lit background behind the subject. (3) Trees, tall grass, bushes, etc., to act as props and vignetters. (4) Accessibility and safety.

Some general rules about good light: (1) Never use direct sunlight unless it absolutely cannot be avoided. (2) If you do use direct sunlight, don't face your subjects directly into the sun, unless you have a compelling reason to do so. (3) Choose an area where the light is not coming from directly overhead. You need light that comes from in front of the subject. (4) You need a minimum intensity of light to work at acceptable shutter speeds.

You don't always have the control you wish you could have. A spot which may work well on a sunny day won't work well on a cloudy day, and vice versa. The amount of haze in the air will change the quality of light significantly from day to day at the same hour. The amount of scatter on a humid day in July is very different from a crystal-clear day in October. You must learn the differences.

The ideal location has some kind of overhang to block out the toplight but leaves the front of the subject exposed to indirect light. An example is the classic "edge of the forest." If you use a wooded area, you will soon learn that the light intensity and quality inside the trees is not very good. The best light is at the edge, where the overhanging

branches of the trees block part of the open sky, providing you with a broad, diffused light source. The trees also act as your props and backgrounds. Sometimes you will find a spot with a perfect background but not so good light. You can modify this light with some of the basic tools of your trade, such as fill flashes, reflectors, or gobos. The most important tool is the *gobo,* a black umbrella made famous by Leon Kenemar. To block out the overhead light, you use a light stand (or an assistant) to hold a flat, black (i.e., nonreflecting) scrim over the head of the subject. This creates the shade which you may be missing. With silver or white reflectors, you may then try to enhance the light coming from the sides to best light the subject.

I prefer to look for spots that give me a true natural light without resorting to all of the hardware necessary to use black umbrellas. However, if you live in an area with limited natural settings, you need to use all of your available techniques. The light on the background should create a three-dimensional sense and should allow similar exposures to the lighting on the subject. If the background is two to three stops brighter, it will wash out. If the background exposure is two to three stops darker, it will go black.

The ideal foliage background should be illuminated by patches of light that create a natural tunnel effect with just enough highlights to give a feeling of the leaves. A solid background, such as a bank of grass, a hill, beach, or mountain, should be illuminated so that the background remains secondary to the foreground. This is not always easy. Evergreens do not make good backgrounds. There is very little sunlight which can get through the thick branches, so when you look into the stand, it becomes black and lifeless. A dense thicket is also too dark. Sometimes the best angle is using the edge of the forest as the background. In this direction, the light intensity is more equal and the trunks of the trees make a good background.

Often a family will request that you photograph them in their yard, which they say is beautifully landscaped. When you get there, you realize that landscaping means one bed of flowers six inches high and that any view other than straight down is of the neighbor's house complete with power lines. Most people don't understand that the outdoors must act as a background, not a foreground. They also have tunnel vision and only see the flowers and not the phone poles. Be very careful when booking a home sitting without looking at the area where you will be working, especially if you live in an area without a lot of trees and foliage.

To most families, their home is the most important place in the world. Using the building itself as a background is often very satisfying to a great number of people. Do not hesitate to suggest the house as the background instead of the grounds. If this approach appeals to the clients, figure out the best time of day to photograph the house and book the appointment for the best time.

A List of Items Needed for a Portrait Camera Room

- four-light setup:
 - one main light
 - one fill light (may be more than one head)
 - one background light
 - one hair or top-separation light
- optional kicker lights
- low hair kicker (a 750 to 1500 watt quartz light)
- one posing table (adjustable height)
- one or two stools (adjustable height)

- three to five posing cubes
- six to ten blocks (2 × 12 × 12 painted light or dark)
- one or two chairs
- two small stools (8") for kids
- three to four backgrounds and system to hold them
- one small step ladder, or three-step poser
- camera system with 150–180mm lens, lens shade, diffusion filters, vignetters, cable release, sync connector, light meters, camera stand, or tripod

Sample Forms

Have your printer print the following format on 4 × 5–inch index cards so that you can file them after using them.

SITTING CARD [front]

LAST NAME	FIRST	MIDDLE
DATE PHONED	SITTING DATE	
CHILDREN (AGES)		
STREET ADDRESS		
CITY	STATE	ZIP
PHONE (HOME)	PHONE (WORK)	BEST TIME TO CALL

TYPE OF SITTING (FAMILY, COUPLE, INDIVIDUAL, BABY, SENIOR, WEDDING)

REASON FOR SITTING

GIFT FOR SOMEONE?

DATE NEEDED	OTHER NEEDS

WHERE DID THEY HEAR OF YOU?

WHAT STYLE OF PHOTOGRAPHY?

KEY?	CLOTHING?	WHEN?

SITTING CARD [back]

SCHEDULE APPOINTMENT _____

CLOTHING CONSULTATION _____

PROOF PICKUP _____

PROOF RETURN _____

ORDER PLACED _____

PROOFS PURCHASED _____

PRINT ORDER_____

$ _____

FRAME ORDER_____

$ _____

The following list is to help you remember to whom you want to give gift portraits. This form is for your use only.

"WHO NEEDS WHAT" FORM

PARENTS

Mom's	A	B	C	D	E	8 × 10	5 × 7	4 × 5	WALLET
Dad's	A	B	C	D	E	8 × 10	5 × 7	4 × 5	WALLET

AUNTS AND UNCLES

_____	A	B	C	D	E	8 × 10	5 × 7	4 × 5	WALLET
_____	A	B	C	D	E	8 × 10	5 × 7	4 × 5	WALLET
_____	A	B	C	D	E	8 × 10	5 × 7	4 × 5	WALLET
_____	A	B	C	D	E	8 × 10	5 × 7	4 × 5	WALLET

FRIENDS OF FAMILY

_____	A	B	C	D	E	8 × 10	5 × 7	4 × 5	WALLET
_____	A	B	C	D	E	8 × 10	5 × 7	4 × 5	WALLET
_____	A	B	C	D	E	8 × 10	5 × 7	4 × 5	WALLET
_____	A	B	C	D	E	8 × 10	5 × 7	4 × 5	WALLET
_____	A	B	C	D	E	8 × 10	5 × 7	4 × 5	WALLET

COPIES FOR THE CHILDREN

_____	A	B	C	D	E	8 × 10	5 × 7	4 × 5	WALLET
_____	A	B	C	D	E	8 × 10	5 × 7	4 × 5	WALLET
_____	A	B	C	D	E	8 × 10	5 × 7	4 × 5	WALLET
_____	A	B	C	D	E	8 × 10	5 × 7	4 × 5	WALLET

COPIES FOR THE OFFICE

_____	A	B	C	D	E	8 × 10	5 × 7	4 × 5	WALLET
_____	A	B	C	D	E	8 × 10	5 × 7	4 × 5	WALLET

Remember: The more prints you order of the same size and pose, the less your cost per unit. Four 8 × 10s are less expensive than three 8 × 10s and one 5 × 7.

Planning

When you have no goals, any path will get you there. Failing to plan is planning to fail.

—C. H. Greenwalt of Du Pont

Our plans miscarry because they have no aim.

—Seneca

We are going to discuss three kinds of goals: (1) financial goals, (2) professional achievement goals, and (3) personal (lifestyle) goals.

The most important thing is to have goals be real. When you write down a goal, it must be real to you, and reachable. If your goal is tangible (such as a car, a vacation to a specific area, or a new house), cut out a picture of that goal and tape it on the wall over your desk. You must be able to visualize yourself obtaining the goal for it to mean anything. You must also be able to visualize the details. You cannot just say that you want a good vacation next year, you have to put a specific place and time in your plan. If you want a car, describe the color, make, and model. If your goal is an intangible, such as becoming president of your state's PPA or becoming mayor of your community, cut out a picture of someone who has achieved that goal and use that as a role model. If your goal is internal, such as losing weight or stopping smoking, you have to imagine yourself not doing what you are doing now. You have to imagine yourself in a pair of jeans four sizes smaller, and then go out and buy the jeans. The path to giving up bad habits is long and full of pitfalls. Always having the goal in sight will help you through the tough times.

If you write down a goal that is truly impossible to obtain, you will ignore it. If you say you want to climb Mount Everest and you have never walked more than a mile in your life, the goal won't be real. If you say you want to be rich and you have no resources and no income, you won't respect your goal. If you say you want to be famous and can't get out of bed in the morning to go to work, the goal is meaningless. You can set some high goals for yourself, if you really feel that you can reach them. There are people in wheelchairs who made climb-

ing a mountain a goal, and then worked to achieve that goal. (A paraplegic who climbed Half Dome in Yosemite is a case in point.) There are people who've had no money, wanted to be rich, and achieved their goal. Nothing is impossible as long as the end is real to you, and you are willing to do the necessary work to achieve it.

The best part of writing down your goal is that you are then forced to think of how to achieve that goal. The goal is easy to state, but the path to that goal may require years of hard work. If you understand the work involved, and still want what the goal represents, go to work. You now have a direction to your life, which is a lot more than most people in this world can say.

Financial Goals

Get up early tomorrow morning, make a cup of coffee, sit down at the kitchen table with a scratch pad, and do the following exercise. Figure out how much money you need to live. The Personal Expenses form at the end of this chapter was prepared to assist you in this job. Write down the rent, car payment, insurance, clothing, kids, food, heat, everything. Remember to allow yourself some treats (vacation, nice clothes, dinner out every so often) and some "miscellaneous" money. Be honest with yourself. Don't think that you can live like a monk in a cell or that you can avoid paying your taxes for a few years to save money. Make sure that you include your bad habits that you wouldn't talk about in public, but which are part of your living expenses. Translate this into a yearly total. Call this number "needs."

Note: Many people really don't know where they spend their money in a given month or year. If you make a certain amount of money and it is gone at the end of the year, your calculation of your expenses should equal your income. If your calculation is significantly less than your earnings, you need to do some more homework. The only way to attack this problem is to buy a small notebook for you (and your spouse if you are married) and write down every cent you spend in the next month. If you buy a pack of gum for forty-five cents, write it down. If you buy coffee and Danish with the people from work, write it down. At the end of the month you will see where your money is going. It is surprising how much a cup of coffee a day or a pack of cigarettes a day amounts to in a month. You must get a good idea of your expenses.

Next write down the things you want, which are different from what you need. You may want a new car next year, or to buy a house, or a new computer, or to start an IRA, to go to St. John for a month, to start a fund for the kid's education. Be reasonable. Don't expect to buy a Mercedes Benz in your first year of business unless you have a very rich uncle. Call this number "wants." Add wants to needs. This is your financial goal for this coming year. If you have an income from another source, or your spouse works, deduct that income from the goal to determine what your new photography business must earn to achieve your total financial goal.

WHAT ARE YOU WORTH AS A PHOTOGRAPHER? What does an average photographer earn? That's a tough question to honestly answer because there is no accurate data on small-studio owners. PPofA has done a survey (1986) and concluded that the average PPofA member has a gross income of $70,000 with an average billing of $243 per job. From the data on gross income and net billings in the PPofA survey, I calculate that the average studio owner nets about $12,000 to $15,000 a year. The range, to the best of my knowledge and personal experience, is from $500,000 a year to a negative (i.e., an established studio lost money in a given year) income.

As a starting point, let's look at the wages of an experienced medical photographer who works for a large university medical school. Her 1992 base salary was $26,500 for

a 37.5-hour work week with three weeks paid vacation, twelve sick days, and twelve paid holidays. She also received full medical and dental insurance (worth about $4,600 to $6,000 to a self-employed person with a family when you can get it), unemployment benefits, and the university paid half of her social security (that is worth 7.5 percent of the gross profits of a self-employed person). With benefits, she made the equivalent of about $35,000 pretax net profit for a small business. This is for a regular work week with some responsibility, but nothing as crucial as doing someone's wedding and losing the film. In an article in *American Photo* a very reputable commercial studio reported paying its full-time photographers up to $30,000 a year, plus a percentage of its actual billings, plus full benefits. Photographic assistants in this firm were paid up to $18,000 (again, with full benefits).

For purposes of this exercise, I am going to assume you want to earn $24,000 next year, before taxes. (I choose this number as a realistic goal for a first-year studio owner starting from scratch and not as a goal for an established studio owner. The established studio owner must aim much higher unless he or she is satisfied with a workman's wages for a professional's job.) There are fifty work weeks in a year with forty hours a week for a total of two thousand normal work hours in a year. This figure implies that to achieve a net income of $24,000, you have to net $12 for every normal work hour from your business. Note: We depart from reality here because, remember, your first year in business you had better work a lot more than forty hours a week!

What is net income? It is your gross income less all material costs as well as the overhead costs of doing business. It is the true profit of your business. If you need to net $12 every hour for two thousand hours, what must you gross? This is a good point for you to consider. A well-established accounting rule of thumb is that a well-run business should net one third of what they gross, with about one third going to overhead and about one third going to cost of materials and production. As a new business, you will not be so efficient and a one-third net is too high a goal what with the heavy start-up costs in stock, capital investment, advertising, and training.

To Net $12 at 25 percent efficiency means Gross = $48 per hour
To Net $12 at 20 percent efficiency means Gross = $60 per hour
To Net $12 at 15 percent efficiency means Gross = $72 per hour

Another factor that you have to take into account is that you will not be working every hour of the year. The time you spend on marketing, bookkeeping, training, interviewing, etc., is not productive time in terms of billing clients even though it is vitally important to the success of your new business. That means that the hours you can bill to a client must carry those hours you are spending on overhead or not working because of seasonal variations in the marketplace.

I think you will do well if you can achieve a 50 percent billable time ratio in your early years, that is, you will actually be working for a fee twenty hours a week, fifty weeks a year. I will call these *contact hours*. What does that do to the gross figures in the table above? It doubles them.

To Net $12 at 25 percent efficiency means Gross per contact hour = $96
To Net $12 at 20 percent efficiency means Gross per contact Hour = $120
To Net $12 at 15 percent efficiency means Gross per contact Hour = $144

Personal Goals

This figure is hard for another person to define for you. What you have to do is have a serious conversation with yourself (and your spouse if you are married) and answer the following questions. Where do I want to be (in a lifestyle sense) in one year, two years,

five years, ten years, twenty years, thirty years, and when I am retired? What do you think you will need in terms of financial resources, personal achievement, market position? Where do you want to be living? What is your family life going to be like? What about your health? These are not easy things, but you must think of them as your actions tomorrow will affect to some degree who you will be in thirty years.

Professional Achievement Goals

Setting professional goals is easier than setting personal goals. There is an established system for you to test yourself against. Once you have achieved the goals, you must then move on to higher goals which you should set for yourself. Too many photographers don't start on the achievement trail by using the excuse that the goals are artificial and not worth striving for. What do they know unless they get there. Once you have achieved a given goal, you may say it wasn't worth the effort, but you made it. The purpose of a goal is to motivate you to move forward. Once you have achieved a difficult goal, don't assume that you have reached the end of the line. Set another goal which is higher (in your mind) and harder, and keep moving. The list below contains some goals and a plan to achieve them.

FIRST WEEK: Join your state, local, and regional PPA. Go to all possible meetings/seminars/conventions. Find out the schedule of events, and write them in your appointment book. Make the time available and go.

SIX MONTHS: Attend your first week-long course at a regional school.

TWELVE MONTHS: Attend your second week-long course. Enter your first print in competition at the state or regional level. Get on a committee at the state or local level. In Canada, earn your first accreditation.

EIGHTEEN MONTHS: Attend your third week-long course. Enter regional or national print competition. In Canada, earn your second accreditation. If you don't have a local PPA, form one.

TWENTY-FOUR MONTHS: Apply for Certified Professional Photographer status with PPofA. Hang a red or blue ribbon print at state or regional. Attend fourth week-long course.

THIRTY MONTHS: Obtain CPP status. Get merit print. Head a state committee.

After this, get involved in the Masters and Craftsmen programs of the PPofA or PP of Canada. Keep active in your state and local PPAs, getting on committees.

Now that you have determined your goals, you have to create a plan to achieve those goals.

Components of a Good Business Plan

A good business plan consists of a number of subplans. In order of importance they are: (1) Income goals for next eighteen months. (2) Marketing plan to achieve the income goals. (3) Cash flow plan for next eighteen months. (4) Personal achievement goals for next twenty-four months (see above). Cash flow planning is different from income planning because it includes your spending plans as well as your income projections. If you are going to buy a major piece of equipment, renovate, mount a major media campaign, etc., the cash outflow must be balanced against the inflow of cash. You sometimes have to balance the cash flow by borrowing to keep it positive. A personal plan would include school and seminars, vacations, competitions, and awards you wish to achieve, and any community or professional organizational commitment you wish to make.

WHAT SHOULD AN INCOME PLAN DO FOR YOU? (1) Make you think about what areas of your business earn the most income for the time spent, and generate the most profit

in your cash flow program. (2) Make you determine how many units of each type of work you want to do next year, and how much income (the average sale per unit) and gross profit (average sale less average cost) you expect to generate from these units. You must also consider when in the year you expect to produce the units. (3) You must plan the use of your time to get maximum efficiency from your labor. You cannot plan to do five hundred weddings by yourself.

In figuring what markets to target and how many units to plan on producing, you need three areas of information: (1) past records, (2) projected increases in current business based on knowledge, and (3) new market areas based on new skills or new opportunities.

For past records, use your previous year's sales summaries. Next, plot projections. For example, if you did five weddings last year, you shouldn't project one hundred weddings unless some major changes have taken place (all your competitors have moved to Peoria). If you photographed one hundred seniors and you think you can land a big contract or promote more efficiently and can realistically get four hundred seniors into your studio, add them to your plan. Plan the activities needed to achieve this goal.

Planning always requires some educated guessing. You may plan to shoot fifty weddings and fifty families and then the major industry in your town goes out of business and lays off 50 percent of the town's population. You have to have a sense of your community. Attend chamber of commerce meetings and service clubs to help you keep your finger on your community's pulse. You also may learn of a new industry coming to town which may offer you a new market.

You also have to remember that there are only so many hours in a year, month, or day. You can't plan on working more than twenty-four hours, even on the worst of days. Scheduling your time is a key to effective planning. There are certain types of work that may not be worth your effort in the busy time of the year, but can earn some money for you during the slower times of the year. You must plan when you will go after certain types of business to use your time and energy efficiently.

Three Major Types of Expenses You Must Plan For

In planning a net income, you must first figure out what your business expenses will be in the coming business year. There are three areas of expenses which you must clearly separate in your mind and on paper.

1. OVERHEAD EXPENSES: The cost of doing business, which is somewhat fixed regardless of the amount of business you do. This includes rent, phone, heat, office expenses, forms, stationery, and interest on bank loans for the business.

2. PRODUCTION COSTS, SUPPLIES, MATERIAL, AND LABOR OTHER THAN YOUR OWN: These costs are directly related to the volume of work you do. If you sell more frames, you have to buy more frames. If you shoot more weddings, you'll need more film, proofing and albums. If you book two weddings for a given weekend, you'll have to hire someone to cover the second one.

3. VARIABLE EXPENSES: Expenses that are important but not fixed or necessary. These expenses include advertising, memberships, training, capital investment in new equipment and fixtures, and fees for professional assistance. You don't have to advertise, but you should if you are going to attract new business.

Profit: What Should Your Business Make?

There are four areas in which any business should make money for you.

1. RETURN ON INVESTMENT: If you had taken all the cash you invested in starting

your business and put it in a money market fund, you'd be paid 6 to 10 percent a year interest on that money, without lifting a finger. You should expect your money to work for you in your own business. Don't ignore this fact when planning your income.

2. WAGES AS A SKILLED TECHNICIAN: As a photographer at the university in the example previously quoted, you'd expect to make $36,000 a year, with no investment and a normal work week.

3. WAGES AS A MANAGER/ADMINISTRATOR: Not only are you the technician, you are the manager of your business. You should be paying yourself a second wage for the responsibilities of running a business.

4. PROFIT: Your reward for hard work and skillful practicing of your trade, above and beyond wages. Note: a proper business analyst will argue that your wages should be considered part of the production costs in your business. In a corporation, you pay yourself a wage, and the money leftover at the end of the year is your profit and return on investment. Most small business owners using the cash method of accounting consider the money leftover at the end of the year their profit and wages and return on investment. I am of the latter school of thought for a small business.

At the end of this chapter is a worksheet for helping you put your goals for profit into your goals for gross income. I have also listed some typical operating expenses for established portrait/wedding studios. Compare your forecasts with these figures. There will be differences, but the list will help keep you within reason. If your income is less than your goals, you have to do one of three things: (1) do more units at the prices you've established, (2) raise your prices so that you can make more net profit per unit, or (3) cut your costs of doing business. You must also realize that certain areas of your business earn less profit per unit investment of cost and labor than others, and you may wish to redirect your business efforts into the more profitable areas.

The cost-cutting option is one which you have to look at seriously. If you are spending too much for rent or too much for equipment, you will have a difficult time making a good profit. You must learn to control your costs to enhance your bottom-line profit. On the other hand, you cannot stop advertising or attending educational courses to improve yourself. If you cut costs in these areas, you will soon start losing business, which will reduce your net again.

Lilley's Rule of Thumb and Profit Margins

A very rough but effective planning guide is the rule of thirds. Even at the minimum, you should price so that one third of the gross goes into your pocket as profit, one third to overhead and variable costs, and one third to production costs. If you wanted to net $24,000 and you had a 33.3 percent net profit margin, you would have to gross $72,000 in sales. To further illustrate the concept of simple calculation based on gross and net margins, look at the following calculation. If you want to have a net profit of $24,000 and you have a profit margin of XX percent, your gross income is the profit divided by the margin.

A Profit margin of 20 percent means a Gross of $120,000 to Net $24,000
A Profit margin of 25 percent means a Gross of $100,000 to Net $24,000
A Profit margin of 33⅓ percent means a Gross of $72,000 to Net $24,000
A Profit margin of 50 percent means a Gross of $48,000 to Net $24,000

The problem with using the simple calculations above is that your overhead costs remain relatively fixed and unless you can price markups in the twelve to fifteen times real cost range, you can't expect a 50 percent net margin with normal business expenses.

There are established photographers who do have a net of 50 percent of their gross income, but they worked a long time getting there and usually have a very low rent because they own their building. If you can get better than 20 to 25 percent in your first few years, you will be doing well; 33 percent is a goal you should aim for and which many established studios have attained.

NET PROFIT CALCULATIONS FOR A SPECIFIC AREA OF PHOTOGRAPHY: Let's go through some more numbers. Let's assume that you can do fifty weddings at a $500 average sale, but you have to hire part-time help at $100 per wedding for twenty-five of the weddings. Using the figures determined in chapter 6 on wedding costs, we can determine that you have an average materials cost of about $203 per wedding. This figure would give you a

GROSS PROFIT of:

INCOME (50 × $500)	$25,000
WAGES (25 × $100)	$2,500
MATERIALS (50 × $203)	$10,150
PRODUCTION COSTS (Wages + Materials)	$12,650
GROSS PROFIT ($25,000 – $12,650)	$12,350 ($243 average per wedding)

Now add a figure for overhead. Let's assume that your overhead expenses work out to $60 per day. A wedding ties up one day, so figure $60 per wedding as your overhead costs.

NET PROFIT = gross profit minus overhead = $9,350 ($187 average per wedding).

And if you figure fourteen to eighteen hours of work, net hourly profit of $13.35 to $10.39 per hour.

As an exercise, let's double your wedding price and lose half of your wedding customers because of the higher prices. You now will do twenty-five weddings at an average of $1,000. However, your material costs will be the same per wedding and your labor cost will be zero since you can do all of the work yourself. Your overhead cost will also remain the same.

INCOME (25 × $1,000)	$25,000
PRODUCTION COSTS (25 × $203)	$5,075
GROSS INCOME	$19,025 ($761 average per wedding)
OVERHEAD	$60.00 per wedding
NET INCOME	$700 per wedding
HOURLY WAGE	$50 to $38

This is more than three times the hourly net profit made in the first example. The point is you made more money per hour on less volume because of a better profit margin.

Planning: The Most Common Mistakes

Here is a list from Bill Delaney's book *So You Want to Start a Business.* The most common mistakes in business planning are: (1) No plan at all. (2) The plan is vague, general, and ill conceived. (3) The plan has no meaning to anyone except the planner. (4) The plan is too fixed and rigid, and cannot be easily changed. (5) The plan is a wish list with no basis in reality. (6) The plan is incomplete. All pertinent and related factors are not included. (7) The plan says *what,* but it does not say *how.* (8) Plans change too often, jumping around like a grasshopper.

Lets analyze some of these problem areas. Lets start with number 8. What is a good

planning period? I think the most natural planning period is your fiscal year, which in a portrait studio should be aligned with the calendar year. You should formulate a business plan for the next eighteen months just after your busiest time of the year. For a portrait/wedding studio, that usually means right after Christmas. If you are a commercial studio, you should base your year on your clients' seasons, which may vary from industry to industry. In general, do your planning after your busiest time. The plan should extend beyond the next fiscal year. If you are planning for the coming calendar year, write your plan for the next eighteen months. This will give you some help at the end of the year, before you formulate the following year's plan. Even though your plan is for a year, do not hesitate to change it if conditions upon which you based the plan change dramatically. You may lose a large account, or you may discover a major opportunity which will require you to change your studio's directions. Redo the plan based on the new data. Be flexible.

A plan must be specific. It should say that you want to earn so many dollars by doing so many specific jobs at certain times of the year. Don't just say you want a certain net income without planning where the money is going to come from. In most years, if you have planned reasonably, you will find that you may have been a little under in one area and a little over in another area, but everything will usually balance out. A plan is too rigid if it narrows your options to only a few choices. If your whole income plan is based on getting two large accounts, and you fail to get one of the accounts, your plan is meaningless. The old adage of not putting all your eggs in one basket is applicable here. There are many established studios which go under because a major client stops doing business with them. They planned themselves into a corner.

A plan is a wish list if it contains business you wish to attract from an area in which you have no experience. You may wish to expand your business into a new area, but you can't plan on the business until you find out what the market is. You may plan on doing thirteen *Playboy* centerfolds next year, but will you get the jobs? That is wish-list planning. A plan is a map for the year, and barring real changes in circumstances beyond your control, you should stick to your plan unless a true opportunity comes along. Just because you get one PR job photographing a Hollywood celebrity, don't change your business plan to do thirty more starlets in the next twelve months.

The Cash Flow Plan: The Where and When of Your Income

Once you understand what type of business you want to attract and how many units you'll need to sell, you have to plan when those units will be producing income. This timetable of figures must be compared to the fixed and variable expenses you expect to incur. These figures will give you your cash flow projection for the coming year. Use the Cash Flow Plan form at the end of the chapter to calculate your cash flow for the coming year.

If your cash flow is negative at any time, you must arrange for a loan to tide you over. Following is a table of my cash flow for 1994. As you can see, I had a negative cash flow in January and February and about break-even in March, after which the flow is more positive. This is typical of my year, and I know to plan for the low-income periods by saving some money from the busy seasons, or I go to the bank and take out a small or short-term loan to get me through the slow periods. The "$ Out" includes money I paid to myself as salary during this time.

Cash Flow: E. R. Lilley Photography, 1994 (in thousands of dollars per month)

	JAN	FEB	MAR	APR	MAY	JUN	JUL	AUG	SEP	OCT	NOV	DEC
$ IN	6.0	5.1	14.9	54.3	35.5	26.9	21.7	38.3	45.4	59.3	33.2	21.3
$ OUT	17.0	15.9	12.6	43.1	32.9	32.8	26.7	26.4	32.4	29.5	24.6	33.0
$ NET FLOW	−11.1	−10.7	2.3	11.1	2.6	-5.9	-5.1	12.0	13.1	3.0	8.6	12.7

How can you improve your cash flow? A major source of cash in our business in the slow winter months are deposits on weddings to be photographed later on. One method to get a little more cash sooner is to offer your wedding couples a discount to pay their balance earlier. Offer a monthly payment plan that will save them 5 percent on the total package charge. If you can get a number of your brides to agree, you'll get a better cash flow.

Another technique is to have specials during the slow months to get more customers into the studio. The major problem is that in northern regions there is not a great portrait market due to weather factors. Some other promotions could be a pet special, children's bunny special for Easter, anniversary specials for older couples, and engagement specials for the upcoming summer's brides. Many labs have special promotions to increase their business, and they can supply you with marketing materials. In the slow season, be a little more flexible in your pricing. Seek out those commercial jobs that you couldn't afford to do in the busy seasons. This is where you need some "sure thing" accounts.

The Promotion and Marketing Plan

At the start of each year, you must also create a marketing plan to make best use of your advertising budget and available opportunities for direct display. The first step in creating this plan is determining the areas of photography in which you wish to generate business in the next eighteen months and when you expect that business to occur. Weddings tend to be in the warmer months (at least where I live), but the couples choose their photographer six to eight months in advance. For me, that means I need to promote weddings December through February, right at the end of my busiest time of the year. This is why you need to have a plan for the entire year. In December, you are usually too busy or tired to really think clearly, so you need the structure and discipline of the plan to make you do what is required to keep busy six months later. Another large account I work with, doing convention photography, requires that I send out bids eleven months before the events. This means that while I am in the middle of doing this year's work, I have to be thinking about next year and how I am going to get new accounts and keep old ones.

If you are going after a high school contract, start working on the project in December and January. If you target seniors through direct mail, you should do the first mailing in late May or early June, which means that you have to prepare your price lists, mailing pieces, and mailing list in April and May. All these steps take time and organization, and your year's plan will tell you when to get working on specific projects.

The family Christmas business normally starts after Labor Day and peaks around Thanksgiving. You are usually limited by your lab's delivery schedule and must work to get the families into your studio in the summer or fall months. If you do a lot of outdoor photography in a northern climate, you must shoot the families before the leaves fall and the scenery disappears. There are other seasonal ideas that you can promote too. Valentine's Day for couple and boudoir photography is a good example. You must start

a Valentine's Day promo right after Christmas for it to be effective. Starting the promotion in late January is too close to the event unless you can deliver proofs and finished prints quickly with your own color lab. Other days to promote are Mother's Day, Father's Day, Easter, Graduation Day, Halloween, and Thanksgiving.

I strongly recommend that you join Kodak's Times of Your Life program. Kodak has prepared a wonderful planning calendar and many ideas about good portrait promotions. The company also has mailing and handout pieces already prepared on which you can put your studio logo. To get more information on this program, call 1-800-233-1650, or write to Eastman Kodak Co., Dept. 454, P.O. Box 92974, Rochester, NY 14692-9939. It is not very expensive to join, and you will receive a wealth of good ideas and information prepared by professional marketing experts. Kodak will also send you a large wall calendar so you can put your marketing plan on the wall in a place where you can see it. We have ours over the main work counter. We have no excuse to say we forgot to start a promotion on time. It's right there in plain sight all year long.

In your promotional planning, you have to use your available opportunities to get direct display space. If you can get a display in the local mall, you must choose carefully what you will emphasize. If the display is in June, don't feature brides, as most of this year's batch have already chosen their photographer. Feature seniors who are in the choosing process at that time and promote families for the upcoming fall season. In a fall or winter show, feature wedding work more. If you do a lot of outdoor work, display it early in your season.

Always remember that any effective promotion requires lead time, the time required to prepare the material, get it into the public eye, book the sittings, and deliver the finished product. It is very inefficient to promote Valentine's Day two weeks before Valentine's Day. You have to plan the idea of a photography session the month before and plan on being in the studio shooting the sessions two weeks before the date.

How Rigid Should a Business Plan Be?

Any plan is only as good as your initial information and your educated guesses. Neither element is perfect, so your plan can't be perfect. A good plan makes you stretch to meet its goals. A good plan seeks new avenues of revenue and achievement. If you make a good plan, sticking to it will make you work a little harder to achieve your goals. It will focus your energy into areas where you make the most profit. If you just prepare for the next year by doing "business as usual plus 10 percent," you'll soon be in a rut so deep they'll have to put a headstone at the end of it. Your plan may include dropping some areas of endeavor and adding totally new ones. Sometimes the old areas look appealing, and you need the structure of the plan to say no, so that you can concentrate on starting new and potentially more profitable areas of emphasis.

You may also go to a seminar and come home with a hot new idea and want to change your whole direction. In that case, modify your plan, but don't totally change it without some experience in the new area. As you become more experienced and busier, you must plan your time better. I am at the stage where I can't physically do all possible jobs that come into the studio. I have to pick those areas where I can earn the most profit and concentrate on them, dropping other areas of work. In my planning, I look for areas to drop instead of looking for new areas. I am always open to new opportunities, but they had better be worth the effort.

Typical Costs of Doing Business for a Medium-Volume Portrait/Wedding Studio

Below I have listed some average expenses for established studios. These figures should give you an idea of what to aim for in your business planning. As a newer studio, you probably will have higher advertising costs, a lower markup on costs, and higher capital investment costs than an established studio. All the figures below are in percent of gross income instead of dollars. This is the best way to think of your costs of doing business, as it automatically ties your figures in with your volume. The gross sales of the studios included in these figures were over $100,000 per year. The sales, by category, of the studios included in these averages were: commercial, 6 percent; portrait, 50 percent; wedding, 25 percent; school work, 14 percent; and miscellaneous, 4 percent.

COSTS	% OF SALES
Beginning inventory	1.5 to 2.5
Film costs	2 to 3
Resale items (frames, mats, etc.)	4 to 7
Lab materials	2 to 18
Other materials	1 to 2
Materials	10 to 14
Lab labor	1 to 5
Photo labor	5 to 9
Lab services	4 to 28
Freight and postage	.32
Professional services (lawyer, etc.)	.6
Equipment rental	.4
Equipment repair	.4
AVERAGE TOTAL PRODUCTION COSTS	46%
AVERAGE GROSS PROFIT (BEFORE OVERHEARD) MARGIN	54%

The average overhead of the studios in the study was about 25 to 33 percent. This implies a net profit of 29 to 21 percent. As you notice, some of the numbers have quite a range. These figures include studios with their own color labs and those without. If you have your own color lab, your outside lab costs are lower but your material and labor costs are higher. The final figures are averages for all types of established portrait/wedding studios doing only a small amount of commercial work.

What Should Your Business Plan Look Like?

In what form and format should your business plan be presented? By this I mean the physical layout of the document as well as the organization of its contents. Some basic rules, from Blechman and Levinson, *Guerrilla Financing*: (1) Make it neat and tidy: laser-quality printing on white paper. (2) Make it grammatically correct. Have a knowledgeable person proofread it. (3) Make it honest. Don't lie and don't exaggerate. (4) Write in layman's language; avoid jargon. (5) Don't overemphasize photography. Sell your business, don't sell the product. Do you think Ray Kroc, founder of McDonald's, was selling hamburgers? No way. He was selling cleanliness, economy, atmosphere, consistency, speed, and convenience. He was selling the business, not the product.

Your business plan must: (1) Be arranged appropriately, with an executive summary, table of contents, and its chapters in the right order. (2) Be the right length and have the right appearance—not too long and not too short, not too fancy, not too plain. (3) Give

a sense of what you expect to accomplish three to seven years into the future. (4) Explain in quantitative and qualitative terms the benefit to the user of your photography. (5) Justify financially the means chosen to sell your services. (6) Explain and justify your level of skill, and describe your growth directions. (7) Contain believable financial projections, with the key data explained and documented under assumptions. (8) Be easily and concisely explainable in a well-orchestrated oral presentation. It should be formatted as follows: (1) cover letter, (2) cover, (3) table of contents, (4) amount requested, (5) purpose of financing, (6) use of funds, (7) description of collateral or source of repayment, (8) history of business, (9) description of business and market, (10) financial history of business, (11) financial projections and assumptions, (12) schedule of major assets and liabilities, (13) management and ownership details, 14) financial status of owners, (15) references, and (16) supporting documentation.

Some Forms to Help You Do Your Planning

Photocopy the following pages and use as many as you need to arrive at accurate figures for determining your plan.

YEARLY GROSS/NET INCOME PLANNING WORKSHEET

OVERHEAD: *Fixed costs of doing business regardless of volume*

Rent ($_____ per month × 12 months)	= $ _____
Heat, water, electricity	= $ _____
Phone (include Yellow Pages advertising)	= $ _____
Taxes, license fees, etc.	= $ _____
Loan interest and payments for business	= $ _____
Insurance: auto, liability, health, etc.	= $ _____
Office expenses (stationery, forms, postage)	= $ _____
Bank service charges	= $ _____
Repairs/maintenance of equipment	= $ _____
Auto expenses (repairs, mileage, tires, etc.)	= $ _____
Depreciation of capital equipment	= $ _____
SUBTOTAL	= $ _____

VARIABLE EXPENSES: *Costs not directly related to volume of business*

Advertising	= $ _____
Memberships	= $ _____
Education	= $ _____
Capital investment (new equipment)	= $ _____
Leasehold improvements	= $ _____
Professional services (lawyer, accountant)	= $ _____
Sample photographs and frames	= $ _____
Donations	= $ _____
SUBTOTAL	= $ _____

MATERIALS AND SUPPLIES FOR THE YEAR: *Only direct production costs*

Film	= $ _____
Darkroom supplies (paper and chemicals)	= $ _____
Lab expenses, proofing	= $ _____
Lab expenses, printing	= $ _____
Retouching expenses	= $ _____

Mounts/frames/albums stock = $ _____

Models/rental of equipment = $ _____

Studio supplies (seamless paper, etc.) = $ _____

Postage/freight = $ _____

Wages to outside labor = $ _____

SUBTOTAL = $ _____

TOTAL: *Overhead + Materials + Variable Expenses* = $ _____

To accurately determine your costs, you must first estimate where your income is going to come from. You have to skip ahead and do your income estimates so that you know how many units of each type of work you'll need to do. You also have to do the individual cost/profit analysis to get an idea of the material costs and net profit in each area of work that you are planning to do. Estimate how many units of each type of job you can reasonably expect to do in the coming year, and what gross income each unit will generate at your planned prices.

INCOME

_____	Weddings	@ $ _____	= $ _____
_____	Family Sittings	@ $ _____	= $ _____
_____	High School Seniors	@ $ _____	= $ _____
_____	Children's Sittings	@ $ _____	= $ _____
_____	Engagement Sittings	@ $ _____	= $ _____
_____	Business/PR Sittings	@ $ _____	= $ _____
_____	High School Seniors	@ $ _____	= $ _____
_____	Commercial Jobs	@ $ _____	= $ _____
_____	Copy and Restoration	@ $ _____	= $ _____
_____	()	@ $ _____	= $ _____
_____	()	@ $ _____	= $ _____
_____	()	@ $ _____	= $ _____
_____	()	@ $ _____	= $ _____
_____	()	@ $ _____	= $ _____
_____	()	@ $ _____	= $ _____
_____	()	@ $ _____	= $ _____
_____	()	@ $ _____	= $ _____

TOTAL INCOME PROJECTED FOR 19___ = $ _____

NET PROFIT = INCOME − COSTS = $ _____

PERSONAL EXPENSES AND NEEDS

List reasonable estimates of your financial needs for the next year.

Rent (Home) (___ per month × 12 months) = $ _____

Utilities = $ _____

Insurance (home, life, health, etc.) = $ _____

Auto (other than business) = $ _____

Food = $ _____

Clothing = $ _____

Appliances and furniture = $ _____

Upkeep of household = $ _____

Children's expenses = $ _____
Vacation = $ _____
Savings = $ _____
Taxes = $ _____
Payments on credit cards, etc. = $ _____
Interest on loans = $ _____
Fun money = $ _____
_____ = $ _____
_____ = $ _____
_____ = $ _____
TOTAL NEEDS = $ _____

WANTS

_____ = $ _____
_____ = $ _____
_____ = $ _____
_____ = $ _____
TOTAL WANTS = $ _____

GOALS (= NEEDS + WANTS) = $ _____

PROFIT, COST, AND LABOR ANALYSIS: PORTRAIT SITTINGS

Do by each type: individuals, baby, senior, couples, family, etc. Do a separate analysis for each type of sitting. Xerox this original.

COSTS

_____	Rolls of film	@ $ _____ /roll	= $ _____
_____	Develop and print	@ $ _____	= $ _____
_____	Folio or folder	@ $ _____	= $ _____
_____	% of overhead	@ $ _____	= $ _____
_____	% of price list cost	@ $ _____	= $ _____
_____	Cost of prints	@ $ _____	= $ _____
_____	Retouching services	@ $ _____	= $ _____

TOTAL COSTS PER AVERAGE SITTING = $ _____

LABOR: *Be sure to include nonbuying interviews.*

Phone interview _____ hrs.
Clothing consultation _____ hrs.
Sitting session _____ hrs.
Preparation time _____ hrs.
Proof numbering, filing, etc. _____ hrs.
Proof presentation—order taking _____ hrs.
Order pickup, framing _____ hrs.
Preparing/receiving lab orders _____ hrs.
TOTAL LABOR _____ hrs.

AVERAGE INCOME (sitting fee plus average reorder) = $ _____
NET PROFIT (= income – costs) = $ _____
DOLLARS EARNED PER HOUR = $ _____

PROFIT, COST, AND LABOR ANALYSIS: WEDDINGS

COSTS

_____	Rolls of film	@ $ _____ /roll	= $ _____
_____	Develop and proof	@ $ _____ /roll	= $ _____
_____	B&W glossies	@ $ _____	= $ _____
_____	8 × 10s (or equiv.)	@ $ _____	= $ _____
_____	Proof albums	@ $ _____	= $ _____
_____	Albums	@ $ _____	= $ _____
_____	% of advertising	@ $ _____	= $ _____
_____	% of overhead	@ $ _____	= $ _____
_____	Forms, price lists, files, etc.	@ $ _____	= $ _____
_____	Outside labor	@ $ _____	= $ _____

TOTAL COSTS = $ _____

LABOR

Selling interview (include no sales)	_____ hrs.
Shooting time	_____ hrs.
Prep. time, finish time, travel time	_____ hrs.
Sort, mail, receive, number, file film	_____ hrs.
Proof number, sort, put in albums	_____ hrs.
Proof delivery	_____ hrs.
Making B&W glossies	_____ hrs.
Proof return	_____ hrs.
Sort reorder to lab, receive back from lab	_____ hrs.
Assemble album, order	_____ hrs.
Order/album pickup	_____ hrs.
TOTAL LABOR	_____ hrs.

INCOME

Initial package	= $ _____
Proofs bought	= $ _____
Additional print	= $ _____
Reorder prints	= $ _____
TOTAL INCOME	= $ _____

NET PROFIT (= income − costs) = $ _____
DOLLARS PER HOUR = $ _____
NET PROFIT PER HOUR = $ _____

PROFIT, COST, AND LABOR ANALYSIS: SENIOR CONTRACT

COSTS

For sittings, use individual sitting analysis sheet to determine costs per sitting.

_____	Individual sittings × average cost/sitting	= $ _____
_____	% of overhead costs	= $ _____
_____	% of advertising budget	= $ _____
_____	Free materials and services to school	= $ _____
_____	B&W film for sports/activities	= $ _____
_____	B&W prints for sports/activities	= $ _____

_____ Other considerations = $ _____
_____ Prom packages @ $ _____ = $ _____
 TOTAL COSTS = $ _____

LABOR
Shooting _____ sittings _____ hrs.
Shooting activity/sports _____ hrs.
Shooting special events _____ hrs.
Filing, sorting, promoting _____ hrs.
Getting contracts _____ hrs.

INCOME
_____ Sitting fees × $_____ average sitting fee = $ _____
_____ Reorders × $_____ average reorder = $ _____
_____ Team photos × $_____ average = $ _____
_____ Proms × $_____ average for prom = $ _____
_____ Miscellaneous income = $ _____
 TOTAL INCOME = $ _____

PROFIT (= income − costs) = $ _____
DOLLARS PER HOUR = $ _____

YOUR CASH FLOW PLAN

	JAN	FEB	MAR	APR	MAY	JUN	JUL	AUG	SEP	OCT	NOV	DEC
EXPENSES												
Fixed												
Variable												
Costs												
Personal												
TOTAL												
Outflow												
Income												
Net cash flow												

Finishing and Framing

The difference between a fifty-cent piece of color photographic paper with an image on it and a portrait worth $50 to $900 is the quality of the photography and the amount and quality of the finishing that is done to the image and the print surface after the lab has printed it.

Retouching: The Finishing Touch

No one I know who produces good quality portraiture at good prices hands a client a floppy piece of paper right out of the lab envelope. In most good-quality portraiture, there is a great deal of skilled workmanship done after the print has been produced in the lab before the client sees it.

HOW FAR DO YOU GO WITH RETOUCHING? The amount of retouching you include has to be built in to the price of the print. Typically, high school seniors pay lower prices for their packages, and you cannot afford to do much print finishing with them. Good adult portraiture must be retouched more extensively, and the price should reflect these costs. Most commercial prints are sold on a print spotted basis and any other corrections or enhancements are billed separately.

Typically, senior retouching removes pimples and other surface blemishes and some hairs that stick up and catch highlights. Senior economy prints usually do not include any print finishing or enhancement. Many studios offer a custom or higher priced print where some retouching enhancement is done to skin color and to the subject's eyes. In most studios, senior retouching does not include fixing braces, ill-fitting clothing, or large glass glare. These things require additional retouching, and the cost is usually passed on to the client.

In adult portraiture, normal retouching includes softening wrinkles, crow's feet, removal of blemishes, and enhancing the eyes and skin color. It usually does not include extensive work on hair, teeth, or clothing. Anything that requires

airbrushing is not usually included in normal retouching. This should be clearly stated in the policies section of your price list. Be careful to word it so that potential clients realize that they are getting a good value, but so that they don't expect the moon.

Photographic finishing falls into the following categories: (1) Spotting, texturing, and spraying. (2) Retouching, negative and print. (3) Extensive correction—airbrushing. (4) Presentation: folder, frames, mounting, and albums. (5) Copy and restoration.

In all probability, as a new photographer you only have a marginal understanding of the skills required, and you probably don't practice many of them. When Sue and I first started, we did not know anything about finishing other than how to pull the raw print from the lab envelope and put it into a cardboard folder. When a client requested that a defect, such as a pimple, be removed from his or her portrait, we would reply, "We don't do that. We believe in the natural look!" What we were really saying is we did not know how to do any retouching. We could ask our lab to do it for us, but we didn't really know what to ask for.

LABS AND RETOUCHING: If you are using a commercial color lab, it probably offers a range of print finishing services, many of which I will discuss in the following sections. It has been my experience that very few labs do consistently good print finishing. There are some, including H&H and Burrell. Good print finishing cannot be automated like good color printing, so everything must be done by hand by skilled finishing artists. You must pay more for this service.

Again, most labs get less consistent as they get busier, which is when you get busier and need their services more. The other problem is in explaining exactly what you want when ordering finishing. Sometimes labs are overzealous when producing work.

Spotting, Texturing, and Spraying

The most basic form of finishing includes print spotting, texturing, and spraying. When a print comes out of the printer in the lab, it usually has some small spots caused by minute dust specks on the negative, or, in the worst cases, a big hair or a long scratch from the negative on the print. Before you give a print to the customer, you must get rid of these little (or not so little) marks.

To spot a print, you need a set of spotting colors, such as those made by Marshalls or Photo Retouch Methods Co. These come in twenty or thirty shades of color. The colors are very bright and are usually used diluted with water and mixed with the other colors to exactly match the shade you are trying to spot. This is the part that takes some skill: mixing and matching the colors for the right hue and then diluting the hue for the right density of color. The tendency when first starting to spot prints is to put the color on too strongly and instead of a white dust spot you have a splotch of a darker color, which looks worse.

The key to spotting is to apply very light layers of the color dyes using a fine point brush, a #2 sable. The layers are built up by applying tiny dots of diluted color to the white area. Once the color hits the color paper surface, it cannot be easily removed, so it is much safer to build up the density in small increments. Mixing the colors takes practice and more practice. Have your lab send you blank wastepaper or old junk prints on which to practice. One trick is to cut out a small (four-by-four-inch) square of white photographic paper (ask your lab to give you some leader materials from its print runs) and cut a one-inch hole in the center. When spotting, put the hole over the spot you are working on, masking out the rest of the print. This mask makes it easier to judge the exact color in the area on which you are working. When you have your brush ready, touch it to the white paper to test the color/density match with the color surrounding

the spot. If it is too dark, or off-color, readjust it. If it is slightly lighter, touch the spot with little dabbing motions using only the point of the brush. Do not try to paint in the spot with the body of the brush. A little dab will do. When starting out, you'll find you will use two basic colors 99 percent of the time. They are gray and flesh tone. As you become more skilled, you can go on to making more complicated color mixtures.

A long scratch or a long hair mark is much more difficult because you have to match the color all along the length of the mark, requiring constant tone matching and density correction. Again, do not try to paint in the mark. Use the point and dabbing motion to create tiny dots and go back and forth to fill in the mark. When the spot gets too large, it is very difficult simply to spot in the color. It is then necessary to use other more sophisticated retouching techniques. Most good labs spot their prints before they leave the lab. Sometimes they are very good about making sure there are no spots, and other times they get sloppy and pass them on to you with obvious marks on them. Sometimes they use beginning spotters and you get back blotchy prints. Send them back.

Print Texturing

Print texturing is the final surface finish you put on a print. There are five common ways of applying a print surface texture different than what is built in to the paper. Note: for all texturing techniques, you must first do all required retouching. Texturing is done just before the final spray lacquers, unless you are using a laminated texture.

1. EMBOSSING a texture directly into the plastic surface of the paper is done with a heavy-duty rotary press. The texture is transferred from special metal plates onto the print surface. Many labs offer print texturing for a small fee per print, or no charge. Ask your lab for prices and samples of the various surface textures available. A texturing press (such as a CODA machine) is expensive, but in my mind it is worth the price if you do your own color printing. A new CODA or Merritt express runs about $2,400.

2. SPRAY TEXTURING: There are various lacquer-based sprays which can be used with a spray gun to apply surface textures to prints. With the lacquers, you can control the patterns and thickness of the textures. There are also antique and Florentine finishes available. These methods require a spray booth, a compressor, a proper spray gun, and extensive practice in application.

3. PAINTED TEXTURES: A product called Pro-texture can be applied to photographs with a paintbrush. With experience you can create an oil painting look by carefully applying the brush strokes in different directions to different color areas. Caution: when used incorrectly, the effect can best be described as cheap imitation art. Oil paintings are not more valuable because of the brush strokes on them, but because of the quality of the image created with them. You cannot make a purse out of a sow's ear.

4. LAMINATED TEXTURES: Companies such as Seal or Ademco make plastic laminate overlays which contain the texture desired. These laminates are applied over the print surface and heated to bond to the print surface. The result is a tough sealed print in a number of beautiful finishes. The laminates require a good dry-mount press and some degree of practice.

5. CANVASSING: Here the photographic surface, which is actually in a thin layer of plastic attached to the thicker paper base, is peeled off the base and then bonded to a heavily textured artist's canvas using heat and extreme pressure. The print and canvas are glued using a nonwater-based glue called Laminall, which, when set, will provide a permanent bond. Canvassing requires specialized equipment and some degree of skill. Most labs offer some type of canvassing. The less expensive type is done on canvas boards, which are canvas mounted on a stiff backing. The result is a print with the canvas texture, but

a relatively stiff feel. The best method uses heavy textured canvas which is then stretched onto a canvas frame. The final product looks and feels like an oil painter's canvas. The canvas is the ultimate in finishes today and will cost you a lot of money. An 11 × 14 costs about $24 and a 16 × 20 about $30, exclusive of print and retouching costs. Canvas should be your best choice in print finishes, and an expensive one.

Spraying

Before any quality print leaves a good studio, it should be protected from the environment by a coating of lacquer, unless it is protected by a plastic laminate seal. Lacquer coatings are applied with a spray gun (or a spray can in the more rudimentary form) to the retouched print surface. The sprays come in a variety of surface glosses, from flat matte to high gloss. Spraying is not difficult to learn how to do, providing you have the proper equipment. Visit a well-equipped studio to see how a spray booth is set up. The sprays serve a number of purposes. (1) They seal all retouching work on the print surface. (2) They protect the print from moisture and dust and other atmospheric pollutants. Lacquer coatings are dust- and waterproof. (3) They partially protect the print from the effects of ultraviolet radiation through the use of UV inhibitors. (4) They give the print the sheen that you want the final look to have, from dull to very shiny.

Note: Spraying is one of the most dangerous operations in a studio. The fumes from the lacquers are highly explosive and also toxic if inhaled. Safe lacquer spraying requires a good spray booth, equipped with an explosion-proof fan. If a spark hits the stream of vapors while spraying—poof! up goes your studio. I know of a number of photographers who have lost their entire studios to fires started in poor spraying booths. A good spray booth with a properly designed fan costs about $800 (Sheila's Dispo booth or Sureguards booth), and the compressor and spray guns can be purchased from Sears for about another $500. Sears Craftsman equipment is dependable and fully backed by the Sears warranty network. You must also check local building codes to determine if there are certain rules which you must follow in installing a proper spray booth.

Retouching

Spotting usually deals with white spots that don't belong on the print. Retouching is the removal or softening of marks, both light and dark, that exist on the subject but which you want to obscure. Among such items are pimples, red marks from rashes or scratches, bags under the eyes, deep wrinkles, reflections of lights in the glasses or subject's eyes, loose hairs on the head which stick out, wrinkles in clothing, and any other undesirable parts of the subject's anatomy, background, or garments. Retouching is also enhancing the original subject. You can put more color into the complexion, good color in the eyes, fill in thin spots in the hair, straighten crooked noses, open up "lazy eyes," take off a few pounds around the thighs, neck, and chin. Retouching consists of both negative and print retouching.

NEGATIVE RETOUCHING: A good negative retoucher can remove pimples, bags under the eyes, and soften harsh wrinkles to a point where a straight economy print will look almost perfect. Once the negative is properly retouched, all subsequent prints will look exactly the same. A great negative retoucher can even remove minor dental problems including small braces. Most senior packages can be retouched with just good negative retouching and often do not need additional print retouching.

Most labs offer negative retouching as a service, charging about $3.50 to $5.00 for a single negative. Negative retouchers charge for each additional head on a negative (i.e.,

a couple is one extra, a group of five is four extra). It has been my experience that labs have their ups and downs retaining good negative retouchers, and you will get good work some months and not so good work the next.

You can also use an independent negative retoucher. Send your negatives to them before sending them to the lab. If you get an independent retoucher, that person soon learns your shooting style and can usually do a much better job for you than the lab's retouchers. I use one lady for my negatives and can honestly say that 95 percent of my seniors require no additional print finishing, and we have some fairly high standards on how well prints should be retouched before they go out to the customer. Good negative work saves us hundreds of hours of labor in print retouching. It is absolutely essential that you have your negatives retouched rather than waste your money with the expensive alternatives, such as pencils, chalks, and dyes. Sometimes the problems are just too big or too subtle for negative retouching to handle. Sometimes the bags under the eyes are huge and dark. A negative retoucher can help a print finisher by lightening the area so that the print can be retouched with spotting colors or other techniques.

All senior, individual, and couple portraits should be negative retouched before printing unless the subjects' complexions are absolutely perfect, which is rare.

PRINT RETOUCHING: Retouching on the print requires use of a number of artistic tools: spotting dyes, flexicolor dyes, colored pencils, colored pastel chalks, and oil or acrylic paints. The application of these materials requires an artist's touch and skill in color mixing, blending, and application.

1. DYES. When large areas need lightening (i.e., they are dark and need to be lightened overall), it is easier to have the negative retoucher roughly blot out the dark area so that it prints very light. Then have the print finisher fill in the area with the desired shades and hues. This technique requires a great deal of skill and practice to do well. A large area is never one solid color, but a gradual shading of tones. Dyes are also used when you remove reflections from eyes and eyeglasses. Usually dyes alone are not enough to achieve a believable effect and other techniques are needed to finish the job. Dyes are also used to help blend loose hairs on the head which the kickers or hairlight may have overlighted. These are tedious to do and can be partially solved by more careful shooting.

2. FLEXICOLOR DYES. Kodak makes a set of transparent dyes which are designed to color correct large areas of a photographic surface. The dyes come as a hard paste and are applied with a cotton swab or a soft cloth. The color is worked into the print surface and is then set by a light steaming (from a teapot) or by breathing on the area. The beauty of flexicolor dyes is that you can rub them off before they are set, thus you can make a mistake and fix it before it is permanent. Flexicolor dyes come in the basic colors, neutral density, but only one flesh color. You can also purchase a custom-mixed flexicolor flesh stick used for most complexions. To put more color in a washed-out face, we simply apply a little dye, rub it in, and set it. The solid colors are useful in adding color to brown grass or blue sky when needed. The dyes can be purchased from any Kodak supplier.

Dyes are a transparent medium and can only be use to darken an area. If the area to be corrected is dark and needs to be lightened (without help from the negative retoucher), you must use opaque media—pencil, chalk, or paints. Note: all opaque media require that you first seal the print surface with a special retouching lacquer, either McDonald's Retouch, Lacquer Mat's Suede, or Sureguard Flat Matte. These sealants protect the plastic surface of the print and provide a "tooth" for the solid materials to adhere to. Retouch lacquer comes in sixteen-ounce spray cans for easy use, or in gallons for use with spray guns.

3. PENCILS. For drawing fine details, pencils can be used. Farber, Derwent, Lacquer Mat, and Prismacolor pencils come in hundreds of shades. They must all be shaped to a needle-sharp point (an electric pencil sharpener is a must) which comes off on the tooth of the retouch lacquer. Pencils can opaque fairly large areas, but pastel chalks, shaved and rubbed into the tooth, are better for larger areas. Pencils come in numerous flesh tones, making it easier to match colors when retouching flesh-colored areas.

Applying pencils is tricky. A fine layer of pencil is first applied to the area to be re-touched. A certain hue is achieved, and then the work is sealed with several light (mist) coats of lacquer. If the lacquer is applied too heavily, the pencil work starts bleeding through. The lacquer dilutes the color. Another layer of pencil and another mist coat of lacquer must be applied. This must be done until the desired effect is obtained.

4. CHALKS. To retouch large areas such as backgrounds, pastel chalks are easier to ap-ply than pencils. The chalks are shaved with a razor blade and the powder is rubbed into the tooth of the retouch lacquer. To achieve desired effects, a number of layers must be built up with each layer sealed with mist coats of lacquer.

5. OIL PAINTS AND ACRYLIC PAINTS. These can be used on photographs, but take spe-cial knowledge of the media to accomplish with efficiency. Oils can also be used in a very diluted form to color black and white photographs. Oil coloring was a popular style of photography in the forties and fifties, and still has its place today. In fact, a number of studios are selling hand-tinted, black-and-white prints at higher prices than they charge for their color prints, as each is a unique work of art. (See Helen Boursier's book on hand-coloring, chapter 12.)

Most accomplished print finishers use all of the above media and techniques in their day-to-day work, so no one medium is perfect for all problems that you will encounter. It is imperative that you learn about all the media in some detail even if you will not be doing the retouching yourself. You must understand what can be done by an accom-plished retouching artist. The above descriptions are very basic. There are a number of excellent teachers on the circuit today who will teach you how to retouch both prints and negatives properly. They are Jane Zeiser, Helen Yancy, Veronica Cass, and Elizabeth Dame, to name a few. By all means, sign up and take a week-long course with any of the above at the various photography schools around the country. If you are a husband/wife team and one is the photographer and the other is going to be a finisher, it is essen-tial that both go to the course so that the photographer knows what is involved in re-touching so he or she can be more careful when shooting. Kodak has also published a good book on the basics of retouching and Amphoto has an excellent book by Jan Way. (See chapter 12.)

Airbrushing

An airbrush is essentially a miniature spray gun that applies paint mixed with a stream of air. The airbrush is the instrument of choice when corrections to prints involve large areas or blending defects into large areas. One example is removing telephone wires from a shot of a building or removing wrinkles from a garment in a fashion shot. In one ex-treme example I saw, a builder wanted to show a house with a car parked in front of the garage. After the shot was done, they changed their minds and wanted the car re-moved from the shot. The garage door was made of cedar shingles. A first class airbrush artist did the job and had to draw in every shingle on the garage door with the correct shading. The bill was about $300, and worth every cent.

Airbrush artists usually charge high fees for their services. They feel (rightly so) that most of the time they are fixing sloppy photography, and that they should get more than

the photographer because without their talents the photographs would be worthless. They are right.

Airbrushing is used when large areas must be blended into a whole coherent unit. Most portrait work does not warrant the cost of airbrushing. However, when you start selling 30 × 40 canvas prints in the four-figure range, you should use all the finishing skills available to you to enhance the client's image. In copy and restoration work, the skills of the airbrush artist are essential. When you have cracks across faces, pieces of photographs missing, or need to combine different photos into some kind of coherent whole, you need an airbrush artist. Finding a good one is the trick. Again, most labs offer airbrushing, but the skill of their airbrush artists varies considerably. Shop around and find an independent airbrush artist with whom you can establish a relationship. They are out there.

The airbrush may well become a thing of the past as digital imaging techniques take over. Many of the jobs that required airbrushing can be done more easily on a computer screen. In the past, if you wanted additional copies of a print that was airbrushed, you had to make a copy negative, which added a generational loss in image quality to the copies. With digital imaging, you can make a good negative directly from the file. This allows you to make good-quality prints in any quantity.

Presentation

After you have retouched and textured your photograph you still need a medium in which to deliver the print to the client. The options are:

1. MOUNTING is the process of putting a backing material on a finished print to give it stiffness and body. You can mount on cardboard, Masonite, plastic, or any number of other materials. We have found that cardboard is fine for 8 × 10 or smaller prints. However, we live in a climate where the humidity levels change drastically throughout the year. We found that on larger prints the cardboard soaks up the moisture through the back and not through the plastic surface of the photographic prints. This differential moisture take-up causes the print mount to "wow" back and forth. Eventually, this wowing breaks the bond between the mount and the print, or, at the least, looks unprofessional. We now use Masonite on all our larger prints. Another option is Foamcore, which is lightweight, very stiff, and moistureproof. The major problem with foams is that if the print is bumped, it leaves behind a dimple. Also, if you drop the print on its corner, it really crumples. An improvement has been the introduction of Gatorfoam, which is tougher than Foamcore.

We do not use a dry-mounting press, and we purchase our cardboard and Masonite backings with the adhesive preapplied. We use Pressmount brand mountboard, and CODA Masonite. CODA also makes sheets of adhesive which are very powerful and easy to use.

2. FOLDERS provide a holder for presenting the finished photograph. They are actually mini-frames. Folders come in hundreds of styles and colors and price ranges. Choose one which is appropriate to your taste and stick to it. Do not spend too much on nice folders. They will cost you a fortune and cut your frame sales. The idea is to provide a utilitarian vehicle in which to deliver the print, not to provide a holder that will actually sit on the mantel for the next twenty years.

Folios: the next setup is the folio. The folio is actually a very fancy folder, but is sold as a frame. These are handsome and come in a variety of formats so that more than one photograph can be displayed in them. They make a nice gift item to offer your customer. See the Art Leather and General Products catalogs for prices and information.

3. MATS are used to surround the print with a protective and complimentary border.

Matting is a whole art in itself. You may have an interest and some talent in this area, or you may wish to use a framing/matting shop to do the work for you. Not too many studio photographers mat portraits or commercial work on a regular basis. One reason is that it is then necessary to cover the mat with glass to protect the mat material. Most photographs look better lacquer coated without glass in front of them. You would require a mat-cutting machine and a stock of mat board to do your own work.

4. FRAMING totally encloses the print in a finished artistic medium, ready to hang on the wall of the client's home. Framing requires the proper selection of color and style of the frame and the proper mounting of the photograph in the framing materials to best preserve and enhance the photographic image. Framing may involve matting or not. If you lacquer your prints, they do not require glass to protect the surface of the print. If you use mats, you require glass to protect the mat material. Glass is not necessarily a positive addition to image quality. Nonglare glass is a definite no-no. It achieves nonglare by diffusing the colors in the image beyond the point of recognition. Don't use it. Proper framing must also provide for the archival aspects of print display. The materials and techniques should enhance the life of the print by protecting it from the ravages of the environment. This is accomplished by the careful selection of materials and the proper sealing of the back of the frame to keep out moisture and dust.

There are two types of frames: ready made and custom made. Since photographers deal in standard formats, such as 16×20 or 11×14, manufacturers produce a large variety of frames already made to fit the most popular dimensions. Custom frames are made from molding stock and are cut to fit whatever dimensions the image requires. Most custom frame makers are no more than simple craftspeople who assemble pieces of wood to certain dimensions. Real framers know how to finish corner joints and to make the frame look like a whole unit. Photographers are lucky in that there are a number of fine frame manufacturers that specifically cater to the trade. (See chapter 12.) Many of these companies exhibit at photography trade shows at regional affiliate conventions with catalogs and samples of their products for your viewing. Learn to use these products to your best advantage. Also, get to know the salespeople from the framing (and album) companies. They are often the best source of information about where the local market is going as they visit more studios than any other suppliers, and their sales are a result of the overall sales in a given area. If you do well, they do well. Trust their taste and judgments (which does not mean you have to buy every special they offer to you).

If you are lucky, you may have a real framer (or perhaps you are a real framer and want to run that business in conjunction with your photography studio, a not uncommon marriage of businesses) just down the street. If you have a good framer available, it is possible to work out a deal to sell its products at a discount (so you make some profit) and deliver fine-quality products to your clients in the best possible time. Having a local framer doing your work gives you flexibility, and you do not have to invest in a stock of good frames to supply to your customers.

Another type of frame is a plaque, where the photograph is mounted directly on wood or plastic, coated with lacquer or plastic, and then hung on the wall. When we were first in the business, we used to sell a ton of plaques in the 8×10 and 11×14 sizes. The typical plaque is a plastic which looks like rough-cut wood. Since moving to New England we have had no customer express interest in them, so I guess that the taste is regional. Plaques come in many sizes and shapes suited to different types of decor in people's homes. Consult with the sales reps of the frame company for catalogs of plaques.

5. ALBUMS OR BOOKS: In wedding photography, the album is usually the main product delivered to the bridal couple. In chapter 6, I go into some detail about various techniques in preparing albums, and I would like to reiterate some of them here. I would

also like to stress the importance of proper finishing to ensure professional quality work and print longevity.

Photo albums have been around since the first photographs were taken. Albums are a convenient way of storing photographs. Many people organize their family photographs by type or place and store them on shelves for easy access. It is a good profit-maker for a studio to get people in the habit of filling in the album on a regular basis. Studios which specialize in baby and children's photography try to sell a young couple a nice album with a series of coupons designed to get them into the studio for sittings every six months. When I was first in business, there was a company called Family Record Plan (FRP), an album company that would sell its albums with sitting coupons, and then have a local studio produce the photographs included on the coupons. When I opened my brand new studio, this company brought me many customers with little effort. Unfortunately, they were not the best buying customers; however, they were warm bodies and I learned a lot from photographing them. What I realized was that FRP had made all the profit on the initial sale, and I was doing all of the work in producing the photographs.

If you are interested in starting your own album plan, contact the sales reps from Art Leather, General Products, Albums Inc., or some of the other album companies for information. I dislike any album that contains plastic to hold the photographs. I think that all prints should be lacquered so that they don't need the plastic to protect the print. However, nonplastic albums are usually larger and more expensive than the plastic ones, and not quite as flexible. General Products Co. makes some quality albums which use good-quality plastic pages to hold the photographs and come in a variety of colors and formats.

Copy and Restoration

A good market for a new studio is the copy and restoration (C&R) business. In any community, there is always a need for the repair and rescue of old and deteriorating photographs of both family and historical events. The C&R market breaks down into two areas.

STRAIGHT COPIES: This is usually where the original negative has been lost and the print is not damaged to any great extent so that it requires no restoration. Many times the original print is the client's own snapshot, sometimes older wedding or family photographs, sometimes extremely old photographs, and sometimes your competitor's proofs from last week's wedding. (See note about copying copyrighted material below.) The old tintypes, ambrotypes, and daguerreotypes, if reasonably well preserved, copy beautifully. They are the actual original negative or plate from the first exposure. To do straight copies you need: (1) a copy stand ($100–$300), (2) two good hot lights, preferably quartz lights, such as the Photogenic Mini-spot or the Mole-Richardson Mini-spot or Lowell Lights ($100 each), (3) a magnetic copy board (by Testrite for about $20), (4) some color correction filters and red and yellow filters for black-and-white copying, (5) extension tubes for your normal lens, a macro lens, or close-up lenses for the front of your normal lens, and (6) your regular light meter. The total cost is about $300 to $500, not counting your camera and meter.

If the original print is in color, it should be copied in color. If the original is a pure black and white or a badly stained toned print, it may look better in black and white than in color. If you have a beautifully toned (sepia, red, or selenium) print, you may wish to copy it in color to preserve the original tone. Getting a color lab to print it correctly is another story. Producing a good sepia-toned print in your own black-and-white darkroom is an exacting and smelly (hydrogen sulfide, i.e., the rotten eggs smell) procedure.

One advantage of copying with black-and-white film is your ability to control the contrast of the final image much more than with color film. A badly faded or stained original may produce a much sharper copy print with a straight black-and-white copy than with color film. A print with yellow stains can be photographed with a yellow filter to reduce the visual contrast of the stain. Sometimes a low-contrast, yellowed color image will look better as a black-and-white image. Many color snapshots from the fifties are turning a strong yellow color with age, which cannot be filtered out in color film. Sometimes it is better to make a black-and-white work print and then hand-color it. Another area for good black-and-white copy work is copying old documents. Many families have old records, such as wedding certificates, military awards, land deeds, notices of famous events, which need to be copied to preserve them and to present to the rest of the family. This is a market which is just starting to be tapped! For more technical details, read Kodak's book on copying.

How to Judge a Copy Job: When a person brings in an old photograph to be copied, you must be able to judge quickly how well it can be done. The biggest problem is the surface texture of the original print. If the original is on silk paper, the silk texture will copy stronger than the image and overpower the final image. If the surface is rough paper, the roughness limits the amount of detail you can get in facial or other fine features on the subjects. The smaller the original, the less you can enlarge it. An analogy I use is comparing the photo with a newspaper photo. At arm's length, a newspaper photo looks good. As you look closer and closer, and finally take out a magnifying glass, the dots that make up the photo become more important than the photo. You can't see the forest for the trees, so to speak. The same idea applies to the surface texture of the original photograph. This is why you should never quote copy prices over the phone, until you have seen the actual condition of the original. Generally, the glossier the surface is, the better it will copy.

Copying and Copyrights: If you do copy work, eventually someone will bring in a proof or photo from another studio in your area. My rule of thumb on a photograph that is stamped with a studio name and logo is: (1) If the photograph is current, I tell the consumer I cannot copy the picture. They should to go back to the original studio for a copy. (2) If the photograph is five to ten years old, I check the PPofA directory to see if the studio is still in business. (If it is a local studio, I will know if it is in business or not). If it is, I won't copy the photo. If it is not in business, I will copy the photograph. (3) If the photograph is more than ten years old, I generally will do the copy, as I know that most legitimate studios don't keep files that far back and it is of little profit to them to dig out a ten-year-old negative for a small reprint order.

Many photographers will defend their copyright ownership to the hilt, but they seldom address the corollary. I feel there is an obligation on the photographer's part to keep negatives available to clients so that they can obtain copies whenever they need them in the future. The copyright period is twice twenty-six years, or fifty-two years. Ninety-nine percent of studios never last fifty-two years, and if one did, the negative files would fill up its building! The cost of filing and storing such a backlog of negatives would be great, and there would be no profit in it for the photographer. There is also a large turnover in this business, and 50 to 75 percent of the studios producing photographs today will not be in business five years from now. Should we pass a law making a bankrupt studio keep its negatives available? Doesn't sound reasonable to me.

A meaningful example of this situation happened to me recently. A man brought in a beautiful canvas-mounted portrait of his child, taken fifteen years ago by a very well-known photographer, a former national president of the PPofA. The child had died tragically in a car accident and the portrait was all that the family had to remember him by.

The family had willingly paid a high price for the original work, and, since the print was starting to yellow badly, they wanted to get a new print, no matter what the cost. The print was quite clearly marked with the photographer's name and a copyright symbol. The photographer had since retired and moved to the sunny south. I found his name in the PPofA directory and the family called him. They found out that when the photographer retired, he intentionally destroyed all his negatives. There were no originals left. Yet, he clearly copyrighted the print. He did the consumer a terrible disservice. The only way to preserve the image is through C&R, which we did for the gentleman.

I have no hesitation about copying an underclass school package photograph because typically the parents cannot get reprints after a few months and the photographers have thrown out the negatives. I do school photographs and I do not take reorders, so if someone wanted more copies, they would take them to a copy shop, with my blessings. I also do not stamp my school work with my name or any copyright notice. I do stamp all of my portrait and wedding photographs. It also costs parents a lot more to have copies made than they paid for the original package, so they are copying not to save money or screw the photographer out of a few bucks, but to get more copies at any price. The next year they buy a larger package from me.

RESTORATION: As soon as an original photograph becomes damaged in some way, you can no longer do a straight copy and produce a quality copy. I divide restoration into two areas, enhancement and repair. Repair is usually required when an original print is badly stained, has physical tears, cracks, or missing sections of the surface. Enhancement is where major features have to be changed to improve the photo, such as paint in a new background, combine images from different prints, or draw in missing detail.

Some extreme examples I have worked on over the years are: (1) A 16 × 20 beveled oval of grandpa that had been crushed and then torn into six pieces, one of which was missing (with one of the eyes). I had to assemble the pieces, use a piece of glass to hold them flat, and then have my airbrush artist put it all back together. (2) A 16 × 20 unmounted original (about 1885) that had been rolled up for fifty years. The family tried to unroll the print which resulted in hundreds of cracks across the faces of forty people in a group photo. What a mess. (3) A couple had eloped in the thirties after a spat with the woman's parents. The woman had taken a portrait of her parents and torn it into four pieces and threw it in a drawer. Fifty years later she found the pieces and realized that this was the only memory of her parents that she now had. We put the pieces back together and gave her back a little of her past. (4) We took two passport photographs and created a 16 × 20, color, three-quarter-length portrait of a couple for the grandchildren. More artwork than photography.

NEVER QUOTE ON A RESTORATION JOB: Unless you are experienced, you should never quote a price on an extensive restoration job without first getting a quote from your finisher. Each job in copy and restoration is unique, and should be quoted as such. We always take in copy and restoration work, "subject to quote." We give ballpark figures to our clients, but do not guarantee them until we get a quote from the finisher. If the quote is much higher than our guess, they have the right to cancel the work. An extensive copy and restoration job with airbrushing and hand-coloring can cost you up to $200 for the first print, so you must be careful. Typically, a studio takes a 100 to 300 percent markup over the artist's charges. There is also the possibility of frame sales, especially near Christmas. There are some nice lines of old looking frames by Levin and Burnes of Boston that compliment copy and restoration work.

Rule one: never do any restoration work on the original photograph. First, make a copy negative of the original, and then make a work print for the artist to actually work on. The artist will only touch the work print. If he or she makes a mistake, nothing is

lost except a little time. Damaging a valuable original will open you up to a lot of liability, so be careful, especially when shipping the originals off to a lab or to an artist. My second year in business, I was doing a job for a local ethnic club's twenty-fifth anniversary. The job included doing a composite of the past presidents, some of whom were long dead and had only been photographed on very small snapshots. I sent these valuable originals off to my lab with a specific deadline. The current president of the club was a huge man with a gruff personality, and he had told me how valuable those snapshots were. As the date of delivery approached, he kept calling me every hour on the hour. The day before, the lab had said it had shipped the finished job to me. The president called me and I assured him of delivery. He asked me, "Are you a young man or an old man?" I replied, "A young man," to which he said "Good, because if you were an old man I would kill you!" I think he meant it. Luckily, the print arrived in time and everyone was happy.

The key to good restoration is a good artist, one who is accomplished in all levels of print finishing, from spotting through airbrushing to oil coloring. Sometimes small cracks and small spots can be handled with negative and basic print finishing (dyes and pencils). A good portrait finisher can handle most of these small problems with no extra equipment or new techniques. As soon as the cracks get large, or start to cross faces or clothing detail, an airbrush artist is needed to do a good job. A skilled airbrusher can blend large areas much better than any other medium I know of. The key is to create a blended, uniform appearance on the finished print. A good airbrush artist can fix cracks of any size, smooth out background, add detail to faded areas, fix other blemishes, and salvage any part of the print. The artist can even draw back the missing sections, as long as he or she has some idea of the looks of the person or item missing. Sometimes a second photo of the damaged subject will help the artist to redraw the missing parts. If the original photograph is in color and the job requires color airbrushing, the price goes up, but it is usually worth it. Make sure you understand the difference and can explain it to your client.

One job that comes up quite often is creating a new portrait of a couple out of two separate originals. This job requires two copy negatives and two work prints to scale so that the airbrusher can connect the two distinct images with a believable background. It is also possible to remove someone from a photograph with airbrushing, like that son-in-law who is no longer in the family but who is in the corner of the family portrait. It is also possible to take the middle two people out of a group of four and move the people on the ends together for a full-length portrait, or to remove the people on the ends for a portrait of the people in the middle.

Another strong technique used to change backgrounds is painting with heavy oils or acrylics. If the client does not like a background in a snapshot, you can simply (if you have the skills) paint in a new one, generally a muted studio-type background. I do a lot of wedding snapshots that people took themselves with poor background. I don't mind telling them that they should have hired a professional as I charge them a handsome fee to fix up their bad photography!

Heavy oils have a certain appeal for some clients, and you can really mark up this service. Heavy oils can also be used to make a plain snapshot into a beautiful portrait. Again, the key is a competent artist.

Hand-coloring requires diluted oil paints applied as a wash over a black-and-white print to produce pastel coloring of large areas. Many color portraits of the fifties and early sixties were hand-colored, black-and-white prints, so when restoring prints of that era, it is the medium most similar to the original. Light oils can help restore the color in badly faded color originals or can enhance a black-and-white copy. Hand-coloring with light

oils can be a very subtle and tasteful art form, if done by a competent artist with a good sense of color and a good touch.

WHERE DO I FIND A RESTORATION ARTIST? Many labs advertise complete C&R facilities and can handle any job you send them. There are companies specializing in C&R that make the same claim. Some are excellent and others produce work that looks like poorly drawn cartoon characters. Be careful. It is a jungle out there. Ideally, you should try to find an independent print finisher who also does copy and restoration work, and with whom you can establish a working relationship. There are a number of artists (99 percent women) who have their own businesses and work out of their homes. Ask around at your local and state meetings to find out who they are and get in touch with them.

When you are first getting established, you probably don't have many retouching skills yourself and you have a lot to learn about taking photographs. It is important that someday you get some training in the basic skills of retouching. If your spouse is entering the business with you, perhaps retouching is an area for him or her to learn, if he or she has the manual dexterity and color skills required. The next best thing is to train your own retoucher/finisher.

There are thousands of women in their fifties and sixties who used to work in the back rooms of large studios hand-coloring senior packages. They may still retain their touch, and the materials are still the same. Put an ad in your local paper and see if you can find one of these women who wants to come back into the work market on a part-time basis as your print finisher. There are many women out there with grown families who may want a part-time job. These people make ideal potential retouchers for you. If you can find the right person, preferably with an art background and some skill in drawing or painting, it is well worth investing money in sending her to the week-long courses previously mentioned. With some of this training, and a lot of work prints, she can develop quickly. When she progresses, hire an experienced retoucher to come to your studio to work with her on a one-to-one basis for a day or two. Invest in the basic retouching equipment, and you'll be on your way to a smoother, more professional business.

Copy and Restoration Promotions

Many studios wait until February, their slowest season, to promote copy and restoration. They run Family History Month ads in small newspapers aimed at older families. If it is possible to have your artist available for a Saturday, and you can get space in a mall, set up a work area where he or she can actually work on prints in the public view. Most consumers have no idea of what copy and restoration can do for their old photographs, and an artist working in public always draws a crowd. Have samples (the artist can provide them) of different types of jobs, before and after, and have plenty of hand-out sheets with some basic facts. It is typical to offer a reduced rate on the original copy negative or on straight copies during a promotion of this type, but don't discount the restoration work.

If you have a local genealogical society, see if you can give a talk on the history of photography and the care of old photographs. Show them how to date photographs from the different types, and show them how your copy and restoration work can save their old photographs. Also write up this talk for the local paper and submit it as an article, or see if you can get a writer to expand on the concept of the family and its fading history. This promotion got me three full pages, with my portrait, in a local paper. That same space would have cost me over $3,000 to purchase for an ad. People do read these types of articles, and they produce clients. Read the Time-Life Series volume on care of old

photographs, James M. Reilly's Kodak publication *Care and Identification of Nineteenth-Century Photographic Prints*, or Peter Turner's *History of Photography* as source book for your talks. Read and understand the materials before speaking in public. Look and act professionally and know your facts.

If you can do some basic copy work and have access to a good artist or can train your own, offer copy and restoration services to the local one-hour photo labs. They usually are not interested in doing the work on the premises, so they may act as a feeder to your business.

Digital Update

A great deal of C&R work, as well as basic portrait retouching, is being done on computers today. I think that as the equipment gets better, more and more of this type of work will be done digitally. The advantages of doing C&R digitally are numerous. You can scan the original photograph quickly, eliminating a copy setup, and the expense of developing the film and making work prints. Using the computer's color scanning layers, you can clean up a faded image very quickly and easily, usually right in front of the customer. Fixing cracks, scratches, and stains is fairly easy, even for a beginner. You can hand the original back to consumers, relieving their fears of loss of these precious photos.

When it comes to more complex restorations, such as adding or removing people from photographs, changing entire backgrounds, combining multiple images into a new whole, fixing garments and hair, etc., the computer can't be beat. I amazed myself doing these kinds of corrections at computer school. Even with very little experience and almost no skill in art techniques, I was making complex changes to some of my photographs.

Many labs are now converting their negative-retouching facilities to digital systems. Your original negative is scanned into the computer, the operator does the retouching, and a new negative is made to be sent to the lab for printing. The speed of an experienced retoucher is greatly enhanced by these machines as well as the range and precision of corrections they can do compared to using wet dyes. Digital imaging is here to stay, and you'll see your labs using it more and more. It may well be worth your while to invest in the scanning technology so that you can compete in the C&R business.

A List of Supplies Needed to Set Up a Retouching Bench
- Color pencils: Derwent, Prismacolor, Farber, Lacquer Mat
- Chalks: (various brands) soft
- Acrylic paints
- Oil paints
- Retouching spotting colors
- Flexicolor dyes
- Electric pencil sharpener
- Retouching lacquer
- Mount board
- Texturing materials
- Surface lacquers
- Folders
- Good retouching lamp—combination fluorescent and tungsten bulbs
- Drafting table and stool
- Lacquer thinner

Paperwork

*U*nfortunately, most photographers think overhead is similar to available light; they wait to compensate for it in the darkroom. Good, basic record-keeping and accounting procedures are more important to your ultimate financial success in photography than the technical skills you work so hard to develop.

The whole purpose of being in business is to earn a living, which to me means earning money, money to feed yourself and your family, and to provide yourself with the lifestyle you wish to have. As soon as you sell your first photograph, you're in business. Most photographers who fail in business do so because they can't identify the sources of their income or where they spend the money once they make it. They can understand the technical problems and find solutions, but they don't know what to charge for their work or what to do with the money they receive. The balance in the checking account and the cash in the till constitute their only measure of success in business.

In this chapter, I will outline a system of daily bookkeeping that works very well for a small studio. Larger and more sophisticated systems are available for larger, incorporated studios with many employees, but this system does the job for the smaller studio and is easily integrated with most commercially available computer accounting programs. All the paperwork forms (except the Daily Cash Sheet) are easily available from business supply houses around the country. My personal favorite is New England Business Systems (NEBS) because it has some very special preprinted forms for photographers that are very well designed. NEBS also delivers quickly and charges a reasonable price for all its materials.

Accounting Systems

There are two fundamentally different approaches to accounting procedures, the cash method and the accrual method. Large corporations use the more accurate and sophisticated accrual method. In the accrual method, accounts receivable (money owed to you but not yet collected) are considered part of your income, and accounts payable (money owed by you to other people but not yet paid) are considered expenditures. The end of each business year involves calculating all of these paper money factors accurately.

The cash method is the usual one for many small businesses and is accepted by the IRS. In the cash system, you do not have any income until you actually receive the money for the job, and you don't have an expense until you actually pay the bill. For example, you book a wedding in October to be shot the following June. Only the paid deposit shows as income for the current year. The balance, which you will collect next June, will be part of next year's income and will not figure into this year's profit/loss statement. It is possible to show a higher gross profit in the cash system by not paying any bills. Your suppliers won't like it, but the IRS will, because you'll have an artificially high net income and therefore will pay higher taxes. Conversely, to lower your net income, pay as many bills as possible at the end of the year. These practices show why the accrual method is a more accurate way of determining your actual income for a given period of time in business.

THE PURPOSE OF BOOKKEEPING AND ACCOUNTING: There are two major purposes for bookkeeping and accounting (bookkeeping is recording the facts and figures; accounting is making proper and legal sense out of the data recorded): (1) to know how well your business is doing financially and to understand your net value as a businessperson, i.e., how much your money and assets are really worth; (2) to determine your net income so that the government can tax you. The two purposes are not the same.

The government does not care how efficient you are, or how hard you had to work to earn your net income. It only wants its cut of the bottom line. Some accountants are more concerned with your tax situation than with your business health. They will set up your bookkeeping and do your accounting with only the tax implications in mind, not your overall business health. Tax accounting is vital to a photographer with a six-figure income, but for the person just going into business, your tax bill is not the most important thing to worry about. If in your first few years you have enough profit to worry about taxes, then you don't have a lot to worry about. If your accountant spends all of your time together talking about tax planning in your first few years, you have hired the wrong accountant. You need help in evaluating your various expenses and income relative to the rest of the small business world. You need to be guided in areas like cost cutting, identifying the best profit centers of your income and in planning a successful business year. Not all accountants are capable of providing this advice.

My first year in business I hired a well-known national accounting firm to do my books. It turned out that in my first year (actually nine months), I had actually made a real profit of about $2,000. With that low an income, I didn't owe any tax to the government, so I thought I was off scot-free until the accountant handed me a bill for $1,800 for his services. All of the fancy typewritten reports about my first year didn't tell me one thing about my business that I didn't already know from my daily cash sheets. For most of my first year's profit, I got nothing. You must be careful when selecting an accountant for your business. Ask around your local business community to see who other businesses use. Select a firm that deals with small businesses instead of larger firms. These accountants may not have household names, but they know your local markets and business environments better than the big firms. Consult your banker (another reason

you should deal with a commercial bank rather than a consumer bank). Banks usually know who does a good job with small businesses. If you owe the bank money, it has a vested interest in seeing you get good accounting services from a reputable and helpful accountant.

I do not want to give the impression that tax considerations are not important when first starting. You should be concerning yourself with how to save tax money in the future, when you will be earning more, as well as how to conserve your capital investment money in the present. For example, leasing a car rather than buying the car outright may pay in the long run. Leasing is more expensive, but there are tax considerations for the future, as a lease does not show up on your balance sheet as a liability. A loan for an automobile purchase is a liability. The answers to questions like this are not simple and require some calculations and a knowledge of the ever-changing tax laws. This is where an accountant can save you hundreds of dollars in the future.

Basic Bookkeeping System for a Small Studio

Let's begin with some definitions.

DAILY CASH SHEET (DCS): A daily record of the invoices and receipts as well as any petty cash spent and the deposits made to your bank. (See the DCS form at the end of the chapter.) The DCS is the heart of this bookkeeping system. It is the central point where all of your income transactions are recorded in proper chronological order. Whenever there is a question about where or when a payment was sent to you or a billing invoice was issued, it should be on the DCS. If there are missing invoice numbers indicating a nonrecording of a transaction through oversight, it can be easily identified on the DCS. You can find all important figures relative to your business income on the DCS. During an audit, the tax person can see exactly where and when your income was generated.

The DCS consists of a number of columns. Column 1 is for the invoice/receipt number. Column 2 is for the name of the client. Column 3 is for money "received on account" (ROA). An ROA is the actual money received when the invoice/receipt was written. Column 4 is for the charge total on all invoices, i.e., the new business transacted on an invoice. Column 5 is for the sales tax on the charge in Column 4. Column 6 is for any money spent from petty cash for small incidental expenses, and Columns 7 and on are for categorizing the charges in Column 4 into various subareas of the business. Typically, these columns might be headed, Portrait, Weddings, Commercial, Frames, Copy Work, Seniors, School Photography, etc. The headings will vary with the specific nature of your business, and you can have as many columns as you can fit on a piece of paper.

At the top of the DCS is a "cash-in" box. This is the amount of money in the cash drawer at the start of the business period (which can be a day, a week, or whatever). At the bottom of the page is a "cash-out" box. This is the amount of money in the cash drawer at the end of the period. There are also areas to indicate deposits. This is the amount of money you put in the bank during the business period.

If you have a studio where employees handle money, it is absolutely necessary to keep close track of the cash in the cash box. At the end of each day, count the money and leave only enough cash to make change for a normal business day. Deposit the rest in the bank. One way to check to see if anyone is stealing money is to do the arithmetic. The cash-out should equal the cash-in plus all ROAs less spents (petty cash spent) and deposits. If there is a difference of more than a few cents, then you have troubles. In certain studios in busy seasons, a lot of the ROAs are in real cash rather than checks. I know of one large studio in the Midwest that was taken for almost $500,000 in cash over three years by the nice little old lady who did the books. She was skimming the cash

and balancing the books to cover it up. Large amounts of green stuff can tempt an employee unless you are careful to let them know that you count the money every night.

In a small studio with only yourself and perhaps your spouse handling the cash, the biggest problem is yourself. I know too many photographers (including myself) who take money out of the till to meet day-to-day personal needs. You are essentially stealing from yourself when you do this. The money will show up somewhere for the tax person, but you will lose sight of how much you took. Don't do it. Put the money in the bank and pay yourself a salary. This way you can keep a good, close account of your own income, as well as of the business's expenses.

To figure out how you are doing income wise in your business, you should try the following exercises. At the end of each week (or each day if you prefer), total all the columns on the DCS. Total money collected is the ROA column; total new business, the charge column; how much you owe the state for that period, the sales tax column; how much money you put in the bank, total deposits; and how much business you did in weddings, portraits, etc., that week, in the appropriate columns. I use a blank DCS to record the daily totals and group them into months so that at the end of each calendar month I can get subtotals. I can now compare these monthly totals with previous years and also with my goals and plans for the current year. You can also get an idea of your accounts receivable by subtracting the ROA column from the charge column for the year to date.

I have found that weekly totals give me a good understanding of my cash flow and monthly totals give me a good understanding of the relative progress of my business. I feel it is worth your time and effort to calculate both these figures and record them on a regular basis.

Some Accounting Terms

Account: A defined area of concern in bookkeeping, such as rent, business expenses, portrait sales. *Credit*: To receive or add to an account (not to be confused with lending money). *Debit*: To disburse or subtract from an account.

Every transaction consists of at least one credit and one debit. For example, when you write a check, you debit the checking account balance and credit the expense account to which you paid the bill (such as rent). All debits should equal all credits to balance the accounts.

ACCOUNTS RECEIVABLE (and giving credit): Money owed to you by clients for work to be done, work in progress, or work already delivered. When you are first starting your business, do not give credit to many people. One of the hardest lessons in life is that customers can cheat you out of your money. Accepting a customer as a charge account is an act of trust. If you are operating on a shoestring, you can't afford to give much credit. For a more established business, giving credit is easier because it can afford to suffer an occasional loss. Giving credit is a studio's gamble that it can sell a client more if it extends the credit. Thus, a slight risk that clients won't pay is greatly offset by the fact that most people will pay.

It is a hard fact of life that giving credit to what appears to be the most credit-worthy clients, such as government agencies or large corporations, is very risky. Many photographers have been burned when large companies are bought and sold and the creditors are frozen out through some fancy legal moves. The government can be the slowest payer, and dealing with a government agency usually requires reams of paperwork to collect what it owes you. Open a charge card account with your bank and allow clients to charge services with their bank cards. Let the bank lend money. You should concentrate on taking the photographs you are going to sell.

CASH: The money in your possession. Cash includes credit card slips you have taken in, checks (but see below) that are made out to you and deposited, the collected balance in your accounts at the bank, as well as the green and silver stuff. It does not include money owed to you but not yet paid. Technically, a check is not your cash until it has cleared the banking system. In usual practice, you can use the money within two days of deposit for checks drawn on local banks and longer for out-of-state checks. Check with your own bank on its check collection policies. Some consumer banks won't let you use the money that deposited checks represent for up to ten days. These banks make a lot of money using your money for those ten days. Do not deal with a bank with this policy. There have been some federal laws passed recently which require banks to give you your money in a faster manner on deposited checks. Be sure to check with your bank.

CASH DRAWER OR TILL: The place where you keep the money in the studio.

CASH FLOW: The rate at which cash comes into and out of your business. When you charge out a $1,000 wedding and collect a $300 deposit, your cash flow is only $300. For many studios, the deposits on weddings are the major source of cash in the January-to-March quarter of the year. When talking about the cash available to pay your bills, charges don't count, only ROAs do.

THE CHECKBOOK/SPREADSHEET: To pay your bills, you maintain a checking account at a bank. As you pay your bills, record the amount both against the balance in the checking account (the checkbook register) and against the totals in certain areas of expense on the spreadsheet. I would strongly recommend that you use a one-write checkbook system to simplify this process. All banks issue checks in a checkbook of some type. A one-write system comes with the checks printed in sheaves which fit into a holder which also holds a ledger sheet. The back of each check, where you write the name of the payee, the date, and the amount of the check, is carbon-copied, and as you write the check out, it automatically gets written in the checkbook ledger sheet (or *spreadsheet,* to use today's computer terminology). The ledger sheet has a number of columns so that you can then spread out the expenses over a number of defined areas. NEBS sells one-write check systems and all of the accessory items to help you get your bookkeeping system going.

DEPOSIT: A transfer of cash from the till to the business checking account at the bank.

INVOICE: A bill for services and/or products delivered, or to be delivered at a future date. This invoice is the legal document describing what you are selling to the client. It should list the services provided to the client in detail, with a specific list of what products the client will receive. Invoices can be considered legal contracts, and should be treated with a great deal of respect when you are writing them out. A commercial studio invoice should specify what reproduction rights are being sold, as well as the expenses for labor and materials. If you plan on using the client's images in advertising or promotion, get a signed release giving the customer's permission for you to do so. The NEBS portrait studio invoice has this feature built in on the bottom.

An invoice charges the amount listed to the client. Because of the nature of photography, my studio uses two types of invoice forms: one for jobs in which negatives or original materials are to be filed, and one for smaller sales not requiring filing of original materials, such as copy work or frames. NEBS makes a great portrait invoice form which also acts as an invoice, receipt, and a storage envelope all in one. These forms are relatively expensive, so I wouldn't use one to write up a five-dollar frame sale. I also keep 4 × 6 triplicate countertop receipts on the sales desk for small purchases and for use as receipts for cash received on account for orders in progress that were billed out on a previous invoice. This procedure can lead to some confusion, but if you order both sets of invoices with widely different starting numbers, it is easy to keep them separated in practice.

Triplicate invoices are usually white, pink, and yellow. The white, or top copy, is for the customer. The yellow copy is your permanent record and should be kept in strict numerical sequence so it can be found quickly for tax audits or easy reference for billing questions. The pink copy can be used as a work order to accompany the order in the various steps of the processing right through customer pickup. If an order is not paid in full, we keep the pink copy in an accounts receivable file until it is paid.

PETTY CASH SPENT: When you take money from the till for small purchases for the business, such as stamps, the UPS delivery person, or pens for the desk, enter a "spent" notation on the DCS. Many businesses have a petty cash slip on which to record how much and for what the cash was spent. At the end of an accounting period, these slips are used to calculate where in the expense spreadsheet these costs go.

RECEIPT: A document recording the receipt of cash during any transactions. Sometimes an invoice is also a receipt for payment or partial payment of charges.

SALES TAX: If you live in a sales tax state, you have to collect the tax for the Department of Revenue. You must add a certain percent to the invoice for certain products and services, and periodically send the money to the state revenue office. This is not your money; it is that of the state. Keep very careful accounting of this money to avoid confusion and to avoid problems. It is advisable to set up a separate checking account for sales tax receipts. At the end of each week, write a check from your regular business account to the tax account to cover the taxes collected during the week. Most states require quarterly sales tax payments. At the end of each quarter, write a check from the tax account to pay your tax bill.

Using the System

Procedurally, here is how the system works. Every time you do a job or sell a product, write an invoice and enter the amount of the total billing in the charge column of the DCS. If there is a sales tax, figure it separately and enter it in the sales tax column of the DCS and on the invoice. All your invoices should be used in sequence. If you make a mistake and mess up an invoice, mark it "void" on the DCS. Tax auditors do not like to see missing invoices when they are searching through your records. It is a good practice to keep voided invoices in the file until you are sure you will not be audited (typically a seven-year maximum). If the customer gives you some money (cash) at the time the order is placed, also write it on the invoice as ROA. Anytime an invoice is written, there are four areas to be entered on the DCS: ROA, charge out, sales tax, and an entry of the charge under the spreadsheet column for the type of business it represents.

Anytime there is a new charge, there is a sales tax (in sales tax states), unless the sale is exempt for some reason. Make a note of the reason for any exemption on the invoice and on the DCS if an exemption is granted. The state usually takes a dim view of exemptions that you don't remember the reason for granting. You may have to pay the sales tax from your own pocket if you make this mistake. Each state has its own rules on what is exempt and what is not. Write to your state's department of revenue and ask for a list of eligible exemptions and how you are required to document granting a sales-tax exemption. Our state requires a form to be on file for any client you do not charge sales tax. If there is no form when they do an audit, you pay the tax out of your pocket.

Now let's go through some typical transactions (all for a 5 percent sales tax state):

A wedding signs up in May for an October date for $1,000. The couple gives you a $300 deposit. ROA = $300, charge = $1,000, tax = $50, wedding column = $1,000.

Note: if a wedding signs up for a date in the next fiscal quarter, such as signing up in September for the following March, I would not recommend entering the whole amount

as a charge because you would have to pay the sales tax at the end of the current quarter. We now just enter the deposit as a ROA and charge out the entire cost of the wedding when the final bill is paid. Many of our weddings sign up eight to twelve months ahead of their date and this lets me keep the sales tax in my bank account drawing interest instead of in the state's coffers.

You do a commercial shoot. Invoice two hours of labor, three rolls of film, and processing. ROA = 0, charge = $326.50, tax = $16.33, commercial column = $326.50.

A portrait customer comes in and picks up a finished order placed three weeks ago. The balance due on the order is $226. The client also buys a 16 × 20 frame to go with the order for $60. ROA = $289 (226 + 60 + 3), charge = $60, tax = $3, frame column = $60.

You receive a check for $74.15 from Acme Realty for a job previously invoiced out and delivered. Acme says that by mistake you charged for an extra print (billed out at $30) not ordered. You credit the account for the mistake. ROA = $74.15, charge = CR ($30), tax = CR ($1.50), commercial column = CR ($30).

In accounting, a negative number is written CR ($X), i.e., a credit in a debit column.

The UPS person delivers a package, and there is $3.15 due for shipping. You pay the delivery person from the till: Spent = $3.15.

At the end of the day, total the columns and count the money in the drawer, then make out a deposit slip for the checks and large amounts of cash. At the end of every week, take your daily totals and transfer them to a master DCS. Total all columns for the week. Also use a separate master sheet to run monthly totals, since weekly and monthly periods don't overlap. I found that a week-by-week plot gives me the information on cash flow to understand where I'm at relative to my ability to pay bills and pay myself. The monthly totals show seasonal variations, reflect real growth or decline in specific business areas, and also allow me to see how the year is progressing relative to my business plan.

The Checkbook

A separate record-keeping document is the checkbook. Every major expenditure should be paid by check, including your salary. The one-write check system makes bookkeeping easier and I strongly recommend you use it (see the NEBS catalog for details). After each check is written, enter the amount into the appropriate expense column (e.g., rent, supplies, lab expenses). Enter deposits as they are made in the appropriate column to keep an accurate current balance. At the end of each month, when the bank sends your statement and canceled checks, justify your calculated balance with the bank's balance to check for errors or mistakes. You should also enter the bank's monthly service charges plus any bank debits or credits (such as charge card charges or bad checks).

You may wish to begin with a computer-based, check-writing system. There are a number of excellent software programs available. One of the most popular is Quicken, which is available for either Macintosh or IBM computers. This program does many of the bookkeeping tasks detailed above at the instant you write the check, which saves time on paperwork. Quicken also interfaces with various tax-preparation programs at year-end to assist you in calculating your taxes.

At the end of each month, total up the columns in the spreadsheet and enter them on a master spreadsheet to get total expenses to date for the year. From these figures you can now estimate your gross profit to date. This is simply the gross income (ROAs, not charges) minus gross expenditures, or income minus expenses.

Depreciation is an accounting term which allows you to "pay" for your expensive equipment over a period of time. The IRS will usually (again, check the new rules each year)

not allow you to buy $50,000 worth of equipment and treat it as a business expense in one year. Depreciation spreads the cost of the equipment over a period of three to six years (or whatever the useful life of the equipment is). For example, you buy a new camera system for $15,000 on December 15. Current IRS rules (which do change every year) allow you to depreciate the item over three years on a straight line basis, or to deduct as an expense $5,000 for the current year, $5,000 for the next year, and $5,000 again for the year after that. If, at the end of this period, or anytime thereafter, you sell the equipment, at any price, the money you receive must be treated as income. The rules on depreciation change every year. For more accurate and current information, get the current IRS pamphlet on depreciation, or consult an accountant. As this is written, the IRS rules allow you to expense out up to $15,000 of capital purchases in the current year instead of depreciating the cost over a period of years. Autos and computers are treated in a special manner. Again, get the current IRS publications for the current rules.

Once you've been in business for a while, plan your capital expenditures (these would include equipment, major leasehold improvement, auto [special rules], and other items) so that you have a good idea of what your depreciation will be for the year. If you have an estimate, it is possible then to estimate your net income from the gross income figures by dividing the expected depreciation by twelve months, and adding the estimate to the expense column. It is a good idea to keep a separate record of all your capital expenditures in a small ledger book. Record the purchase price of capital purchases, the date, the supplier, the invoice number, the serial number, and the amount of depreciation to be deducted in this year, the next, etc. In this way, you can calculate your total depreciation easily in the years to come.

One advantage of having a net income estimate on a month-to-month basis is that if you are drawing money for personal expenses faster than you are making it, you'll know that you are in trouble. It is not uncommon to have slow seasons, especially after the Christmas rush during the slow months of January through March. Many studios have to take more money out of the business to meet their family obligations than the business is making. The best policy is to arrange with your bank for a short-term demand loan to tide you over during the slow seasons. Banks usually understand the seasonal nature of business and will set up a reasonable plan with you. If your bank won't, you're in the wrong bank.

Paperwork: The Lifeblood of Any Business

Lee Iacocca has a saying about paperwork: "Touch it once." Of course, he has to look at a document, decide what is to be done, and then give it to the person who will actually carry out the course of action required. Lee has executive VPs, VPs, deputy department heads, etc., to actually do the work, but he starts the ball moving at the top. This practice contrasts with letting the paperwork pile up and constantly reshuffling the pile of papers without making any real decisions or starting actions that will complete a task. As a self-employed, small-studio owner, you must: (1) Read the paperwork (bills, invoices, work orders, forms, catalogs, etc.). (2) Decide what must be done to completely take care of the job. (3) Do it now. Complete the transactions.

A number of people have said, "a person's desk is a mirror image of his mind." (I hope you never see my desk.) The wealthy and successful people in the business world have clear desktops. They do what has to be done immediately. They do not create piles of paper and then waste their time restacking these piles at the start of each day. They confront the problems and make the decisions that solve them immediately.

How to Avoid Procrastination: (I'd be a charter member of the Procrastinators'

Club, but I didn't send in my dues on time.) (1) Set daily work tasks (mini-goals). Use a blackboard or desk pad to indicate what has to be done today: "Write new price list to-day"; "Get quote on insurance for equipment and arrange for policy today." Write down these necessary tasks on the work task schedule. Write down who is involved and what specific items of information or materials you will need to complete the task. Note where any materials you need are located. If you don't know, find out first.

2. Set aside a specific time each day to get the work done. If you are open for business at 9:00 A.M., come in to work at 8:30 A.M. and do the day-to-day paperwork, or perhaps do it at lunchtime or at the close of business. Establish a pattern and make your co-work-ers aware that this is a *job*, and you should not be disturbed for unimportant reasons.

3. Organize your desk so that the information you need is readily accessible. People waste hours of time each day looking for lost scraps of paper with critical information on them. Use proper forms and write down vital information in a place you can easily find it again.

Wah Lui has an interesting system. In his desk drawer there are twenty-five folders numbered one through twenty-five. On the wall is a blackboard with the numbers one through twenty-five written on them. When opening the morning mail (he runs a very large operation with many studios and employees) he might get a letter requiring some action (customer relations, new equipment offer, speaking engagement, etc.). He puts the information into the first available folder and writes on the blackboard what is in that folder. At the end of opening the mail, he looks at the blackboard and starts the tasks on the blackboard. Some things may require a number of days to complete or further information to be gathered from other files. Some items can be taken care of with a phone call or a jiffy note, and they are quickly completed. As the folder is emptied, it is erased from the blackboard. Until the job is complete, all information is kept in the folder and on the board. At a glance, Wah knows what he has to do in the morning and where the information at hand is located. If he has a speaking engagement in Ohio, he has the of-fer letter, his airline schedule, and any other information in the folder and on the board.

4. The key is organizing the work. Paying bills should be highly organized, especially if you are living on a day-to-day basis waiting for the cash to come in to pay outstand-ing bills. Bills have due dates, and some suppliers will give you a small discount to pay early. All bills will specify what time they will give you before they expect to be paid. When you get a bill, put it on a clipboard with the due date and amount due written on the outside of the envelope. Pay the bills in the order they are due. If it is difficult to make a payment when it is due, hold on to it for the period prescribed on the invoice. If you cannot pay the bill for a period of thirty days, do one of two things: (1) call the supplier and tell them exactly when you will pay the bill, or (2) go to the bank and borrow the money on a short-term note. With important suppliers, such as your lab or your film/ frame sales houses, pay them as promptly as possible. These business are not in the loan business, banks are. Sometimes suppliers will give you the extra thirty days, but ask for it first, don't assume they will give it to you.

5. In addition to organizing things to be done, it is critical to file away the results of your paperwork. Your own business receipts and invoices should be in one place, filed chronologically by number. Paid bills should be filed alphabetically in an accordion file so that they can be located quickly. Even a catalog for a product you don't want now should be filed somewhere where it can be found. I have cardboard magazine files where I put these catalogs when they come in the mail. Every so often, I weed out the old stuff, but I know where they are. Catalogs from companies I deal with on a regular basis are filed in a file drawer with the appropriate order forms, newsletters, etc. File magazines you have read so that you can find them easily if you have to refer to an advertisement

or a technical article. Inexpensive cardboard magazine files on a bookshelf are adequate. Every year, go through the magazines and cut out the good articles or interesting photographs and create a clip file in a folder. A year's worth of magazines that take up a couple of feet of shelf space can be reduced to less than an inch of file space.

6. Periodically purge your files. Every so often, go through your various files and discard useless or dated information. If you get a new catalog, throw out the old one. If you have saved information about an upcoming convention, throw it out after the convention date has passed. Letters of inquiry or of response should be deep-filed after twelve months, and dead-filed after twenty-four months.

Check with the IRS and with your state office of revenue as to how long you have to keep your invoices and receipts and canceled checks. After two years, put them in clearly labeled transfer case files, and store them in the cellar or attic. Clearly labeled, they are readily available for a tax audit, but out of your way on a day-to-day basis. Long-term information, which includes profit and loss statements, bank statements, canceled checks, bills, ledgers, daily cash sheets, etc., should be kept forever and ever (at least seven years) in a safe place.

If all of this sounds boring, try spending two hours in the middle of your busiest shooting day trying to find a canceled check to prove to an irate supplier you have paid a bill. That's a waste of valuable time, very frustrating, and it makes you look inept. You might also lose a job because you couldn't find the proper technical information to successfully bid on it. An interesting example of this type happened to me once. A good friend of mine got a call to photograph a commercial airliner for a local airline. We had both seen Bud Shannon talk about how to do this but couldn't remember the exact details. I had my clip files and there was the article Bud had written in *Professional Photographer* magazine. My friend saved hours of time looking and experimenting with technique. Filing pays off: not now, but in the future, when your time is even more valuable.

COMPUTER FILES: The computer is a useless filing tool unless you sit down and enter the appropriate data on a regular basis. If you first fill out paper records and then have to take time to enter the data into the computer, you have actually doubled your workload. If you are going to computerize your business, look seriously at getting a software package which allows you to use your computer as a point of sale device. *Point of sale* means that you actually bill everything out to the client on the computer while taking the order. The computer then will print the invoice, debit and credit the various accounts on the DCS, keep track of inventory, and all other areas of your business that you want tracked. There are sophisticated systems on the market for most of the popular computer brands. By doing all your invoicing through the computer, you are forced to keep good records with only one entry of data into the machine, a tremendous labor-saving device. There are also some very well-designed hardware/software combinations made specifically for photography studios. If you don't want to waste time selecting a brand of computer and then researching the best software and adapting it to your business, it may be worthwhile to investigate these totally designed systems. They are not cheap, but they will be working for you minutes after they are installed in your studio.

If you don't have any experience with computers and have not bought one, I strongly suggest that you look into a system which has been designed specifically for photography studios. Larry McHugh of Lawrence, Massachusetts, has such a system, called Photofocus. Larry is one of the best business-minded photographers I know, and he also runs a good-quality photography studio. He devoted over 10,000 man-hours developing the software in his system, and then finding the right hardware to run it effectively. The beauty of the system is that it can be installed and running in your business in a matter of one or two days. You don't need to learn any obscure language or learn the

ins and outs of the general software available in the more well-known brand names. Trying to adapt someone else's programs to your specific business needs takes a lot of time and effort, and it is time which you should spend on photography, not software. The system is expensive, about $10,000 to $20,000, but it is complete and gives you all of the important business information you will need in your business. I wouldn't jump into purchasing the computer until you get your business off the ground. In a year or two, as your volume starts to grow, it is an investment well worth investigating.

A great book on how to organize your paperwork is *Organized to Be the Best*, by Susan Silver. She covers the basics (mastering your desktop) to the complex (organizing your computer files).

Areas of Paperwork

GENERAL BUSINESS
1. Checkbook and bank statement
2. Accounts payable (who you owe)
3. Accounts receivable (who owes you)
4. Brochures, price lists, logos, contracts
5. Taxes—state, federal, withholding, sales, income, social security
6. Ledgers and business statements, wages paid
7. General correspondence (in and out)
8. Mailing lists, prospecting files, contact articles
9. Inventory: stock and capital equipment
10. Equipment catalogs, technical information, frame/album catalogs, and order forms
11. Magazines and newsletters for organizations
12. Insurance papers

PHOTOGRAPHIC FILING
1. Invoices and receipts
2. Negative storage: work-in-progress and long-term storage
3. Transparency filing
4. Samples, display prints, competition prints
5. Work-in-progress and sent to lab/retoucher
6. Completed orders
7. Albums in progress

PERSONAL RECORDS
1. Taxes—state and local
2. Birth certificates, passports, discharge papers, etc.
3. Insurance papers, home inventory
4. Family photographs and negatives

How to Organize It

1. CHECKBOOK: Keep all canceled checks in an accordion file made for this purpose in numerical sequence. Keep monthly statements in a file folder. At the end of each month, justify (i.e., check your balance with the bank's) the account and check for errors. If there is any discrepancy, consult your bank and find out why.

2. ACCOUNTS PAYABLE: Keep invoices on clipboard until paid, and then file them in accordion file alphabetically. Each year start a new file.

3. ACCOUNTS RECEIVABLE: Keep pink copy (work order) of your billing invoice on clipboard until paid. Every month (minimum) send out a statement to account showing balance due. If account is over sixty days late, start phoning. That's your money out there. Use "friendly reminder" notes.

4. BROCHURES, PRICE LIST, ETC.: Keep all master copies of your written information in a file folder. Keep old price lists in separate files for future reference. Keep copies of logos, membership decals, etc., in one folder for your printer. If on computer, keep backup copies of all information just in case of loss of memory.

5. TAXES: Keep copies of all past years in separate folders clearly labeled by years. Keep state and federal taxes separate. You need your past history for audits, for your accountant and for your banker at different times. Keep separate receipts for sales tax collected and paid to the state, as well as any exemption certificates you may receive.

6. LEDGERS, WAGE AND HOUR BOOKS (IF YOU HAVE EMPLOYEES), AND STATEMENTS: These are the documents the tax person wants to see and your banker periodically needs. If prepared by an accountant, make sure he or she has copies on file in his or her office. Statements should be copied to have ready to show anyone you need to show. Ledgers can be purchased at business stores. Consult an accountant.

7. CORRESPONDENCE: Every letter you've received requiring attention should be in a "correspondence in" file. After six months, throw out outdated ones. Keep every letter you have written for at least the period under discussion in a "correspondence out" file, especially if the letter quotes prices for services. Purge the file yearly.

8. MAILING LISTS, CUSTOMER CONTACTS: If you have created a mailing list, keep it in one file and update it periodically. If you clip engagement announcements or have other means of getting contacts, keep them for a while to avoid duplicating mailings. If on computer, keep backup copies of all files in a safe place.

9. INVENTORY STOCK: At least once a year (usually on January 2), count all stock in the studio: frames, mounts, folders, albums, sample frames, film, paper, etc., and calculate the value of the stock. If you have employees, you may wish to take inventory more often to check for theft. If dealing with expensive frames, it may be worthwhile to record receipts of new stock and sale of existing stock in a stock book to keep tight control. Some computer programs are designed to keep a running inventory for you, but you have to enter the data as it becomes available.

Equipment/capital items: In a small ledger, record equipment, serial numbers, date purchased, invoice number, where purchased, and the price. As you acquire new equipment, record it. As you sell older equipment, record the sale price in the book. If you donate junk equipment to a school or charity, record where and when for tax purposes. This is all vital information for income taxes, depreciation calculation, and insurance claims in case of loss. If you have your camera stolen and can't prove ownership, your claim will not be paid. In equipment inventory, spread out each year's depreciation amount so you know at a glance what your depreciation is for the coming year.

10. CATALOGS, TECHNICAL INFORMATION, ETC.: Keep your catalogs in magazine files in one place. When you need to order something, you need the catalog. When you get a new one, throw out the old one. Same with tech data. If special order pads are needed, keep them with the catalogs in the files.

11. MAGAZINES, NEWSLETTERS: Keep a year's worth in magazine files. At end of year, clip good stuff, put it in a clip file, and file the remainder in the renewable rotary file, also known as the garbage can.

12. INSURANCE PAPERS: Keep all insurance policies and information in one spot. Update as new policies come into effect. Keep auto, life, equipment, and liability policies in separate files.

I like the pocket-style file folders because things can't fall out easily. All files should be in a file drawer, arranged alphabetically or by some other system. I have two levels, current files and older files. The key is all of the information is in one file.

Photographic Materials Files

These files are your day-to-day working sources. It is where you store your negatives, transparencies, or anything else related to your work in progress. As you do each job, you must do five things: (1) Invoice the job, entering it on the DCS. (2) Create a file number for the materials produced by the job: negatives, slides, prints, etc. (3) Mark and label a holder for the materials involved. (4) Actually place the materials in the file and file it properly. (5) Cross-reference the file number with a name file. (The simplest numbering system uses the invoice number as the file number. The invoices should be used sequentially, so your file will be sequential chronologically as well as numerically. Some studios use a number with the date included, such as wedding number 87-3, i.e., the third wedding in 1987 or 87-6-3, the third wedding in June of 1987. However, this method involves creating and maintaining cross-reference files for matching names with numbers.)

Most people can remember when you did work for them, so keeping files in a chronological sequence makes sense. This is especially true with weddings, as everyone involved in a wedding party remembers the exact date. Weddings are complicated to file by name, as there are two family names involved, and with divorces and remarriages of the parents there can be four significant file names to deal with. The date system is the easiest for weddings. Weddings usually require a larger storage box than your typical portrait or senior sitting. There may be three hundred negatives in glassines, copies of contracts, price lists, order forms, some old proofs, some written correspondence, etc. We use a small box to keep all of this together, and have found that they stack easily and are easy to use.

We use the NEBS Portrait Invoice for the majority of our portrait work. This form has all of the information recorded in triplicate, and the fourth form is actually a storage envelope large enough for the negatives and some 4×5 proofs. It is not adequate for a sitting with over thirty-five 6×7 negatives, which is not that common. We use the invoice number as the file number.

File commercial accounts by invoice number. The only confusing part is when you do a given job that is billed out over a number of invoices. Some large commercial shoots, or a large commercial client for whom you do a lot of separate jobs, are billed out as you progress. Each invoice should be quite clear on what part of the job, or which specific job was billed out. This information must be carried over into your filing system. If you have one or two large accounts, it may be worth having a separate section in your file box or drawer just for them, with each job clearly marked by date, invoice number, and job description. Just make sure when using a separate file that all invoices are entered on the DCS when they are invoiced out.

WHERE TO KEEP THE FILES: In our studio we have four levels of filing. We do mostly portraits/weddings, but I think this general system will work for a commercial studio also. When a client comes in for the sitting or shoot, we invoice the job, enter it on the DCS, and place the invoice form in a "being proofed" box. When the proofs are completed, we file the negatives, deliver the proofs, and place the file into a "proof out" box. When an order is received, the file is removed, the work started, and the file is placed into a "work in progress" box. When the work comes back from the lab, is finished, and then delivered to the client, the file is placed in the permanent working file in strict nu-

merical sequence by its original invoice number. The only exceptions are (1) weddings, which are stored in boxes in the same manner as above (i.e., being proofed, proofs out, work in progress) and (2) our high school seniors. We do two schools on contract and have found it easier to maintain two separate file boxes for each year's corps of seniors. Each school box has the same divisions as above (being proofed, proofs out, in progress, and to be filed). The only other difference is that the box is kept on the current shelf until the end of the school year. Then it is put in the permanent file as a unit. If a senior calls back for a reorder after a number of years, we just have to ask what year and from which school he or she graduated to easily find the file. All individual units are billed out by invoice number and entered on the DCS as any other job.

In reality, after six to twelve months (except for weddings) most portrait negatives can be deep-filed. We keep weddings in the current files for twelve to eighteen months. Commercial jobs involving transparencies are usually not needed after the film is delivered, except for billing purposes. Jobs that have negatives need to be available easily for some period of time. Each client is different in this regard. I have one small commercial client who has ordered fifty new prints every year for the last seven years from the same negative.

It is important to file written information concerning specific jobs with the materials from that job. Sometimes a commercial job will involve getting quotes for outside services, and correspondence with the client or suppliers over important details. All of this information should be filed for easy access in case of future problems. If there is a lot of paperwork, a 9 × 12 manila envelope would serve better than the typical 5 × 7 envelope required for most portrait jobs. Having different size filing envelopes can make the file drawer quite messy.

Negatives should be filed in materials which are safe for long-term storage. I had a whole summer's worth of family work almost destroyed when we had an unusually long period of very humid weather. The particular batch of negative glassines I had used had excess glue on them, and the excess humidity that summer caused the glue to stick to the negatives. What a disaster. Care must be taken for good-quality storage devices. If you are concerned with the longevity of your negative, you should consult publications on archival storage techniques and materials. You will find a number of techniques and materials available to you.

Another area to organize is your sample prints or the extra prints you have of an order. I am always making extra copies of prints being ordered. Many times we will get an order a few months later for another 5 × 7, and we will have the print already in the file. This saves a lot of work if we can find the original easily. We keep extra prints by type in jacket file folders, e.g., weddings, families, seniors. We just have to look in that folder or box (for seniors) to see if it is there. When it is, it's like finding a $20 bill on the sidewalk!

We store our large samples by type and size. Some studios will run a sample sale promotion in their slow months to make some money from wall samples that are getting a little stale. The samples are still valuable to the client, and they are usually offered at a 33 to 50 percent discount, frames not included. In this way, you can raise money to buy new and larger wall samples to keep your displays looking fresh and current. This only works with good filing, so do your paperwork.

DAILY CASH SHEET: a record of the day-to-day transactions of

DATE _____ **CASH IN =** _____

INVOICE	CUSTOMER NAME	RCV ON ACCT	CHARGE	TAX	SPENT	PORTRAIT	SENIORS	WEDDINGS	FRAMES	COMMERCIAL	MISC.
TOTALS FOR											
DEPOSITS											
CASH OUT											

Sources of Information

In this chapter, you will find a list of some suppliers where you can get both everyday and hard-to-find products and services for your new studio. I have listed national, regional, and state photographers organizations. Contact the state organization for a list of sectional groups in your area. I have also listed many of the books referenced throughout *The Business of Studio Photography.* If the book is available in bookstores, I have indicated the publisher and date of publication. If the book is available only through the publisher, I have given the name and address of the publisher.

Professional Photography Associations

NATIONAL ASSOCIATIONS

American Society of Media Photographers (ASMP) (609) 799-8300
14 Washington Road, Suite 502, Princeton Junction, NJ 08550-1033
Great books on pricing commercial work on copyrights, well worth owning.

Evidence Photographers International Council (EPIC) (800) 356-EPIC
600 Main Street, Honesdale, PA 18431

Professional Photographers of America (PPofA) (404) 522-8600
57 Forsyth Street NW, Suite 1600, Atlanta, GA 30303
Annual five-day convention in July or August. Annual dues $272, including indemnification insurance and monthly magazine, The Professional Photographer. *Some courses offered throughout year.*

Professional Photographers of Canada (PPOC)　　　　　　　(519) 284-1388
Ms. Felicity Powell, Box 2740, St. Marys, Ontario N4X 1A5, Canada

Wedding and Portrait Photographers International (WPPI)　　(310) 451-0090
1312 Lincoln Boulevard, Box 2003, Santa Monica, CA 90406
Annual convention in March. Annual dues $70, includes subscription to Rangefinder *and monthly newsletter.*

REGIONAL ASSOCIATIONS

Associated Professional Photographers of Illinois
Serves Illinois.

Heart of America Region　　　　　　　　　　　　　　　(316) 624-4102
Mr. Stephen L. Harvey, Executive Director, Box 1163, Liberal, KS 67905
No dues for members of state associations in region. Biennial five-day convention in April held in Kansas City or Omaha. Serves Kansas, Iowa, Missouri, Nebraska.

Intermountain Professional Photographers Association　　　(801) 364-6645
Mr. Drake Busath, 701 East South Temple, Salt Lake City, UT 84102

Mid-East States PPA
Serves Ohio, West Virginia, Indiana, Kentucky, Michigan, Pennsylvania.

Northern Lights Region　　　　　　　　　　　　　　　(507) 238-2969
Ms. Pam Carlson, 525 Tilden, Fairmont, MN 56031
No dues to member of state/provincial associations. Semiannual, four-day convention in winter/ spring season. Serves South Dakota, North Dakota, Minnesota, Manitoba.

Professional Photographers of New England (PPANE)　　　(203) 423-1402
Mr. Roland Laramie, Executive Director, 98 Windham Street, Willimantic, CT 06226
Annual dues of $70, includes convention and seminar. Annual four-day convention in September. Annual two-day seminar in summer. Annual five-day school (NEIPP) in March. Serves Connecticut, Rhode Island, Massachusetts, Vermont, New Hampshire, Maine, Quebec, and Maritime Provinces.

Professional Photographers Society of New York　　　　　(518) 283-8089
Ms. Christine M. Paulsen, Executive Director, 3 Douglas Avenue, Rensselaer, NY 12144
Annual dues of $95. Monthly meetings plus four-day convention in March. Annual school. Serves New York, New Jersey, and Ontario.

Rocky Mountain Photographers Association　　　　　　　(406) 587-1300
Mr. Duncan MacNab, Box 638, Bozeman, MT 59715
Annual four-day convention in February. Serves Wyoming, Utah, Colorado, Montana, Idaho, Alberta.

Southeast Professional Photographers Associations (SEPPA)　(803) 582-3115
Mr. Randy Bradford, Box 3191, Spartanburg, SC 29304
Annual convention. Serves Delaware; Washington, DC; Florida; Alabama; Georgia; Virginia; North Carolina; South Carolina; Tennessee; Mississippi; Puerto Rico.

Southwest Photographers Association (SWPPA)　　　　　　　(412) 869-9281
Serves Texas, Oklahoma, Arkansas, Louisiana, New Mexico, Mexico.

Triangle Professional Photographers Association
Mr. Sam Pelaia, 441 State Street, Baden, PA 15005
Runs annual school in January. Serves parts of Pennsylvania, Ohio, Kentucky.

Western States Photographers Association
Serves California, Alaska, Arizona, Hawaii, Nevada, Oregon, Washington, British Columbia.

Wisconsin Professional Photographers Association
Serves Wisconsin.

STATE ASSOCIATIONS

Alabama (*See* Mississippi/Alabama)

Arizona Professional Photographers Association　　　　　　(602) 493-1833
Mr. Thomas Cleswick, Box 54007, Phoenix, AZ 85078
Dues $50, six meetings per year, annual three-day convention in spring.

Arkansas Professional Photographers Association　　　　　　(501) 946-1641
Mr. Ralph Relyea, 424 Court Square, DeWitt, AR 72042

Professional Photographers of California　　　　　　　　　(415) 626-2525
Mr. Alessandro Baccari, 1873 Market Street, Suite 3, San Francisco, CA 94103

Professional Photographers of the Greater Bay Area　　　　(304) 599-3840
Mr. Fred English, Business Manager, 251 Fifth Avenue, Redwood City, CA 94063
Dues $95. Eleven meetings per year, no annual convention. Sponsors week-long school.

PP of Colorado　　　　　　　　　　　　　　　　　　　(303) 848-2326
Beverly Arnold, 713 South Fir, Yuma, CO 80759

Connecticut Professional Photographers Association　　　　(203) 388-3573
Mr. Roland Laine, Executive Director, 392 Main Street, Old Saybrook, CT 06475

Professional Photographers of Delaware　　　　　　　　　(302) 934-9366
Nick Varrato, Box 138, Millsboro, DE 19966

Florida Professional Photographers, Inc.　　　　　　　　　(813) 872-0532
Ms. Theresa A. Saylor, Executive Director, 2312 Farwell Drive, Tampa, FL 33603
Dues $105. Four meetings per year, annual four-day convention in September. Annual school.

Georgia Professional Photographers Association　　　　　　(912) 264-2037
Ruth Caples, 805 George Street, Brunswick, GA 31520

Professional Photographers of Hawaii　　　　　　　　　　(808) 591-9044
Dwight Okumoto, 1236 Waimanu Street, Suite B, Honolulu, HI, 96814

Professional Photographers of Idaho (208) 529-1988
Mr. Leon Larsen, 312 North Ridge, Idaho Falls, ID 83402
Dues $30. Four meetings a year, annual three-day convention in February.

Associated Professional Photographers of Illinois (217) 422-2212
D. R. Roberts, 1270 North Edward, Decatur, IL 62526

Professional Photographers of Indiana (317) 398-2221
Jerry Kinder, Box 848, Shelbyville, IN 46176

Professional Photographers of Iowa (515) 276-8318
Jan Sigler, Box 3674, Urbandale, IA 50322

Kansas Professional Photographers Association (316) 722-3585
John Alt, Box 9552, Wichita, KS 67212

Kentucky Professional Photographers Association (606) 278-5309
Carol McCaslin, 1730 Normandy Road, Lexington, KY 40504

Professional Photographers of Louisiana (504) 626-8526
Emile Narvarre, 1200 West Causeway, #19, Mandeville, LA 70448

Maine Professional Photographers Association (207) 839-8441
Ms. Pat Lawton, Secretary, 3 Burnham Road, Gorham, ME 04038
Dues $110. Six meeting a year. Annual three- or four-day convention in February.

Professional Photographers of Massachusetts (PPAM) (617) 828-6675
Mrs. Mary Ann Nourse, Secretary-Treasurer, 943 Washington Street, Canton, MA 02021
Dues $110. Six meetings a year. Annual four-day convention in March.

Maryland Professional Photographers Association, Inc. (410) 974-1751
Ms. Vivian Vizzini, 1250 Masters Drive, Arnold, MD 21012
Dues $130. Twelve meetings per year. Annual four-day convention in January.

Professional Photographers of Michigan (313) 283-8433
Mr. Ron Tocco, 15777 Eureka, Southgate, MI 48195
Dues $180. Two meetings per year. Annual five-day convention in April. Must be full-time photographer.

Minnesota Professional Photographers Association (507) 238-2969
Ms. Pam Carlson, Executive Secretary, 525 Tilden Street, Fairmont, MN 56031
Dues $140. Three meetings per year. Annual four-day convention in the spring.

Professional Photographers of Mississippi and Alabama (601) 624-2667
Chuck Lamb, 108 Leflore Avenue, Clarksdale, MS 38614

Professional Photographers Association of Missouri (816) 425-6335
Tom Strade, Box 443, Bethany, MO 64424

Montana Professional Photographers Association (406) 452-6300
John Metcalf, 2815 10 Avenue South, Great Falls, MT 59405

Professional Photographers of Nebraska (308) 537-3552
Donnis Hueftle-Bullock, Box 253, Gothenburg, NE 69138

New Hampshire Professional Photographers Association (603) 623-7912
Mrs. Jennifer Raiche, 305 Stark Lane, Manchester, NH 03102
Dues $100. Ten meetings per year, annual three-day convention in April.

Professional Photographers Association of New Jersey (908) 264-2313
Ms. Jane Pedersen, Executive Secretary, 228 Main Street, Keyport, NJ 07735
Dues $135. Eight to ten meetings a year. Annual three-day convention in September.

Professional Photographers Association of New Mexico (505) 268-8192
Carl Jamison, 4312 Lomas Boulevard, N.E., Albuquerque, NM 87110

Professional Photographers Society of New York (518) 432-9148
Shannon Leonardo, 48 Howard Street, Albany, NY 12207

Professional Photographers of North Carolina, Inc. (919) 787-0063
Mrs. Loretta Howell, Box 52179, Raleigh, NC 27612
Dues $155. Four meetings a year. Annual five-day convention in February/March. Annual week-long school.

Professional Photographers of North Dakota (701) 232-0645
Ms. Cecelia Gast, 822 10 Avenue North, Fargo, ND 58102
Dues $60. Two meetings a year. Annual three-day convention in March.

Professional Photographers Society of Ohio (216) 772-4905
Mr. Leo Wilhelm, Box 196, Hartford, OH 44424
No dues. Two meetings per year. Semiannual, three-day convention in May and October. Membership by unanimous invitation only. Only so many members per population in a given locale. Call for complete rules and restrictions.

Professional Photographers of Oklahoma (405) 949-9938
Toni Moore, 3104 North May Avenue, Oklahoma City, OK 73112

Professional Photographers of Oregon (503) 476-3229
Shirley Holzinger, Box 849, Grants Pass, OR 97526
Annual four-day convention in February.

Professional Photographers Association of Pennsylvania (301) 463-2827
Genevieve Wilt, Box 307, Barton, MD 21521
Annual four-day convention in April.

Rhode Island Professional Photographers Association (401) 351-4910
Ms. Diane Yeatman, 1408½ Atwood Avenue, Johnston, RI 02919
Annual three-day convention in January.

South Carolina Professional Photographers Association (803) 233-8934
Mark Massingill, 24 Poinsett Avenue, Greenville, SC 29601

South Dakota Professional Photographers Association (605) 853-3672
Joan Bertsch, Box 107, Miller, SD 57362

Tennessee Professional Photographers Association (901) 345-0188
Hud Andrews, 2041 Winchester Avenue, Memphis, TN 38116

Texas Professional Photographers Association (409) 830-8600
Mr. Doug Box, Box 321, Brenham, TX 77834
Dues $65. Four to seven meetings a year. Annual five-day convention in January/March. Runs annual school.

Vermont Professional Photographers Association (802) 728-9934
Mr. Arnold Spahn, 34 Pleasant Street, Randolph, VT 05060
Dues $100. Six to eight meetings a year. Annual two-day convention in May.

Professional Photographers of Washington, Inc. (206) 361-8920
Ms. Bernice Workman, 1613 N.E. 143rd Street, Seattle, WA 98125
Dues $100. Four meetings a year. Annual four-day convention in March. Runs annual school.

Professional Photographers of West Virginia, Inc. (304) 599-3840
Ms. Mary Ann Phillips, Executive Director, 1497 Eastern Avenue, Morgantown, WV 26505
Dues $50. Three meetings a year. Annual three-day convention in February.

Wisconsin Professional Photographers Association (414) 833-6357
Mr. Steve Kemp, 835 South Main Street, Seymour, WI 54165
No dues. Two meetings a year. Annual five-day convention in February/March.

Schools for the Working Professional Photographer

ANNUAL SCHOOLS: These schools usually offer five-day (forty-hour) courses. The courses are usually taught by experienced photographers/artists. Courses may also include basic studio photography, retouching, business, and marketing/selling, in addition to special weeks with "famous" photographers. Class sizes are usually small, with twenty-four to thirty students being the maximum. There are smaller class sizes offered in some advanced courses, at a higher rate, of course.

An asterisk (*) indicates that tuition includes room and board. If not marked, room and board are additional. Quoted room rates are usually for double occupancy, with an additional fee if you want a private room. The prices usually change each year, so use them for comparison only. The location and dates may also vary. I include the dates to give you an idea of what time of the year the schools usually run. Check with the registration person for the exact details of the current year.

This is the best money you can possibly spend in your professional development. Beg, borrow, or steal the money; but make the time and go. You'll not only learn from professionals, you'll make many new friends within the profession. These new contacts are as valuable as the ideas and techniques you learn from the instructors. Besides, you'll have a lot of fun. Many photographers consider school time as vacation time while they are learning. The majority of these schools are run by groups of men and women dedi-

cated to bringing good educational opportunities to photographers at rock-bottom prices. Most of the trustees of these school serve for no pay and work hard to keep the schools open and to keep the prices down. I know; I am a trustee of the New England School (NEIPP). Sign up early. Most of these schools fill up fast.

The Florida Professional Photographers School
Daytona Center for Photographic Education, Daytona Beach, FL
Registration: (800) 330-0532. Dates: May 14–18, offering six courses. Tuition: $395

The Georgia School of Professional Photography
Northern Georgia Technical Institute, Clarkesville, GA
Registration: (800) 805-5510 or (404) 844-7329. Dates: April 23–28, offering eight courses. Tuition: $395

Golden Gate School of Professional Photography
College of Notre Dame, Belmont, CA
Registration: James Inks at (800) 422-0319. Dates: June 11–16, offering eleven courses. Tuition: $350 for PPofA and CPA, $475 for nonmembers.

Illinois Workshops
Pere Marched State Park, Grafton, IL
Registration: Stephen Humphrey at (618) 327-8500. Dates: June 18–22, offering five courses. Tuition: $465

Kansas Professional Photographers School
Bethel College, Newton, KS
Registration: Gary Fail at (316) 431-1235. Dates: June 11–15, offering six courses. Tuition: $400 for whole week (half weeks available); room is $25 per night extra.

Long Island Photo Workshop
Dowling College, Oakdale, NY
Registration: Ronald Krowe at (516) 487-1313. Dates: July 10–14, offering four courses. Tuition: $425 for PPGNY and PPofA members, $475 for nonmembers.

Mid America Institute of Professional Photography
University of Northern Iowa, Cedar Falls, IA
Registration: Janet Lee at (515) 683-7824. Dates: June 4–9, offering twelve courses. Tuition: $450 PPofA or any state members, $500 for nonmembers.*

Mt. Carroll Center for Applied Photographic Art
Cambell Center for Historic Preservation Studies, Mt. Carroll, IL
Registration: Doug Bergren at (815) 946-2370. Dates: June 4–9, June 18–23, June 18–30, offering four courses. Tuition: $425 for five-day classes, $625 for twelve-day classes.

New England Institute of Professional Photography (NEIPP)
Sea Crest Resort, North Falmouth, MA
Registration: Sal Genuario at (401) 738-3778. Dates: March 26–31, offering eleven courses. Tuition: $500 to $575*, double occupancy. Higher for single-room occupancy.*

New York State School
Hobart College, Geneva, NY
Registration: Lois Miller at (716) 226-8351. Dates: August 13–19, offering four courses. Tuition: $475; $375 for early registration.

Pacific Northwest School of Professional Photography
Pacific Lutheran University, Tacoma, WA
Registration: Russell Rodgers at (206) 565-1711. Dates: June 25–29, offering six courses. Tuition: $350 members; $400 for nonmembers.

PPNC/NCSU Professional Photography Short Course
North Carolina State University, Raleigh, NC
Registration: Rex Truell at (910) 476-4938. Dates: August 28–31, offering six courses. Tuition: $395 to $595

Texas School of Professional Photography
Sam Houston State University, Huntsville, TX
Registration: Don Dickson at (806) 296-2276. Dates: April 23–28, offering twelve courses. Tuition: $350 TPPA members; $375 nonmembers.

Triangle Institute of Professional Photography
Pittsburgh Greentree Marriott, Pittsburgh, PA
Registration: Sam Pelaia at (412) 896-9281. Dates: January 22–27, offering nineteen courses. Tuition: $395 Triangle members; $425 for nonmembers. Includes meals but not room.

West Coast School *(Two sessions at different locations)*
Brooks Institute of Photography, Santa Barbara, CA
Dates: February 25 to March 3, eleven courses being offered
University of San Diego, San Diego, CA
Dates: June 25–30, eleven courses being offered. Registration: Allen Roedel at (800) 439-5839. Tuition: $425 PPC members; $490 nonmembers.

Wisconsin Indianhead Photographers School
Treehaven, University of Wisconsin-Stevens Point, WI
Registration: Dave Wacker at (715) 823-2422. Dates: May 14–17, offering four courses. Tuition: $450

Sources of Materials and Equipment

GENERAL SUPPLIERS

APEC (American Printing and Envelope Co.) (212) 475-1204
900 Broadway, NY, NY 10003
A great source for glassines, file envelopes, and other specialized items for photographers. Write for catalog. Great service.

Calumet Photographic Inc. (312) 860-7447
890 Supreme Drive, Bensenville, IL 60106
A great source for camera, darkroom, and studio equipment. Not the cheapest, but not bad. Good service and many unique products. Good library of books for sale.

F.W.I. (Far West Industries) (800) 876-0607 -
1730 East Holladay Boulevard, Salt Lake City, UT 84124
*Studio, lighting, and camera equipment at good prices. Unique posing aides, filters, stands, and
other objects. Also the source for Dave Newman's books.*

Hunt's Photo and Video (800) 924-8682
100 Main Street, Melrose, MA 02176
*Extensive line of camera and studio supplies. Great prices, good service. If you live in the East and
can get to Boston on the last weekend in October, they have the best camera-buying show I know
of. Everything at dealer net. Worth waiting for.*

NEBS (New England Business Systems) (800) 225-6380 or (800) 225-9540 -
500 Main Street, Groton, MA 01471
*The best supplier of business forms and products I know of. Many unique items, especially for
portrait photography studios. Ask for its photographer's catalog in addition to its regular catalog.
Good prices and fast service. Many one-write check systems, computer speciality forms, and com-
puter software to help with your business.*

PSS (Photographers Speciality Services) (414) 567-5213
650 Armour Street, Oconomowoc, WI 5306
Unique and hard-to-find items for the camera room and studio.

Pierce Co. (612) 884-1991 ·
9801 Nicollet Avenue, Minneapolis, MN 55420
Studio supplies, backgrounds, and framing supplies.

Porter's Camera Store (800) 553-2001
Box 628, Cedar Falls, IA 50613
A great source of small supplies for the camera and darkroom.

Spiratone, Inc. (800) 221-9695 -
135-06 Northern Boulevard, Flushing, NY 11342
Some unique lighting and camera products. Unique AV products.

Zeff Photo Supply (800) 343-5055
Box 311, Belmont, MA 02178
*Excellent supplier of film, paper, mounts, matting supplies, art supplies for photographers, and AV
products. Also has a digital service bureau. Excellent service. Call and ask Brad for a catalog.*

EQUIPMENT MANUFACTURERS

Adams Retouching Machine Co.
1036 West 8th Avenue, Denver, CO 80204
Machine for retouching negatives in studio. Requires some skill.

Arion Corporation
701 South 7th Street, Delano, MN 55328
AV equipment and dissolve units. Best quality.

Bogen Photo Corp.
565 East Cresent Avenue, Box 506, Ramsey, NJ, 07446
Light stands, tripods, studio rail systems, Metz strobes, etc. Get catalog.

Camerz
4800 Quebec Avenue N., Minneapolis, MN 55428
Long-roll cameras for school photography.

Eastman Kodak Co. (800) 242-2424
343 State Street, Rochester, NY 14650
The granddaddy of suppliers. Get in touch with your local pro rep.

Fuji Photo Film USA (800) 788-3854
555 Taxter Road, Elmsford, NY 10523

GMI Photographics
P.O. Drawer U, Farmingdale, NY 11735
Bronica distributor for USA. Great repair service and product support.

Lindahl Specialties, Inc.
Box 1365, Elkhart, IN 46515
Best bellows lens-shade system around. Also other nice studio products.

Lumedyne Inc.
6010 Wall Street, Port Richey, FL 34668
Batteries, strobe units, and accessories.

Morris Co.
1205 West Jackson Boulevard, Chicago, IL 60607
Small and inexpensive flash units that are handy for studio and location work.

Paul Buff, Inc. (800) 443-5542
2725 Bransford Avenue, Nashville, TN 37204
Makes and sells the White Lightning and Ultra Lighting units. Great buys.

Photogenic Machine Co. (800) 682-7668
525 McClurg Road, Youngstown, OH 44513
Great lighting units, studio rail systems, light stands, and other equipment for studio.

Saunders
21 Jet View Drive, Rochester, NY 14624
Rota-trim cutters and other studio and darkroom products.

Studio Dynamics
2400 Gundry, Long Beach, CA 90806
Motorized background system for studio, as well as backgrounds and studio supplies.

Tamrac (800) 662-0717
6709 Independence Avenue, Canoga Park, CA 91303
Great camera bags for pros.

Wescott Co.
Box 1596, Toledo, OH 43603
Light boxes, umbrellas, and portable reflectors and backgrounds.

ALBUMS, FRAMES, MOUNTING, AND MATTING SUPPLIES

Albums Inc. (800) 662-1000
Box 81757, Cleveland, OH 44181
Great selection of albums and mounts. Excellent service. Call for your local rep.

American Hardwood Frames (800) 426-1933
N.E. Industrial Park, Cleveland, TN 37312

Art Leather Mfg. Co. (718) 699-6300
45-10 94th Street, Elmhurst, NY 11373
*One of the best companies to deal with. Call for the number of your area rep. Area reps are usu-
ally very helpful to new studios in all matters. Great supporters of regional and state associations
and education.*

Capri Album Co.
327 Walnut Avenue, Bronx, NY 10454

CODA, Inc. (201) 825-7400
30 Industrial Avenue, Mahwah, NJ 07430
*Best mounting materials in the business. Self-adhesive Masonite, cardboard, Foamcore, etc. Also
texturing materials and machines. Great service.*

Graphik Dimensions Ltd. (800) 221-0262
41-23 Haigt Street, Flushing, NY 11255
Metal and wood frames. Good services and good prices.

Hartcraft Frames
855 Madison Drive, Hartford, WI 53027
Good line of frames and mounts.

Lacquer Mat Inc.
Box 24, Syracuse, NY 13201
Sprays, artist supplies, spray booths.

Leather Craftsman Album Co.
51 Carolyn Boulevard, Farmingdale, NY 11735

The Levin Co. (TLC) (800) 345-4999
Box 4999 Compton, CA 90220
*Excellent selection of frames and mounts. Good service and range of styles. Good prices. Call for
the number of your area rep.*

Tap-Loomis
2160 Superior Avenue, N.E., Cleveland, OH 44114
Mounts, frames, and albums.

STUDIO BACKGROUNDS

Backgrounds by David Maheu (800) 237-1883
483 Steere Farm Road, Harrisville, RI 02830
My last five backgrounds came from David. He has a wonderful sense and touch. Try Midnight Sky or Spring. Get Catalog. Also does muslins.

Bright Backgrounds (800) 821-5796 for catalog
Some very nice backgrounds.

Denny Mfg. Co. (800) 888-5616 or (800) 235-7012
Extensive line backgrounds and studio props. Call for catalog.

SPECIALIZED SUPPLIERS

American List Consel (800) 252-5478
Mailing lists of every type, including high school seniors by zip code. Good service.

Bulbman, Inc. (800) 648-1163
Bulbs of all types, cheap.

Burrell Color (800) 348-8732
1311 Merrillville Road, Crown Point, IN 46307
Wide range of services and good prices.

Caddylak (800) 523-8060
Tools for management. Time-control tools and card file systems. Get catalog.

Cardinal Comb Co. (800) 222-COMB
Supplier of bulk combs for school photography. With or without names. Cheap.

CPQ Color Lab
1525 Hardeman Lane, Cleveland, TN 37311
Wide range of services and good prices.

Don Feltner Photo Inc.
4330 Harlan Street, Wheat Ridge, CO 80033
Mailing materials for seniors and weddings. Good stuff.

Great Papers! (800) 287-8163
Beautiful papers, preformatted brochures, business cards, etc., to use with laser printers.

H&H Color Lab (800) 821-1305
Wide range of services and good prices. Limited new customer acceptance.

Impact Images (800) 233-2630
4961 Windplay Drive, El Dorado, CA 95762
Crystal Clear envelopes for packaging scenic or art prints. Good product.

Luck Color Lab (800) 763-5825
Box 4438, Cleveland, TN 37320
Wide range of services and good prices.

McGrew Color Graphics
1615 Grand Avenue, Kansas City, MO 64108
One of the better postcard printers. Write for catalog.

Marathon Press Inc.
Box 407, Norfolk, NE 68702
Postcard printers. Many exciting marketing ideas for photographers. Write for catalog.

Noteworthy Co. (800) 888-6685
100 Church Street, Amsterdam, NY 12010
Bags and products for store front.

Paper Direct (800) A-PAPERS
100 Plaza Drive, Secaucus, NJ 07094
Beautiful papers to use to promote your business. Preformatted brochures. Great service and selection.

Veach Corp. (800) 523-9944
14535 Arminta, Van Nuys, CA 91402
Gold stamping machine and gold writing pens.

Books, Magazines, and Publishers

America: What Went Wrong? Donald Barlett and James Steele. Kansas City: Andrews & McMeel, 1992.
Bottom-Up Marketing. Al Ries and Jack Trout. New York: McGraw-Hill, 1990.
Business and Legal Forms for Photographers. Tad Crawford. New York: Allworth Press, 1997.
Camera and Lens. Ansel Adams. Dobbs Ferry, NY: Morgan and Morgan, 1970.
Care and Identification of Nineteenth-Century Photographic Prints. James Reilly. Rochester, NY: Kodak Publication #G-2S, 1986.
Do-It-Yourself Marketing. David Ramacitti. New York: Amacom, 1994.
Entrepreneurship. James Holloran. New York: McGraw-Hill, 1994.
Guerrilla Financing. Bruce Blechman and Jay Levinson. New York: Houghton Mifflin, 1991.
Guerrilla Marketing. Jay Levinson. New York: Houghton Mifflin, 1993.
Horse Sense. Al Ries and Jack Trout. New York: McGraw-Hill, 1991.
How to Form Your Own Corporation Without a Lawyer for Under $75. Ted Nichols. Chicago, IL: Dearborn, 1992.
How to Master the Art of Selling. Tom Hopkins. 1980, Champion Press, Scottsdale, AZ 85252.
How to Photograph Women Beautifully. J. Barry O'Rourke. New York: Amphoto, 1986.
How to Shoot Stock Photos That Sell. Michael Heron. New York: Allworth Press, 1996.
In Business for Yourself. Bruce Williams. Lanham, MD: Scarborough House, 1991.
In Search of Excellence. Tom Peters. New York: Warner Books, 1982.
Marketing to the Affluent. Thomas Stanley. Homewood, IL: Business One Irwin, 1988.
Marketing Warfare. Al Ries and Jack Trout. New York: McGraw-Hill, 1986.
The Official Guide to Success. Tom Hopkins. 1982, Champion Press, Scottsdale, AZ 85252.
On Photography. Susan Sontag. New York: Farrar, Straus and Giorux, 1973.

The One Minute $ales Person. Spencer Johnson and Larry Wilson. New Jersey: William Morrow and Co., 1984.

Organized to Be the Best. Susan Silver. Los Angles, CA: Adams-Hall, 1991.

Passion for Excellence. Tom Peters. New York: Warner Books, 1986.

Photographic Retouching. Villa Reed. Rochester, NY: Kodak Publication #E97, 1987.

The Photoshop WOW! Book. Linnea Dayton and Jack Davis. CA: Peachpit Press, 1993.

The Portrait. Rochester, NY: Kodak Publication #O-24, 1993.

Professional Photographic Illustration Techniques. Rochester, NY: Kodak Publication #O-16, 1978.

Professional Techniques for the Wedding Photographer. George Schaub. New York: Amphoto, 1985.

Secrets of Studio Still Life Photography. Gary Perweiler. New York: Amphoto, 1984.

Shooting Your Way to a Million. Richard Sharabura. Toronto: Chatworth Books, 1981.

So You Want to Start a Business. William Delaney. Englewood, NJ: Prentice-Hall, 1984.

Starting Your Own Business. Stephen Harper. New York: McGraw-Hill, 1991.

Street Smart Marketing. Jeff Slutsky. New York: J. Wiley & Sons, 1989.

Thriving on Chaos. Tom Peters. New York: Harper & Row, 1987.

Thirty-Six Hour Marketing Course. Jeffrey Seglin. New York: McGraw-Hill, 1990.

Wedding Photography, Building a Profitable Pricing Strategy. Steve Herzog. 1992, Incite Publications, 1809 Central Avenue, Ceres, CA 95307.

● The following titles by Helen and/or Michael Boursier are available from Boursier Publications, 184 Jones Road, Falmouth, MA 02540; (800) 344-7227.

Black and White Darkroom Techniques for the Small Studio

The Cutting Edge, 105 Success Factor Rules for Faster, Higher Profits

Marketing Madness: A How-to Manual for Professional Photographers

The Modern (Hand-Colored) Black and White Portrait

Top-Ten-Marketing and Press Kit for Helen's Bestsellers

The Studio Sales Manual: How to Triple Your Sales Without Raising Prices

Super Sales Strategies: Forty Photographers Share Success Secrets

● The following titles from Studio Press, Box 160 Soulsbyville, CA 95372, and are usually not available in regular bookstores. Write for current catalog.

Family Portraiture. John Hartman, 1991.

Location Portraiture of Families and Executives. Van and Pam Frazier, 1992.

$100 an Hour Photographing Models. Art Ketchum, 1988.

Promoting Portraits. Paul Castle, 1988.

Senior Portraits. Larry Peters, 1990.

Story Telling Portraits of Children. 1993.

● Dave Newman's four-book series is available from FWI (see above), or from Dave Newman Photography, 4479 Highland Drive, Salt Lake City, UT 84124; (801) 272-8221.

Lens, published by CPQ Color Lab (see address above). Good-quality magazine, well worth the subscription.

Rangefinder, Box 1703, Santa Monica, CA 90406. A monthly magazine for Professional Photographers. Good to have. Also sponsors WPPI and many seminars around country.

Nightingale-Conant, 7300 North Lehigh, Chicago, IL 60648; (800) 323-5552. Tapes on selling, motivation, self-improvement, etc.; good stuff. Tapes by Brian Tracy, Dennis Waitley, and Zig Zigler are especially worth purchasing.

Index

Books from Allworth Press

ASMP Professional Business Practices in Photography
by the American Society of Media Photographers (softcover, 6¾ × 10, 416 pages, $24.95)

Pricing Photography, Revised Edition by Michal Heron and David MacTavish
(softcover, 11 × 8½, 144 pages, $24.95)

The Photographer's Guide to Marketing and Self-Promotion, Second Edition
by Maria Piscopo (softcover, 6¾ × 10, 176 pages, $18.95)

How to Shoot Stock Photos That Sell, Revised Edition by Michal Heron
(softcover, 8 × 10, 208 pages, $19.95)

Stock Photography Business Forms by Michal Heron
(softcover, 8½ × 11, 128 pages, $18.95)

Business and Legal Forms for Photographers by Tad Crawford
(softcover, 8½ × 11, 192 pages, $18.95)

Legal Guide for the Visual Artist, Third Edition by Tad Crawford
(softcover, 8½ × 11, 256 pages, $19.95)

The Law (in Plain English) for Photographers by Leonard DuBoff
(softcover, 6 × 9, 208 pages, $18.95)

The Copyright Guide by Lee Wilson
(softcover, 6 × 9, 192 pages, $18.95)

Mastering Black-and-White Photography by Bernhard J Suess
(softcover, 6¾ × 10, 240 pages, $18.95)

The Digital Imaging Dictionary by Joe Farace
(softcover, 6 × 9, 256 pages, $19.95)

The Photographer's Internet Handbook by Joe Farace
(softcover, 6 × 9, 224 pages, $18.95)

Overexposure: Health Hazards in Photography, Second Edition
by Susan D. Shaw and Monona Rossol (softcover, 6¾ × 10, 320 pages, $18.95)

Wedding Photography and Video: The Bride and Groom's Guide
by Chuck Delaney (softcover, 6 × 9, 160 pages, $10.95)

Please write to request our free catalog. If you wish to order a book, send your check or money order to Allworth Press, 10 East 23rd Street, Suite 210, New York, NY 10010. Include $5 for shipping and handling for the first book ordered and $1 for each additional book. Ten dollars plus $1 for each additional book if ordering from Canada. New York State residents must add sales tax.

If you wish to see our catalog on the World Wide Web, you can find us at Millennium Production's Art and Technology Web site: **http://www.arts-online.com/allworth/ home.html** or at **allworth.com**